THE

ART
BUSINESS
ENCYCLOPEDIA

Leonard DuBoff
Attorney-at-Law

ALLWORTH PRESS, NEW YORK
Copublished with the American Council for the Arts

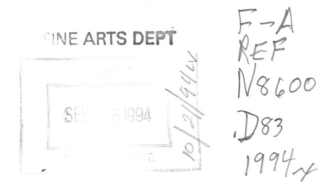

© 1994 by Leonard DuBoff

Published by Allworth Press, an imprint of
AllworthCommunications, Inc.
10 East 23rd Street, New York, NY 10010

Distributor to the trade in the United States:
Consortium Book Sales & Distribution, Inc.
1045 Westgate Drive
Saint Paul, MN 55114-0165

Distributor to the art material trade:
Arthur Schwartz & Co.
234 Meads Mountain Road
Woodstock, NY 12498

Book design by Douglas Design Associates, New York

Paperback ISBN: 1-880559-13-7

Hardcover ISBN: 1-880559-14-5

Library of Congress Catalog Card Number: 93-071921

TABLE OF CONTENTS

ACKNOWLEDGEMENTS

The task of identifying appropriate entries, researching the issues presented, compiling the material and, where appropriate, obtaining the necessary resource references could not have been completed without the help of numerous friends, colleagues, students, and other members of the art community. While it is impossible to identify all of the people who have contributed to this volume, it is nevertheless necessary to identify some of the more active ones. I would, therefore, like to express my sincere appreciation to Lynn Della for all of her help and diligence in working with me on weekends, evenings, and holidays for more than a year on this work. Her skilled hand can be observed throughout this entire book.

I would also like to thank Christy King, J.D., Northwestern School of Law of Lewis and Clark College, 1993; Michael Cragun, J.D., Northwestern School of Law of Lewis and Clark College, 1993; Carrie Majors, J.D., Northwestern School of Law of Lewis and Clark College, 1995; and Troy Bundy, J.D., Northwestern School of Law of Lewis and Clark College, 1994.

Sharon Pack of the Northwestern School of Law of Lewis and Clark College also deserves thanks for her help with the transcription of this work. Her computer skills and clever manipulation aided immensely in verifying entries and polishing this work. Both Sharon and Cynthia Peek aided in the arduous task of indexing.

Lenair Mulford, as usual, has been diligent in assisting with the transcription and editing of this work.

From time to time, it was necessary to enlist the aid of specialists in a variety of fields. I was quite fortunate to have Ormond Ormsby, a business planner and CLU, review all of the entries on insurance and provide valuable recommendations.

I was also pleased to have accountant John V. Tunison critically evaluate the accounting and financial information. His recommendations, suggestions, and corrections have added immensely to the quality of this publication. Joe Marcunuas, a CPA, was kind enough to also review the financial and tax data and provide some useful recommendations. Tax preparer David J. Switzer was helpful in examining the tax entries for completeness and accuracy in light of the new tax law.

It is also important to recognize Allworth Press and its publisher, Tad Crawford, for the insight in perceiving the need for this

book. Tad, himself an art lawyer and author, is a valuable resource. His endorsement of this volume is an appreciated accolade.

I have also been fortunate to have friends in the museum community review this manuscript and provide me with dome extraordinarily valuable insight. George Hicks, director of the Airmen Memorial Museum, spent countless hours sifting through this manuscript and recommending additions and deletions. Dan Monroe, director of the Peabody Essex Museum and president of the American Association of Museums, was also kind enough to review the manuscript and recommended some additional and deletions. Their contributions have certainly added to the quality of this work.

My children, Colleen Rose DuBoff, Robert Courtney DuBoff and Sabrina Ashley DuBoff, have also helped with this work. In addition to actually assisting with some of the research, they were able to provide some useful insight and, on many occasions, afford me the time to work on this book. Finally, it is clear that *The Art Business Encyclopedia* would never have become a reality without the tireless aid and support of my wife, Mary Ann Crawford DuBoff. Her attention to detail and participation in this project, as with all of my projects, helped make it happen.

INTRODUCTION

More than two decades ago, I realized that the amalgamation of art and law was inevitable and necessary. I was fortunate to be in a position to collect legal material related to art and offer one of the first law school courses on this subject. Later, with the help of such notables as Melville Nimmer of the U.C.L.A. Law School; James Nafziger, then Executive Director of the American Society of International Law; Albert Blaustein, of the Rutgers University School of Law; and Paul Bator of Harvard Law School, I was able to persuade the Association of American Law Schools to establish a section for Art Law. Since that time, this section has been one of the most dynamic in the Association and has presented relevant programs which appear in several major law reviews as symposia.

Traditionally, the phrase "art business" was considered by many in the field as an oxymoron. It was felt that business was the antithesis of art; yet artists, dealers, galleries, and the myriad of other individuals who are involved with art, are in fact engaged in a business. The notion of a starving artist working in a garret and barely scratching out enough to survive is no longer acceptable. Artists and those with whom they interact are rarely willing to sacrifice everything for the quality of their work which, they hope, will be recognized some time after they die. Today, professional artists expect to receive fair compensation for the work they create. Dealers and galleries want to sell artwork for what they consider fair prices. There are few, if any, Medicis left in the private sector and government support for the arts has never been adequate. Museums are no longer able to shield their activities behind a cloak of prestige and Attorneys General throughout the U.S. are continuously requiring more accounting from those who control and work for these public organizations.

In order for the members of the art community to competitively engage in business, it is necessary to understand the vocabulary and effectively use the business tools available. Just as one cannot create a work of art without having the necessary skill and raw materials, one cannot engage in the art business without learning the language of that business and properly applying it.

As a law professor, lawyer, and an active member of the art community, I have been asked to recommend literature which would assist interested members of this profession in understand-

ing or applying some basic concepts. Unfortunately, very little has been available. I have noted at the end of this text other books which I feel are useful resources, but there are very few of them and none which can serve as an encyclopedic reference. It was for this reason that I commenced work on this project and compiled the most common terms in the industry. My goal was to have an encyclopedic discussion of each which would explain (In Plain English)® the meaning and application. While all of these terms are in common use in the art world, many of them are not otherwise defined in any of the art references that I have been able to find.

My mission in writing this text was to have a comprehensive collection of commonly used terms which are crucial to the art business. It is hoped that this volume will, like my other works (In Plain English)®, provide the reader with a tool which will foster the art business and aid the art community in having a more fertile arena for creative growth.

I encourage comments and recommendations for future development of *The Art Business Encyclopedia.*

Leonard D. DuBoff

Portland, Oregon 1994

A

ACCOUNTANT

An accountant is a professional qualified to practice accounting. Accountants can be found in public, private, or governmental settings. Public accountants represent a number of independent clients; management accountants are employees of particular businesses; and governmental accountants are employed by city, county, state, or federal agencies.

Accountants design and maintain the recordkeeping systems of a business. Bookkeepers may also be used for records maintenance. Accountants may also assist with tax return preparation, business financial planning, budgeting, and, in conjunction with an attorney, personal estate planning. Accountants are usually graduates of an accredited accounting program at a college or university, although they may have practical experience and no degree. They may or may not be certified. Accountants are certified by the individual states, based on a variety of criteria including tests, experience, and continuing education. Certified public accountants are known as CPAs; certified management accountants are known as CMAs. (*See also* **Accounting, Budget, Tax**)

ACCOUNTING

Accounting is a professional discipline concerned with analyzing, verifying and reporting financial transactions.

Each art business is unique, so each set of books has to be created to suit the business' particular needs. Most systems include the following basic categories:

1. *Cash Receipts:* incoming cash
2. *Cash Disbursements:* outgoing cash
3. Sales: the value of "product" (artwork) sold
4. Payroll: employee wages and deductions, including taxes and Social Security
5. Equipment: capital assets, such as machinery (like a glass artist's furnace), office equipment (like a computer), furniture and fixtures, a business vehicle

6. Inventory: the value of raw materials, works-in-progress and unsold art
7. Accounts Receivable: what the business is owed
8. Accounts Payable: what the business owes

The more extensive and involved the financial records and activities become, the more necessary it is to engage the services of an accountant on a regular basis. Many businesses use an accountant on a monthly or quarterly schedule to check on the proper maintenance of the records, prepare financial statements, prepare tax returns, and furnish other accounting services.

Literally hundreds of decisions that involve money or management can benefit from an accountant's advice. For example: should you buy that new piece of equipment in November, or can you get a tax break if you wait six weeks and buy it in the next tax year? Will a move to bigger quarters at more rent be justified by the expected return? Which of your activities are profitable, which are not, which can be made profitable, and which should be abandoned?

Applications for business loans from a bank almost always require that the applicant furnish a financial statement prepared by an accountant.

A competent accountant is as important to a business activity as a competent lawyer, both to prevent problems from arising and to solve them if they do arise. The proper use of an accountant's services requires you to be candid and to disclose all relevant information. Your banker, lawyer, or other business acquaintances can probably recommend a good accountant, especially one who is experienced in financial matters of a business such as yours. Choose carefully and feel free to discuss fees in advance.

Accounting Methods

Cash Basis—A method used for tax purposes in which income and expenses are counted in the tax year in which the money actually changed hands, regardless of when the work was created or sold or invoiced by the seller, or the invoice received by the buyer. This is a common method used by small businesses, unless the business carries a large inventory. Accrual basis is the other type of accounting procedure; you need permission from the Internal Revenue Service to switch from one method to the other.

Accrual Basis—A method in which items of income and expense are charged against the accounting period in which they are

incurred, regardless of when the money was actually spent or received. For example: If you order a quantity of clay at the end of one year but do not receive the bill or pay for the clay until the next year, the accrual basis of accounting would list the expenditure for the year in which the clay was ordered, and the clay would be carried in inventory. Similarly, an invoice you send to a customer for several paintings is credited as sales on the date the invoice was sent, and carried on the books as an account receivable. If you carry a large inventory of unsold work, however, the accrual basis may give you a better picture of your business' financial condition, and may also provide tax advantages, because the costs incurred in producing the unsold work can be charged against that work, regardless of when it is sold.

Cost Accounting

While financial accounting concerns itself with the accurate recording and interpretation of the financial activities of a business, cost accounting analyzes those records in terms of the various costs involved in the production and distribution of goods and/or services.

Most artists engage in some form of rudimentary cost accounting every time they determine the price to be charged for a particular art object. You may not know it, but whenever you take pencil in hand to break down the cost of raw materials, time, and overhead invested in an item you are engaged in cost accounting. When an accountant works with you, it becomes much more sophisticated and serves to pinpoint problems of which you may hardly be aware. Why, for example, did it cost 10 percent more in September to produce a dozen pots than it did in May? Are you in a rut with your present supplier, who keeps raising prices? Perhaps you should go shopping. Or do you spend more time on cleaning and packing than on productive work? Maybe you should hire a part-time helper.

Cost accounting is also helpful in avoiding errors in pricing and in determining your real costs. For example, suppose you have determined that your annual sales costs are $1,000. The simplest way to apply that cost is to break it down by the week ($20) or even by the hour (50¢) and apply that figure to the work you produce that hour or that week. Let us further assume that you have a regular customer for whom you produce $200 worth of items a month all year long. You made that sale once, you spent $100 to do it, and have hardly any further sales costs for the $2,400 you're going to produce this year. On the other hand, you go to an art show, spend

$100 on booth space, transportation, meals, etc., and sell $600 worth of artwork. Proper cost accounting would obviously apportion a larger sales cost to the show than to the one good customer. Averaging the sales cost would not be a true reflection of your real costs in this example, even though the totals come out the same at the end of the year.

While raw materials and labor are usually simple to apportion to a specific item, expenses for supplies, equipment, selling, and overhead are not. And that's where your profit can disappear down the drain. A good cost accounting system helps you to determine what steps must be taken to improve performance and reduce expenses.

Your profitability, in the final analysis, depends on only two factors: increasing production and sales, and controlling costs. And the only way to control costs is to know precisely what the costs are and how they are incurred.

Having a professional do the cost accounting may be luxury in a small art business where the owner does all the work. But the greater and more varied the activities of the business, the more necessary it becomes to analyze the specific cost ingredients of everything that is produced.

Bookkeeping

Bookkeeping is an essential operation in the conduct of any business. It involves the recording of every financial transaction. It is important to every business, from the artist in a garret to a large multi-national gallery chain. It may be considered the lifeblood of every art business, since it involves the recording of income, expenses, profits, obligations, and the like. The results help the owner to evaluate the success of the business, as well as any reverses. The bookkeeper maintains the day-to-day records, including accounts payable and accounts receivable, and will often handle bank deposits.

Bookkeeping is not a matter of choice, but of necessity. Your financial records are the basis on which your business' financial statements are prepared and on which your business income tax returns and other taxes, such as personal property and sales taxes, are calculated.

When analyzed, properly maintained financial records can reveal where your activity is profitable and where it is unprofitable, where you may be able to save money, where the price of your work needs to be adjusted, how to plan your cash flow, budget for future business, and many other factors that spell the difference between economic survival and economic disaster.

Unless you are involved in complicated credit transactions, elaborate accounts receivable operations, or other ultrasophisticated financial dealings, you'll find that the bookkeeping mystery really boils down to this simple principle: Keep track of every penny that comes in and every penny that goes out. This can usually be done in a simple manual ledger. There are also many software programs, such as Peachtree, Quicken, and OneWrite Plus, which provide accounting support. You and your accountant can select software that best suits your business needs.

Recordkeeping

Keeping good and accurate records serves at least three purposes: First, to comply with legal requirements, such as those related to taxation, and the like; second, for business monitoring; and third, as the basis for developing a business plan.

Preparation of tax returns requires accurate books, which must be retained for at least three years beyond the filing date in case of an audit. Some payroll records have to be kept for as long as seven years.

Business monitoring is facilitated when you have complete and accurate records. In order to determine which galleries owe you for work on consignment, you should have a complete list of your unsold work, its location, and the date the work was consigned. You should periodically request a report from galleries which hold your work.

You may also learn a great deal about your art business by analyzing your records. Is an ad in an art magazine cost-effective? Should you continue to attend a specific art show year after year, or is the cost higher than the return?

It is wise to develop a business plan in order to establish the structure, growth pattern and direction for your business. In addition, you should periodically review the plan and, where appropriate, revise it. Accurate recordkeeping is essential for your periodic reviews.

Recordkeeping is also necessary for you when applying for loans and other forms of credit, insurance, and the like. Business people expect good recordkeeping and even artists must adhere to this practice when engaging in the art business. (*See also* **Accountant, Break-Even Point, Budget, Business Plan, Cash Flow, Collection Problems, Computers, Financial Statements Inventory, Pricing, Tax**)

ACCRUAL BASIS (*See* **Accounting**)

ACQUISITION

"Acquisition" is a term used to describe the process of obtaining a work of art. When a museum acquires a work of art by purchase or gift, it must then formally place it in the collection by having the appropriate committee of the governing board—usually trustees—formally "accession" the piece into the collection. The work is then carried on the museum's inventory for all purposes, including insurance, government-mandated inventories, and the like. Frequently, the processes of museum acquisition and accession are accomplished simultaneously. (*See also* **Deaccessioning, Museum**)

ADVERTISING

Advertising is used to create public awareness of a product or service for the purpose of stimulating sales. Advertising is commonly purchased—such as newspaper and magazine ads and television and radio commercials—but may be free—such as word-of-mouth, interviews and reviews.

Advertising can take many forms: newspapers, magazines, radio, television, billboards, handbills, direct mail. Within certain limitations, you are in complete control of what you want to say, how you want to say it, and to whom it is said.

Artists who have established gallery relationships rarely have reason to advertise independently. Artists who engage in direct sales, on the other hand, have a great need to advertise.

Favorable reviews in major publications from respected critics are probably the best advertisements. In addition to being free, they establish your reputation and create or expand the market for your work. Regrettably, there is no way to control this situation. As an alternative, many artists arrange to have the galleries which sell their work also handle their advertising. The artist-gallery contract should include a provision dealing with advertising.

Artists who do their own advertising must evaluate the costs and benefits to be derived from particular types of advertising. They must also determine the most appropriate places for their ads. For example, art of the American West will likely reach a more receptive audience through Southwest Art than through Architectural Digest. It may be an ego trip to advertise on television, but it is not likely to be cost-effective. It may be worth the investment, when beginning your advertising program, to hire an agency experienced in

advertising your type of art, at least until you gain some experience.

No matter how much experience you have, however, you should monitor your advertising. Keep track of each ad, whether it's a display ad of 10 inches on two columns, a classified ad, a handbill, postcard, or whatever. It is best, in the beginning, not to run more than one type of ad at a time. Using only one makes it easier to track results. See what each type of advertisement brings in. Does one magazine produce better results than another? Dollar for dollar, does a mailing piece produce more sales than a magazine? Some artists publish periodic newsletters for their collectors. Try various types of advertisements, one at a time. This is not to suggest a specific sequence, but only an approach to testing various media. Since advertising is expensive, it pays to keep records of results so that you can concentrate on the more effective methods and eliminate the less effective.

Cost should be a factor only as it relates to results. A $100 ad that produces $1,000 worth of sales is more productive than a $50 ad that produces $500 worth of sales, though the ratio is identical. Your overhead and the cost of preparing the ad remain fairly constant, no matter how much or little you sell. In this hypothetical, then, it is more profitable to produce $900 above the cost of the ad than $450. On the other hand, if the $50 ad produces $800 worth of sales, it is probably wasteful to spend another $50 simply to produce another $200. Each situation is specific, and each result must be judged by the advertiser's particular needs and objectives.

When noting results, take into consideration special circumstances.

A good way to record the effectiveness of ads and other promotional materials is to organize them into a book and make notes of the results right next to them. Include not only the cost of the ad and what income it produced, but also any outside influences. For example, if gallery sales were down because of hurricane damage to the gallery, this should be noted. Keep both the good and the bad so you can repeat your successes and avoid your failures.

Several ingredients contribute to results: (1) where the ad runs; (2) what the ad looks like (whether it will be read); and (3) the nature of the offer.

Simplicity and visual appeal are essential. This is particularly true in small-space advertising. That small space has to stand out among all the other ads and other textual material appearing on the same page. Plenty of white space, a catchy headline that grabs the

reader's attention, brief but explicit copy, and an uncomplicated illustration all contribute to readability.

The basic principle to observe is that your advertisement has to compete for attention. Everything in the ad should help achieve that goal; nothing should detract. Printing a headline upside down, for example, may be clever, but it usually interferes with the readability of the ad.

Let's examine some of these factors.

White Space

When you buy advertising space, whether it's two inches in a newspaper, an 8" X 11" flyer, or a billboard on the highway, what you are really buying is empty space. You now have to fill it with your message. Don't fill it too full. Keep some "white space"—breathing space—in the ad. Properly used, white space is not wasted because it helps direct the eye toward the relevant material, whether text or an illustration.

The Headline

Do you need a headline? Will it aid in getting your reader's attention?

Copy

This is the text of your advertisement. The same principle of reader benefit applies. Keep the copy brief. If you're using a very small space, don't try to tell a story. Strip it down to the bare essentials that will excite the reader. You may not even need text: A picture may, indeed, be worth a thousand words.

Illustrations

Simplicity applies here, as well. Better to use a small, dramatic drawing that reproduces clearly than a cluttered photograph that can barely be deciphered and comes out a gray glob.

Finally, every piece of printed material, every advertisement, must include the relevant name, address, and telephone number.

The Nature of the Offer

Advertising falls into two basic categories—immediate response or long-range impact.

Immediate response advertising is expected to produce quick results. Included in this category are announcements of gallery openings and events, mail-order ads, offers of specific products, and the like.

Immediate-response advertising is relatively easy to measure. It either brings results at once or it doesn't. A gallery event generally brings large crowds, though it may bring smaller profits. When you do have an opening, the size of the crowd is an extremely important factor in the success of the opening. A mail order ad is the easiest of all to measure: you simply count the responses. There's no confusion as to the source of the sale.

Long-range impact is created through advertising which is expected to bring the artist's or gallery's name to the attention of the public and keep it there, so that collectors will remember it. This type of advertising would stress craftsmanship, artistry, exclusivity, or whatever other attribute makes the gallery or artist distinctive and unusual.

Several other considerations should enter into advertising planning. One concerns repetition. Should you repeat the same ad again and again? That question does not arise, of course, with ads for special events, but advertising experts generally agree that an "institutional" ad—one which promotes a gallery or an artist on a long-range basis—works best when the same ad is repeated several times in the same publication. The cumulative effect often pays off better than running a different ad each time.

Even where ads are different, they should have a "family resemblance." That's best observed in department store advertising. You could probably identify the ads of several local department stores even if the names were removed, simply because the ads have a similar appearance, although the specific content of each ad is different. Stick to the same style of illustrative device, the same typeface for the headline and text, the same signature for your name and address. Familiarity produces recognition.

Everything mentioned so far is based on your advertising needs and budget being very limited. If they are not, you may wish to retain the on-going services of an advertising agency. Agencies come in all sizes and specialties. Their services are concentrated in two important areas: selection of the media in which you advertise, and preparation of your ad copy.

Advertising agencies have two primary sources of income: (1) They are paid a commission by the newspapers or magazines in which the advertisements appear, and (2) they are paid fees by the advertiser for such special services as preparing artwork, making engravings for printing purposes, and so forth.

The more complicated an advertising program is, and the larger

the budget becomes, the more useful it is to engage the services of advertising specialists. On a very limited budget, a small agency or a friend who works for a large agency may be enough to fill the need. A gallery with an annual volume of $100,000 may spend as much as $10,000 on advertising. If you are in that category, take your business to professionals who are as experienced in creating effective advertising programs as you are in selling beautiful art.

How to find an advertising agency? Pretty much the same way you look for any other professional service—legal, accounting, etc. Ask other business people who advertise extensively. Interview several agencies. Tell them what you hope to accomplish and what your budget estimate is. Ask them to make a proposal containing their approach to your advertising needs. Find out what they've done for others in similar situations.

The bigger the agency, the more likely it will have a variety of talent and expertise to serve you. In choosing an agency, it is sometimes better to be as important to the agency as it is to you. The more important your business is to an agency's annual income, the better the service you are likely to get. (*See also* **Catalogue, Press Release, Publicity, Public Relations**)

AFTER, AS IN "AFTER MICHELANGELO"

A copy of a known work by a particular artist. (*See also* **Attributed to, Authenticity, Manner of, School of, Studio of**)

AGENTS (*See* **Artists' Representatives**)

ALTERNATIVE DISPUTE RESOLUTION

Several methods whereby a legal dispute is resolved without having a traditional trial.

Alternative dispute resolution includes arbitration, in which one or more independent individuals—known as arbitrators or arbiters—are selected and paid by the parties to resolve their dispute. Arbitrators need not be lawyers, although most are. Arbitration can either be binding—in which case the parties have agreed to be bound by the arbitrator's decision, or non-binding—in which case the decision of the arbitrator is merely advisory and the parties may resort to traditional litigation. In addition, arbitration may be final—in which case the decision may be appealed only if it can be established that the arbitrator was arbitrary and capricious, or non-final—in which case the arbitrator's decision may be appealed on the merits.

The other most common form of alternative dispute resolution is mediation. In this situation, an individual known as a mediator (not necessarily a lawyer) assists the parties in negotiating a mutually agreeable solution to their dispute, usually a compromise. Some courts require the parties to subject their dispute to mediation, which must be unsuccessful before proceeding with litigation. If the mediation is successful, litigation is unnecessary.

The arbitrator acts like a judge, in hearing the parties' positions and rendering a decision. Arbitration, however, is much less formal than litigation and frequently occurs in the arbitrator's or an attorney's office.

Mediation is usually conducted by having the parties confidentially present their positions to the mediator, who shuttles between them in an attempt to cause them to present or accept a workable solution. The mediator is a go-between for the parties, rather than a decisionmaker, though the mediator may make recommendations. Henry Kissinger's "shuttle diplomacy"—which resulted in his Nobel Peace Prize—was mediation on a grand scale.

There are numerous organizations which specialize in alternative dispute resolution. Probably the most well-known is the American Arbitration Association, which has offices in most large cities. Most larger communities also have public and private alternative dispute organizations. In fact, at least one Volunteer Lawyers for the Arts group—California Lawyers for the Arts—offers mediation services for art-related disputes. (*See also* **Contract, Appendix F**)

ALTERNATIVE SPACE

While most artwork is exhibited and sold through galleries, some artists have chosen to have their work displayed in other locations. For example, restaurants and banks, post offices and other government agencies have arranged with artists to enhance their business' appearance by displaying artwork; in exchange for this privilege, the artist is permitted to display a sales notice. The notice may merely instruct interested parties to contact the artist directly and state the artist's name and phone number, or it may provide that individuals may purchase the works through the artist, gallery, or directly through the displaying business.

Artists have rented display space in airports and hotels. Many municipal offices have display areas and permit artists to show their work free of charge for a specified period of time.

A collector interested in promoting an artist's career may host

an exhibition in his or her home and permit the artist to invite other potential buyers. Frequently, the artist will thank the generous collector with an appropriate gift, since home exhibitions can be expensive if food or drink is served and the home is opened to strangers.

Some schools have permitted artists to display their work in lobbies, hallways, and administrative offices. In fact, the only limitation to alternative space used by artists is their imagination. From mall shows to sidewalk exhibitions to displays in the park, artwork is displayed virtually everywhere.

When establishing an arrangement for display in an alternative space, the artist should consider the following and the understanding should be reduced to writing: Who will bear the risk of loss and be responsible for insurance, if any? Who will pay for refreshments, if any? Who is responsible for sales and, if it is the displayer, what commission will be paid? Will the artist provide replacement work for work which is sold or removed? Will the artist remove the work if the displayer desires its removal? Who has control over the content of the art to be displayed? (*See also* **Consignment, Contract, Dealer, Gallery**)

AMERICANS WITH DISABILITIES ACT

A federal law which requires employers to make reasonable accommodation for disabled employees in hiring, promotion, and retention. The term "reasonable accommodation" is not precisely defined, but would include, for example, access ramps, adjustable-height work areas, and restrooms for wheelchairs; Braille or vocal elevator operation instructions.

The law also requires places of public accommodation, such as art galleries, museums, and even artists' studios, if they are open to the public, to be reasonably accessible to the disabled. This would, for example, require wheelchair ramps, handicapped-accessible restrooms, and the like.

The law is very complex and the regulations which have been promulgated are extremely technical. There are, however, severe fines for non-compliance, so you should consult with a lawyer knowledgeable in this area in order to determine your obligations.

AMORTIZATION

Amortization is an accounting concept whereby a cost is spread over the period of the supposed "useful life" of the item being amortized. It is used for purposes of calculating tax deductions, such

as when a capital asset like an artist's van is purchased. The artist may deduct—or amortize—a portion of the cost of the van over its projected useful life. Amortization is also used for purposes of calculating payments on, for example, a mortgage. The mortgage is amortized—or reduced—by the regular periodic payments for its term. Capital investments, such as equipment with a useful life of more than one year, are amortized through depreciation, which means they are carried on the books at a predictable annual reduction in value on the assumption that they will wear out at the end of the amortization period. In simplest terms, a $5,000 sculptor's kiln with a life expectancy of ten years would be amortized at $500 a year. This is important both for tax purposes and for establishing the current value of your fixed assets at any given time. A good accountant or business advisor can assist you in determining the most appropriate time to buy an asset and the best method for depreciating it. (*See also* **Appreciation, Assets, Depreciation, Loans, Tax**)

ANIMATION ART

Most animated movies are created by artists who draw the characters on celluloid sheets which are laid on hand-painted backgrounds and photographed. The "cels" are drawn in such a way as to project movement as the artist changes the character's position in each drawing. Thousands of cels are needed in order to produce the illusion of movement in the movie. Initially, each celluloid was drawn by hand. Today, cels are created by having the outline of the character photocopied onto the celluloid and the artist coloring in the outline.

The earliest animators, such as Disney, Warner Bros. and others, sold the backgrounds and cels as souvenirs for nominal prices, later these pieces became more valuable and, today, animation art is handled by many galleries. Prices for animation art depend on the period when the work was created, the film in which the cell was used, the artist who created the film and whether the piece consists of the hand-painted background, celluloid sheet and drawing. There are a number of other factors contributing to value, such as the popularity of the movie or character depicted in the cel.

Perhaps one of the reasons animation art has become popular is that collectors are able to relate the cels to the animated movies which they remember seeing during their childhood. The poularity may also come from the resurgence of collectibles from the 1940s, 1950s and 1960s.

Since the cels themselves are becoming quite expensive, some publishers have begun producing limited edition prints of the cels which themselves have become collectibles. These limited edition prints may depict the image from a cel including its hand-painted background and are subject to the print disclosure laws enacted in many jurisdictions, and are another form of animation art. *See also* **Prints.**

Three dimensional forms of animation art are also available. These clay sculptures of animated characters are photographed in miniaturized stage settings and the illusion of movement occurs when the clay figure itself is repositioned and another photograph taken. The dimensional clay characters are also quite popular and command impressive prices from collectors.

ANTIQUITIES

Antiquities are items which are old, and include, among other things, functional works which have historical value. For purposes of customs duties, items which are more than 100 years old or which are ethnographic—that is, created by an indigenous people, may enter the United States duty-free. This is true even if the item would not be considered "art" for customs duty exemption.

Many countries have passed laws to protect their antiquities. These laws are intended to prevent historical sites from being destroyed, by regulating the disposition of defined items. The laws fall into three general categories. Some, like those enacted in Mexico, Guatemala, and other Latin American countries, absolutely prohibit the export of antiquities, such as pre-Hispanic ethnographic items. Other countries, such as England and Egypt, allow export without restriction. The government is given the option to purchase any item for its fair market value, rather than allow it to be exported. One of the most praised schemes for protecting antiquities is found in Japan, where only a very limited group of items is controlled by the government, and the vast majority of other work is unrestricted so far as export or sale is concerned.

The international community has responded to the concern expressed by many countries regarding antiquities, or "cultural property," by adopting cultural property treaties. (*See also* **Customs, Treaty, UNESCO Convention on the Means of Prohibiting and Preventing the Illicit Import, Export and Transfer of Ownership of Cultural Property**)

APPRAISAL

Appraisal is a process whereby an item is examined by a qualified professional, who renders an opinion as to its worth or value. Appraisals may be oral but, as a practical matter, should be written. Written appraisals are often used for insurance purposes, and must accompany donations of works of art to charitable institutions when the work exceeds $5,000 and the donor wishes to take a charitable tax deduction. (*See also* **Charitable Contributions, Insurance**)

APPRECIATION

"Appreciation" has at least two meanings in the art world. The first is the favorable response to one's work which may lead to recognition or purchase. Second, in financial terms, "appreciation" refers to an increase in value. Artwork may appreciate because of the artist's enhanced reputation, death, or popularity of the art style. It may also appreciate merely as a result of inflation.

The foundation for development of the European *droit de suite*, or resale royalty, is the notion that an artist should be entitled to participate in the increased—appreciated—value of his or her artwork when it is resold. (*See also* ***Droit de Suite***)

APPRENTICE

For most of human history, before there was a system of formal education, apprenticeship was the only way to learn a craft or trade. Boys from ages 10-14 would be indentured to a journeyman, earning no more than subsistence-level room and board, doing all the unpleasant, dirty jobs around the shop at first, and learning the craftsman's trade bit by bit.

Apprenticeship is still the official term used for learners in some trades, for example, printing and skilled construction work. Such apprentices are now paid salaries and other benefits that increase according to specific formulas as they learn their trade.

Traditionally, artists have apprenticed themselves to masters, and this process is still popular. In fact, it is well known than artists such as Renoir, da Vinci, Rembrandt, Rodin and others used apprentices in their studios. While some basic techniques and principles can be learned in the classroom, most aspiring artists find that their technical and artistic development depends to a great extent on working with an experienced artist. This helps them not only to refine their skills but also to understand the production methods, operational procedures, and business problems of earning a living in the art business.

The old method of room and board in exchange for learning the craft is no longer common, although it does still exist. Nor is the apprenticeship a lengthy process that extends over several years. Few apprentices today stay more than a year with the same artist and, in almost all cases, money changes hands: sometimes the artist pays the apprentice a small sum, often the apprentice pays the artist for the privilege of studying with him or her, and sometimes an outside source provides the funds.

A major problem encountered by some artists in hiring apprentices involves state and federal labor laws. Some artists have been required to pay their apprentices the minimum wage, withhold income taxes, and meet a variety of other requirements demanded by the labor laws. In other cases, especially where the apprentice pays a fee to the artist, the apprentice may be considered a student and, thus, not subject to the labor laws, even though no formal curriculum exists. Still other artists have proposed the term "intern" for someone whose work is both productive and a learning experience, to get away from the employee connotation of apprentice. It is advisable to consult with state and federal labor departments about the specific conditions that would apply in each case.

The relationship between the artist and the apprentice is a very special one. Careful thought should be given to (1) whether the craft and the apprentice are personally compatible; (2) whether the artist is emotionally and psychologically equipped to teach his or her technique with patience and understanding; and (3) what the specific arrangements and working conditions will be.

Will the apprentice, for example, contribute to the artist's work, will the apprentice have an opportunity to create his or her own work, who pays for the materials for the apprentice's own work, is there a clear understanding about work hours and the operation of the studio, who is responsible for what particular chores?

The relationship between an artist and an apprentice is not a one-way street. The apprentice benefits from the learning experience; the artist benefits from the apprentice's contribution to the production process. These benefits are available only if the artist and apprentice select each other carefully and understand their arrangements completely before they begin. (*See also* **Education, Employees, Wages**)

ARBITRATION (*See* **Alternative Dispute Resolution)**

ARCHITECTS

Architecture is the profession concerned with designing buildings. Architects frequently work with artists, and architectural and interior design commissions can become a lucrative part of an artist's income, especially in metalwork, stained glass, woodwork, paintings, sculpture, glass art, and similar media.

Historically, artists worked hand-in-hand with architects and builders in order to create appealing structures. The ceiling of the Sistine Chapel, the flooring of the Chartres Cathedral, the United States Capitol, and the Rainbow Room at Rockefeller Center are but a few examples of the integration of art and architecture.

The federal government and most state and municipal governments now require that a percentage of the remodeling or construction costs of government buildings must be spent for artwork in those buildings. The definition of "art" for these purposes is not clear; whether a well-designed door will qualify has been the subject of some controversy. Similarly, it has been claimed by some that the intent of the legislation is to provide opportunities for living artists; others claim that the purpose of the law is to beautify the structure and that antiquities should, thus, be eligible.

Architectural commissions are available through a number of sources. Perhaps the most effective way is to let architectural firms and the state or local arts commission in your area know of your availability.

Architects working on religious, university, or government buildings are particularly good prospects. Contact them with a brief resume, some photos or slides of your work, and a request for an interview at which you can show your portfolio. The results will not be as immediate as an approach to sell a painting to a collector, but ultimately can bring very satisfactory returns. Design competitions also provide occasional opportunities.

Since construction of a new building is a lengthy process which requires the approval of numerous government agencies, building departments, zoning commissions, etc., it is not difficult to become involved in these projects if you can find out where such information first becomes available in your locale (city clerk, county clerk, buildings department, arts council).

It is important to contact architects in the very early stages of the process. Once construction has begun, it is usually too late. The architectural work has been completed, budgets firmly established, and the artwork selected.

Working with architects or interior designers usually requires a high degree of professionalism. Sketches, design proposals, color samples, even maquettes are often necessary. There is almost always a fixed amount of money earmarked for art, so it becomes necessary to calculate your costs and what you can do on the basis of the ultimate fee. The architect's requirements must be closely studied. If the artwork becomes an integral part of the structure, as with a mural, it is necessary to work closely with the architect and the construction firm to coordinate the completion and installation of the artwork with their schedules.

Architects normally do not take a percentage of the fee you are paid.(*See also* **Arts Councils, Collector, Commission, Customer**)

ART DEALER (*See* **Dealer**)

ART EXECUTOR (*See* **Estate Planning**)

ARTISTS' EQUITY
A national organization for artists which, among other things, prepares and disseminates form contracts, monitors legislation, and assists with some art-related legal problems. The organization has several regional constituents, which network on a fairly regular basis. There are also Artists' Equity organizations at the state and local levels—for example, New York—which may or may not be affiliated with the national organization. (*See* **Appendix B**)

ARTIST'S PROOFS
When artwork such as a print or editioned sculpture is created as a multiple, the artist creates some works as "proofs" until the artist is satisfied that the reproduction is exactly what is desired. These so-called "working proofs" are marked as such and customarily are used by the foundry or master printer as the standard for the edition.

In addition, it is customary to create some additional proofs for the artist's personal collection and use. These proofs are marked as "artist's proofs" (or "AP"), which are sequentially numbered as such and traditionally do not exceed 10% of the size of the edition.

Printers proofs or foundry proofs may be created and retained, though this is not universal and may be done only with the artist's permission. (*See also* **Customs, Foundry Proof, Multiples, Prints, Printer's Proof, Working Proofs, Appendix A**)

ARTISTS' REPRESENTATIVES

In most industries, a common means of getting products from the manufacturer to the retailer is the sales representative. He or she represents several non-competing manufacturers who have neither the need nor the finances to hire their own sales force.

The vast majority of artists sell their work through galleries. Very few produce in such quantity that employing their own salespeople can be justified. More and more artists, however, utilize the services of independent artists' representatives (also known as dealers or sales representatives), especially for sales outside of areas where the artist has established arrangements.

Industrial sales reps usually carry lines of related but non-competing products, and cover specific territories. To some extent, every work of art competes with every other work of art. Artists' representatives, therefore, cannot avoid some competition between the artists they represent. In fact, it is desirable to use the services of a representative who is experienced in selling the kind of work you create—both genre and medium. An individual experienced in selling or placing western and wildlife sculpture will likely not be the best representative for abstract paintings. It is for this reason that artists' reps are likely to handle directly competing artworks.

Artists' reps customarily work on commission, often 15 percent of the wholesale price. The commission is a selling expense to the artist, but it has several distinct advantages: (1) payment is made only on the basis of what is sold; (2) a good sales rep allows an artist to devote time to creating artwork rather than selling; and (3) the commission is much lower than that customarily charged by galleries. You should establish the terms of your relationship with the artists' rep. If the rep is permitted merely to place your work on consignment, then you will likely be paying two commissions: one to the rep and one to the gallery. An appropriate adjustment between the selling team should be established before you receive a nasty surprise.

Artists' representatives are "dealers" within the meaning of state artist-gallery consignment laws. In most jurisdictions, the relationship will, therefore, be governed by statute. Even if the laws do not require a written agreement, it is wise to use one, spelling out all of the terms of the arrangement—the territory, the terms of sale, the commission structure, credit policy, how the relationship is to be dissolved, and so forth.

It is extremely difficult to find a reputable artists' rep who is

available to take on additional artists. The good reps are very busy and may not be able to handle another artist, and you wouldn't want an incompetent rep. Reps would naturally prefer to handle work by recognized artists.

The best source for finding a rep is by asking other artists, gallery owners, museum curators, arts commissions, art show promoters, and so forth. There is a directory available from Artists Network (*see* **Appendix D**).

Once you establish a relationship with an artists' rep, work closely with him or her. Let the rep know promptly when you have a new series, edition or genre; let him or her know equally promptly if you run into a problem with delivery. Let the rep learn from you when a delivery is going to be late, not from an angry purchaser.

Unless it's specifically spelled out otherwise, don't invade the rep's territory. Don't compete with yourself. If you are dissatisfied with the rep's performance, terminate the relationship; do not undermine it.

One of the most important points to consider when selecting a rep is that, in the eyes of the customer, this person is you. What the sales rep says, the rep's appearance and conduct, how your artwork is presented, all reflect on you. That does not mean they have to be exactly like you; indeed, as sales specialists, their interests and personalities may be quite different from yours. But, since he or she represents you to the customer and is your contact with the buyers, the rep must reflect your business policies and standards. A good sales rep can enhance your image and reputation, a bad one can destroy your career.

If you have a good rep, you'll find that he or she can be an excellent source of information about conditions in the art market. (*See also* **Consignment, Dealer, Sale, Salesmanship, Appendix C, Appendix D**)

ARTS COUNCILS

There is an arts commission or council in every state of the Union, as well as the District of Columbia and all U.S. possessions. Many municipalities have arts councils, as well. Canada has Provincial Arts Councils in each of its provinces. Arts commissions are government agencies which receive monies from both the federal and state governments for the purpose of stimulating art in their respective jurisdictions. Arts councils may or may not be government agencies, though they customarily have the same objectives. A com-

plete list of all state arts agencies, with addresses and telephone numbers, is available from the National Endowment for the Arts. These organizations should conduct their activities in a business-like way and counsel cultural organizations they deal with to do the same. For an excellent source of up-to-date information on impor-tant business issues for cultural organizations, see *The Cultural Business Times* (**Appendix D**). (*See also* **National Endowment for the Arts**)

ASSETS (*See* **Financial Statements/Balance Sheet**)

ASSIGNABILITY, ASSIGNMENT
Assignability is a term used in contracts to describe the ability of either contracting party to assign certain rights or obligations un-der the contract. Generally, performance of personal services con-tracts, such as those for the creation of works of art, is not assign-able. On the other hand, the right to receive payment for those services may be. Since there can be some ambiguities in whether a right or performance is assignable, it is best to specify in the con-tract whether or not an assignment is permissible. In fact, lawyers consider the clause regarding assignment standard. (*See also* **Con-tract**)·

ATTRIBUTED TO, ATTRIBUTION
Technical terms used by experts to describe a work of art which can be ascribed to a particular artist on the basis of style, though use of these terms suggests that the expert is not absolutely certain that the work is by that artist. (*See also* **After, Authenticity, Manner of, School of, Studio of**)

AUCTION
There are three basic forms of conveyance in a free market eco-nomic system. The first form, with which the individual consumer is probably most familiar, is fixed pricing, in which the buyer may choose either to accept or reject the price designated by the seller. This form is most efficient in minimizing transaction costs, but has the disadvantage of being a take-it-or-leave-it system. The second form, private negotiation, on the other hand, allows the parties to mutually determine an acceptable price, but the potential costs of advertising or contracting through an agent to find a buyer may be significant.

When several buyers are attracted at the same time and compete with each other for a desired piece, the transaction is an auction, the third form of conveyance. Like private negotiation, auctions also have fairly high transaction costs, since it is necessary to attract numerous competitors to the proposed sale. Most auction houses recover their costs by requiring the seller to pay a commission, and some require the buyer to pay a surcharge, as well. The system of gathering all interested buyers together to set the price by competitive bidding is especially useful for art transactions, since each art object is subject to radical fluctuations in its market price. These fluctuations occur because the value of art stems not only from the cost of the materials used but also from its aesthetic appeal, the artist's present status, the availability of similar works, and anticipated appreciation based on performance of other works by the artist. Auctions are effective mechanisms for gauging the value of these kinds of intangibles. Thus, appraisals for insurance are frequently based on auction sales prices. Auctions are important even for non-participants because, simply stated, auctions establish prices.

Auctions are the most popular means of acquiring and disposing of art; today, nearly 50 percent of art transactions are handled by this method. Auctions take many forms, and many complex tactics for influencing prices are used.

Many states require auction houses and auctioneers to be licensed. The licensing requirement is intended not only to protect against fraudulent auctioning techniques but also to raise revenue and prevent the use of auctions for the disposal of stolen merchandise. Problems occasionally arise, however, in determining what constitutes an auction for licensing purposes.

Bidding at an auction can take many forms, from raising a paddle with a number on it to pulling one's ear. If bidders desire to use techniques other than the conventional raising of the hand or bidding paddle, then special arrangements must be made with the auctioneer. Bidders will often use secret bidding techniques to avoid being identified as a party interested in a particular work. It is well known that interest by, for example, museums or important collectors, may drive prices up.

There are a variety of techniques used by both auctioneers and bidders to affect auction prices. Auctioneers may, for example, suggest that a work has sparked a lot of pre-auction interest. Although the practice is illegal, auction patrons sometimes band together in

a so-called "ring" and agree not to bid against each other.

The Uniform Commercial Code ("UCC") deals with some aspects of auctions and provides, among other things, that the auctioneer and the person consigning the work for auction may agree that the work may not be sold unless a threshold price, known as a "reserve," is reached. Reserve prices are typically kept secret and the UCC provides that all works to be sold at auctions are presumed to be subject to a secret reserve price unless the auctioneer expressly states otherwise. Some states require the auction house to disclose the fact that a reserve price exists, through none require disclosure of that price before the auction is completed. (*See also* **Contract, Reserve, Uniform Commercial Code**)

AUDIT

An audit is an examination of a business' books, records or other documents to determine whether they are kept properly, whether all financial transactions are entered according to accepted accounting and bookkeeping practices, whether there is legal compliance, and to ensure that the company's records comply with the applicable rules and regulations. In addition, there are operations audits which examine and evaluate the business' operations and procedures.

The type of audit with which most artists are familiar is a financial audit. For small businesses, an annual financial audit is usually conducted by an accountant in conjunction with the preparation of the business' tax return. A financial statement or balance sheet is drawn up following a financial audit. Corporate law usually requires corporations to periodically distribute these reports to the shareholders.

Operations audits are commonly conducted by experienced accountants or business advisors who evaluate the propriety of a business' practices and procedures.

Attorneys may also conduct a legal audit in order to determine whether the business is complying with all applicable laws. This type of audit is less common but nonetheless important for small businesses which desire to avoid becoming entangled in costly litigation for non-compliance. For example, corporations are required to hold annual meetings of the shareholders for the purpose— among other things—of electing the board of directors. Similarly, corporations are required to file annual reports with the state or they will be dissolved.

Audits may also be conducted by government agencies, such as the Internal Revenue Service, the Department of Labor, or the Occupational Safety and Health Administration. (*See also* **Accounting, Financial Statement, Statute of Limitations, Tax, Tax Preparer**)

AUTHENTICITY

This is a term used to describe an attribute of a work of art. It may be divided into two general categories. First, scientific authenticity is objective, and describes the attributes of a work of art which can be tested using accepted technological methods such as carbon 14, thermoluminescence, or the like. Scientific tests are used primarily to determine the age of a work or the material from which it is made.

The second type of authenticity is stylistic. This is subjective, and is the determination by an expert, based on experience, that a work is by a named artist, from a particular period or from a particular locale. Stylistic experts cannot emphatically state that a work is by a named artist unless the expert observed the artist creating the work; rather, the expert will be in a position to state that, based on all relevant factors, it is likely that the work is what it purports to be.

Since technology is becoming more sophisticated and since there is a continuing evolution of knowledge, pronouncements by an expert regarding authenticity may subsequently be changed. It is for this reason that many museums have upgraded or downgraded works in their collections. (*See also* **After, Certificate of Authenticity, Manner of, Museum, School of**)

B

BAILMENT

Bailment is a legal concept which is used to describe the situation where one is in rightful possession of another's property.

The bailment (or possession) can be for the benefit of the property owner ("bailor"), as when an art restorer holds a painting for purposes of repair or restoration. Bailments can also be for the benefit of the holder of the property ("bailee"), as when a work of art is loaned to a museum bailee for purposes of display. Generally, the bailee's obligation to protect the item in the bailee's possession is greater when the bailment is for the bailee's benefit and weaker when it is for the benefit of the bailor. In any event, a bailee must exercise reasonable care in protecting the item.

Some state laws impose a greater obligation on certain kinds of bailees; e.g., hotels and common carriers traditionally have had much greater liability for damage to or theft of bailed property.

BALANCE

For financial purposes, this word represents the difference between two amounts, or what remains after one amount is deducted from the other.

In the art business, it has several fundamental meanings:

1. Your checking account balance represents the amount that remains after all the checks and other deductions are subtracted from all the deposits and prior balance. If you had a balance of $250, deposited $1,000, wrote checks for $800, and were charged a $10 service charge, your new balance is $440.

2. The balance on your account at an art supply store is the amount you still owe after all your payments are subtracted from all your purchases and all credits are taken into account. If you have overpaid, then all your purchases are subtracted from all your payments, and you have a credit balance.

3. If a customer leaves a $100 deposit on a $1,000 print, the balance due you is $900. (*See also* **Bank Statement, Checking Account, Financial Statement**)

BALANCE SHEET (*See* **Financial Statements**)

BANK LOANS (*See* **Loans**)

BANK STATEMENT

Periodically, usually monthly, you should receive a statement from your bank which lists all the deposits that were made to the account, all the withdrawals made from your account, any bank charges, plus the opening and closing balances.

You should reconcile the bank statement; that is, compare it against your own records. The bank usually provides an easy-to-use form on the back of the statement to help you do this. If you cannot reconcile your balance with the bank balance, review all the entries and totals very carefully. The error might not be yours. If it still doesn't balance, contact the customer service department of your bank. Most banks offer free assistance with account reconciliation.

The bank statement has another important value: It signals a problem if a check you wrote long ago hasn't cleared. If a check has been outstanding for more than two bank cycles, you should find out why. For example, it may have been lost in the mail, the payee may have neglected to negotiate it, or you may have forgotten to mail it.

Keep your bank statements and the cancelled checks, if any, together in a safe place. You may need this information to establish that a payment was made by you or if your business is ever audited. (*See also* **Checking Account, Computers**)

BANKRUPTCY

When your liabilities exceed your assets and there's no other way to settle your debts, you may wish to seek protection from your creditors by filing for protection under the United States Bankruptcy Code. Bankruptcy is a federal court procedure whereby the court, often through a trustee, administers your assets to pay your creditors. This usually involves selling your assets, in which case the creditors may receive only part of what is owed to them, but you are free from all further dischargeable obligations. Your debts are wiped out and you can start all over again.

There are some situations in which the business debtor is allowed to reorganize the business affairs under the court's watchful eye. This happens when creditors have reason to believe that

there's a real chance that the financial difficulty can be resolved under the conditions imposed by the court. They approve a plan of reorganization in the hope that they'll collect more of the debt, even though they may have to wait longer to do it.

Bankruptcy can be either voluntary (when you petition the court to declare you bankrupt), or involuntary (when your creditors petition the court to declare you bankrupt).

There are some debts which cannot be discharged in bankruptcy, for example, taxes, certain student loans, and obligations incurred for intentional wrongful acts. (*See also* **Collection Problems**)

BANKS

A bank is, essentially, a money store. Money is the product it buys, sells, and rents. The interest rate a bank charges on a loan is the price the borrower pays for the use of the bank's product. Like renting a car, sooner or later you have to bring it back and, meanwhile, you're paying rent for the use of it.

Conversely, the bank has to rent its product (money) somewhere. The depositor is the supplier, who is paid for the use of its money, just as a collector pays for artwork.

Like all successful enterprises, banks try to buy at the lowest price and sell at the highest. That's how profits are made, and that's why it always costs more to borrow money from a bank than a depositor is paid for depositing money in that bank.

There are essentially three types of banks: commercial banks, savings banks and savings and loan institutions, and credit unions. Commercial banks deal primarily in business and commercial money transactions, such as checking accounts, credit cards, automobile loans, international money transactions, and the like. Savings banks and savings and loan institutions deal primarily in a variety of savings accounts and long-term loans, such as home mortgages. Credit unions are very much like savings banks but provide services only for their members, who typically must be part of an identified group, such as teachers, government workers, and the like. A number of banking services, such as safe deposit boxes, traveler's checks, Christmas and vacation clubs, education and home improvement loans, may be offered by all types of banks.

Since banks are regulated by both state and federal agencies, the specific services which may be offered vary from state to state. In some states, for example, commercial banks may offer savings accounts and savings banks may offer checking accounts. Credit

unions typically offer both savings and checking accounts, as well as consumer and other loans.

Even within the same city, however, different banks often charge widely differing fees for the same services. A government study found, for example, that home mortgage interest rates in New York were as much as .75 percent apart in different institutions. This may not seem like much of a difference, but look at the end result: a 20-year, $50,000 mortgage costs $5,324.49 more in interest at 7 percent than at 6.75 percent. Interest rates for home improvement loans showed an even wider spread in the study—as much as 4 percent.

Businesses which write numerous checks will find that it pays to shop around. Some banks charge a fixed monthly fee plus 15¢ to 30¢ per check. Others charge nothing for checks if a certain minimum amount is kept on deposit. Still others base their charges on an average monthly balance, and some banks even charge for the deposits that are made. Money market accounts permit check writing features while paying competitive interest rates on the amount in the account.

Minimum balance accounts are sometimes advertised as "free." While you do not pay directly for checking services, you do pay for them indirectly if you must maintain a minimum balance larger than the amount you would ordinarily keep in the checking account. If those excess funds were in a savings account they would earn interest.

Even the cost of maintaining a checking account varies, depending upon the services from bank to bank. For example, some banks charge for providing checks while others do not. Checks may also be purchased from outside sources such as bank printing companies or other printers. (*See* **Appendix F.**)

The same principle applies to the extra services. Banks charge anywhere from $15 to $25 if a check bounces. One bank may charge $4 for a stop-payment order, another only 50¢. One bank will charge $2.50 to certify a check, another only 25¢.

As a savings account depositor, it is important to understand where the best returns are. Savings banks pay a wide variety of interest. The lowest rate is on accounts from which you can withdraw virtually at will. Certificates of deposit, which last from one to seven years, pay different rates: customarily, the longer the term, the higher the rate. Generally, however, these cannot be converted into cash before their maturity without a penalty being assessed, except in cases of extreme emergency.

Even the same interest rate may provide different returns in actual dollars, depending on what basis the interest is calculated. The "low average monthly balance" method is less favorable to the depositor than the "day of deposit to day of withdrawal" method.

Like every trade or profession, banking has its own language. Don't be afraid to ask questions, and don't hesitate to ask your banker to explain what a particular transaction means in actual dollars and cents. (*See also* **Bank Statement, Cancelled Check, Cashier's Check, Certified Check, Checking Account, Cleared Check, Commercial Bank, Credit Union, Deposit, Indorsement, Funds, Interest, Letter of Credit, Loans, Money Order, Mortgage, Savings Bank, Traveler's Checks, Appendix F**)

BARTER

Barter is the exchange of one item for another. The practice of barter predates the use of money, though it was not totally displaced by money. The classic image of the country doctor is one who cares for patients in exchange for chickens, corn, and other commodities. Artists have traditionally exchanged their work directly for goods or services, rather than paying for the goods or services from the proceeds of sales of their work. While the practice is common, there are some formalities.

Bartering transactions are taxable to both parties and each must pay tax on the value of the item or service received. Bartering clubs have sprung up and assist individuals in establish-ing bartering relationships. The Internal Revenue Service has been diligent in identifying members of such clubs in order to determine that the appropriate taxes have been paid.

While bartering is taxable, it still may be economically advantageous. You should remember, when evaluating the merits of a barter transaction, that the IRS does not accept artwork for the payment of taxes. (*See also* **Accounting, Tax**)

BEQUEST (*See* **Estate Planning**)

BERNE COPYRIGHT CONVENTION

The first major multinational copyright treaty was open for signature in Berne, Switzerland more than a century ago. The United States initially refused to sign that treaty, since it was felt that the rights which were available under it were inconsistent with U.S. interests.

In the mid-1950s, it became clear that the United States intended ultimately to become a party to the Berne Copyright Convention, and many of the revisions contained in the Copyright Revision Act of 1976 were designed to conform to Berne.

In 1988, the United States became a party to the Berne Copyright Convention and, as a result, United States copyrights may be enforced in the 88 member countries.

In order to become a party to Berne, it was necessary for the United States to relax some of the formalities traditionally required for U.S. copyright protection. As a result, copyright protection now attaches whenever a copyrightable work of art involving some creativity is put into a tangible form. It is no longer necessary to use the copyright notice, though it is still a good idea to do so. The statute provides that one who relies in good faith on the omission of notice and copies is an innocent infringer. Only nominal damages, if any, may be assessed against innocent infringers and they may even be permitted to continue copying after learning of the copyright owner's rights.

The Berne Convention Enabling Legislation, the law which made the U.S. a party to the treaty, also permits copyright owners from other countries which are parties to the treaty to litigate their copyrights in U.S. courts without registering those copyrights in the United States. Registration is still required for U.S. copyright owners suing in U.S. courts and there is a presumption that a registered copyright is valid. Infringements which occur after a work is registered may give rise to statutory damages and the infringer may have to pay the copyright owner's reasonable attorney fees. Registration is quite simple. (*See also* **Buenos Aires Convention, Copyright, *Droit Morale*, Treaty, Universal Copyright Convention**)

BETTER BUSINESS BUREAU

The Better Business Bureau ("BBB") is a non-profit association of businesses set up to aid both business and the consumer. It is a form of self-regulation which utilizes the power of public opinion to encourage legal and ethical business practices.

Over 150 local BBBs throughout the country provide background information on local businesses. Such information is free and available to anyone.

Although many consumers contact the BBB only when problems arise, the BBB can be helpful to buyers before they make a purchase or sign a contract.

If an artist is considering a significant purchase, such as a kiln, and desires business information about the manufacturer or seller, the artist may contact the BBB in the area where the manufacturer or seller is located. The BBB may be able provide such information as how long the company has been in business, its record for reliability, how it deals with complaints, and other relevant information which can help the consumer make a more informed decision.

The BBB usually handles only written complaints. While a BBB has no enforcement power, it often succeeds by exerting peer pressure on the offending merchant if investigation proves the consumer's complaint to be valid. While that may not always succeed, the Bureau will at least have the complaint on file; responses to future inquiries about that merchant will contain reference to the complaint and may discourage others from dealing with that merchant.

Most BBBs also perform a great deal of work in the area of consumer education to help people make wise buying decisions. There are several things a BBB will *not* do:

1. Handle matters that require a lawyer, such as contract violations;
2. Make collections;
3. Give recommendations or endorsements;
4. Furnish lists of companies or individuals in a particular line of business;
5. Pass judgment. The BBB may indicate that a particular store has had complaints about its refund policy, for example, but will not say that the store is disreputable.

While the vast majority of major cities and most states have a BBB, not all do. Where no BBB exists, the local Chamber of Commerce can often be helpful in solving problems that arise between buyers and merchants in its area. Other organizations which provide relevant information include the Consumer Protection Division of the State Attorney General's Office, licensing bureaus such as those granting real estate and insurance licenses and municipal business licenses, and associations like the BBB which confine their information to certain kinds of businesses, such as automobile dealers.

BBBs are supported by local business people who pay annual dues, which vary from one BBB to another. Art retailers who conduct mail-order business or advertise extensively may find membership in a BBB helpful. Mentioning such a membership in an advertisement or catalogue may establish the advertiser's reputation for integrity. (*See also* **Chamber of Commerce**)

BILL, BILL OF SALE (*See* **Invoice**)

BILL OF LADING

When you ship by freight, the trucker or carrier will give you a bill of lading which specifies what is being shipped, how it is to be shipped, and to whom it is to be delivered. The recipient of the shipped goods normally gets a copy of the bill of lading, which serves to notify him that the goods have been shipped, and also to identify the recipient as being authorized to receive the shipment.

Bills of lading come in various forms, including some that are negotiable. A negotiable bill of lading is a document of title and must be presented as a prerequisite to delivery of the shipment. Such uses are rare for artists. If you ship via freight, you would normally get a straight bill of lading, which is not negotiable and authorizes delivery only to the person or company named on the document.

Bills of lading are regulated by the Interstate Commerce Commission, as well as local governmental agencies. They are also issued in accordance with the Uniform Commercial Code. (*See also* **C.I.F., C&F, F.O.B., Shipping, Uniform Commercial Code**)

BON Á TIRER (*See* **Printer's Proof**)

BOOKKEEPING (*See* **Accounting**)

BREAK-EVEN POINT

The point at which income and expenses match is called the break-even point. Your business is neither making money nor losing money. The break-even point can be an important tool in proper pricing and cost control. The break-even point is based on the assumption that an artist will sell everything created or a dealer will sell everything in inventory.

Finding the break-even point is not complicated. Two things must be known: the price at which you plan to sell an item, and the cost of creating or acquiring it.

For simplicity, we will consider a single product created and sold by a sculptor. Let us assume that you want market limited edition bronze sculptures at $100 each. You have two cost factors to consider: the fixed cost (rent, overhead, etc.) which remains pretty much the same whether you create one sculpture or 100, and the variable costs (bronze, finishing supplies, labor, etc.) which change in direct proportion to the number of pieces in the edition.

In this example we'll set the fixed costs at $1,000 and the variable costs at $30 per piece. Each $100 sculpture now contributes $30 toward its own cost of production, which leaves $70 for fixed costs. Without drawing any charts or graphs, it is apparent that you have to sell more than 14 pieces just to cover the fixed costs (14 x $70 equals $980). No profit yet. In fact, the break-even point has not yet been reached. You must sell 15 pieces to reach the break-even point and start to make a profit.

If you find that you can realistically exceed the break-even point, then your business will likely be profitable, though you should determine whether the return on your investment of money, time and energy is reasonable in light of other possible uses of those resources. That is, if you can earn more by putting your money in the bank, for example, why create limited edition sculptures?

If, on the other hand, you determine that your sales activity is such that you cannot even reach the break-even point, you have several options: (1) remain in business, continuing to lose money, with the expectation of the business ultimately becoming profitable; (2) raise the sales price of your work, though you should recognize the so-called elasticity of demand, which theorizes that, as the price increases, the demand decreases; (3) reduce the cost of creating your works, if possible; (4) increase the size of a limited edition or your general productivity and sales; (5) go out of business; (6) evaluate the marketability of your work and determine whether you would be willing to modify the creation in order to make it more marketable.

Be careful of points 2 and 4. If you can't sell your work at the increased price, or if you can't sell the greater quantity, you are left with only two options: (1) cut costs; or (2) go out of business. (*See also* **Accounting, Financial Statement**)

BROCHURES (*See* **Advertising, Printed Materials**)

BUDGET

A budget is a plan which outlines expected income and expenditures during a given period. It helps to anticipate needs and decide how to meet them. A wide variety of budgets exist in the business world, but two are of interest to a small enterprise such as an art business.

The *capital budget* is concerned with the purchase of equipment and major outlays that are not immediately used up in the

creation of artwork. Preparing such a plan for the coming year, for example, indicates not only what you expect to buy and when, but also how you expect to pay for it, whether through loans, savings, out of income, or by taking on an investor.

Much more important to the success of a small business is the *cash budget*. This should indicate, on a monthly basis for at least 12 months, what you expect to take in as a result of sales and what you expect to pay out in order to operate. The number of entries can be as brief or as elaborate as you or your accountant feel you may need in order to forecast properly and evaluate the accuracy of your budgeting.

Under "Income," for example, it might be sufficient to have four entries: *Wholesale, Gallery Shows, Consignment Sales,* and *Other.* If you also operate your own gallery, *Retail* would be another category.

Under "Expenses," you may also need only a few entries: *Raw Materials, Rent & Utilities, Selling Expenses, Payroll, Taxes,* and *Miscellaneous.*

At the beginning, if you are not using computer software, it is useful to create two columns next to each line. In the first column, you enter the budget figure—how much you estimate the income or expense for that item will total. Leave the second column blank. When you have the actual figures, enter them in the second column. You will see at a glance where your budget has been accurate, where it needs amending for the future, where the weak spots and the strong points are. That makes your next budget more realistic. The use of computers for accounting, bookkeeping, and budgeting is quite common, and spreadsheet software such as Lotus 1-2-3 is very useful for this purpose.

By pinpointing the periods of high expense versus low income which happen in almost every business, the cash budget can also help to reduce the need for borrowing money, or predict more accurately how much needs to be borrowed or how much should be held in reserve.

Budgeting, in other words, is not simply a bookkeeping exercise. It is an indispensable tool in avoiding costly mistakes and correcting errors of judgment. (*See also* **Accounting, Business Plan, Computer Software, Financial Statements, Investment**)

BUENOS AIRES CONVENTION

This multilateral copyright treaty is in effect only in the Western hemisphere, and has 17 signatories, including the United States. It

is, therefore, not a global treaty such as the Berne Copyright Convention or Universal Copyright Convention.

In order to obtain international protection under the Buenos Aires Convention, a copyright owner must comply with the copyright laws of his or her own country and use the legend "All rights reserved" as a part of the copyright notice. The legend must be in Spanish or English, whichever is the official language of the copyright owner's country. (*See also* **Berne Copyright Convention, Copyright, Treaty, Universal Copyright Convention**)

BULK SALE
(*See* **Collection Problems; Uniform Commercial Code**)

BUSINESS EXPENSES
(*See* **Accounting, Expenses, Financial Statement, Overhead, Sales Cost, Exhibitions and Shows, Wages**)

BUSINESS FORMS
Business forms are necessary for any business, including the art business. They range from simple business letters to complex contracts, government reports, sales documents, and certificates of authenticity. Businesses which have a need for large quantities of the same form will usually have them professionally printed. Some business publishers have commonly-used forms, such as leases, security agreements, and the like available for a nominal cost.

With the advent of personal computers and desktop publishing, it is becoming more common for business people to input commonly-used documents and merely fill in the blanks for the computer-generated form. This may include letterhead and envelopes, artist-dealer contracts, and the like.

There are many useful form books available for those engaged in business in general, and some which are particularly valuable to the art business. (*See* **Appendix D**)

BUSINESS INTERRUPTION INSURANCE (*See* **Insurance**)

BUSINESS NAME (*See* **Trade Name**)

BUSINESS PLAN
A business plan is a document which includes, among other things, a description of your business, its objectives, and the methods by

which you intend to achieve them, a profile of key personnel, an analysis of the market, necessary resources, and an earnings forecast.

It is extremely useful, when beginning a business, to prepare a written business plan so that you will have a road map to your ultimate business goals. Business plans are often necessary when applying for loans, attempting to obtain venture capital, or when working with an attorney in structuring your business organization.

A business plan need not be a professionally generated, complex document, but it should be as comprehensive and professional as possible. It is common for start-up businesses to work with professionals who have experience in preparing formal business plans, but this is not a necessity and many successful businesses began by having their principals create their own documents.

It is best to block out a period of time—such as a weekend—and to isolate yourself and your team from outside distractions while brainstorming the issues and writing the plan. The time invested in this process is worthwhile if well spent by focusing on the issues and the goals. It may be that the development team will identify the impossibility of some aspirations and even this is an important use of your time, since you will then be in a position to redirect your energies toward objectives which can be realized.

There are many books and articles about business plans and how to write them. There are consulting firms which can assist with the process. Consult your telephone directory. In addition, your attorney or accountant may be able to assist you or recommend other resources. (*See* **Accounting, Financial Statement, Loans, Appendix D**)

BUSINESS TAX
Every business must file a federal income tax return. In addition, states, counties, cities and other governmental entities may also impose other forms of taxation, such as income tax, inventory tax, and transfer taxes of all kinds. (*See also* **Income Tax—Business, Tax, Unrelated Business Income**)

BUSINESS TRIPS
When you go to an art show at which your work is being exhibited or engage in field research for a painting, it's a business trip and, therefore, tax-deductible. The important thing isn't how much you sold at the show or how successful the trip was, but only that it was for business reasons.

If the trip is primarily for business, all reasonable and necessary business-related expenses, including transportation, lodging, and 50 percent of the cost of meals, are deductible. If the trip is primarily for pleasure or personal reasons, then only the business-related expenses may be deducted.

Extending a business trip for pleasure or making a non-business side trip does not qualify for business deductions. There are many combinations, of course. If you fly to Hawaii for an art exhibition and then spend another week to work on your tan, your travel expenses are covered, as well as the allowable expenses during the business portion of the trip. Only the expenses of the vacation week are not deductible.

Expenses for your spouse and family have to be treated very carefully. If your spouse is an active participant in your business, helps you set up and take down your exhibit, etc., the spouse's allowable expenses are deductible. Even if your kids run a few errands for you, however, you'll have a hard time proving to the tax auditor that they are essential to your business. Automobile expenses are usually deductible. They don't change whether you're driving alone or transporting the whole family.

You can take several precautions to be able to establish that your trip was for business purposes. First, set up an itinerary which spreads your business contacts along the whole route of the trip. This is not necessary when you travel to an art show, because your exhibit at the show is, in itself, sufficient reason to go that distance.

Next, write to all the business contacts you plan to see. Tell them when you want to see them and what you want to discuss. Keep copies of the letters in your tax file. They may prove your intentions.

Make a note of all the business contacts you made during the trip, who you saw, when and where, what the results were.

Finally, keep an accurate record of all expenses.

There are special rules with respect to deductibility of expenses for luxury water travel and trips abroad. When considering such business trips, consult with your tax adviser regarding the current restrictions on their deductibility. (*See also* **Expenses, Sales, Exhibitions and Shows, Tax, Travel**)

C

C.A.F. (*See* **C.I.F.**)

C.I.F.
This term, used on invoices, order confirmations, or contracts, when used with a geographic destination, means that the total price includes cost of goods, insurance and freight to the named destination. For example, "C.I.F. New York," when used on an order confirmation stating a price, means that the amount stated includes, in addition to the purchase price, sales tax, etc., the costs of insurance and shipping from the place of shipment to New York. Some European countries use the designation "C.A.F.," which means the same thing, since they use "assurance" for "insurance." (*See also* **C&F, F.O.B., Invoice, Order, Shipping, Uniform Commercial Code**)

C&F
This term, used on invoices, order confirmations, or contracts, when used with a geographic destination, means that the total price includes cost of goods and freight to the named destination. For example, "C.F. Los Angeles," when used on an order confirmation stating a price, means that the amount stated includes, in addition to the purchase price, sales tax, etc., the cost of shipping from the place of shipment to Los Angeles. (*See also* **C.I.F., F.O.B., Invoice, Order, Shipping, Uniform Commercial Code**)

CANCELLED CHECK
A cancelled check is a check which you have issued and which your bank has paid from your account. There was a time when little holes were punched into such checks, but other forms of cancellation today accomplish the same purpose. A check that has gone through this procedure is also referred to as a check that has cleared.

Cancelled checks may or may not be returned to you with your monthly bank statement. Some banks do this automatically; others make it optional. Bank which do not return cancelled checks usu-

ally make copies available either free or for a nominal charge. Cancelled checks may serve at least two important purposes: (1) to enable you to double check the bank statement, and (2) as proof that you have made payment. If you mark the bills you pay with the check number and date of payment, it is easy to identify the check as proof of payment.

Conversely, when your records show an unpaid receivable which it is claimed has been paid, request copies of both the front and back of the cancelled check. (*See also* **Bank Statement, Checking Account, Indorsement, Uniform Commercial Code**)

CAPITAL

This word has at least two business meanings.

The accountant's definition, which is of immediate interest, loosely refers to the invest-ment in a business expressed in terms of money. This includes not only the cash put up by the owner(s) of the business, but such sources as loans, trade credit, equipment, or real estate, although, technically, loans and credit are not capital.

Capitalizing a new business often draws on a combination of resources. Suppose you and a partner want to open an art gallery. You calculate that you'll need $25,000 to get started. Where do you get that capital? Partner A invests fixtures worth $7,500, plus $2,500 in cash. Partner B puts up $10,000 in cash. You're still $5,000 short, so you go to the bank or your college roommate to borrow the balance. And you're in business.

The initial investment is not the only source of capital. The income earned by your business increases the company's capital if some of it is reinvested. Similarly, if you borrow money in order to expand several years after you've started, that also counts as capital. (*See also* **Capital Gains, Equity, Financial Statements, Loans**)

CAPITAL GAINS

Suppose you own a glass studio: building, tools, equipment. You decide you want to move to some other part of the country, so you put the studio up for sale and sell it at a profit. That profit is known as a capital gain—your capital investment has increased in value and you realized the increase in dollars and cents.

The capital gain becomes part of your income for tax purposes. The capital gains tax applies to the net profit on the sale of any capital asset, including corporate stocks, buildings, equipment, and similar capital investments. Prior to the 1986 Tax Reform Act, capi-

tal gains were taxed at significantly lower rates than ordinary income, a practice which many believed would encourage capital investment and, thus, expansion of the economy. Under the 1986 Tax Reform Act, capital gains were taxed at the same rates as ordinary income. In 1991, legislation limited the tax on capital gains to a maximum of 28 percent, thus providing a slight tax benefit for capital gains. While capital gains tax treatment remained the same under the 1993 legislation, the relative benefit improved because of other changes in the tax laws. Stock acquired after August 10, 1993 in qualified small businesses which is held for at least five years is entitled to even more favorable treatment. In this situation, 50 percent of the gain realized on the sale of that stock may be excluded from gross income, up to the lesser of ten times the basis in the stock or $10 million. A small corporation for this purpose is defined as a C corporation using at least 80 percent of its assets in the conduct of a trade or business. It may not be a personal service or other designated businesses. In addition, the small corporation's gross assets may not exceed $50 million when the stock is first issued. Even now, many in Congress would like to amend tax laws to have even more favorable tax treatment for capital gains. (*See also* **Tax**)

CASH BASIS (*See* **Accounting**)

CASH FLOW
Cash flow is the stream of money which enters your business in the form of income and leaves your business in the form of expenses and compensation. It includes money from sales and other receivables, and expenses such as labor, cost of materials, and the like; it does not include the return on your investment or the value of your assets. It is short-term income and outgo, rather than the value of your business. Alternatively, some accountants define cash flow as cash in from whatever source and cash out for whatever reason. A business may have assets worth millions of dollars—such as unsold paintings and sculptures—but, without sales, there is no income. Without income, expenses cannot be paid; therefore, there will be no cash flow. (*See also* **Financial Statements**)

CASHIER'S CHECK
Most checks are written by depositors against their checking accounts. A cashier's check is written by the bank against its own funds. It is considered more secure than a personal or business check.

Creditors often require cashier's or certified checks. You must provide the bank with cash in the amount of the check to be drawn; the bank may also charge for its services. Two drawbacks to using cashier's or certified checks are that you don't have a cancelled check as proof of payment (although you may have a check stub or carbon copy) and it may be difficult, if not impossible, to stop payment on the check.

A cashier's check and a certified check are similar, in that the bank is responsible for payment in both cases. As stated above, a cashier's check is drawn against the bank's own account and will be issued to anyone who pays for it. A certified check is drawn against a depositor's account; the bank merely certifies that it has isolated the funds and restricted them for payment of that check. (*See also* **Certified Check, Letter of Credit, Money Order**)

CATALOGUE

A catalogue is an expensive promotional device which few artists produce, though most auction houses and many galleries do. Occasionally, artists will either produce their own catalogues or band together with other artists and cooperatively publish.

Slick catalogues are good sales tools but, if the catalogue is not first-rate, it will reflect poorly on the artist. Thus, if you cannot afford a superior catalogue, you may consider purchasing ad reprints or flyers. Publishing a catalogue is a job for a skilled publisher, and most artists would rather invest their time and energies in creating their art.

Catalogues play several roles in the art business. Exhibition catalogues are created for the sole purpose of depicting and describing the artwork in an exhibition. Museum catalogues are prepared for special shows of works on display or in the museum's permanent collection. Mail order catalogues customarily contain works which are produced in multiples and offered for sale by, for example, galleries, museum gift shops, or artists' coops. (*See also* **Advertising, Cooperatives, Direct Mail, Printed Materials**)

CERTIFICATE OF AUTHENTICITY

A certificate of authenticity is a document which certifies that a work of art is what it purports to be. Many jurisdictions require certificates of authenticity to accompany fine prints and editioned sculptures when they are sold. The certificates must contain certain information, such as the name of the artist, the title of the work,

the medium and method of creation, the year the multiple was created, the number of pieces in the edition—including any proofs, the disposition of any plates or molds, and whether the work was created posthumously.

Certificates of authenticity are also commonly used in connection with antiquities. These certificates usually contain information about the artist (if known), the work, the medium, the age of the work, country of origin, and any other relevant data, such as provenance.

While certificates of authenticity are not universally required, they are nevertheless a good idea, since collectors appreciate the disclosures contained in them, and the information may, thus, be preserved for future generations.

Works of art may enter the United States duty-free; limited edition prints which are hand-pulled from handmade plates and the first 12 pieces of editioned sculptures are also entitled to duty-free treatment. Certificates of authenticity can be used to establish the qualifying criteria. Even if a work of art has been created in a functional medium, such as an Oriental rug, it may still be entitled to duty-free entry if it is of a certain age or is in a specified category of work from certain underdeveloped countries which have been granted special privileges under the General System of Preferences ("GSP"). Here, too, the certificate of authenticity has great evidentiary value. (*See also* **Authenticity, Customs, Limited Editions, Multiples, Prints, Sculpture, Appendix A**)

CERTIFIED CHECK

When a check is certified, it means that the bank has confirmed that the person who writes it is a depositor of that bank and that the money has been set aside by the bank for payment of that particular check. The bank is now responsible and liable for payment. The depositor has no further access to that money. Payment cannot be stopped on a certified check. Certified checks will not be dishonored unless the bank fails and is uninsured.

To have a check certified, you present it to the bank on which it is drawn. An officer stamps the certification across the face of the check and adds his or her signature.

A check is normally presented for certification by the person who writes it, but it can also be done by the person who receives it, as in the case of a check which will not be cashed until some future time when the service for which it is presented has been performed.

Certified checks are often required in substantial or irrevocable transactions, such as the transfer of real estate. (*See also* **Cashier's Check, Checking Account, Letter of Credit, Money Order**)

CHAMBER OF COMMERCE

A chamber of commerce is a group of business people and companies whose purpose is to encourage commercial activity.

Chambers of commerce are organized on local, state, and national levels, and occasionally even within certain industries. They are supported by dues payments from members and engage in a variety of activities. Since they represent a diversity of business interests, one of their major functions is to bring various business people together to exchange ideas and help support each other and their community.

Some chambers of commerce have given support to artists by establishing business committees for the arts, sponsoring museum shows, and supporting local arts commissions. Others are involved in attracting tourists to their areas, occasionally include listings of local galleries and art-related activities in their literature, and have gone so far as to produce maps depicting art business locations.

Artists who consider relocating to another area of the country often find that information about business conditions, taxes, facilities, and other details from the local chamber of commerce can be very helpful in reaching a decision. In this connection, it should be remembered that a chamber of commerce rarely, if ever, mentions any negative aspect of its community. (*See also* **Better Business Bureau**)

CHATTEL MORTGAGE (*See* **Mortgage**)

CHARITABLE CONTRIBUTIONS

Charitable contributions are gifts of money or property, including art and antiquities, which are made to charitable institutions. If the recipient is a "qualified charity"—that is, one which is created for the purpose of public benefit and which has obtained an appropriate ruling from the Internal Revenue Service (traditionally under 501(c)(3) of the Internal Revenue Code), then the maximum charitable donation may be taken by the donor.

Prior to 1969, artists could deduct the fair market value of their works which they donated to qualified charities. Since then, artists have been allowed to take charitable deduction from their *federal* income tax for only the cost of the materials used in creating the

donated work. Some states provide artists with the right to deduct either the fair market value of their donated work or the difference between the fair market value and the amount deducted for federal income tax purposes.

Collectors may deduct only the amount they paid for a work donated to a qualified charity, regardless of the fair market value, though the deduction for artwork donated to qualified charities will not affect the donor's alternative minimum tax. (*See also* **Income Tax—Business, Income Tax—Personal, Tax**)

CHECKING ACCOUNT

Most people are familiar with checking accounts. A check is a negotiable instrument which is written as an order to the bank as agent of the depositor instructing it to pay the amount specified to the named payee of the check or, if the check is written as payable to "Cash," then to the person presenting the check. Checks and checking accounts are governed by Article 3 of the Uniform Commercial Code, as well as a host of other state and federal laws and regulations.

When you begin your business, you should establish a business checking account. If your art business is a corporation or limited liability company, you will need to present the bank with a copy of your articles of incorporation or articles of organization and federal Taxpayer Identification Number. Businesses operated under assumed business names or trade names will have to register the assumed name with the appropriate government office and provide the bank with proof of registration, along with the appropriate taxpayer ID number.

Business checking accounts should never be used for paying personal obligations. Instead, the business should issue an appropriate check to the individual, who should then deposit it into his or her personal account before writing personal checks against it. Similarly, personal funds should never be used for directly paying business obligations. If the individual finds it necessary to advance money on behalf of the business, he or she should promptly submit a receipt for reimbursement from the business.

Checks come in a wide variety of sizes, shapes, designs, and colors. They are available from banks and from commercial printers. Generally, the printers charge less per check than the banks, so it is a good idea to shop around when ordering new checks.

More important than the look of the check is how it is used. Care

should be taken when writing a check. It should be properly dated—and should never be post-dated. The payee's name should be spelled correctly, and the amount, both in the numerals and the words, should be written in such as way as to preclude alteration. The first numeral should be written as close to the pre-printed dollar sign as possible, and there should be little space between the numbers. The first number word should be written as close as possible to the left edge of the check and any space between the words and the pre-printed word "Dollars" should be filled with a line. The check should always be signed when written.

When you receive a check, if you indorse it "for deposit only," it cannot be cashed, even if it is stolen. You can obtain an indorsement stamp from your bank or stationer which makes your art business look more professional. **Never** indorse a check before you are ready to negotiate it. It is unwise to carry indorsed checks—other than those "for deposit only." It is very risky to sign a blank check. If you do, you should promptly ascertain the amount which was filled in. Note that amount in your check register and be certain to verify it as promptly as possible. Consider using petty cash to avoid using blank checks.

Forging a check is illegal, and a forged check cannot be charged against your account. If you believe that you are being charged for a forged check, notify the bank as promptly as possible. Altered checks are treated the same way as forged checks.

When you write a check, the recipient negotiates it, either by depositing it in the recipient's bank or obtaining cash. The negotiating bank then transmits the check, through banking channels, to your bank, which deducts the amount of the check from your account. You will be notified of the deduction on your next statement. You should promptly reconcile your monthly bank statements to determine whether there are any irregularities. You should also keep a running balance of deposits, checks, and other deductions in your checkbook register so that you always know what your balance is.

It is unlawful to knowingly write a bad check, and the penalties can be severe. Mistakes in arithmetic do occur and, if you inadvertently write a check which results in an overdraft in your account, you will likely be charged by your bank and the check may not be honored. Some banks have special provisions for covering overdrafts on behalf of certain depositors, for example, those who have maintained their accounts for some time and have had a good record with the bank.

You may wish to stop payment on a check after it has been issued. Most banks will permit this, though there are certain rules which must be followed. It must be done promptly and before the check has been paid. There is generally a charge for the service and most banks require the stop payment order to be in writing. Some banks will limit the number of stop payments orders they will honor within a prescribed period. Care should, therefore, be taken with your use of the stop payment procedure. If a problem arises, you should immediately contact your bank to find out what its rules and policies are with respect to stopping payment.

If you make an error in writing a check, you should write "VOID" prominently across the face of the check and keep it with your register, mark the space in your register for that check number "void," and start again with the next check.

Check writing in no longer confined to paper and pen. Today, many computer programs will write checks and some will even make the appropriate bookkeeping entries. For example, Quicken is a sophisticated bookkeeping software package which will not only provide a computer data base for bookkeeping entries, but has check writing capabilities. Other packages available for this purpose include One Write Plus and Microsoft Money.

With the advent of limited electronic banking, some banks will permit regular automatic withdrawals, such as payment of your rent or mortgage. In fact, any fixed, on-going payment which must be made monthly—such as insurance premiums—is a prime candidate for this service. The advantage of automatic withdrawal is that you save the time of writing a check and save the cost of mailing it. Unfortunately, the service is automatic and you may find that your account becomes overdrawn either because of cash flow problems or because you forgot to deduct the automatic payment from your checkbook balance. (*See also* **Banks, Bank Statement, Indorsement, Uniform Commercial Code**)

CLEARED CHECK

The term "cleared check" commonly means that the person to whom you wrote a check deposited it in his or her bank, that bank presented the check to your bank, your bank paid it from your account, and that the check has been cancelled. (*See also* **Cancelled Check, Checking Account**)

COLLATERAL

In financial terms, collateral is something of value that is pledged as security against the repayment of a loan. If the payments are not made, the lender can foreclose through a specified procedure, which may include, among other things, a sale of the collateral. Your inventory of artwork may be collateral for a line of credit. This inventory would likely be secured by the lender using a UCC-1 Financing Statement. Your house or business real estate will likely be collateral for your mortgage. The security interest in this form of collateral is perfected by having the mortgage recorded. Both UCC-1s and mortgages must be "perfected" by recording with the appropriate government office, since subsequent lenders and others interested in your financial situation will check these offices and since the law allows secured a lender to enforce its security interest only if it is perfected. (*See also* **Loan, Mortgage, Uniform Commercial Code**)

COLLECTION AGENCIES (*See* Collection Problems)

COLLECTION PROBLEMS

Collection problems fall into three major categories:
1. Bad checks;
2. Change of ownership or insolvency; and
3. Slow payers.

Bad Checks

It would be nice if everyone in this world were honest. Unfortunately, a good many checks have been known to bounce. Protect yourself by following a few simple rules:

1. Before you accept a check as payment, ask for a check guarantee card or identification that includes the person's signature and photo. Driver's licenses and major credit cards are best. Double-check the signature and address. On the check, note the driver's license or, if allowed in your state, credit card number, and the customer's address and telephone number, if different than what is pre-printed. Do not accept as proof of identity such items as business cards, bankbooks, library cards, Social Security cards, and the like.

2. Never cash a check for someone you don't know.

3. Accept a check for payment only if it is made out to your business and in the exact amount of the sale.

4. Don't accept third-party checks, i.e., checks made out to someone else and indorsed to you. That only adds another element of potential trouble. You don't know the person who wrote the check originally; it could be a stolen check.

5. Mark all checks "for deposit only" the moment you receive them. That makes it impossible for a thief to cash them.

None of this guarantees that a check won't bounce, but you'll at least be more likely to find the maker of the bad check. You'll also protect yourself from being known as an easy mark.

Not every bad check is uncollectible. Occasionally, checks are returned marked "non-sufficient funds" ("NSF") because of an oversight or bank error. In that event, it is best to make polite contact with the customer, who will usually ask you to redeposit the check. In almost all cases, the check clears the second time. If it bounces again, take legal action. Banks will rarely allow more than one redeposit.

If payment on a check issued to your business has been stopped before the artwork has been delivered, it is probably best to treat the sale as rescinded. If, however, the work has been delivered and payment is stopped without there being a good reason, you may have to take legal action to recover the artwork or payment for it.

Change of Ownership or Insolvency

If there is a change in ownership of a business which owes you money or if the debtor becomes insolvent, there is a good chance that you will not be paid. There are four common ways this can happen.

1. *Bulk sale.* When a business with inventory is sold, the creditors of the selling business have a continuing claim on the sold assets, even after the buyer of the business has paid for it. Very often, the sales contract stipulates that the buyer takes over all assets and liabilities of the business. When the liabilities are not paid, the creditors must be notified.

Bulk sales are governed by the Uniform Commercial Code, and apply to the sale of all or substantially all of a business' assets. Each state has adopted variations, but the basic requirement generally is that a 10-day notice of sale must be given to all creditors before the sale closes. This is to allow creditors to make their claims, find out when and how they will be paid, and take legal action if they are not satisfied with the terms. Prompt action is necessary. If a security interest in the inventory was perfected under the Uniform Commercial Code prior to the sale of the business, the buyer of the

business will have "constructive notice" of the obligation. Many states have artist/dealer consignment laws which, among other things, make it clear that work which is not purchased outright is on consignment and that the artist's interest is secured until the artist has been fully paid. This is true even after a bulk transfer to a new owner. (*See* **Appendix C** for a list of state artist/dealer consignment laws.)

2. *Common law composition.* This is the most flexible and least formal way for a business which owes more than it can pay to liquidate in an equitable manner, or arrange to continue in business. The debtor offers a certain proportion of the amount owed to all creditors who agree to take that amount in full payment. Since the legal costs are low, there is usually no point in a creditor rejecting such an offer if it is satisfied that the debtor is acting in good faith and that no other creditors are being treated better. If a check for the proposed settlement is enclosed with the notice, remember that depositing, cashing, or even just keeping the check may be considered acceptance of the plan.

3. *Assignment for benefit of creditors or receivership.* This is a more formal way of liquidating a business, but it is less formal and less expensive than bankruptcy. It is a state court proceeding in which all the assets of a business are turned over to a court-appointed receiver, who sells off the assets, usually at auction. The proceeds are distributed to the creditors in proportion to their claim after such items as wages, taxes, the receiver's fee, and certain other expenses have been paid. It is important to file a claim on the proper form when you receive a notice of assignment.

4. *Bankruptcy.* This is a proceeding in federal bankruptcy court and costs are usually higher than the previous methods. Once the petition is properly filed, the court clerk will begin the process of notifying creditors listed on the bankruptcy schedules of the bankruptcy filing, the date of the first meeting of creditors, and the deadline for filing proofs of claim. Prompt filing of your claim is very important. If the case has been determined to be a "no-asset case," the court will not accept proofs of claim. Certain transactions, both before and during the bankruptcy, may be disallowed or avoided, and the recipient of the preferential treatment may be required to return to the bankrupt estate what was received so that it can be more fairly distributed. This is a very technical area and you should work with an attorney experienced in bankruptcy law whenever you become involved with bankruptcy, either as a creditor or a debtor.

The artist/dealer consignment laws mentioned above also deal with the disposition of artwork in bankruptcy.

Slow Payers

This is a common collection problem and usually results from the purchaser's cash flow problem. During hard times, galleries may use earnings for the purpose of paying overhead costs, such as rent, utilities and wages, while postponing the payment of artists' commissions or fees. It essentially converts artists into unsecured lenders who are not earning any interest for the use of their money. From the gallery's perspective, it is an economically advantageous situation, since late charges are generally not imposed. The various state artist/dealer consignment laws were enacted, in part, to overcome this problem. In states without such laws, or even where they are present, a good follow-up procedure for collecting unpaid bills is absolutely essential.

Most sales contracts specify when payment is due. To encourage customers to pay their bills quickly, it is a common practice for many businesses to allow a discount if the bill is paid within 10 days. Unfortunately, this is not common in the art business. It is also quite common for businesses to assess a late charge if the bill is not paid with 30 or 60 days. Here, too, artists have traditionally not followed this business norm.

If you haven't been paid by either a collector or a gallery 35-45 days after the payment is due, mail a courteous reminder. Ten or 15 days later, if you still don't have your money, another reminder should be sent, this one more insistent. In most cases, 60 days should be the outside limit for the final reminder. That one should alert (not threaten) the buyer that you plan to take further action if the bill is not paid immediately. If that doesn't bring results, turn the bill over to a collection agency or your attorney, especially if the buyer has not even had the courtesy to contact you and explain what the difficulty is.

There are always exceptions. If a gallery owner with whom you have had good payment experience suddenly falls behind and explains that he's had a fire and needs a few extra weeks to get back on his feet, it is usually prudent to give the extra time. But just because past experience has been good does not necessarily mean that a gallery can't get into financial trouble. Judge each situation on its own merits. If you have any real reason to worry, activate your collection effort promptly.

Follow-up

Several systems can be used for collection follow-up. First, you should keep a written record of every transaction, both sales and consignment. Your record should reflect the day payment is due and the dates you send follow-up notices. You should also note follow-up dates on your calendar.

Collection agencies

The services of a collection agency may be desirable. Collection agencies generally charge a percentage of the amount they collect; the smaller the bill, the larger the percentage. Collection agencies have no greater powers to collect debts than individuals, but their services may be cost-effective and save a good deal of time. It is well known that collection agencies turn their experience with bad debts over to credit bureaus.

It is important to select a collection agency whose reputation is sound. Heavy-handed tactics can backfire and expose you to legal liability under the Fair Debt Collection Practices Act. Check with other artists in your area to learn what their experience has been with particular collection agencies, or if they have other recommendations to make.

Whether you should turn the matter over to an attorney depends upon a variety of factors, including the size of the debt and whether your state has enacted an artist/dealer consignment law which provides for the payment of attorney fees in situations such as yours. Even in states without such laws, the artist/dealer contract may have an attorney fee provision which will entitle you to recover the amount you spend on the lawyer, provided you are successful and the debtor has the means to pay the bill. Collection practice in the art business is a specialized field and you should work with an attorney who has experience in dealing with these kinds of problems. (*See also* **Bankruptcy, Consignment, Small Claims Court, Appendix C, Appendix D**)

COLLECTOR

"Collector" is a term used to identify one who acquires art for the purpose of retention and enjoyment, as distinguished from "dealers," who acquire artwork for the purpose of resale, and "investors," who acquire and hold artwork for economic appreciation. The same person may play any or all of these roles, since many collectors have been fortunate enough to resell items from their collection for sig-

nificant profits, and many dealers enjoy the artwork they sell.

Some collectors begin by acquiring a work which appeals to them, then learning more about the artist, school, or movement, which sparks additional interest and results in more collecting. Other collectors start out with a great deal of knowledge and purchase work which they have researched. Collectors, like artists, have a variety of tastes and economic resources. It is difficult to make any general statement about collectors, except that the art world could not exist without them. (*See also* **Dealer**)

COMMERCIAL BANK

This is a bank whose main function is to handle checking accounts, although it also performs numerous other banking functions such as lending money and renting safe-deposit boxes. While many commercial banks also offer savings account services, the interest paid on those accounts is generally lower than that offered by savings banks or credit unions. (*See also* **Banks, Credit Unions, Savings Banks**)

COMMISSION

This term has a variety of meanings, but only two are relevant in the art business:

1. *Sales Commission:* the amount of money paid to an agent or dealer, usually a per-centage of the dollar value of the sale. The percentage a gallery retains on consignment sales is also called a commission. The specific amount or percentage should be agreed upon when the relationship begins.

2. Commission is also a term used to describe a work made to order. The term does not usually apply to work that is to be resold, but is generally used in connection with a work made to the specifications of the person commissioning the work; e.g., a portrait or a large mural incorporating a company theme for display in a corporate headquarters.

Such a commission should always be in writing. The contract should include, among other things, how and when the client approves the work; payment schedules (advances, etc.); completion date; installation responsibility, if any; responsibility for packing, shipping and insurance; what happens if the artist dies or become disabled before the work is completed; whether the artist retains rights to the work if the customer finds it unacceptable; post-completion rights and obligations, such the client's right to reproduce or the artist's right to insist upon restoration. Detailed specifications of the work itself (size,

materials, design style, subject matter, etc.) should be clearly defined to avoid later controversy or, worse yet, rejection. *(See also* **Architects, Customers,** *Droit Morale,* **Order, Selling, Visual Artists Rights Act, Appendix C, Appendix D**)

COMMON CARRIER

A common carrier is anyone, individual or company, who publicly offers to transport goods for a fee. Truck companies, bus lines, railroads, and airlines are typical examples. They are usually regulated by some government agency, operate on a franchise, and are required to charge the same fee for the same service to all customers. Common carriers have the responsibility for transporting the goods safely, speedily, and correctly, and are legally liable for the fair market value of works which are lost or damaged.

Local truckers with whom you make your own arrangements are called private carriers. They can charge anything the market will bear, pick and choose their customers, and their liability and responsibility are much less clearly defined. Artists delivering their own work locally may either do it themselves or use the services of a private carrier. It is rare for artists to use common carriers, except for interstate deliveries. *(See also* **Bailment, Freight Allowance, Insurance, Shipping**)

COMPUTERS

As the name indicates, these devices were originally invented for the purpose of performing computation tasks. They have become popular for a variety of business tasks. In addition, the prices on computers have dramatically declined since the early days and, today, most small businesses have become computerized.

Computers can be used for bookkeeping, check writing, retaining customer and supplier lists, inventory control, and even for the purpose of performing some design functions. At one time, it was necessary to have special programs designed to accommodate each business. Today, there are numerous software programs available which can probably be used in most small businesses. Art business people who desire to have specific programs created for their business can work with systems analysts who can evaluate the unique needs of the business. These individuals will either write the necessary software or work with software programmers to create a program which, if properly implemented, can save countless hours and perform numerous tasks necessary for the conduct of an art business.

Computer technology has been improving at a rapid pace and the prices charged for both hardware and software are in constant flux. You should purchase a system which can be upgraded as the technology evolves and your business grows. Systems and prices are very competitive, and it is worthwhile for you to shop around. You may also find it cost-effective to hire a consultant to analyze your needs and make appropriate suggestions. Be sure the person is experienced—ask around for recommendations. Be sure that you purchase equipment (hardware and software) which will be able to service the needs of your business as they expand. Care should be taken to acquire compatible components. The worth of a knowledgeable adviser cannot be overemphasized. Be sure, for example, that the hardware you purchase can support the software you need.

Hardware

Hardware is the term used to describe the machinery which accommodates the programs known as software and which perform computing functions. Hardware includes the hard drive, printers, scanners, and the other ancillary components which collectively are a computer system.

Software

Computer programs generally come in the form of 3 1/2" or 5 1/4" floppy disks or CD-ROM, and are available to accomplish a host of business operations including word processing, desktop publishing, database management, bookkeeping, accounting, and tax preparation. In addition, specialized software has been created for designers and nearly every other aspect of the art business. You should consult with your accountant before purchasing accounting, bookkeeping, or tax preparation software. (*See also* **Accounting, Equipment, Tax**)

CONSERVATION

Art conservation is usually performed by experts who have been trained to protect works of art and antiquities from deterioration. Many museums have conservation labs which establish the norms for protecting the museum's collections and may assist others with conservation needs.

Conservation includes, for example, cleaning, revarnishing oil paintings, arresting bronze disease, and dealing with the myriad complex problems which will result in deterioration or destruction of art or antiquities.

Conservation which is limited to protecting the items from deterioration should be distinguished from *restoration*, which is the act of reconstructing a work to its original state or condition. There is a good deal of controversy over the acts of some restorers, who may introduce their interpretation of the work. As a result, the restored work may not retain its integrity as the creation of the original artist.

Occasionally, the distinction between conservation and restoration blurs. For example, was the recent cleaning of the Sistine Chapel ceiling an act of mere conservation, preserving the work which had always appeared as it was created by Michelangelo, or did the experts engage in acts of restoration which returned the work to that which was intended by the artist but which had been modified over the centuries? It is clear that the ceiling in its current state is different from that which was on display prior to the recent activity, and the world is divided on the appropriateness of some of the recent work. There is no question that the act of removing genital overpainting—which is documented to have been added after Michelangelo—is restoration. What is unknown is whether the work as completed by Michelangelo more closely resembled the ceiling prior to the most recent work or whether it looked like the newly-displayed work.

CONSIGNMENT

The majority of artist/dealer relationships involve consignment. It is a transaction whereby the artist retains legal title in the work while the dealer has possession of the work for the purpose of sale. The title is transferred to the purchaser when the artist is paid.

Unfortunately, the artist is forced to wait until the work is actually sold before receiving money; thus, many artists dislike consignment arrangements. They claim that it converts the artist into an involuntary banker for the dealer, in essence providing an interest-free loan with no prescribed payment date.

While it has long been the norm in the crafts industry for works to be purchased at wholesale and then resold, fine art has rarely been purchased outright by dealers for the purpose of resale. In recent years, however, the practice has begun to change. There are a number of wholesale art shows, such as Art Expo, L.A. Expo, and the like, which allow for both wholesale and retail sales. While this is an option for some recognized artists, it is highly unlikely that dealers will purchase the work of artists who have not yet estab-

lished their reputations or a track record for the sales of their work. Consignment sales will, therefore, be the starting point for virtually all artists and the common marketing method for most others.

Before entering into a consignment arrangement, it is imperative that an agreement be signed to avoid pitfalls and misunderstandings. Following are five major points that should be included in every written consignment agreement:

1. *Description of Artwork.* Every time you deliver artwork on consignment, describe the items in detail. Don't simply sign a blanket consignment agreement which does not specify the work being consigned. The best way to do this is to have the consignment agreement refer to an appendix or exhibit listing the artwork. Each time you consign additional works or the dealer sells previously-consigned art, you merely update the appendix or exhibit.

2. *Term of Consignment.* Specify how long the works can remain unsold in the dealer's inventory before you have a right to demand their return.

3. *Pricing.* The most common method is to establish the retail price for your work, and to spell out the percentage of that retail price which you and the dealer will each receive when the work is sold.

You can also agree to a specific dollar amount which you, the artist, will receive and let the dealer set its own retail price, but that's not recommended except in unusual circumstances. Under no circumstances should the dealer be allowed to reduce the price on your artwork without your permission. This is because a dealer could hurt your market by underpricing your work.

On very high-priced works, it is sometimes useful to establish a minimum retail price and allow the dealer to negotiate a sales price at or above the minimum. In these instances, your percentage should be based on the ultimate sales price, not on the minimum price. This kind of relationship requires a high degree of confidence in the integrity of the dealer.

4. *Method of Payment.* This depends on the nature of the sale. If it is a cash transaction, you should be paid within a relatively short period of time. If, however, there is an installment sale, then you may be paid a pro rata portion of each installment payment, though the artist/dealer consignment laws usually require that the artist receive the full amount of all installments until the artist has been paid in full.

5. *Risk of Loss.* What happens if consignment items are damaged, stolen, or destroyed by fire? The consignment agreement can

place this risk on the dealer, but damage by fire or theft to artwork the dealer does not own (e.g., artwork on consignment) may not be covered by the dealer's insurance policies. There are at least two methods for dealing with this situation:

(a) Artists can carry their own inventory insurance, including works out on consignment;

(b) Dealers can carry special insurance to cover consignment items.

These are just a few of the major considerations that should be included in every consignment agreement. Two things are clear: First, if substantial amounts of money are involved, consult an attorney; second, the integrity and solvency of the people with whom you do business are among the most important elements of consignment selling.

Even with a contract, you may still lose your work if the dealer goes bankrupt, is sold, or gives its creditor(s) a security interest in its inventory. Article 9 of the Uniform Commercial Code is designed to afford protection to the artist in these situations. If you comply with the requirements of that law by filing a financing statement with the appropriate state office (usually the Secretary of State), and by giving written notice to the holder(s) of any perfected security interest in the inventory of the dealer *before* the dealer receives possession of your work, you will have established priority over a secured party who is or becomes a creditor of the dealer. This means that, if any conflict arises as to the ownership of the inventory of the dealer, your claim to your work will take precedence over that of any other claimant, including a trustee in bankruptcy, *if* you have complied with the filing and notice requirements.

You can easily find the identity and address of any holder of a perfected security interest by contacting the office of your Secretary of State or Attorney General, where such interests are normally kept on file and are available for public examination.

Filing a financing statement will protect you as against other creditors of the dealer or as against a trustee in bankruptcy. This will not help you to recover the merchandise from customers of the dealer who have paid for it and are not aware of your interest in it. Yet, filing will be important in such cases as when a bank or other creditor attempts to seize the dealer's assets in satisfaction of debts.

Many states have responded to the problems faced by artists in consignment relationships by adopting artist/dealer consignment laws. Typically, these statutes make a work of art placed on con-

signment "trust property" in the hands of the art dealer and the proceeds of its sale "trust funds" for the benefit of the artist. Even if the dealer subsequently purchases the work for his or her own account, the art remains trust property until the consignment price due the artist is paid in full. Trust fund status imposes several well-defined legal duties on the art dealer (in the role of trustee and/or agent) and, more important, affords much greater protection to the trust property and funds as against the claims, liens, and security interests of creditors of the art dealer-consignee.

Other typical provisions of consignment statutes require the use of a written contract and payment to the artist-consignor within a prescribed period after the sale. Also, most such laws prohibit outright or severely restrict the consignor from waiving his or her rights and protections under the law.

Artist/dealer consignment laws vary from state to state; thus, you should consult your attorney as to the specific rights and duties provided by your state's law, if any. (*See also* **Alternative Space, Artists' Representatives, Bankruptcy, Collection Problems, Retailing, Salesmanship, Uniform Commercial Code, Wholesaling, Appendix C**)

CONTRACT

A contract is an agreement between two or more people which is enforceable and for which the law provides a remedy when it is breached.

You enter into contracts all the time. Every time you offer artwork for sale and someone accepts the offer, a contract exists. Every time you buy supplies, you are entering into a contract that requires one party to deliver and the other party to pay.

Your mortgage, your lease, your relations with the telephone and electric companies, employees you hire, consignment agreements, the gas you put into your car—all of these are contractual situations and they are all legally enforceable.

It is important to understand that a contract, to be enforceable, must meet all of the following four conditions:

1. *Competence.* The parties to the contract must be competent to enter into an agreement. Convicted prisoners, the insane, and certain other people generally are not considered competent to make contracts in the legal definition of the term. Children may be able to make contracts, although they may be able to rescind them in some situations.

2. *Mutual agreement.* Both parties must agree on the terms of the contract. That's why there is often a great deal of negotiation before a contract is signed.

3. *Consideration.* The parties have to do something for each other. This is usually expressed in terms of money, although that's not necessary. It can be the performance of some kind of service. But there has to be some balance. A contract which is very obviously lopsided in favor of one party or the other may not meet the requirements of the law.

4. *Lawful purpose.* An agreement to do something illegal is not enforceable. The following are some examples which may be useful in understanding contracts:

a) You promise your cousin that you'll paint his portrait. Somehow you're always too busy. What can your cousin do?

b) A 12-year-old girl admires a $25 necklace at your gallery. "Here's a $5 deposit," she says. "I'll get the rest from my mother and be back in a little while." She comes back and says her mother won't let her buy the necklace and she wants her $5 deposit back. Can you insist that she buy the necklace?

c) You pay the building inspector $50 to overlook the kiln you installed in violation of the zoning laws. But he's an even worse crook than you are. He takes the money and reports you anyway. Can you sue?

d) You want a booth at an art show and you are offered space at $50. You send the check, but when you appear at the show there's no booth for you. Can you sue?

Let's examine the answers:

a) Your cousin may be sore, but he has no legal leg to stand on. There was no consideration involved, no agreement that he would pay for the portrait or do something for you in return. All he can do is never speak to you again. Perhaps you win.

b) A 12-year-old could have fulfilled the contract, although, because of her age, she may rescind it. You'd better give her back the $5 and sell the necklace to someone else.

c) A contract to commit a crime is not enforceable. You're probably better off to keep quiet about the whole deal and learn from your mistake.

d) Here's a perfectly good contract. Both you and the show management are competent to enter into a contract, you both agreed on the terms, it's a perfectly legal activity, and you upheld your end of the bargain. You can sue.

A contract does not have to be in writing. Oral contracts, even contracts which are created merely through the actions of people, are legally enforceable. It is always better to put an agreement in writing to avoid misunderstanding. The law does require certain contracts to be evidenced by a writing: all real estate transactions and most contracts which extend over a long period of time (more than a year or, in some instances, more than a lifetime) or involve large sums of money ($500 or more). This is a technical area. When in doubt, consult an attorney.

It is also wise to specify a starting date and a termination date under certain conditions, as in employment or consignment agreements. They can always be renewed if both parties agree.

Most ordinary, everyday contracts require no legal advice; you'd need in-house counsel to handle them all. But it is important that you read all the fine print. When you receive a contract, even an insurance policy, read it carefully, front and back, so that you understand not only the basic terms, but all the conditions that apply. When you apply for a bank loan, read every clause and ask the bank officer to explain anything you don't understand. After all, the bank's lawyer drew up the form. You have a right to read and understand what you're signing.

When you come to more complicated contracts, i.e., those which may have the potential of significant impact on your rights, interests, or obligations, a lawyer's advice is absolutely essential. A real estate sale or purchase, for example, should never be undertaken without a lawyer's review, advice, and active involvement to protect your interests. A partnership agreement or artist/dealer consignment agreement also should be undertaken with legal advice. In fact, any long-term or out-of-the-ordinary contract should be signed only after consultation with a lawyer. Expensive as legal advice may seem, it is more cost-effective to hire a lawyer before you sign a contract than it is to hire one after a problem develops. (*See also* **Alternative Dispute Resolution, Alternative Space, Consignment, Employees, Labor, Lawyers, Lease, Loans, Partnership, Exhibitions and Shows, Appendix D**)

COOPERATIVES

A cooperative is an organization formed by a group of people with similar interests to achieve a common goal or to accomplish one or more objectives more effectively or economically than any individual would likely be able to on his or her own.

Most cooperatives are organized because its members have a need for centralized buying or marketing; some have even begun to develop technical assistance programs, obtain group insurance, and other services.

Cooperatives are customarily created as either unincorporated associations or non-profit corporations, though some operate as business corporations. The fundamental advantage of having the cooperative conduct its activity through a non-profit or business corporation is that the members may shield their personal assets from business liability. The distinction between these two types of corporation is that non-profit corporations are established for the purpose of performing a public service and no individual can own an interest in the organization or receive dividends as a return on investment. Individuals may be members of a non-profit corporation and be permitted to vote for its governing board. They may also receive salaries for work per-formed on behalf of the organization. Getting a return on their investment is not the major reason why people join a cooperative; obtaining goods or services at a low cost is its basic purpose. In the case of a cooperative operating as a non-profit corporation, all profits must be used for the organization's benefit. In the case of business corporations and unincorporated associations, profit may be distributed among members according to a formula based on ownership interest, resource or labor participation, or some other basis.

A cooperative is democratically controlled by its members. Unlike the typical business corporation, in which shareholders vote according to the number of shares they own, most cooperatives operate on a basis of one vote per member. The members elect a board of directors, and hire specialists in business administration, marketing, or purchasing to conduct the business affairs of the cooperative.

Since most art retail cooperatives have the marketing of artwork as their primary purpose, the activity of the members is usually in the production of the art. The staff specialists take care of the marketing, purchasing, and so forth. Knowing the market conditions and what will sell, the marketing specialists occasionally make useful aesthetic suggestions to the members of the cooperative.

In the case of cooperatives which are engaged in the art retail business, it is common for members to commit to spend a specific amount of time in the gallery.

The membership fee structure of cooperatives, especially those

in depressed areas, is very modest. Many such co-ops are launched with long-term loans and even with federal assistance under various economic development programs.

Several excellent booklets on the principle of cooperatives and how to organize them have been published by the Agricultural Cooperative Service of the U.S. Department of Agriculture. (*See also* **Catalogue, Appendix B**)

COPYRIGHT

Copyright is an intangible right which was deemed so fundamentally important to the United States that the founders included, in Article I, Section 8, Clause 8, of the U.S. Constitution, a provision granting Congress the power to create a copyright law. The First Congress did just that, and copyright has been a part of American law since its beginning. Today, there are three major multinational copyright treaties which, in essence, provide reciprocal copyright protection in 95 countries with similar copyright laws.

Copyright grants the creator of a copyrightable original work of art the exclusive right to reproduce, market, sell, make derivative works, publicly display, and, where appropriate, publicly perform the copyrighted work. For a work to be copyrightable, it must be original and involve some degree of creativity. It may not be a simple geometric shape or merely functional. Functional works are protectible under the patent laws, if at all. Simple words and phrases may be not be copyrighted; they may be protected as trademarks. Work on which the copyright has expired or which is not copyrightable is in the public domain and freely copyable.

Generally, the artist who created a work will own the copyright in it. There is, however, a significant exception. If the work is created by an artist who is an employee working within the scope of his or her employment, the copyright in that work will belong to the employer. If the artist is independent, the copyright in the work will belong to the person or organization commissioning the work if a) the work is specially ordered or commissioned, b) it falls into any of the following nine categories:

1. contribution to a collective work,
2. as a part of a motion picture or other audiovisual work,
3. as a translation,
4. as a supplementary work, which is a work intended to accompany or illustrate another work,
5. as a compilation,

6. as an instructional text,

7. as a test,

8. as answer material for a test, or

9. as an atlas; and

c) there is a written agreement stating that the work shall be a "work made for hire." The parties can also vary copyright ownership by contract. The law provides that an assignment of a copyright must be in writing, though a non-exclusive license—or permission to use—may be oral.

The copyright law provides that, whenever an original idea embodying some creativity is put in a tangible form, it is automatically protected by the federal statute. Adding a copyright notice: "Copyright," "Copr.," or © [owner's name] and year of first "publication," will prevent others from copying a work, believing that is it not protected and claiming that they are "innocent infringers." This is important, since "innocent infringers" may be held liable for nominal damages, if any, and may even be permitted to continue copying. The notice need not mar the work. It should be permanently affixed but may, in the case of sculpture, be put on the back, base or bottom of the work. The notice on two-dimensional works may be placed on any reasonably accessible portion of the work, including the back. Wearable art, including jewelry, should have the notice permanently affixed, but at least one case held that, if there is no space for the notice to be etched on filigreed earrings, for example, a hang tag may be used.

The copyright should also be registered. While registration does not create a copyright, it does provide the copyright owner with certain important additional remedies in the event of an infringement. If an unregistered work is infringed, the copyright owner is entitled to enjoin the infringer and to obtain any actual, provable damages. This could include the copyright owner's lost profits or the infringer's actual profits. When a work was registered before it was infringed, the owner is also entitled to recover statutory damages of between $500 and $20,000 or, if the infringement was willful, up to $100,000, in lieu of actual damages, and is eligible to receive reasonable attorneys' fees and costs for litigating the case.

If the copyright is registered within three months of the work's first "publication," registration is retroactive to the date of publication. If, on the other hand, registration occurs after three months have elapsed, it will be effective prospectively from the date of registration. "Publication" is a technical term, defined by the law as

meaning a distribution of the original artwork or any copy to the public by sale, rental, loan or the like.

The Copyright Office will not assist you in protecting your copyright. In fact, the Copyright Office is merely an administrative office which will register any work if the registration application is complete and in the proper form. It is, therefore, necessary for you to enforce your own copyright through private litigation.

Registration is quite simple and inexpensive. It requires submission of a prescribed form, payment of a fee (currently $20), and deposit of two of the best copies of the work. The administrator of the Copyright Office, known as the Register of Copyrights, has been granted authority to modify the deposit requirement. In the case of works of art, two photographs may be used instead of original artworks. Prints in limited editions of 300 or fewer are considered "art" for deposit purposes. The registration forms most commonly used by artists are Form VA, for visual art, and Form TX, for written work, including advertising brochures, pamphlets, and the like. See Appendix E for examples.

A copyright lasts for the life of the copyright owner, plus 50 years when the owner is a human being using his or her own name. For "works for hire," works published under a pseudonym or anonymously, the period of protection is either 100 years from creation or 75 years from first publication, whichever expires first. The copyright on works which were protected prior to and still in effect on January 1, 1978, the effective date of the present copyright law, is 75 years from the date of registration.

There are several exceptions to the copyright owner's rights under the law. The most important for artists is the so-called "fair use doctrine." This essentially provides a copier with a defense if the unauthorized copying is within the scope of "fair use." In order to determine whether a use is "fair," the courts must consider at least four factors:

1. the nature of the work,

2. the nature of the use,

3. the extent of the copying, and

4. the effect on the market.

This area is quite dynamic and, before copying another's work, you should consult with an experienced copyright lawyer in order to ascertain whether you can consider your copying "fair use."

For additional information about copyright protection and registration procedures, write to the United States Copyright Office.

(*See also* **Berne Copyright Convention, Buenos Aires Convention, Indorsement, Intellectual Property, License, Patent, Trade Dress, Trademark, Treaties, Universal Copyright Convention, Appendix B, Appendix E**)

CORPORATION

There are two kinds of corporations: business corporations, which are owned by individuals, and non-profit corporations, which are created for public benefit. This entry will consider business corporations; non-profit corporations are discussed under Non-Profit Corporations.

Incorporation usually provides a shield from liability for business debts, i.e., the owners of the corporation will customarily not be personally liable for the obligations incurred by the corporation. In the eyes of the law, a corporation is considered a separate legal person.

A corporation can have any number of owners, who are called shareholders or stockholders. There should be a stock purchase agreement which defines what each owner gives to the business in exchange for his or her stock. If a shareholder is also an employee of the business, there should be a separate agreement spelling out the specific terms of employment.

A form, usually known as Articles of Incorporation, must be filed with the Secretary of State in the state of incorporation, which will issue a charter or Certificate of Incorporation. A copy of the Charter or Certificate must be filed in every state where the corporation has a business presence, such as a permanent office. Filing fees for incorporation are approximately $40 to $900. In addition, there are annual fees, taxes, and other various reports to be filed. All this involves legal and accounting expenses.

For small businesses, i.e., 35 or fewer individual shareholders who are U.S. citizens, an election may be made under the Internal Revenue Code, known as an "S election," to have the corporation taxed as if it were a sole proprietorship or partnership. This means that the corporation is not a taxable entity and that the shareholder owners will have to pay tax or may deduct losses as if the business were not incorporated. For all other corporations, known as C corporations, the Internal Revenue Code provides that the entity must pay its own corporate income tax, though the rates charged are different from those which are levied against individual income.

If the shareholders do not treat the corporation as a separate legal entity, the courts may pierce the corporate veil and hold the

owners personally liable for business obligations. Factors which have been used to enable creditors to pierce the corporate veil include commingling funds (using corporate and personal funds interchangeably) and failing to adhere to the corporate formalities (filing annual reports, keeping accurate books, filing taxes), among others. (*See also* **Joint Venture, Limited Liability Company, Non-Profit Corporation, Partnership, Sole Proprietorship**)

COST ACCOUNTING (*See* **Accounting**)

CRAFTS

Historically, skilled artisans, known as craftspeople, have created functional objects for everyday use. Their work was expected to be well-designed and constructed. Although these items were primarily utilitarian, it was common for them to be artfully created. The Industrial Revolution changed this tradition and, although some artisans continued to produce quality handmade crafts, the vast majority of consumers began purchasing assembly-line work which, while functional, lost much of its aesthetic appeal.

During the last quarter-century, there has been a crafts renaissance and, today, craft artists again design and create functional art for discriminating consumers. Indeed, the market for craft art has become so popular that there are numerous wholesale and retail craft shows conducted throughout the world.

The distinction between the so-called "fine arts," which include painting, sculpture, and the like, and "crafts," which include pottery, weaving, metalworking, and the like, is becoming blurred, and there are numerous skills which are difficult to categorize. For example, glassblowing has long been considered a craft, yet, today, glass is considered an art form for most legal purposes. Similarly, jewelers have traditionally been considered craftspeople and were among the earliest craft guilds. Jewelry making is now considered an art form and jewelers who create unique works are considered to be artists for many purposes.

"Craft art" should be distinguished from home crafts, which are usually created by hobbyists and amateurs. There is a world of difference between the magnificent creations which appear at the Renwick Gallery at the Smithsonian, which features crafts, and the pieces of bent metal, painted rocks, and Christmas ornaments offered for sale at flea markets and mall shows.

CREDIT

Credit, in its broadest application, is based on trust and belief.

Credit is the ability to borrow money based on the lender's belief that the loan will be repaid. Credit is the ability to purchase goods without cash on the seller's belief that the bill will be paid. Credit cards are issued to people considered reliable enough to pay the debt when due.

Open credit or credit line means that money can be withdrawn from an account, or purchases can be made, up to a specified amount. An adaptation of this principle is revolving credit, very common in department store charge accounts and with credit cards, where a maximum credit line is established, and the balance of available credit changes as purchases and payments are made.

Credit also has an accounting definition and refers to a bookkeeping entry. It may also refer to credit on an account; i.e., an amount owed to you and carried on someone else's books. This could occur when, for example, you overpay or if you are required to prepay or when you have sold work and not yet been paid for it.

Credit may also have a non-financial meaning, such as when you are "given credit" for fine work or "credited" with a successful art show. (*See also* **Credit Card, Credit Reference, Debit, Ledgers and Journals, Revolving Credit, Trade Credit**)

CREDIT CARD

A credit card is colloquially referred to as "plastic money" since it allows a purchaser to buy goods and services without paying cash at the time of purchase. For millions of credit card holders it is an easy and convenient way to shop, facilitating "impulse buying." It grants the cardholders an instant loan for the credit limit established by the credit card issuer. It is not, however, without its problems.

The most widely used credit cards are those issued by banks, such as VISA and MasterCard, which are honored at thousands of stores and other business enterprises. Other cards, such as American Express and Diners' Club cover primarily travel, hotel, restaurant, and entertainment expenses, although most of them are moving into expanded use. Still others, such as gasoline and department store credit cards, are even more limited, being honored only by the issuing stores or gas stations.

A bank credit card is relatively easy to obtain through a local bank, usually the one at which you do your other banking business, although with the volatility in interest rates, it is probably worth

while to shop around for the best deal. The bank will make a quick credit check and place a top limit on the credit available on purchases with the card. There may be an application fee charged for a bank credit card. As a result of the difficulty experienced by some in obtaining credit cards, some financial institutions have established a special type of account whereby the applicant is required to deposit a fixed amount, often $400 - $600, in a special savings account with that institution, which establishes the credit limit. The cardholder is still required to make regular payments, though the savings account is frozen so long as the card account remains open.

The bank makes its money in two ways: (1) by charging the merchant a percentage of each credit card sale, and (2) by charging the credit card holder interest on the unpaid balance.

A few cards, such as the American Express card, charge cardholders an annual fee and expect full payment of the outstanding balance each month, except for certain types of purchases, such as travel.

On most credit card bills, a minimum payment amount will appear next to the total amount due. This is typically in the range of three to ten percent of the total outstanding balance. The cardholder has a choice — to pay the total amount and clear the debt, or to pay at least the minimum amount and to continue to accrue interest on the unpaid balance.

The unpaid balance is borrowed money, and the interest rates are often very high, frequently as much as 24 percent per annum. The interest rates vary according to state law and the terms of the credit account.

This annual interest should be taken into account when paying a credit card bill. Unless the credit card is used judiciously and bills are paid promptly, the final cost may outweigh the card's convenience. It is certainly more economical to borrow the money at a lower interest rate, or take it out of the bank account to pay a credit card bill in full, than to run up high interest payments.

The amount of money on which you pay interest is computed in various ways by different lenders. Cards such as MasterCard and VISA are issued by individual banks, each of which sets its own policies. Thus, you should read the fine print to see how the interest is computed. There are four basic methods: adjusted balance, previous balance, average daily balance excluding current transactions, and average daily balance including current transactions. It is not at all uncommon for the amount of interest charged to be

twice as high under the average daily balance including current transactions method than under the adjusted balance method, even though the rate of interest is the same.

Credit card purchases need not be made in person. The cardholder can furnish the number and expiration date, and the merchant fills out the form and signs it with his name plus the initials MO (mail order) or TO (telephone order). One copy is sent to the customer, one to the credit card company, and the merchant's copy is attached to the original order which serves as authorization in place of the customer's signature on the charge slip.

Credit cards can also be used for actual cash borrowing. Some banks will make cash advances on presentation of a credit card or through automated teller systems ("ATMs"), and others may, in addition, automatically cover any overdraft on a checking account (up to a set limit) by charging it to the credit card. Cash advances begin to accrue interest from the moment they are made; there is no interest-free grace period as with purchases. In addition, some credit cards have a higher interest rate for cash advances then for purchases.

Credit card companies are very competitive and, because of the high profitability, have created incentives such as rebates. The Discover Card, for examples, issues a credit to the cardholder at the end of a specified period equal to a percentage of the purchases made during that period. Other companies allow credit purchases to be counted toward airline mileage, car rental, or hotel benefit programs. Automobile manufacturers have recently entered the credit card business by issuing cards which may be used for general purchases but which provide a specific amount of credit toward the purchase of one of their vehicles at the end of a prescribed period. American Express entitles cardholders to go to any American Express office, write a personal check for up to $1,000, of which $200 can be for cash and $800 for traveler's checks. Credit cards are also often accepted as identification if you want to write a check.

Not every business is authorized to accept credit cards. In order to become a credit card merchant, you must apply (usually to the bank where you maintain your business account) and receive authorization to accept credit card transactions. Not every business will qualify and it is important to determine whether it is economical. Credit card companies charge merchants between two and ten percent per annum of the charge sales, depending on the size of each sale, the total volume of charge sales, and the type of merchan-

dise being sold. In addition, most banks require merchants to maintain a minimum deposit in their bank account for certain chargeback purposes.

The procedures vary among different credit card companies, but the basic principle is the same. The credit card merchant is provided with the card imprinting machine and charge slips. The merchant deposits its copy of the charge slip similarly to depositing checks, using the designated deposit slip. The bank immediately credits your account.

It is important for a merchant who accepts credit cards is to be sure the card is valid. The customer's signature on the back of the card should be compared with the signature on the charge slip. The expiration date should also be noted. If the card is expired, the cardholder is no longer entitled to use the card and, if a sale is made under those circumstances, the credit card company cannot be able to collect from the cardholder and will charge the merchant's account.

Some credit card companies require that charges exceeding a certain amount, $25 for example, must be pre-approved by the credit card's central office before the sale is made. It is always advisable, even when this is not required, to check the card number against the list of lost or stolen credit card numbers which the card companies furnish periodically. Some even give an award for picking up such cards. Of course, a sale should never be made on a credit card if the number shows up on that list.

For the same reason, lost or stolen cards should be reported immediately by the cardholder. If the loss or theft of a card is not reported promptly, the cardholder may be held responsible for all purchases made by others; prompt reporting generally limits the cardholder's liability to $50. (*See also* **Credit, Loans**)

CREDIT REFERENCE

Conducting a credit check is prudent when dealing with a new customer in credit or consignment transactions. Getting credit information before the transaction is completed can avoid collection problems.

If you know the customer well, either personally or by reputation, you may not wish to run a credit check, though it may be a good business practice to do it anyway. Many gallery chains have been around a long time, but even they may experience financial difficulties.

There are numerous local credit bureaus and national credit rating organizations such as Dun & Bradstreet, but they may require

you to be a member, and that could be expensive for a small art business with only occasional need for credit checks. Your bank can be helpful. It has access to numerous sources of credit references.

The most direct way to get some idea of a prospective customer's credit rating is to ask for credit references, such as one bank reference and three trade references. While they will not give you specific financial information, they will usually provide information based on their experience as to how reliable the customer is, how long they've had business relations, whether the customer is considered a good credit risk, the maximum amount of credit they extend to the customer, and the customer's current balance.

You may be able to get this information with just a phone call to the credit manager of the reference, but it is probably better to have written verification for your files. Write a simple, courteous letter to the reference, providing the name of your prospective customer, and request that they advise what their credit experience has been. Enclose a self-addressed stamped envelope for their convenience in responding to your request.

If you have doubts about the credit risk after having made these inquiries, it is a perfectly acceptable business practice to ask for cash, especially when dealing with individuals. When consigning work, you should monitor the account regularly and keep a tight rein on payments. Many states' consignment laws address payment for consigned works. (*See also* **Collection Problems, Consignment, Credit**)

CREDIT UNION

Credit unions have increased in popularity as banks and savings and loans have failed or gone out of business in alarming numbers and lost or placed in jeopardy staggering sums of depositors' money.

Credit unions offer many of the same services as banks and savings banks, such as checking and savings accounts, various certificates of deposit and time savings instruments, and loans ranging from small signature (unsecured) loans to residential second mortgages, and even first mortgage financing at some larger, stronger credit unions.

The major difference between credit unions and banks is that banks are operated as for-profit businesses, whereas credit unions are member-owned and operated not-for-profit. By operating not-for-profit, credit unions can maintain a tighter spread between the interest rates they pay their member-depositors and the rates they

charge their member-borrowers. Thus, they tend to pay slightly higher interest on deposits and charge slightly lower interest on loans.

Besides not having to generate a profit for its shareholder-owners, a credit union is operated for the benefit of its members via a board of directors elected from among its members. Thus, the management of a credit union tends to be more member- and service-oriented than a commercial bank. Furthermore, the constituency or membership of a given credit union tends to be comprised of individuals sharing some common interest, such as all working for the same employer or group of related employers, e.g., teachers, government workers, timber industry workers, etc. (*See also* **Banks, Commercial Banks, Savings Banks**)

CREDITOR

A creditor is anyone to whom money is owed and who has a legal claim to payment. It may be a bank which has made a loan, a supplier which has shipped raw material, an employee who has worked in expectation of being paid, or the government which will collect taxes.

If someone owes you money, you are that person's creditor.

Creditors can improve their chances of being repaid in the event the debtor defaults on a loan by requiring the debtor to pledge collateral or have a co-signer or guarantor. If the creditor files its security interest in the collateral with the Secretary of State or other appropriate authority, the security interest is then said to be "perfected" under the Uniform Commercial Code and the creditor becomes a "secured creditor." A security interest gives the creditor certain rights in the collateral if the debtor defaults. If you've borrowed money from a bank to buy your business van, for example, and the bank has perfected a security interest in the van, the bank can repossess the van and sell it if you default on your loan payments.

The law establishes several classes of creditors. A first mortgage, for instance, has seniority over a second mortgage. That's one reason why the interest on a second mortgage is generally higher; the lender takes more of a risk.

In bankruptcy proceedings, government claims for unpaid taxes take precedence over all other claims. Employee claims on wages come next, then secured creditors and, finally, unsecured creditors. (*See also* **Collateral, Credit, Uniform Commercial Code**)

CURRICULUM VITAE (*See* **Portfolio, Resume**)

CUSTOMER

A customer is someone who buys something from someone else. For artists, there are basically two types of customers: the retail customer, who is the ultimate consumer or collector, and the wholesale customer, the gallery or dealer which acquires (by purchase or consignment) in order to sell to the ultimate consumer.

Artists may sell to both types of customers. While the artist who sells directly to a collector will likely receive a higher profit per sale, the artist who sells through a gallery will likely make more sales.

A mix of the two approaches is the most desirable. Even artists who have established relationships with dealers may make some direct sales to individual collectors. Bartering is quite common and artists have been known to pay for cars, professional services and the like with works of art. In fact, Charles Russell used artwork to pay his bar bills. Such bartering is, however, treated by the Internal Revenue Service as income and is, therefore, taxable.

Another group of customers, less common in terms of total sales but very important to some artists, is architects, interior designers, corporations, government entities, and the like. Most states have laws which require that a percentage of the cost of certain construction projects must be used to purchase art.

Prices and discounts vary according to the nature of the sale. Wholesale customers almost always buy at 50 percent off the retail price; interior decorators normally buy at 10 to 30 percent off the retail price. Architects and governments buy at the full price, since they are the ultimate consumer. Consignment sales are usually paid for at 60 to 66 percent of the retail price, after the work has been sold. While these percentages are common, they are by no means universal and the more successful artists will be able to negotiate a higher percentage. (*See also* **Architects, Art Councils, Barter, Collector, Commission, Consignment, Exhibitions and Shows, Gallery, Retailing, Tax, Wholesaling**)

CUSTOMS

"Customs" is duties, tolls, or taxes imposed by the government on transactions across its borders. "Customs" is also the agency which administers the laws regulating these transactions.

Customs works in two directions, import as well as export. If an object being shipped out of the country will ultimately be returned—for example, fine jewelry on loan to a museum—this should be noted on the export declaration so that the Customs officials will permit the

item back into the country duty-free as "American goods returned."

If you are the recipient of a shipment from another country, you will have to clear it through Customs. It is necessary to have the bill of lading, invoices, and other documents to bring the shipment into the United States.

This is all a very specialized kind of activity, and most people who only occasionally do this sort of thing find that the services of a specialist are worth the cost in the time and aggravation you save. Freight forwarders who specialize in overseas shipments can handle the whole export operation. To clear an incoming shipment through Customs, a customshouse broker is often the most knowledgeable expert to call. These specialists are listed in the telephone yellow pages. Freight forwarders can be found in cities which have major ports and international air terminals.

Works of "art" may enter the United States duty-free. There are a number of cases in which the courts have grappled with the definition of "art" for Customs purposes. If the item is not functional, it is generally considered to be "art." Editioned prints are considered "art" for Customs purposes if they are hand-pulled from handmade plates, regardless of the size of the edition. The first 12 pieces of editioned sculpture, on the other hand, are considered duty-free "art."

Even if the work is determined to be "art," it may still be subject to a Customs duty if the purpose for which it is imported is commercial, as, for example, an illustration to be used on a magazine cover. The U.S. Customs Service will also prohibit the importation of works which are illegally exported from their country of origin and which have been identified by the United States Information Agency ("USIA") as protected by a treaty between the U.S. and the country of origin.

There is a procedure whereby the U.S. Customs Service can prevent the import into the U.S. of work infringing a copyright, trademark, or patent which is properly registered in the U.S.

For information about specific situations, the U.S. Customs Service can be consulted. The Service maintains offices at every point of entry into the United States: border crossings, international air terminals, ports, and other locations. Their telephone number can be found in the white pages under U.S. Government, Treasury Department, Customs Service. Or you can write to the U.S. Customs Service (*see* **Appendix B**). (*See also* **Export, Import, Intellectual Property, Shipping, Treaties, UNESCO**)

D

DAMAGE INSURANCE (*See* **Property Insurance**)

DEACCESSIONING

Deaccessioning is the process of formally removing artwork from the collection. Museums deaccession works when the governing board determines that an item should be removed from the collection. This is traditionally based on a recommendation from the institution's professional staff. The term is used by some to refer to removal from a particular collection within the institution. For example, when the Metropolitan Museum of Art believed that its Etruscan bronze horse was actually a more recent creation, the work was said, by some to have been deaccessioned from the display collection and accessioned into the study collection.

The more common and popular use of "deaccession" is when work is sold or transferred outside of the institution. This may be done to reduce the museum's holdings of duplicative works, inferior quality works, or simply for the purpose of generating money. This last reason is quite controversial and has been condemned by most professional associations, including the American Association of Museums and the American Association for State and Local History as an inappropriate use of a museum's holdings.

The College Art Association has taken a firm position on the inappropriateness of a museum's acquiring donated work for the purpose of reselling it without the donor's consent.

The American Association of Museums has suggested guidelines for appropriate deaccessioning which include, among other things, governing board consideration and approval, and public sales. (*See also* **Acquisition, Appendix B**)

DEALER

A dealer is one who engages in the sale or distribution of an item for profit. Art dealers act as the go-between for artists and collectors. They own galleries, staff booths at art shows, conduct auctions, and sell work directly to consumers. Dealers may purchase artwork outright or take it on consignment.

Most states have enacted artist/dealer consignment statutes which, among other things, identify the individuals or businesses which will be considered "dealers" for purposes of the law, define the relationship between the dealer and artist, provide that all transactions which are not outright purchases shall be considered consignment sales for purposes of the law, and define the terms of those consignments. The statutes vary from state to state, but they generally establish a good deal of protection for the artist's consigned work and require that payment be made by the dealer to the artist within prescribed periods. (*See* **Artists' Representatives, Alternative Space, Consignment, Gallery, Appendix C**)

DEBT

A debt is an amount acknowledged as due and owing in the accounting records of a business and, as such, may be viewed as a charge to a particular entity, project, or account.

DEBTS—BAD

There comes a time in the life of every artist when a dealer or collector will not pay a bill. No matter how many reminders you send or how many phone calls you make, the bill remains unpaid. When economic times are difficult, the problem gets worse. Collectors go bankrupt or disappear. Galleries go out of business. The trouble and expense of having a collection agency go after the account is rarely worth the effort in the art business if the uncollected amount is fairly small. Even if you use a collection agency, the day arrives — not more than a year later — when you have to decide that it's a lost cause. At that point it becomes a "bad debt."

Accountants make provision for bad debts on the books of a business because bad debts are tax-deductible to the business if it is an accrual basis taxpayer, although bad debts are not deductible by cash basis taxpayers unless it is a business related loan. Bad debts should not exceed one percent of your accounts receivable. If they are higher than that, it's time to examine how you extend credit and how well you monitor your consignments. (*See also* **Collection Problems, Consignment, Credit, Credit Reference**)

DEDUCTIONS

(*See* **Accounting, Income Tax, Exhibitions and Shows**)

DEFICIT

A deficit occurs when expenses exceed income. A new business often operates at a deficit in the beginning. In the long run, this is something to be avoided.

"Deficit" is also used to describe any other shortage. If your books show 50 prints in your inventory, but there are only 48 in your print chest, your inventory shows a deficit.

DELIVERY CHARGES
(*See* **Post Office, Shipping, United Parcel Service**)

DELIVERY METHODS (*See* **Shipping**)

DEPOSIT

This word has several meanings for people engaged in the art business.

1. Making a payment, known as a "deposit" in order to reserve a work for purchase at a future time. Deposits may or may not be refundable, depending upon the terms of the agreement. The parties may also establish the size of the deposit, although this is usually dictated by the seller, who would customarily like the deposit to be large. As a practical matter, however, the deposit will likely equal a percentage of the purchase price.

2. Putting money in the bank, either by cash or check. There are two major types of bank deposits: demand and time. A demand deposit is one where you can withdraw your money at any time, as with most savings and checking accounts. A time deposit is a deposit for a fixed period of time, usually not less than six months. Time deposits include, among others, certificates of deposit and certain accounts where money may be withdrawn only after the depositor gives the required notice of intent to withdraw. Most time deposit agreements provide for penalties for early withdrawal.

3. Complying with the registration requirements of the copyright law. The copyright statute requires a copyright owner to deposit copies of copyrighted works with the Library of Congress within three months of first publication. This deposit requirement is separate from the registration of the copyright, though the Copyright Office has stated that, if the deposit is not accompanied by an application and registration fee, an additional deposit must accompany the application for registration. (*See also* **Copyright, Consignment, Credit**)

DEPRECIATION

When you make a capital investment, such as buying a building or a piece of equipment, the assumption is that it will last a number of years. This expenditure is part of the cost of doing business and, thus, may be subtracted from gross income, along with other deductions, for purposes of determining taxable income. Since a capital investment is, in reality, however, a conversion of one type of asset (cash) into another (equipment, building, etc.), it is not realistic (nor do the tax laws permit) for you to deduct the total cost of such investments in one tax year. Instead, you are permitted to deduct a portion of the undepreciated cost (your adjusted basis) each year you use the property in business. This corresponds, in theory, to the actual diminution in value of the property as it wears out.

Depreciation is the method used to determine what portion of capital investments you can deduct from your gross income as a business expense each year. The tax laws provide for a method of depreciation known as modified accelerated cost recovery system (MACRS). Under MACRS, every fixed asset is assigned to one of several property classes based on its class life (its expected useful life). The property classes are: 3-, 5-, 7-, 10-, 15-, and 20-year property. In addition, most real property is classified as residential, rental or non-residential real property.

In calculating depreciation, it is customary to determine the salvage value, if any, of the asset; that is, what the asset is likely to be worth when it is no longer used in the business. If the asset is ultimately sold for an amount which exceeds that salvage value (adjusted value), then it is necessary to "recapture" the depreciation; in other words, to recognize the gain on the sale of the asset; that is, the difference between the sale price and the salvage value. The rules on recapture also apply if the asset is sold before it is fully depreciated.

In theory, two methods of calculating depreciation are used:

1. Straight Line. The value of an item is reduced by a fixed dollar amount each year. For example, if a kiln costing $1,000 is expected to last ten years, it will be depreciated by the fixed amount of $100 per year ($1,000/10 years). After one year, the kiln has a remaining undepreciated ("book") value of $900, after two years, $800, and so on, until, after ten years, the kiln is fully depreciated and thus has, theoretically, no remaining value (its adjusted basis is zero).

2. Declining balance. The value of an item is reduced by a fixed

percentage each year. For example, the $1,000 kiln with expected life of ten years would be depreciated at the fixed percentage rate of either 15 percent or 20 percent per year (either are permissible under the tax laws); we shall assume 20 percent). The depreciation of the kiln would be $200 for the first year. For the second year, the adjusted basis is, therefore, $800 and the depreciation would be $160. For the third year, the adjusted basis of the kiln would be $640 which would be depreciated by an amount equal to $128, and so on. These calculations are arrived at by taking 20 percent of the adjusted basis. Note that, under this method, the remaining value never reaches zero, since each year's depreciation is only 20 percent of the remaining value of the item.

In practice, MACRS specifies a method that is either a modification or combination of the classic straight-line and declining balance methods. For property in the 3-, 5-, 7-, or 10-year class, you use the double (200 percent) declining balance method over 3, 5, 7, or 10 years and the half-year convention. For property in the 15- or 20-year class, you use the 150 percent declining balance method and the half-year convention. In other words, the classic fixed percentage is either doubled (200 percent) or multiplied by 1.5 (150 percent) to determine each year's depreciation.

MACRS also specifies another modification for these classes of property, whereby you change to the straight-line method for the first tax year for which that method, when applied to the adjusted basis at the beginning of the year, will yield a larger deduction than the declining balance method.

The half-year convention assumes that a given item of depreciable property was placed in service at the midpoint of the year (July 1, if your tax year is the calendar year), regardless of when it was actually placed in service. Consequently, the first year's depreciation is just half what the declining balance method would otherwise determine. Another consequence is that the full depreciation and corresponding tax deductibility for an item actually span a period that is one tax year longer than the class life of the item, with a partial deduction in both the first and last years.

When a fixed asset has both a business use and a personal use, for example, a building which houses both your residence and your studio, or a car which is used for family as well as business purposes, only that portion of the depreciation attributable to the business purpose can be deducted as a business expense. Owners of residential property should be particularly cautious when characterizing

a portion of the property as being used for business. When the residence is sold and a replacement of greater value is purchased within two years, then no tax is due on any profit from the residential portion, though the business property sale is taxable. Of course, non-business property is never depreciable for tax purposes.

If business property other than residential rental and nonresidential real property is sold for a price which exceeds its book value, any such gain must be claimed as ordinary income to the extent of depreciation previously allowed on that property.

Depreciation not only helps you more accurately calculate your cost of doing business, but also establishes the value of your fixed assets at any given time. Note, however, that different methods of depreciation may be appropriate for the same asset, one for purposes of business valuation, credit worthiness, personal net worth, etc., and a different method for tax purposes. (*See also* **Accounting, Appreciation, Equipment, Tax**)

DESIGN PATENTS (*See* **Patent**)

DIRECT MAIL

This is a method of advertising which uses the mails to reach the public, rather than using such media as newspapers, magazines, radio, or television.

Direct mail is customarily sent to individuals on selective lists, such as museum members, gallery patrons, or identified collectors. One potential disadvantage is the cost, both in terms of time and money. Catalogues, mail order promotions, and announcements of openings are all forms of direct mail. (*See also* **Advertising, Catalogues, Mailing Lists, Mail Order, Post Office, Printed Materials**)

DISABILITY INCOME INSURANCE

A serious illness or accident can spell economic disaster for an artist, especially if the artist is not eligible for unemployment benefits and has no source of income other than sales of his or her artwork. While medical insurance may cover the cost of treatment, there is no provision for the loss of income. A permanent disability will likely entitle the artist covered by Social Security to certain minimum payments from that agency.

An artist in a successful enterprise who has partners or employees may continue to receive income even while disabled, though this puts a burden on the business. Disability income insurance can be

a wise investment. It allows you to choose a specific weekly or monthly income for the duration of the disability or for a specified period of time. Premiums are based on the type and amount of coverage requested. Savings in premiums can be effected with a deductible clause, which provides that no benefits are paid during the first months of a disability. Most people can make it through a short disability, and the savings are worth the deductible.

Disability income insurance generally cannot be bought to pay out more than 60 percent of normal income.

This insurance may be obtained through certain cooperatives or artists' organizations, such as Artists Equity. (*See also* **Cooperatives, Insurance**)

DISCOUNTS

A discount is a legitimate reduction in price, based on some stated reason and deducted before payment is made.

A common discount encountered by artists is the two percent discount allowed when an invoice is paid within ten days. That's known as a cash discount and is usually stated as "2/10" on the invoice. It means that an invoice for $100, for example, is paid in full if you send a check for $98 within ten days.

Another common practice is the quantity or volume discount. This applies to the price if the number of items purchased exceeds a certain minimum, e.g., 100 pounds of clay may be 10 percent less per pound than ten pounds of clay.

A trade discount is a reduction from the normal retail price when the merchandise is sold to someone in the trade, e.g., a professional artist can often buy frames or framing materials less expensively than a collector or hobbyist.

Volume and professional discounts are the primary reasons behind the increase in artists' buying cooperatives. (*See also* **Cooperatives, Sales Terms and Conditions**)

DISPARAGEMENT OF ART

Disparagement of art is sometimes referred to as "trade libel" and is a *prima facie* tort, that is, a civil wrong. It occurs when one, without justification, disparages the work of another. This could be excessive and unjustified criticism of a living artist's work, though mere adverse criticism would not rise to the level of "disparagement." An art critic has extraordinary latitude when critiquing work. If, however, the statements are made for purposes other than com-

ment or criticism—as, for example, when trying to obstruct a sale—the words may be actionable.

Disparagement of art also occurs when one carelessly discredits the authenticity of a work. In *Hahn v. Duveen*, Hahn, the owner of a painting, sued Lord Duveen for the loss of a sale resulting from his lordship's careless statement about the authenticity of the painting. The case was settled, but is frequently cited for the proposition that one who disparages the authenticity of a work without justification may be liable for any injury resulting from the unprivileged, inaccurate statements. (*See also* **Authenticity, Droit Morale**)

DISTRIBUTORS (*See* **Artists' Representatives**)

DONATIONS (*See* **Charitable Contributions**)

DROIT DE SUITE

The droit de suite, or "resale royalty," was first conceived in France, and provides the visual artist rights similar to those available to authors of, for example, books, under the copyright law. The theory of *droit de suite* is that unique works of art should generate some profit for the artist who created a work when the work is subsequently resold by someone other than the artist. It recognizes that art is a unique form of property which is an extension of the artist/creator.

The concept of *droit de suite* spread through the European continent and is now recognized in 24 countries. It provides that, when a work of art is resold, a percentage of the resale price should be paid to the artist. Under the French law, the percentage is three percent, and the payments must be made if the resale occurs during the life of the artist or 50 years thereafter. The right is inalienable; that is, it may not be sold.

There are certain other technical requirements and restrictions under the French law; however, it is popular. An organization known as the Union of Artistic Property (referred to as SPADEM) administers the law by collecting the royalty and paying it to artists or their estates.

The United States has not enacted a nationwide *droit de suite*. The original version of the Visual Artists Rights Act of 1990 had a resale royalty provision, but it was removed because of extreme pressure from museums and art dealers. Instead, the Copyright Office was required to study *droit de suite* and provide Congress with a report. The copyright study was completed in 1992 and it was equivocal.

Resale royalties are available to American artists through contract. When the work of art is sold, the parties to the sale can agree that a royalty shall be paid to the artist whenever the work is resold. Contracts such as this are used by many successful artists, though beginners would likely find it difficult to obtain an agreement for the payment of resale royalties. For a form contract which has been used for several years, see *The Deskbook of Art Law* (*See* **Appendix D**). The first municipality in the United States to have a resale royalty was the City of Seattle, which enacted the law as part of its art in public places program. The Seattle ordinance provides that whenever a work acquired for that program is resold by the City, the artist or his or her estate will receive a royalty if there is a current name and address on file with the municipality.

The first and, to date, only state resale royalty law was enacted in California in 1976. That law provides that whenever a work of art is resold in California or by a Californian, a royalty of five percent must be paid to the artist. The royalty is required to paid only if the work is resold at a profit and for a price which exceeds $1,000. The obligation to pay the royalty is imposed on the reseller or dealer and it must be paid to the artist where possible and, if not, to the state arts commission. Artists who are required to enforce their resale royalty rights through litigation are entitled to recover reasonable attorneys' fees in addition to any unpaid resale royalties.

The California Resale Royalties Act has been controversial, though a study conducted by the Bay Area Lawyers for the Arts (now known as California Lawyers for the Arts) concluded that there is general support for resale royalties and that the California version of the law is considered by most of those surveyed to be successful. (*See also* **Contract, Copyright, Appendix D**)

DROIT MORALE

Droit morale recognizes that a work of art is an extension of the artist who created it. It is a right of personality which attaches to the work. *Droit morale* originated in France, has now been adopted by 81 countries, and is a part of the Berne Copyright Convention. The European *droit morale* contains a number of elements. It includes protection of:

 a) The right to create or to refrain from creating;

 b) The right to decide when a work is completed and whether it should be published or displayed;

 c) The right to withdraw a previously published work, provided

that the withdrawal may be subject to the artist making a required payment;

d) The right to require name attribution, including the right to prevent the use of an artist's name in some circumstances;

e) The right to require that integrity of all the work be preserved; and

f) The right to respond to excessive criticism.

Early American cases stated emphatically that the United States did not endorse the *droit morale,* yet there were some comparable rights found in the federal copyright and trademark laws, and state unfair competition laws. Thus, under U.S. copyright law, an artist is granted the exclusive right to publicly display his or her creation and, therefore, the right to refrain from permitting such a display. Trademark law grants the trademark owner the right to enjoin the use of any name, symbol or logo which is likely to cause confusion in the marketplace. Since the copyright law grants the copyright owner the exclusive right to prepare derivative works, then an unauthorized alteration of the copyrighted work would be a violation of this right.

Art advocates recognized the importance of *droit morale* and realized that the American counterparts had some limitations. They, therefore, worked diligently for the U.S. to embrace the European *droit morale.* California was the first state to enact a law dealing with artists' moral rights, known as the California Art Preservation Act. Later, ten states followed California's lead and, in 1990, Congress added the Visual Artists Rights Act ("VARA") to the U.S. copyright law. While VARA is not as inclusive as the European *droit morale,* it is still a major step forward and now provides American artists some of the benefits previously available to their European counterparts.

American artists desiring greater protection than VARA grants may obtain it by contract. Many established artists have used contracts containing extensive protection for the work of art as well as the artist's name. Newcomers will likely find it difficult to negotiate for contractual moral rights protection, though the world-renowned artist Angelo de Benedetto claims that collectors were more impressed with his work when he began his career because he used a moral rights-type contract. (For a sample form, *see **The Deskbook of Art Law** and **The Form Book of Art Law**.) (See also* **Berne Copyright Convention, Copyright, Trademark, Visual Artists Rights Act, Appendix D)**

E

EDUCATION

The traditional practice of apprenticing to an artist dates back hundreds of years, and is still in use to some extent.

Formal art education is a fairly recent phenomenon. Many colleges and universities have degree programs in the fine arts, sometimes leading up to master of fine arts degrees. A formal education, however, does not automatically guarantee that an artist will be successful. It may help in developing an understanding of design and its evolution. A degree is usually required for teaching.

More and more educators are coming to the conclusion that some combination of formal education and practical experience is beneficial for success. Most colleges and universities have art departments, and there are many schools which specialize in one or more of the arts.

Travel is another excellent educational experience at any level of an artist's development, especially for those whose work has its roots in some specific geographic or ethnic environment. This is particularly true for artists who wish to experience firsthand the original works of particular artists or art styles.

An immense body of literature is available to artists who want to continue their education, both in the form of books and professional publications. These provide technical knowledge, new methods and processes, and inspiration.

A major flaw in the education of working artists is the scarcity of business education. Several universities have incorporated classes on business subjects of special concern to professional artists into their curricula. Workshops have begun to appear here and there at which experts discuss such subjects as taxes, bookkeeping, legal affairs, and other problems which confront artists who sell their work and are, therefore, in business. For example, the Oregon Arts Commission periodically sponsors workshops known as "The Artist's Survival Kit," which deal with subjects including art law, marketing, exhibit design, resume-writing, and the like.

Expenses for education which is necessary for *improvement*

in your field are usually tax-deductible as business expenses. This can include the purchase of books—such as this one, attendance at seminars and workshops (travel included), as well as formal education. Your educational expenses are tax-deductible if you are already working as a professional in the art world and are merely enhancing your skill. Education expenses to qualify you to *become* a working artist are not deductible.

The College Art Association (CAA) is very active in promoting art education of all kinds and is a useful resource for the professional artist. (*See also* **Apprentice, Grants, Appendix B**)

EMPLOYEES

When someone works for you, it is important to determine whether that person is an "employee" or a so-called "independent contractor." This is because employers are obligated to comply with various state and federal laws, such as tax, labor, Social Security, workers' compensation, and the like. Independent contractors, and not the persons with whom they contract, are primarily responsible for complying with these laws for themselves and their employees.

The label you attach to the worker is not conclusive, nor is the fact that the worker is full- or part-time, permanent or temporary. The labor laws, both national and state, make no distinction between payment in wages or commissions, whether the employees are paid by the hour or by the job, or even necessarily where the work is done.

The U.S. Department of Labor defines the term employee as it relates to the enforcement of labor laws as follows:

> Generally the relationship of employer and employeeexists when the person for whom services are performed has the right to control and direct the individual who performs the services, not only as to the result to be accomplished by the work, but also as to the details and means by which the result is accomplished. That is, an employee is subject to the will and control of the employer not only as to what shall be done buthow it shall be done. In this connection, it is not necessary that the employer actually direct or control the manner in which the services are performed; it is sufficient if he has the right to do so.

The right to discharge is also an important factor indicating that the person possessing that right is an employer. Other factors characteristic of an employer, but not necessarily present in every case, are the furnishing of tools and a place to work to the individual who performs the services.

In general, if an individual is subject to the control or direction of another merely as to the result to be accomplished and not as to the means and methods for accomplishing the result, he is not an employee.

The Labor Department makes it clear that it doesn't matter what you call the worker: employee, partner, salesperson, agent, independent contractor, or whatever. If the relationship meets this definition, then the worker is an employee.

Two examples: If you hire a contractor to build a studio, you are purchasing the result. How the contractor does the work, what tools are used, where supplies are purchased, and so forth are the contractor's decision, not yours. The contractor is, therefore, not an employee.

On the other hand, if you hire a carpenter to assist you in building the studio, and you buy the materials, you direct the specific work to be done, and you determine when to come to work and go to lunch, then you have an employee.

In the case of a business entity like a corporation or limited liability company, the business entity is the employer, and everyone who works for it is an employee. That even includes you, the owner, if you work for the company and draw a salary. The size of a paycheck does not determine whether an employer-employee relationship exists.

Some ticklish situations have arisen in the case of apprentices and cooperatives, where the Labor Department and some taxing authorities have determined that an employer-employee relationship exists.

As an employer, it is important to keep abreast of the constantly changing labor and tax laws. Aside from tax and salary considerations, which are discussed elsewhere in this text, both federal and most state legislation expressly prohibit the employment of children under 14, regulate employment of children to age 18 in certain types of occupations, and prohibit discrimination in hiring, training, promotion, or compensation, based on race, nationality, sex, age, disability, or other conditions not related specifically to the objective requirements of the

job, known as a "bona fide occupational qualifications."

When you first become an employer, it is necessary to obtain a Taxpayer Identification Number from the Internal Revenue Service and, in some states, a separate state employer identification number. This number will then appear on all forms, tax payments, and other documents you file as an employer. It is advisable to obtain the services of an accountant or bookkeeper so that tax payments are made properly and on time, and payroll records and other books are kept in proper order. Be sure to consult your state labor department for applicable rules and regulations which go into effect the minute you put the first employee on the payroll.

Aside from complying with all the rules and regulations, it is important to select the right employees. The first consideration is where to look. This depends to a great extent on what you're looking for. If you want an apprentice, a local art school may be the best place to look. If you're looking for a salesperson for your gallery, a classified ad in the local newspaper may be best.

It is surprising how many employers rush headlong into hiring someone without checking out their credentials. Business owners are usually diligent when purchasing equipment. They will customarily do a great deal of investigation before actually acquiring a device. Yet, when hiring employees, the level of inquiry is often far more superficial. As a result, the quality of individuals hired may be less than desired.

The owner-managers of most small companies would not think of buying a piece of equipment until they had evaluated it systematically. They want to be sure that the machine meets specifications, can help pay for itself, and last for a reasonable length of time. However, when selecting personnel to operate the equipment, some owner-managers use no system. Little, if any, time and energy are spent trying to match the applicant to the job. The result is waste. In the long run, mistakes in selecting employees may cost far more than the loss caused by selecting the wrong equipment.

It is, therefore, prudent to take these four steps:

1. Write a job description and determine exactly what qualifications, experience, and attitudes you are seeking;
2. Interview a number of applicants to determine how they meet those standards;
3. Check their references, if any, especially if they're going to handle money or if you have to leave them alone in your studio or gallery;

4. Establish a probationary period, perhaps four weeks, and evaluate your decision during that time.

The first few weeks are critical. Any new employee, no matter how experienced, will need a little time to function effectively in a new situation, working with unfamiliar people and under differing circumstances. As an employer, it pays to keep a watchful eye on new employees to see how they fit in and how they perform. You may not get top performance the first few weeks because the new employee is learning your business. If you decide you've made a mistake, don't compound it by wasting more time and money. Find someone else.

For most employers, the only thing more difficult than hiring is firing. After all, you're holding someone else's livelihood in your hands. Try to make it gentle. Don't fire someone in the presence of others. During the probationary period, dismissal notice or severance pay is not necessary. If someone has been on your payroll for some time, however, giving two weeks' notice is common, just as you would want two weeks' notice when someone quits. Many employers prefer to give a discharged employee two weeks' pay instead of two weeks notice to avoid having a disgruntled employee around.

An employee may legally be fired for a proper reason, e.g., theft or incompetence; or for no reason at all. It is unlawful, however, to fire a person for the wrong reason, e.g., an employee's pregnancy, "whistleblowing," or other illegal discrimination.

Finally, be certain that all employees understand your business' rules and regulations, and that you uphold them equitably. It is not fair to allow one employee to get away with tardiness when you require others to be prompt. It is also wrong to penalize or even discharge employees for not observing rules you never told them about. Changing the rules midstream without giving employees an opportunity to reorient themselves is also poor practice. If you're going to change the working hours, for example, give sufficient notice; don't just tell everyone to show up half an hour earlier starting tomorrow. If at all possible, notify employees of anticipated overtime.

How you treat your employees has a significant effect on how effectively and enthusiastically they work for you and that, in turn, has an effect on your business.

Occasionally ask yourself whether you would want to work for a boss like you. (*See also* **Apprentice, Cooperatives, Minimum Wage, Unemployment Insurance, Workers' Compensation, Withholding Tax**)

EMPLOYER IDENTIFICATION NUMBER
(*See* **Employees, Withholding Tax**)

ENDANGERED SPECIES
Some works of art contain parts of animals which have been determined to be endangered. This has been especially common in the works of indigenous peoples, such as eagle feathers in Native American art, walrus tusks in Eskimo scrimshaw, and elephant ivory carvings from Africa and the Pacific Rim. There are both domestic and foreign laws governing the use, sale, and transfer of ownership of parts of endangered and other protected species. The United States is a party to several treaties dealing with international regulation of protected species.

When acquiring an item containing animal parts, it is important to determine whether the work is subject to regulation. This is particularly important when acquiring work for importation into the United States. The U.S. Customs will seize any object which it believes contains parts from any protected species.

It is also essential to determine whether you may sell work which you legally acquired before the laws were enacted. It has been held, for example, that the Eagle Protection Act is retroactive, and any item containing eagle feathers or other parts may not legally be sold, although it may be donated to a museum or other cultural institution. Care should be taken, however, to determine whether a proposed donation will fall under the Native American Graves and Repatriation Act of 1991. If this is the case, then the only appropriate donation would be to the tribe which was responsible for creating the work. (*See also* **Customs, Museum, Native American Graves Protection and Repatriation Act, Treaty**)

EQUIPMENT
An artist's most important equipment is hands and head. When you go into business, it is essential to determine your needs. This should be done in conjunction with preparation of your business plan.

If your budget is limited, you may wish to buy or lease equipment, but be careful. A used computer, for example, may not be compatible with the software you need.

Maintaining equipment is essential for the smooth operation of any business; breakdowns can be both costly and inconvenient.

Since equipment is often a major expense, financing its purchase should be carefully evaluated. The best way, of course, is to

plan ahead and save the money. That way you not only avoid paying interest on a loan, but the savings themselves earn interest. Don't save in a checking account; it usually pays lower interest than a savings account.

If you must finance the purchase out of future earnings, the best source is probably a bank loan. Shop around; interest rates and other conditions vary from institution to institution. (*See also* **Banks, Business Plan, Credit, Lease, Loans**)

EQUITY (*See* **Financial Statements, Loans**)

ESCROW

"Escrow" refers to money held by a third party for a specific purpose, to be held until the purpose is accomplished. The money cannot be withdrawn by the depositor or touched by the person for whom it is intended until the purpose is achieved. For example, an escrow account may be established with a bank for payment of a large order in lieu of a traditional credit line, usually because credit references are not satisfactory.

Escrow accounts are most commonly used in real estate purchases. The escrow agent (usually a bank or title company) holds "in escrow" the buyer's down payment and the seller's deed contract until the transaction closes. (*See also* **Mortgage**)

ESTATE PLANNING

Determining what will happen to your assets after you die is known as estate planning. While everyone should have some sort of estate plan, even if only a simple will, it is more important for artists and collectors, since the problems of posthumous disposition of artwork can be quite complex.

Artists should determine whether they wish to permit their work to be reproduced after their death, and a person whose integrity, skill, and knowledge is respected should be identified as an "art executor." Arrangements should be made for an alternate in the event the named person is unable or unwilling to serve.

Both artists and collectors must consider the disposition of the art in their estates. Should it be sold, donated, or retained as a collection honoring the decedent? All restrictions on posthumous disposition should be spelled out in a will or other instrument. The tax implications of the particular arrangement should also be considered.

Since the date of one's death is usually impossible to predict,

an estate plan should be prepared as promptly as possible and should be reviewed at least annually. Lawyers and accountants who are experienced in this area should be relied on to assist you in preparing an estate plan which is appropriate for your situation. (*See also* **Accountant, Income Tax—Personal, Lawyer**)

ESTIMATED TAX

All income from which no payroll taxes are withheld is subject to estimated tax payments. Estimated tax payments on such income are due April 15, June 15, September 15 and January 15 for the preceding calendar quarters.

A Declaration of Estimated Tax (Form 1040ES) must be filed on or before April 15 of each year for the current calendar year and with each estimated payment. Estimated taxes must be paid even if some of your income is subject to withholding taxes. Such a combination situation is quite common among artists who earn part of their income as teachers or at some other job (on a payroll), and another part in their own studio or gallery (self-employed).

The interest imposed for underpayment of estimated taxes is based on a short-term federal rate plus 3 percent. This rate, published by the I.R.S., is known as the Applicable Federal Rate. There are two ways to avoid paying the interest charge:

1. Pay the same quarterly estimated tax this year as last, less any payroll taxes that may have been deducted from wages or salary if you held a job this year but not last year;

2. If you pay lower estimated taxes because you expect your income to be less this year than last, your total estimated tax payments must be at least 90 percent of your final tax obligation, paid on an even quarterly basis. The balance of 10 percent or less is payable without penalty when you file the next tax return by April 15. Beginning in 1994, taxpayers with an adjusted gross income in excess of $150,000 may avoid a penalty if they pay an estimated tax at least equal to 110 percent of the prior year's tax.

Suppose things change midstream? Suppose you suddenly run into a big selling streak after you filed your estimated tax return last April and you are, therefore, likely to have more income than at first expected. In that case, you amend your return when the next estimated payment is due and increase those payments.

The reverse is also true if your self-employed income falls below what you had expected. This can happen if you switch from self-employment to a salaried job in the middle of the year, or if an illness puts

you out of commission for an extended period. In that case, you may reduce your quarterly payments by amending your return.

Be careful, though, to avoid estimating too low. If your payments drop below 90 percent of what is due in any quarter, you'll owe the interest on the shortage. If they fall far below, you may be subject to extra penalties for willful failure to pay the proper estimated tax.

If you have had any income subject to withholding, the amount withheld is figured into the 90 percent determination. Here's what that means in practical terms. If, for example, from your self-employed income you owed $1,000 in estimated taxes, and your salary was subject to $1,300 in withholding taxes, your total tax obligation would be $2,300. Let's assume you paid only $800 (80 percent) of the $1,000 estimated taxes. That would seem to fall below the 90 percent requirement. However, 90 percent of the $2,300 total is $2,070. The withholding tax payment ($1,300) and the estimated tax payment ($800) total $2,100, which is above the $2,070 requirement. In this example, you're safe.

The Internal Revenue Service also assumes that withholding taxes, even if calculated for earnings of only part of the year, are spread over the entire year to meet the even quarterly payment rule.

Social Security taxes on self-employed income are required to be included in the estimated tax declaration and quarterly payments. (*See also* **Income Tax—Personal, Social Security, Withholding Tax**)

EXCLUSIVITY AGREEMENT

"Exclusivity" is the term used to describe the arrangement whereby an artist agrees that a gallery shall be the only distributor of the artist's work in a defined territory. Some exclusi-vity agreements exempt studio sales directly by the artist; others exempt charitable donations.

Most galleries desire exclusivity contracts, since they feel that, by promoting an artist in a defined territory, they would be promoting a competitor unless they had the exclusive right to sell that artist's work in that territory. Artists, on the other hand, may feel that exclusivity arrangements deprive them of the ability to make as many sales as they can.

It is, therefore, important to determine whether an exclusivity arrangement will serve your needs. Exclusivity arrangements should be in writing and define with some particularity the territory covered, the scope of the agreement (including the medium to be covered), whether there are any exemptions (such as studio

sales or charitable donations), and the period of the contract. The agreement should also deal with advertising and other promotional activities, including the artist's participation in openings and the like. Some artists insist upon controlling the price at which their work is sold and it is common for artists to retain some control over promotional materials. Many artists insist upon having a guaranteed minimum in either number of works sold or income generated as an exchange for the arrangement; conversely, many galleries insist upon the artist's agreement to produce a minimum number of works in a given period. If the guarantees are not met, then the agreement may become non-exclusive or may be terminated.

Exclusivity arrangements are quite controversial, though some galleries refuse to handle the work of any artist who will not enter into one. It is, therefore, important to determine whether you feel that the arrangement will serve your interests. (*See also* **Artists' Representatives, Consignment, Gallery**)

EXHIBITIONS AND SHOWS

Art shows are held indoors and out, at street fairs and in exhibition halls, in school gyms and shopping malls. Some are open to all comers, including amateurs, while others involve a jury process.

Show organizers run the gamut from art organizations to commercial promoters to charitable organizations and local Chambers of Commerce. Among the most successful, from the artists' point of view, have been Art Expo, L.A. Expo, and Art Fair Seattle.

From the collectors' point of view, an art show is an excellent way to shop among a large variety of artworks in one place. It often offers them an opportunity to watch artists at work and, even if they don't buy, is worth the experience of seeing and admiring and meeting the artist. A good art show also raises the level of appreciation among the attending public so that they will buy more art in the future.

A show may provide the only outlet for new artists who have not established relationships with galleries. Since most artists work in comparative isolation, their attendance at shows also provides an opportunity to interact with collectors, gallery representatives, other artists, and others involved in the art world. New ideas may emerge and relationships develop. Occasionally, artists will meet at shows and begin a dialogue which culminates in a collaborative work. There may be great value in the industry gossip which flows freely during most art shows.

Choosing a Show

Since there are excellent shows, mediocre ones, and even poor ones, picking the shows you want to attend is an important consideration. A show which has been running for some years and enjoys a good reputation is obviously preferred. The extent of advertising by the show promoter, as well as past attendance figures, are useful guides, though attendance figures alone don't tell the whole story. A commercial promoter of a shopping mall show, for example, may report attendance of 150,000, but that includes all the people who come to the mall for their normal shopping excursions. Some of those people may stop to buy a poster for $15 or $20, but they're less likely to buy a limited edition print for $500. Mall shows are a subject of controversy among some artists, who feel that their presence there serves primarily to draw crowds for the mall merchants. Many mall shows also restrict the type of art that can be sold in order not to compete with mall tenants who sell similar products—jewelry, for example.

An established show in a popular resort area where people are in a spending mood, which is promoted as a cultural event rather than a commercial operation, is an ideal setting for a weekend of selling.

Many artists and galleries have successfully exhibited at shows other than art shows. It is quite common for many conventions to have exhibitor space which can include art exhibitions. For example, several wildlife artists have popular exhibitions at Safari Club International conventions. Similarly, the dealer rooms at Star Trek® and other sci-fi conventions regularly include the work of artists who specialize in space and fantasy subjects.

A clue to the integrity of a show can be found in the requirements stated by the show management.

How to Find Shows

The best source for listings of forthcoming shows are art publications, such as Art Business News; Westart, which concentrates on West Coast events; and the National Calendar of Indoor-Outdoor Art Fairs. *(See* **Appendix D**.) Numerous local and regional publications, arts organizations, arts commissions, and Chambers of Commerce can often be helpful in providing lists of art shows.

What It Costs

Fees to rent space at an art show are generally modest, ranging between $15 and $100. Only the most prestigious shows charge

higher fees, and are usually worth the price. In addition to the fee, numerous shows also take a commission on sales, normally around 10 percent. This is particularly true when the rental fee is very low. Outdoor shows are almost always less expensive than indoor ones, but they also offer less in terms of facilities. An art fair in a park, for example, may furnish only an 8'X10' plot, with no protection against sun or rain. An indoor show may furnish the same size space, but it is under cover, well-lighted, with restrooms and other facilities nearby and, therefore, costs more.

It is important to determine what is included in the fee. Does the show management provide tables, chairs, overnight security, electric outlets, a printed program that includes your name and address? Are there any labor problems or extra costs connected with moving in and setting up your display? What rules and regulations does the show management impose on exhibitors?

Major expenses in attending shows, often exceeding the cost of the exhibit space itself, are the costs of travel, meals, and lodging, if the show is some distance from home. Some outdoor shows in warm climates provide camping facilities at reasonable cost. Others are in high-price areas, where hotel rooms can run $150 a night or more. It is quite common for artists to stay with friends and agree to provide a reciprocal arrangement when appropriate. All of this expense must enter into the determination of whether a particular show is likely to be a profitable experience.

All costs associated with show participation are tax-deductible business expenses. It is necessary, however, to keep accurate records. The Internal Revenue Service requires that receipts must be kept for each expense exceeding $25, though it is a good idea to obtain receipts for everything. Automobile expenses can be calculated at the rate the IRS allows for deduction on your taxes (28¢ per mile, plus parking and tolls). When you go on a show trip, it is best to take a notebook in which to record all expenses as soon as they are incurred. Don't trust to memory; even the dimes and quarters for parking meters and phone calls add up. Keep your receipts together. At the end of the trip, the notebook and receipts should provide an accurate record of every expense, which is then put away in a safe place until it's time to prepare your tax return.

Your Display

It is remarkable how many artists—consummate in the creation of tasteful work—make a totally cluttered mess of their displays at art

shows. Simplicity is the essence of selling. Variety is important, but not so much that the collector is put off.

1. Keep table coverings and backgrounds simple. Plain colors enhance, fancy prints detract. Table coverings should come neatly down to the floor. It not only looks better, but provides space under the table to store cartons and extra pieces.

2. Try to display your work in its natural habitat: wall hangings should not lie flat on a table but hang from a wall; sculpture should be displayed on a table or pedestal.

3. If you construct your own display unit, keep it simple so that it can be transported easily and assembled without elaborate tools. Study what others do—not to imitate, but to learn.

4. If you go to an outdoor show, bring a tarp to protect yourself against the elements.

5. Display your work so that small, expensive pieces are not out in front where shoplifters (yes, they visit art shows) can get their hands on them. This is particularly important for jewelers.

6. Have some kind of printed material available, even if it is only business cards. An illustrated piece of literature showing your work is even better. It need not be expensive, but your name, address, and telephone number should be included so that collectors can find you after the show. Many exhibitors find that the interest generated at a show turns into sales later.

7. Nothing attracts attention as much as activity in your booth. If an artist is painting, sketching, or sculpting, a crowd will gather and, hopefully, buy. Demonstrating generally requires prior arrangement with the show management, but most show managers encourage demonstrations because it brings the show to life. It is likely to require more than one person in the booth so that one can sell while the other demonstrates. Having two people at a show is useful under many circumstances, especially at a long show, for rest breaks and other purposes.

8. Bring a chair, but don't sit on it too often. Nothing discourages a potential buyer more than to see an exhibitor sitting in a chair, reading a book, or looking bored. Hard sell is neither necessary nor appropriate, but a pleasant greeting and an offer to help and explain is the first step toward making a sale at an art show.

Wholesale Days

A prominent feature of some major shows is a day or two set aside exclusively for wholesale buyers from department stores, galleries,

museums, and the like. Such days are known as wholesale days and are becoming more and more prevalent. The crowds at wholesale days may not be as large as retail days, but the sales volume can be incredible.

Wholesale days at a few major shows can provide the bulk of the annual income for some artists. Orders are written for later delivery dates. As in all other forms of wholesaling, the ability to deliver when promised is as important a consideration as the quality and the price of the artwork. Wholesale buyers are experienced and careful. They may not buy from an art exhibitor the first time but, after they've seen the same exhibitor at several successive shows, they are more likely to patronize that artist.

What to Expect from Show Management

In return for paying the necessary fee, an art exhibitor has a right to expect certain services from the show management. First, of course, are the things specifically promised in the show brochure: a space of the promised size, setup time when specified, equipment if included, proper promotion to bring a crowd, etc.

Some show managers fall down even in those areas, but most keep their basic promises. Thereafter, however, management ranges from the superb to the abominable. Some show managers walk away as soon as the show has moved in. Others are constantly on the premises, alert to every problem and ready to solve it.

The first annual art show at Disney World in Florida, for example, provided hammers and wire for exhibitors who ran into difficulties in setting up their displays, furnished sitters for booths which had to be left temporarily unattended, and even accommodated pets at their kennels.

Admittedly, this sort of service is rare. But show managers do have certain responsibilities above and beyond providing the promised facilities.

Are booths positioned so that the traffic pattern helps to bring visitors past every exhibit? Are aisles wide enough to enable customers to move around without knocking into displays or each other? Are restroom facilities available? Are all instructions clear, and have they been furnished to exhibitors well in advance of the show so they can prepare for it properly?

If the show is juried, do applicants know who the jurors are and what criteria are used? Are rejected applicants given an explanation? Does the show management interrupt constantly with entertainment

or other distractions which draw people away from the booths where exhibitors are trying to sell? Is a show program or catalogue published with names and addresses of exhibitors? Does the management report to exhibitors on the success of the show afterward?

Are promised awards actually given? Is the show well-publicized? Does the show management listen to complaints or suggestions with some expression of concern? Above all, are exhibitors treated with respect or are they simply moved around on the show floor like chess pieces?

The exhibitor also has some responsibilities. The major one is to comply with all the rules that were provided in writing; beyond those, to be friendly and courteous, to operate the booth in a professional manner, to be considerate of the exhibitor in the next booth.

If you've never exhibited at a show, it may be useful to attend a number of different shows as a visitor to get a feel for how they're run. Ask questions, both of visitors and exhibitors. Study all the details carefully. If you're visiting a show you plan to enter in the future, ask yourself some questions. How does your work compare with the work of other exhibitors? Do the prices at the show make your prices seem realistic? Can you produce enough work in advance to keep your exhibit well-stocked for the entire run of the show?

Even if you answer all these questions affirmatively, there is still no guarantee that the show will be a success for you. You have no control over certain factors, such as the weather and the economy but, by properly managing those factors which are within your control, you can avoid serious mistakes and better judge the prospects of a show at which you plan to participate. (*See also* **Marketing, Selling**)

EXPORT

When an item is exported, a "value added tax" ("VAT") may be imposed on it by the country from which it is being exported. If the goods are returned, as, for example, unsold goods or artwork being returned from an exhibition, the VAT may be returned. Bonds are frequently purchased for the purpose of guaranteeing payment when the exporter claims that no tax is due and the exporting authorities demand some security. This is a very technical area and a customs broker should be consulted for assistance. Many treaties, such as the European Economic Community and the North American Free Trade Agreement, reduce the complexity of export restrictions, at least for items which are destined for member countries. (*See also* **Customs, Import, Treaty**)

F

F.O.B.

The term "F.O.B.," which means "free on board" at a named place, indicates to which point the seller of a product will deliver it and bear all the risks of loss, and at which point the buyer assumes responsibility. F.O.B. is most commonly followed by the word "factory" or "seller's place of business," which means that the seller will prepare the goods for delivery to the buyer or his/her agent (such as a freight carrier) at the seller's factory or place of business. In practice, this means that the buyer pays the shipping charges, makes the shipping arrangements, and assumes the risk of loss during shipment. The Uniform Commercial Code provides that, if the contract is silent regarding shipping, it is presumed that the parties have agreed that the seller will tender the merchandise at the seller's place of business or, if the seller has none, the seller's residence.

Sometimes the term F.O.B. is followed by the identification of a location other than a foundry or studio. This means that the seller is responsible for delivering the goods to the named location. If a San Francisco collector buys a large bronze sculpture from a New York artist whose foundry is in Los Angeles, then the difference between "F.O.B. foundry" and "F.O.B. studio" is significant in terms of shipping and insurance costs. "F.O.B. studio" means the collector pays the shipping costs from New York to Los Angeles. "F.O.B. foundry" means that the collector pays for shipping and bears the risk of loss only from Los Angeles to San Francisco. Silence, in this example, would only obligate the artist to make the work available for the collector at the artist's New York studio.

Note that, under the Uniform Commercial Code, title to the merchandise has nothing to do with the delivery term F.O.B. (*See* **C&F, C.I.F., Shipping, Uniform Commercial Code**)

FEES

Payments for such professional services as those of lawyers, accountants, and doctors are known as fees, as distinguished from wages and salaries. If an artist serves as a consultant or speaker,

payment for that service is also known as a fee, even if it is called an honorarium. Other payments called fees include admissions to entertainment or sports events, art shows, some educational activities (such as seminars), official documents, licenses, registrations, and charges established by law for the services of a public official, such as a notary public.

FINANCIAL MANAGEMENT

(*See* **Accounting, Banks, Budget, Financial Statement, Gross, Investment, Loans, Tax**)

FINANCIAL STATEMENT

The term "financial statement" commonly includes three types of reports: the income statement, balance sheet and statement of cash flow. The income statement reports the income and expenses of the business during the reporting period. The balance sheet reports the assets, liabilities, and equity at the end of the period. The two reports complement each other, because the income statement helps to indicate how the business got to where the balance sheet says it is.

Ledgers and Journals

Ledgers and journals are accounting records in which the various financial transactions of a business are recorded. The journal is used to keep the day-to-day records. Many businesses keep several journals: one in which to list sales, one for cash receipts, one for payroll, one for accounts receivable, and so forth.

While some businesses may keep several subsidiary ledgers for different purposes, they will always have a general ledger. An arts business must have a general ledger. The information recorded in the general ledger is based on the entries in the journals, and is listed side by side in columns marked "debit" and "credit," according to the nature, type, or source of the transaction.

Income Statement

This summary of the income and expenses during a given period is also known as a profit-and-loss statement or "P&L." The most common reporting period is monthly. The income statement lists the total income and the total costs of running the business. The difference is known as gross profit (or gross loss). Gross profit is determined by deducting the cost of goods sold from the gross sales. Operating expenses, sales costs, and taxes are deducted from the

gross profit to determine the net profit (or net loss).

Entries commonly found on an income statement include sales/receipts, income, business expenses, overhead, profit, and net profit, although all of these may not appear and others not listed here may be appropriate.

An examination of the income statement and a comparison with income statements of previous periods can be helpful in pinpointing improvements or shortcomings in specific areas of income and expense. Evaluating the income statement and comparing it to a proposed budget is useful for predicting business growth and expenditures. It is also useful to compare current expenses with past expenses for comparable periods (e.g., first calendar quarter).

Income, generally, is money, property, or anything of value from whatever source derived, commonly thought of as the financial gain resulting from business activity, investment, labor, personal service, or other source.

Expenses—Anything you spend is an expense. If it is related to your art business, it is a business expense. That includes salaries, taxes, insurance, rent, dues and subscriptions, travel expenses, and a great many other items. Business expenses are generally tax-deductible.

Overhead consists of all the operating costs that are not directly related to the production of artwork. The cost of raw materials and labor (including your own) change in direct proportion to how much is produced. Overhead does not. It remains fairly constant, even if nothing is produced. That's why overhead is also known as a general or fixed expense.

Rent, insurance premiums, telephone bills, and utilities have to be paid every month, whether or not you are producing and selling artwork. Overhead must be included in the formula you use to price your work.

Profit—For accounting purposes, there are several categories of profit: *gross profit* (the sale of merchandise less the cost of that merchandise); *net profit* (total income less the cost of production and other expenses in running the business); *paper profits* (profits not yet realized, as represented, for example, by items in unsold inventory); and a number of others.

Most artists are concerned only with net profit. Some people call it the bottom line—the last line in the financial statement which indicates what's ultimately left over for the business owner.

It is a common misconception that "the more you sell, the more

profit you'll make." To sell $300 worth of artwork that costs $100 to produce is usually more profitable than to sell $400 worth of artwork that costs $250 to produce. In the first case, you have $200 above the cost of production; in the second, only $150, even though sales dollars were higher.

Since profits are so directly tied to both sales and costs, any change in either of those factors affects the profit. To increase sales can increase profits, as long as costs don't rise out of proportion. Profits can also be increased if costs are cut even if sales don't go up. Indeed, this is the part of the equation customarily focused on by business consultants. The ideal situation, of course, is to increase sales while reducing costs per unit. A on-going analysis of your business operations is essential for maximizing profit.

Balance Sheet

Unlike an income statement, which summarizes the income and expense activity over a given period, the balance sheet reflects the financial condition of a business at any given time. The balance sheet reports the assets (everything you own) and the liabilities (everything you owe)

$$\text{Assets} = \text{Liabilities} + \text{Owners' Equity}$$

The owners' equity is the net worth of the business.

A balance sheet is prepared by an accountant and is used to inform the owners or stockholders of the condition of the business. It is also required with most applications for a bank loan.

Assets are all the things you own, but accountants give them a slightly more restricted meaning, namely all the things you own that can be measured in terms of money. Assets include real estate, personal property, machinery and equipment, cash in the bank, inventory, raw materials on hand, and even the money others owe you. You may think that your own good name is your biggest asset but, unless you purchased it, neither it nor the goodwill associated with it can be carried on your books as an asset. For accounting purposes, there is a whole host of assets. For artists, the following are the most common:

Fixed Assets: Such items as real estate, personal property, tools and equipment.

Liquid Assets: Such items as bank accounts, inventory, accounts receivable; in short, the kind of assets that can readily be turned into cash. The most liquid asset is cash itself.

Tangible Assets: An asset which has physical properties. Equipment, tools, raw materials, and inventory are all tangible assets.

Intangible Assets: Assets which have value but are not tangible. These include intellectual property rights, customer lists, a trade name, or a unique process.

Accounts Receivable: A balance due from a debtor on a current account. This includes short-term obligations such as installment credit payments and receipts from consignment sales. As these receivables "age" (or become past-due), they become less collectible. Banks and other lenders will rarely—if ever—lend money against receivables which are more than 90 days old.

Liabilities are what you owe others, in terms of money, goods, or services. Unpaid bills and mortgages are liabilities. So is the obligation to deliver artwork which has been commis-sioned. Liabilities fall into two categories: current and long-term. Current liabilities include all obligations that are due in the current fiscal year. Long-term liabilities are obligations that stretch over a number of years: a mortgage, a bank loan, or the pay-out on a piece of equipment such as a car.

Liabilities and assets appear together on the balance sheet. In a profitable business, assets are greater than liabilities. The difference represents profit plus the owner's equity, which may either be withdrawn or retained as an addition to your investment.

Equity—The *value* of an owner's interest in a business is called equity. This value is determined by subtracting the total liabilities of the business from its total assets. Equity is rarely equal to the owner's capital investment. In practical terms, the total equity of a business is equal to the liquidation value of the business. In the case of a mortgage, "equity" is used to describe the owner's (borrower's) share of the total value of the property. As the mortgage loan is paid off, the owner's equity increases, provided the value of the real estate does not decrease. Thus, if you buy a $100,000 house with $20,000 in cash and an $80,000 mortgage, your initial equity is $20,000. After you've paid off $4,000 of the principal, your equity has grown to $24,000 (plus any appreciation in the value of the house since the loan was initiated), and so forth, until finally your equity is 100 percent.

Dividend—In the literal sense, the dividing of profits. The most common dividends are those paid on the basis of stock ownership, insurance policies, and other investments. A dividend is the investor's share of the profits in proportion to the size of the invest-

ment. Dividends are generally paid on a regular basis: annually on insurance policies, quarterly on many stocks. Preferred stock will customarily have a fixed dividend which should be stated on the stock certificate, but dividends on common stock and insurance policies will vary from period to period according to the profits of the company. Dividends must be declared as income for tax purposes; IRS Form 1099-DIV is required to be sent to the taxpayer by the payor. (*See also* **Accounting, Computers**)

FINE ARTS FLOATER

Proper protection for what insurance companies describe as periods of "storage, transporting, and exhibiting" requires the addition of a "fine arts floater" to your property insurance policy.

To protect against theft from your vehicle, the policy must be endorsed to include off-premises theft coverage. To protect work which is transported by other means (parcel post, UPS, freight, someone else's car), specific transit coverage must be added to the fine arts floater. Rates for floater coverage depend on such variables as the type of storage area being used (home, shop, warehouse, garage), whether the vehicle has a burglar alarm, security conditions in the exhibition building, packing of items, etc. Some artwork is more fragile or more tempting to thieves, and that can also affect the rates.

The only way to obtain a fine arts floater is by adding it to an existing homeowner or renter policy. Floater premiums ordinarily are about $5 per $100 of coverage, with a $25 minimum. If the risk is large enough ($10,000 or more), it may warrant being underwritten separately. A deductible (ranging from $50 to $500 per occurrence) may be made part of the policy and, the higher the deductible, the lower the premium.

This coverage is offered by most casualty and property insurance carriers. To determine whether you need such coverage, how much to buy and what it will cost, you should consult your insurance agent. Be sure to determine whether your state has enacted an artist/dealer consignment law and whether that law makes the dealer absolutely liable for consigned work. If it does, the artist may be interested in obtaining insurance only for work in transit. (*See also* **Consignment, Insurance, Property Insurance**)

FIRE INSURANCE
(*See* **Insurance, Property Insurance**)

FIRE PREVENTION

Few disasters are as tragic or as costly as a fire, and most such disasters can be prevented with proper attention to safety precautions. Consider not only that a fire can pose a serious threat to your life and the lives of those who live or work with you, but that it can also destroy your life's work, your prized possessions, your business records, your means to earn a living.

The following recommendations for safety in five major areas of fire danger are based on information from the National Fire Protection Association, which publishes electrical and fire codes, maintains statistics, and conducts investigations.

Hazards

Smoking Hazards

Smoking is one of the most common causes of fires, especially around vapors and dusty areas. Post *No Smoking* signs in potential danger areas, and be sure the signs are observed. It is common for offices and studios to be designated smoke-free.

If you must smoke, be sure to use an ashtray. Do not rest cigarettes on window sills, edges of your easel, or other surfaces. Do not throw matches, cigarettes, or pipe dottle into waste baskets, even if you think they're out.

Of all the fire hazards, those caused by smoking are the easiest to prevent. For visual artists who work with flammable materials, smoking while working is particularly dangerous. You should either designate a smoking area or permit smoking only outside of your premises.

Electrical Hazards

Never hang electrical wiring over nails, around metal pipes, near heat or oil, across passageways, or run wiring across the floor. Frayed insulation, broken plugs, loose connec-tions, and defective switches or outlets must be repaired or replaced promptly. Keep hot bulbs away from liquids and flammable materials.

Overloading electrical equipment or bypassing the safe amperage of the fuse box creates a real fire danger. Never use electrical equipment near sinks or bathtubs. If a motor emits sparks or gets wet, it needs attention. A spark can cause a fire. The small amount saved on delay or skimping can easily become thousands of dollars of fire loss.

If you must use electrical equipment near flammable liquids, gas, or dust, be sure it is designed for that purpose, i.e., is explosion-proof, and that proper ventilation is maintained at all times.

Cutting and Welding Hazards

All torch cutting and welding should be done in a safe place, away from flammable materials or explosives. Walls, ceilings, and floors can catch fire from flying sparks. It is always best to have a fire watcher on hand to extinguish flying sparks that land anywhere, including cracks or crevices. Don't immediately walk away when you're through; examine your work area and stand watch for a while to be certain no sparks are smoldering anywhere. Use a fireproof apron to protect yourself and your clothing; use covers and shields to contain sparks.

Flammable Liquid Hazards

Don't ever allow flammable liquids to accumulate. Use them only outdoors or in a well-ventilated area. This is particularly true for painters who commonly use a variety of flammable solvents. Clean up spilled liquids immediately, and keep only a small amount in a clearly-marked metal safety container (never glass) in your studio.

Never use gasoline as a cleaning fluid; it is one of the most dangerous things you can do since gasoline is one of the most flammable liquids available. Don't take the chance. Gasoline is a fuel, not a cleaner.

Keep flammable liquids away from all sources of flame or sparks (kilns, torches, heaters, electric tools). Oil- or turpentine-soaked rags should be kept only in tightly-covered metal containers, if at all. Get rid of them as soon as you can.

Housekeeping Hazards

Neatness counts! If your work area is littered with cartons and scraps and leftover materials, you're inviting a fire. Ditto with accumulations of chips, cuttings, oil drippings, dust, and other trash. Keep such debris in covered metal containers and dispose of it regularly (and properly, recycling whenever possible). Don't let it accumulate.

Be sure that exit doors, stairways, and fire escapes are not blocked, and that your sprinkler system, if any, is in good working order. Establish a fire escape plan and have periodic fire drills. Be sure that all family members and/or employees know the fire escape procedures. Make a fire safety fact sheet available (*see* **Appendix B**).

Fire Extinguishers

Every workplace and every home should have one or more fire extinguishers, depending on the size of the premises and the potential type of fire.

Different types of fire require different types of fire extinguishers:

TYPE A (water type) is used for ordinary combustible fires such as paper, cloth, wood, or trash;

TYPE B (dry chemical or foam type) is used for flammable-liquid fires such as gasoline, paint, turpentine, lacquer, or oil;

TYPE C (carbon dioxide type) is used for electrical-equipment fires, such as for motors or wiring;

TYPE D (dry powder type) is used for combustible metal fires, such as certain metal chips, shavings, etc.;

TYPE A-B-C (multipurpose chemical type) can be used for any of the various types of fire created by combustible materials, flammable liquid, or electrical equipment.

Never use a fire extinguisher on a fire for which it is not intended. Using TYPE A (water) on an electrical fire can cause an electric shock and may cause the fire to spread.

Read the instructions on the fire extinguisher carefully. Be sure you know how to use it before you need it and be sure that the extinguisher is properly charged. Have the extinguisher inspected on a regular basis.

Place the fire extinguishers in strategic locations and be sure they are always easily accessible.

What to Do If a Fire Starts

If you see smoke or fire, the first thing to do is to turn in a fire alarm.

If the fire is small, fight it properly while you wait for the firemen; but stay low and be sure you have an escape route available. Those first few minutes are vital, but remember that personal safety is more important.

If the fire grows and gets out of hand, get out fast! Close doors behind you to retard the spread of the fire.

For information, fire standards, and statistics, contact the National Fire Prevention Association (see **Appendix B**). (*See also* **Insurance, Work Area**)

FIRST NATION ARTS

First Nation Arts is a non-governmental organization formed to promote American Indian art and crafts. Its goal is to assist Indian artists in achieving financial independence without having to rely on the government for assistance. The organization provides seminars for Indian artists, as well as for collectors of Indian art, and has assisted Indian artists in participating in numerous professional shows. (*See also* **Southwest Association on Indian Affairs, Appendix B**)

FORECLOSURE
(*See* **Collateral, Loans, Mortgage, Uniform Commercial Code**)

FOUNDRY PROOF
When creating an editioned sculpture, the artist will generally create a "foundry proof," which is used by the foundry casting the work as the standard for the edition. Foundry proofs should be marked as such and should not be counted a part of the edition. A foundry proof the equivalent of a printer's proof used in printmaking. All proofs belong to the artist unless otherwise agreed. (*See also* **Artist's Proofs, Multiples, Printer's Proofs, Working Proofs**)

FRANCHISE TAX (*See* **Income Tax—Business**)

FREIGHT ALLOWANCE
Most artists and galleries require the purchaser to pay the cost of shipping and insuring the work while in transit. This is usually added onto the bill, and some artists and galleries state this in their order confirmations or bills of sale. Occasionally, artists or galleries will make a freight allowance; that is, the freight charges will be paid by the seller. This is usually based on two considerations: (1) the dollar amount of the sale and (2) the distance the work has to travel.

For example, a $50,000 oil painting may have the freight paid by the shipper. This is important to artists and galleries, both as purchasers of equipment and supplies, and as suppliers themselves. In both situations, the question is who pays the freight charges.

Some shippers make a freight allowance for deliveries within a certain limited area, e.g., 100 miles if they have their own truck delivering to that area. In other instances, a freight allowance may be made to distant locations if the supplier wants to build customers in that area but can't compete if the freight charges are added.

A freight allowance need not be 100 percent. It can be graduated, for example, 10 percent if the order is under $200, 20 percent if it is $200 to $500, and so forth.

As a supplier, an artist or gallery should not offer freight allowances unless they are necessary to make the sale. As a buyer of equipment and supplies, on the other hand, artists and galleries should try to get as much freight allowance as is possible. Any freight you pay—coming in or going out—is an expense that eats into your profits.

Galleries obtaining work on consignment frequently pay the cost of obtaining the work and this should be covered by any artist/dealer consignment agreement. Collectors who purchase artwork at shows may save the cost of shipping and in-transit insurance. Similarly, not having to bring work back after a show can save the artist or gallery money. It may, therefore, be worthwhile to discount a work at the end of a show in order to save these costs. (*See also* **C&F, C.I.F., Consignment, F.O.B., Shipping**)

FREIGHT COLLECT

This means that the recipient of a shipment pays the freight costs when the shipment is received. The carrier will not leave the shipment unless those costs are paid. If this situation applies, it should be stated in all price lists, order confirmation forms, bills of sale, etc. (*See also* **C&F, C.I.F., F.O.B., Freight Allowance, Freight Prepaid, Shipping**)

FREIGHT FORWARDERS (*See* **Shipping**)

FREIGHT PREPAID

This means that the seller pays the costs of shipment, even if those costs are ultimately added to the bill. If so, it should be stated clearly in all price lists, order confirmation forms, bills of sale, etc. (*See also* **C&F, C.I.F., F.O.B., Freight Allowance, Freight Collect, Shipping**)

FUNCTIONAL ART (*See* **Crafts**)

G

GALLERY

A gallery is a retail sales outlet for artwork, with some important features which distinguish it from other outlets called stores or shops. Those distinctions are traceable to the original meaning of the word "gallery," the definitions of which included walkways, promenades, places where the audience sits at a performance. In other words, a room with a view. The upper balcony of an opera house, the spectator section at a golf tournament, and exhibition halls at museums are still known as galleries.

A gallery which sells artwork is still a room with a view, since its selling activity is based on exhibitions rather than simple store display. Such galleries generally specialize in innovative works of art, including antiquities, work by contemporary artists, and even wearable art. Galleries attract collectors who are interested in buying unique or unusual aesthetic objects, rather than buyers of mass-produced functional objects.

While galleries deal with art and antiquities, they must still conduct their activities in a businesslike manner. For an excellent resource, see *The Cultural Business Times* (Appendix D.).

Whether a gallery will be willing to display a particular artwork is subjective. Galleries develop their own personalities and will accept only work which is consistent with their cultivated or desired images. Galleries frequently demand exclusivity arrangements in order to preserve their unique offerings. Galleries do not depend primarily on walk-in customers who are attracted by a window display or a big ad in newspapers or magazines but, rather, on a carefully developed list of clients who respond to invitations to an opening or on collectors who frequently attend regular openings. For example, in Portland, Oregon, a number of galleries have chosen to host openings known as "First Thursday," which occur on that day each month and which are promoted through the media as well as a jointly-published flyer. To be successful, a gallery must offer collectors something that is artistic, unique, or innovative. To accom-

plish this, many galleries build their reputations and clientele by specializing in certain types of work, certain artists, certain periods, certain schools, and so forth.

For the artist, gallery acceptance includes many benefits beyond actual sales. Since competition for gallery acceptance is very keen, a great deal of prestige attaches to having a gallery relationship, even with a non-selling gallery in a museum. Gallery exhibitions and openings are frequently reviewed in the press, and a good review is an important addition to an artist's resume.

All of this background is by way of introducing the methods of approaching a gallery and the specific arrangements that should be made. First, determine whether your work is really suited to a specific gallery. Visit some galleries in your area or whenever you are on a trip. Walk in as a spectator and try to visualize your work in that setting. Does the gallery's general approach appeal to the kind of collectors who might be interested in your work? Does the price structure seem compatible with yours? Do you like the way the gallery exhibits the work and prepares the catalogue, if any? Is there some reason why that particular gallery should be interested in handling your work?

The initial approach to a gallery, unless you know the owner or have a personal introduction, is to send a letter, enclosing a brief resume which outlines your background, describes your experience, and includes some reference to exhibition or competition experience. You may also enclose slides; be sure to include a self-addressed, stamped envelope. Indicate in the letter that you will call in a week or so for an appointment to discuss the gallery's representation of your work and, possibly, to show additional slides or actual samples of your work.

Don't be discouraged if gallery owners don't immediately agree to handle your work. They usually have contracts and commitments for many months in advance. Unlike retail shop owners, they don't work under intense daily pressure, and their concern is not how many units of a given item they can sell tomorrow. On the other hand, they are in business to make a profit, and anything you can tell them that would lead them to believe in the possibility of a profitable connection if they handle your work is an obvious advantage. For example, if you already have a list of potential collectors who came to another show of your work and could be invited to an opening, you are more likely to attract a gallery owner's interest. Similarly, if you have had your work favorably reviewed in a magazine

or newspaper or if you have won awards for your work, your work is more likely to be accepted by a gallery.

If your work is accepted, you should insist upon a written contract with the gallery, whether the work is to be taken on consignment or purchased outright. Do not sign the gallery's form until you have had an opportunity to read it and consult with your legal or business advisor. While the most common artist/dealer arrangements are consignment arrangements, galleries will sometimes purchase work outright. Even if the gallery purchases your work and pays you an acceptable price, it is still important for you to determine the price at which the work will be resold, since control over the market for your work is important to your career growth. Some artists insist upon obtaining resale royalties and some demand post-sale control over the work for purposes of conservation, restoration, prohibition against destruction, and even access to the work for the purpose of retrospective shows. Whether you are in a position to obtain these concessions and whether you feel they are important to you is subjective. Artists should determine which contractual provisions they consider valuable and determine how important they are. It would, for example, be sad for a new artist to lose an important sale merely because the gallery refuses to agree to a resale royalty provision.

Galleries can be located almost anywhere, though the most successful ones appear to be clustered in neighborhoods which cater to a distinctive group of people. For example, Manhattan's 57th Street is commonly referred to as "Gallery Row." Galleries may also desire to be located in upscale malls or in close proximity to compatible businesses, as the galleries in San Francisco's Ghirardelli Square.

Despite the importance of gallery relationships, some artists have chosen to have their work exhibited and sold in alternative locations, either in lieu of or in addition to galleries. (*See also* **Alternative Space, Consignment, Contract, Dealer, Fine Arts Floater, Insurance, Portfolio, Resume, Retailing**)

GOVERNMENT ACTIVITIES

Dozens upon dozens of art-related activities are part of the programs of various federal and state government agencies and departments.

Federal

Perhaps the best known of these are the programs of the National

Endowment for the Arts ("NEA"). Although the NEA in recent years has focused its support on the organizational infrastructure of the arts, there are still some major programs available to individual artists. Categories for which fellowships are available are outlined in the NEA "Visual Art Fellowships" catalog. (*See* **National Endowment for the Arts**)

The activities of the Small Business Administration, while not specifically art-oriented, have had an impact on art businesses through its extensive series of publications on a wide range of business subjects. Regrettably, the loan program is unavailable to art businesses. (*See* **Small Business Administration**)

Other government agencies involved in art are the Department of Health and Human Services, Department of Education, Commerce Department, Interior Department, Department of Justice (through its Prison Arts Program), the armed forces, Smithsonian Institution, Tennessee Valley Authority, National Park Service, and the State Department (Art in the Embassies and cultural exchange programs).

Many of the programs do not deal with individual artists (the National Endowment for the Arts is the major exception), but are more involved with institutions and organizations.

Complete details about federal funds and services available to artists and art-related businesses can be found in the *Cultural Directory* published by the American Council for the Arts. This volume should be in the collections of most good libraries.

State

All states and provinces and many municipalities have arts commissions or councils. The state organizations provide funds to artists and art-related organizations for a variety of programs. In addition, many states and municipalities have both public and private advocacy programs or groups which, among other things, monitor legislation, assist artists and arts organizations with projects, and generally attempt to make art available to the public. There are awards for significant contributions to the arts (for example, the President's Arts Awards, the Governor's Arts Awards in many states, and comparable municipal awards). The executive branch of many governments provide display space for artwork, either in the executive offices or in other government buildings. The federal government and most states have adopted percent-for-art programs, which require that a percentage of the total cost of any new

construction or remodeling must be spent on the purchase of art for that building. (*See also* **Arts Councils, National Endowment for the Arts, Small Business Administration**)

GRANTS

A grant is a sum of money given to an individual, organization, or institution for a specific project which has a defined purpose.

The major sources for grants are:

1. Government agencies such as the National Endowment for the Arts and state arts councils;
2. Private organizations or institutions, such as museums or foundations;
3. The business community, such as major corporations.

Most grants are given for specific purposes. Some foundations, for example, specify that they will give grants for legal education only; some corporations support symphony orchestras, and so forth.

The largest single source for grants in the arts is the National Endowment for the Arts, which has a separate visual arts department. Its annual *Guide to Programs*, published in August, outlines in detail the eligibility requirements for various grants.

The other major source are state arts councils or arts commissions. They can usually be located in the state capital. Both the size and the nature of grants vary from state to state. Most major cities have their own arts councils or arts commissions which generally have grant programs.

A number of federal agencies, notably the Department of Education, give grants for specific educational purposes. A complete list of federal funds for cultural activities is found in the *Cultural Directory*, published by the American Council for the Arts.

A major source of information about private funding is the *Foundation Directory* (*see* **Appendix D**). This volume is available in most major libraries.

Scholarships and fellowships for elementary and advanced university study are closely related to the concept of grants. The best approach is to decide which particular university offers the most suitable curriculum, and then inquire what scholarship aid is available at that institution. A good source for information is the *College Blue Book,* a multi-volume reference work revised every two years. It includes supplements on fellowships, grants, and loans for study at both the undergraduate and graduate levels, and is cross-referenced by institution and by subject matter. It is available in most libraries.

Various agencies of state and federal government make some money available for scholarships, or underwrite student loans. Such programs are, of course, subject to fluctuations in the economy as well as the direction of the political winds which dictate the size of available budgets for such purposes. A good place to start looking for information is the Office of Student Financial Assistance (*see* **Appendix B**).

Every institution of higher learning also has its own student financial aid office. If you've already determined which institution you want to attend, consult with the financial aid office to find out what kind of scholarship, fellowship, grant, or loan assistance is available at that institution.

There are no prescribed general rules about how to apply for a grant, although most grant application forms outline in specific detail what type of information is required. Since a grant always has a purpose, the information the applicant furnishes must stress how the use of the funds will help accomplish the purpose of the grant.

Some granting agencies require the applicant to match the grant funds by a specified ratio. Most granting agencies are impressed by applicants whose match is in the form of real contributions of money or property, rather than so-called "in kind" contributions. Applicants who have previously received grants are more likely to be successful in the future. Even previously unsuccessful applicants who continue to apply to the same agency, thereby establishing some familiarity, are also more likely to receive favorable consideration at some point. Some grants are one-time grants; others are so-called "continuation grants," i.e., they provide funds for a particular project for a specified number of years, provided that the grantee continues to meet the agency's criteria for that grant. To be eligible for most grants, organizations must be non-profit and tax-exempt; this restriction does not apply to individual artists. (*See also* **Art Councils, National Endowment for the Arts, Appendix B, Appendix D**)

GROSS

This word has at least four meanings:

1. In poor taste, unrefined, ugly, coarse, garish;
2. 12 dozen, 144 pieces;
3. Big or bulky; excessively fat; and
4. As applied to financial statements, indicating that deductions have not been taken.

For example, "gross income" is the total amount of money, property, or anything of value received from any source before any deductions are taken. This is distinguished from "gross profit," which is the amount of profit left after certain expenses are deducted from gross income and before deducting applicable taxes to arrive at "net profit."

"Gross" is distinguished from "net," which is essentially "gross" less specific deductions.

When including these terms in a contract, care must taken to define with particularity the items which shall be deducted from "gross" to arrive at "net." The definitional criteria has been the subject of numerous lawsuits, including the battle between Art Buchwald and Eddie Murphy over the extraordinary definition of "net" in determining the compensation due Mr. Buchwald for his contribution to the film *Coming to America*. The definition of "net" in contracts can run for many pages and it is sometimes said that the term "net," in the entertainment industry, if not specifically defined, equals zero. (*See also* **Financial Statement, Net, Income, Profit**)

GROUP INSURANCE

Life, accidental death, health and major medical, dental, and disability income insurance policies can be bought at comparatively lower rates when a single policy is issued to a group to cover members of that group, and the group pays one premium to the insurance company on behalf of the enrolled members. A group can be formed by a business firm, an organization of artists, or any similar organized entity.

Most such policies require that the group consist of at least three members, and that a certain percentage of all members participate in the group policy. Premiums can be paid by the employer or organization, or they can be paid by the members through the employer or the organization.

Many major insurance companies offer group health plans. Among the better-known in the hospital and medical field are Blue Cross/Blue Shield and Kaiser Permanente, but there are many local and regional companies which can compete very favorably.

Members generally need no physical examination to qualify for life insurance coverage, although medical history is routinely required. As a result of the AIDS crisis, however, this may change.

The federal law known as COBRA requires employers with more than 25 employees to permit terminating employees to retain their

membership in the company health and medical plans for a period of up to 18 months, provided the individual personally makes the appropriate premium payments. Many states have similar laws. There is no federal law covering continuation of benefits for other types of insurance, although some employers and insurers may allow former employees to convert from the group plan to an individual plan.

Group life insurance policies are almost term insurance and, therefore, do not accumulate cash values as do other life insurance policies. Members sometimes cannot select their own amount of coverage. The insurance company cannot cancel an individual member's participation in a group policy other than for lack of premium payments.

Group insurance is used by many companies as an added form of compensation and to induce employees to remain with the firm; organizations offer it as a service to members and to attract new members.

There are three types of group medical plans: indemnity, preferred provider organizations ("PPOs"), and health maintenance organizations ("HMOs"). In an indemnity plan, the insurance company receives the premiums from the group and pays for the medical services on either a scheduled or "reasonable and customary" basis. With some exceptions, the participant is able to choose his or her provider. With preferred provider organizations (PPOs), the insurance company contracts with medical providers and organizations to perform services at specific rates. There are economic disadvantages to the participant for obtaining services from nonparticipating providers. In the case of health maintenance organizations (HMOs), the insurance company owns the medical facilities and employs the professionals to provide the medical services. The attempt is to control costs through close supervision of the delivery system. (*See also* **Disability Income Insurance, Insurance, Life Insurance**)

H

HANDICAPPED ACCESS (*See* **Americans with Disabilities Act**)

HEALTH HAZARDS (*See* **Safety**)

HONORARIUM (*See* **Fees**)

HORS COMMERCE
A sample print to be used for sales purposes and not to be sold. These are not counted as part of the edition and should be appropriately marked. Their existence must be disclosed under most state multiples laws. (*See also* **Multiples, Prints, Proof**)

I

IMPORT (*See* **Customs, Export**)

INCOME TAX—BUSINESS

The federal income tax laws require different things from different types of business organizations. Sole proprietors, partnerships, S corporations, and limited liability companies (LLCs) do not pay a business income tax on the business' profits; instead, profits and losses are included on the individual's income tax return. In these instances, information returns must be filed by the business so that the Internal Revenue Service can verify that the business owners have properly declared their business income on their personal returns. Form 1065 is filed by partnerships; Form 1120-S is filed by S corporations and LLCs. In addition, the business must provide its owners with the appropriate forms, Form 1099-DIV for C corporations if the shareholder receives more than $10 in dividends in the tax year, K-1 Form 1065 for partners, and K-1 Form 1120-S for S corporations and LLCs. The business owners will file additional forms with their tax returns, such as Schedule C with Form 1040 for sole proprietors. Limited liability companies use the same forms for tax returns as partnerships.

C corporations are another matter. Corporate taxable income up to $50,000 is taxed at 15 percent. That portion of taxable income over $50,000 but not over $75,000 is taxed at 25 percent. That portion over $75,000 is taxed at 34 percent, buta less than $335,000 the rate is 39 percent. For income exceeding $335,000 but less than $10 million, the rate drops to 34 percent. Between $10 million and $15 million, the rate is 35 percent. From $15 million to $18,000,333, the rate is 38 percent. For all higher earnings the rate is 35 percent.

The corporate tax is, in effect, a double tax. First, the corporation's income is taxed, and then, when the income has been distributed to stockholders as dividends, it is taxed again on the stockholder's individual income tax return.

All states, and many cities, impose their own taxes on corporate profits. Some even tax the incomes of unincorporated businesses. That

tax is often called a franchise tax, though it goes by a variety of names. It is, in effect, a tax on the right to conduct a business. An accountant or the applicable taxing authorities should be consulted to determine the specific tax requirements in your area.

The Internal Revenue Service has published an unusually clear "Tax Guide for Small Business" (Publication 334), which is revised annually and is available without charge from the nearest IRS office (see telephone white pages under "U.S. Government, Internal Revenue Service") or by writing to the IRS (*see* **Appendix B**). (*See also* **Accounting, Estimated Tax, Income Tax—Personal**)

INCOME TAX—PERSONAL

Income is defined, for federal tax purposes, as money, property or anything of value which you receive from any source, including but not limited to wages, fees, receipts from sales of work, resale and other royalties, dividends, interest, rent, profits, pensions, annuities, alimony, prizes and awards, jury duty fees, tips, unemployment compensation, profit from the sale of real estate, etc. If you barter your work, you have received income equal to the fair market value of what you received. For example, if you exchange your painting for studio space, you will owe tax on the amount of rent which you would otherwise have paid for that space. There is a presumption that anything you receive will be considered taxable income. The Internal Revenue Code specifies some limited exceptions to this general rule.

The exceptions include Veterans Administration benefits and disability payments, some Social Security benefits, proceeds of a life insurance policy, worker's compensation or other benefits paid for injury or sickness, interest on certain state and municipal bonds, gifts and inheritances.

Who Must File?

Federal income tax returns are required to be filed on or before April 15 of each year by everyone whose income in the preceding calendar year exceeded a specified minimum amount, dependant on the taxpayer's status. Each year, the Internal Revenue Service publishes the minimum amount of gross income figures which require the filing of a tax return.

Even if you are not *required* to file an income tax return, it is necessary to file if you were employed during the year and want to get a refund of money which was withheld for income tax purposes. It is

also a good idea to file a return so that the Internal Revenue Service will not see a gap in your annual filings and in order to start the statute of limitations for IRS claims or audits running in your favor.

Even though personal income tax returns are due by April 15, an automatic four-month extension is be obtained by filing the appropriate form on or before April 15. Any taxes due are required to be paid on or before April 15, or the taxpayer will be liable for late payment penalties and interest. Delaying the date the return is due does not delay the date the tax payment is due.

Long Form or Short Form?

Taxpayers with taxable income below $50,000 whose income was solely from wages and who have no itemized deductions will generally find it easier to file the short form 1040A as their federal income tax return. All you need do is to record the amount of income received and tax withheld as shown on the W-2 forms which are required to be provided by employers by January 31. The Internal Revenue Service allows a standard deduction and calculates the tax due or the tax refund based on the number of dependent exemptions claimed. If you also happen to be filing as single, under 65 and not blind, and claiming no dependents, you may have it even easier yet by filing Form 1040EZ, but this is available only for income received from wages and tips and not, for example, from unemployment compensation or sales of artwork.

Persons with larger incomes, self-employed income—such as professional artists, or deductions beyond the standard deduction must complete Form 1040, calculate their tax obligation, and send a check for the payment due or claim a refund.

Estimated Tax Declaration

Taxpayers who have income from sources other than wages subject to payroll deduction must file a declaration of estimated tax when they file their income tax return. Estimated taxes are required to be paid in equal quarterly installments on April 15, June 15, September 15, and January 15 for the respective preceding calendar quarters. There are several ways to calculate the estimated tax, the most convenient and common being the use of the previous year's self-employed income as the basis for estimating the current year's tax obligations. There are penalties for underpayment of estimated tax as well as for wage earners who claim excess exemptions during the year in order to reduce the amount of money withheld for tax purposes. (*See also* **Estimated Tax**)

Accuracy and Audits

It is a crime to intentionally falsify tax returns; even carelessness can lead to severe penalties. A tax return may be completed by hand or by computer; in addition, it may be filed either by mailing it to the Internal Service or "electronically filing" through use of a computer modem. Computer-generated returns tend to have fewer calculation errors—and, in fact, can be advantageous in identifying tax benefits, but the computer adage "garbage in, garbage out" applies to tax information, as well. Electronic filing is advisable only if you are expecting a refund.

There are many reasons why the Internal Revenue Service would examine, or "audit," a tax return. Every year, the IRS randomly selects tax returns for rigorous audits in order to establish standards. In addition, if a return contains entries which are inconsistent with the IRS statistical averages for those entries or contain internal inconsistencies, the return may be audited. It is impossible to identify the criteria used by the IRS to trigger an audit. Nonetheless, it is believed that taxpayers whose returns have been audited and who have been required to pay additional tax as a result of those audits are more likely to be audited in the future.

An audit can take place in the auditor's office, the taxpayer's place of business, residence, or the office of the taxpayer's professional representative. Audits are stressful, and the best thing you can do is attempt to be calm. Take a deep breath, relax, tell the truth, and merely answer the questions asked—do not volunteer information. Be sure that your records are in order. Never merely bring a shoebox full of papers and dump it on the auditor's desk.

An audit may result in your return being accepted as written, you receiving a tax refund for overpayment, or you being required to pay additional tax which the auditor calculated is due. In addition, you may be required to pay interest and penalties. The statute of limitations for the government's challenge of tax returns is three years, except in cases of fraud or where the taxpayer failed to report more than 25 percent of gross income. (*See also* **Audit**)

Where to Get Help

Taxpayers will usually find that the cost of professional help for preparing their income tax return often represents a savings in tax payments, because professional tax preparers are more likely to be familiar with the latest regulations, what may be deducted and what may not be, and the other intricacies of the tax laws. Even they can

make mistakes, however. In a survey conducted by Changing Times—the Kiplinger newsletter, accountants and professional tax preparers were given hypothetical taxpayer situations and asked to calculate the tax liability. The results were very disappointing— very few of these professionals were able to prepare a tax return which would have satisfied a tax auditor. If you deal with a licensed professional who has a good reputation, however, you are more likely to receive accurate, up-to-date information. Taxpayers can also get free help and advice from the nearest office of the Internal Revenue Service. (*See also* **Tax Preparation**)

Other Income Taxes

In addition to the federal income tax, most states require the payment of a state income tax. Many of these states have laws which parallel the Internal Revenue Code, though there are some differences and you should consult with a local tax adviser in order to determine what the state tax laws are in your jurisdiction. Some cities, counties and other municipalities also impose income tax obligations. (*See also* **Accounting, Estimated Tax, Income Tax— Business, Tax, Tax Preparation.**)

INDEMNITY (*See* **Museum**)

INDEPENDENT CONTRACTOR

An independent contractor is defined as one who exercises his or her own independent trade, profession, or calling. The *Restatement 2d of the Law of Agency* distinguishes between an "employee," who works for another and is under the other's control or right of control, from an "independent contractor" who merely provides an independent service or finished product. The *Restatement* contains a list of criteria which may be used to evaluate whether a person is an employee or an independent contractor. These include, among other things, whether the person uses his or her own tools, whether the person is engaged in a calling traditionally independent, where and when the work is performed, whether the person holds him or herself out as being independent, whether the person performs similar work for others, and whether there is a written agreement characterizing the relationship. The parties' own characterization is the weakest criterion.

Federal and state governments also attempt to characterize working relationships for tax and other reasons. The federal laws

cover such issues as taxes, minimum wage, and the like. The federal authorities tend to ignore some of the *Restatement* criteria and, in most cases, characterize individuals as employees wherever possible. State laws evaluate a worker's status for purposes of workers' compensation, unemployment insurance, state income tax and the like. State authorities tend to follow the federal government's pattern in leaning toward characterization of workers as employees.

For example, if you have an apprentice working in your studio who prepares your canvasses, that person is your employee. On the other hand, your accountant, attorney, and insurance broker are all likely to be independent contractors. If you create a wax and have the bronze cast by a foundry, the foundry worker is an employee of the foundry, which is an independent contractor to you, the artist. On the other hand, if you cast your own bronze, using your apprentice to help you, your apprentice is your employee.

The most important factor distinguishing an employee from an independent contractor is control. If you have the right to control the conduct of the work—whether or not you exercise that right—the person is your employee. On the other hand, if you have only the right to accept or reject the finished product or service, then the person providing it is an independent contractor.

The distinction is very important for a variety of reasons. First, employers are responsible for obtaining workers' compensation insurance, paying a portion of their employees' Social Security taxes, and withholding all required income and other taxes. Independent contractors pay their own. Employers are liable for all wrongful acts committed by their employees within the scope of their employment and are obligated on all contracts entered into by employees within their actual or apparent authority. Generally speaking, employers are not liable for the wrongful acts of independent contractors or contracts obtained by the contractor. (*See also* **Contract, Employees, Social Security, Tax, Workers' Compensation**)

INDORSEMENT

"Indorsement" is the technical legal term used to define the act of signing the back of a check so that it can be cashed or deposited. The indorsement should be exactly the same as the payee on the face of the check. If that is different from the name you use on your bank account, sign it twice: first as it appears on the face of the check, then as it appears on your account. For example, if you receive a check made out to Art Gallery but your account is under the

name of Arthur Smith, indorse the check first as Art Gallery, then as Arthur Smith.

If you accept a check made out to someone else (a "two-party check"), the same principle applies. First have the other person indorse the check, then add your indorsement. If you don't know the person from whom you are accepting such a check, be sure you see satisfactory identification, preferably a driver's license or other photo identification, as well as a credit card or other document bearing a signature for comparison. If permitted in your state, note the document number on the check, as well as the person's address so you can find him or her if the check bounces. Try not to take two-party checks.

You should never indorse a check and then leave it lying around. If it is lost or stolen, it can easily be cashed by someone adding a second indorsement. Any check which is to be deposited, and any check on which you are the second indorser, should have the words "for deposit only" and your bank account number written right under your indorsement. That way it cannot be cashed.

The indorsement (reverse) side of the check can also specify other restrictions, such as making the check payable upon delivery of goods or when a certain service has been performed. When the recipient of the check indorses it, the recipient accepts those restrictions. It is not clear whether indorsing a check which states that it is "payment in full" is binding when the payment is, in fact, for less than the full amount due, and there is conflicting case law. For this reason, you should either insist upon a new check or, at the very least, indorse the check "with reservation." It is also not clear whether a check indorsement will serve as a "writing" for purposes of assigning a copyright. There is some authority suggesting that it will, but the matter has not been resolved by the courts. (*See also* **Checking Account, Collection Problems**)

INLAND MARINE INSURANCE (*See* **Property Insurance**)

INSTALLMENT

Installment is defined as a part. Thus, in an installment sale or an installment loan, the whole amount is paid off in parts. Interest charges are customarily added to the face amount, and the total is then divided into equal payments, usually on a monthly basis for one or more years.

The question of title to the property being purchased is sepa-

rate from the payment method used. The agreement between the parties may state that the title remains with the seller until full payment is made, or that title is immediately transferred to the buyer. The agreement should also cover the seller's remedies if the buyer defaults, which may include, among other things, the right to repossess the item, the right to retain any amounts previously paid, and the right to demand payment of the full amount from the buyer. If there is no written agreement, transfer of possession of the item to the buyer transfers title and the seller merely retains a security interest which must then be perfected, if it is to be protectible.

Mortgages, automobile loans, and other long-term borrowing for major purchases are installment loans. If title passes to the buyer before payment has been made in full and the buyer is given possession of the item being purchased, then the seller retains a security interest in the item (then known as "collateral"), which should be perfected in accordance with the appropriate law. Generally, for land and buildings, a security interest is perfected by recording the mortgage document in the same place deeds are filed (usually, the county clerk or recorder). For all other tangible property, perfection is accomplished by filing a UCC-1 Financing Statement with the appropriate government office (often, the Secretary of State or county clerk). Perfecting a security interest in an intangible item, such as a copyright, patent, trademark, or interest in a business, varies depending upon the asset. For example, a security interest in a copyright may be perfected by recording the appropriate document with the Copyright Office *and also* by complying with the Uniform Commercial Code. The collateral serves as security for the repayment of the loan and may be repossessed if the borrower fails to pay installments when they are due, in accordance with the law under which the security interest was perfected. If the security interest is not perfected, then the seller can sue the buyer for the amount due but may not be able to repossess the property.

Interest on installment purchases is customarily charged on the unpaid balance and the interest rate is generally higher than that charged by banks. State usury and other laws limit the rate of interest which may be charged on loans. Sellers may restrict an installment purchaser's ability to prepay installments, though the contract between the parties may permit the purchaser to prepay all or any portion of the obligation without incurring any prepayment penalty.

Laws and regulations covering installment selling and loans vary from state to state. It is always wise to read and understand the entire agreement before signing. (*See also* **Collateral, Contract, Loans, Mortgage, Uniform Commercial Code**)

INSTALLMENT SALES

An installment sale is any sale of property where the payment is to be made over time in separate parts. As previously discussed, there are a variety of legal issues which should be considered when contemplating an installment transaction. These include, among other things, the seller's perfection of a security interest in the item being sold (collateral) and the other terms of the installment arrangement. State laws, such as artist-dealer consignment laws, cover other aspects of installment sales, such as the requirement that all payments received by the dealer must be paid to the artist until the artist is paid in full, unless the parties otherwise agree.

If payments extend beyond a single tax year, then the installment method of taxation may be used by the seller whose accounting system is cash-based. The installment method allows the taxpayer to prorate the taxable income attributed to each payment, i.e., the selling price minus the seller's cost basis in the property sold, in the same proportion as the gross profit bears to the selling price. Thus, the tax obligation is spread over the period of payments rather than totally included in the year of the sale.

For example, you sell the van you purchased after a few years of service. You agree to sell it for $5,000; your basis in it is $3,000. You sell it on an installment contract, taking $1,000 down and $100 per month. Your gross profit is $2,000, which is 40 percent of the total price. Thus, under the installment method, 40 percent of each installment payment is taxable income in the tax year that payment is received. The benefit is that you avoid having to pay the tax on the whole $2,000 in the year of the sale, instead, spreading your tax liability out over the full period of the installment contract, i.e., two tax years.

You are entitled to make an irrevocable election out of installment sales tax treatment, but only if you do so in the year of the sale. This might be advantageous if, for example, you were expecting to be in a low tax bracket this year but a higher bracket in later years, or if you had certain one-time losses to offset this year, or if you simply did not want to be bothered with the paperwork for the next two years. In the last instance, however, if the sale is large

enough (i.e., real estate), the tax savings associated with install-ment sales treatment can easily take the sting out of a little extra paperwork. Be careful to structure the transaction properly since it may trigger a depreciation recapture and you may then have to report all income in the year of sale rather than as it is received.

There are exceptions to the eligibility for installment sales tax treatment. Dealer sales and sales of inventory of personal property, such as artwork, are excluded. Thus, it may be used by collectors selling work in their collection. Dealer sales include sales of prop-erty by a person who regularly sells property of the same type on installment contracts, such as an art gallery, and sales of real prop-erty which is held for resale to customers in the ordinary course of the taxpayer's trade or business. (*See also* **Collateral, Consign-ment, Dealer, Installment, Tax**)

INSURANCE

Life is fraught with risks. Insurance has been developed to reduce the consequences of some of those risks. An insurance policy is a contract which transfers some of the risk from the policyholder to the insurance company, in return for which the policyholder pays the insurance carrier a fee known as a premium. Some risks can-not be insured, some risks are not worth insuring, and some risks must be insured.

To cite three examples: Buying a lottery ticket creates a risk of not winning, which cannot be insured; casting a bronze which may turn out distorted is a risk hardly worth insuring against; owning and operating a car is considered by most states a sufficiently high risk to require insurance.

There are some basic things that should be understood about insurance in order to buy wisely. These include the nature of risk, the types of insurance, what to insure, insurable interest, how much to buy, deductibles, telling the truth, and from whom to buy.

The Nature of Risk

Risks fall into two basic categories. One is pure risk, where you have no choice in the outcome. If you own a building and a fire breaks out, there is a loss. Pure risks don't allow any other result but a loss.

Speculative risks, on the other hand, are those in which you have a choice. You have a hand in controlling the risk and can, therefore, make a decision whether you want to take it. Going into business is itself a speculative risk. You might make money or you might not.

Both types of risk can be insured, though the premiums for insuring against speculative risks are usually quite high.

Types of Insurance

There are two general categories into which insurance may be divided: personal and property. Personal includes life, accident, disability, medical and hospital, public liability, and a few others. Property covers fire, theft, title, and automobile, plus some minor ones of little consequence in an arts business. Many of these are discussed in detail in this book under their appropriate alphabetical entries.

Insurable Interest

In order to obtain insurance, you must have an "insurable interest"; that is, a bona fide interest in the item being insured. This is a means by which the law prevents insurance contracts from being used as gambling contracts and a means of protecting the person or item insured from being exposed to an increased hazard.

You can insure a building you own against loss by fire, since you would be economically injured if it were lost. You cannot insure the Empire State Building (unless you happen to own that, too), because you have no insurable interest in it. Permitting insurance without an insurable interest might encourage the insured party to damage the property.

Similarly, you can insure the life of your family's breadwinner, but you cannot insure the life of the President of the United States (unless you are the First Lady), again because you have no insurable interest.

The real test of insurable interest is whether the insured or beneficiary of the insurance policy would suffer a loss if the risk covered by the policy came to pass. You need not own a piece of property to have an insurable interest in it. For example, the holder of a mortgage certainly has an interest in a building on which it made the mortgage loan. Nor need you be related to the person on whose life you take out a policy. An employer has an insurable interest in a key employee whose death might seriously damage the earning capability of the business.

The insurable interest must exist not only at the time the policy goes into effect, but also at the time a claim is made. If you have a fire policy on a building which you subsequently sell, and it then burns to the ground, you no longer have an insurable interest, even if you continued to pay the premiums.

The exception is life insurance, where the insurable interest needs to exist only at the time the policy is written. Two examples: If you take out a policy on a key employee who subsequently leaves your business, you can still collect in the event of his or her death, even many years later, as long as you continue to pay the premiums. If you divorce, your former spouse may still collect on your life insurance if you have not instructed the insurance company to change the beneficiary on your policy.

It is sound judgement, therefore, to examine your insurance policies periodically to determine what should remain in effect, what should be added, what can be cancelled, and whether any of the beneficiaries should be changed.

What to Insure

While it is theoretically possible to insure virtually anything from an artist's hands to the success of an opening, the cost of such insurance may be prohibitive. You should, therefore, prioritize your insurance needs.

The first and foremost consideration has to be the risk in relation to your capability to afford it. Fire insurance is clearly a top priority. A serious fire can put you out of business. Even a minor fire can pose a serious loss if your productive activities are interrupted for any length of time. In addition, you may wish to consider business interruption insurance, which is intended to provide benefits comparable to earnings lost due to any of several catastrophic events, such as fire, flood, windstorm, etc.

In automobile insurance, liability takes precedence over collision. If a $25,000 car is totally destroyed, you've lost $25,000. If, however, that same car gets into an accident without proper liability coverage, it could cost you $1,000,000. Saving on the latter to pay for the former can be penny wise and pound foolish and may not be possible. In addition, most states which require vehicle insurance require liability insurance but not collision insurance.

If you have a home studio, whether it is in the house or a separate building on your property, be sure you are properly covered. The typical homeowner policy expressly excludes business property and activities from its coverage. You may be able to add your art activities to the homeowner policy at a fairly small premium.

If the worst anyone can steal from you is a few hundred dollars worth of oil paint and canvas, you may not want to buy theft insurance. But if you're a jeweler with a tempting supply of gold, silver

and gemstones on hand, theft insurance may be essential.

How Much to Buy

A big question always is "How much insurance do I need?" In property insurance, that depends to a large extent on the value of the property, how much of a loss you can sustain without insurance, and how much money is available for premium payments.

Underinsuring serves little purpose, and can be expensive if trouble develops. For example: You own the building where your gallery is located. The building's current cash value is $250,000. Most fire insurance policies require that you insure at least 80 percent of the fair market value, or else you assume some of the risk yourself.

Now, you insure that $250,000 building for only $125,000. That's 50 percent of the value. This doesn't mean that the insurance company will pay your losses up to $125,000, and you pay the rest. If the particular policy requires 80 percent coverage, and you buy only 50 percent, then the insurance company will pay only 50 percent of a claim. The rest is your responsibility. That's also known as "co-insurance," because you are, in effect, sharing the risk of loss with the insurance carrier. Expensive as fire insurance may be, few artists or galleries can afford to underinsure or co-insure. In addition, if the building is mortgaged, most lenders require that adequate insurance be maintained on it, often through a carrier acceptable to the mortgage holder, and that the mortgage holder be a named insured, that is, named in the policy as an additional beneficiary.

Overinsuring is wasteful, because property insurance policies do not pay off the face value of the policy, only the actual loss up to the "actual value" of the property. Again, the same $250,000 gallery—only now it is insured for $500,000 and you are paying a higher premium for the higher coverage. Even if the gallery is totally destroyed, you will still collect only $250,000.

There are two methods of defining "actual value" for insurance purposes. It may be defined either as the cost necessary to replace the item or as the current fair market value. Thus, the same 25-year-old gallery building may be worth only $250,000 on the real estate market, but it may cost more than $500,000 to rebuild it. It is generally more expensive to have a replacement value endorsement, though it may be well worth the difference.

The principal exception to the rule regarding valuation is life insurance. Since no one can place a precise dollar value on a hu-

man life, the purchaser of life insurance is entitled to determine how much insurance is desirable or necessary, and the entire amount is paid to the beneficiaries when the insured dies.

It is essential that all insurance policies be reviewed periodically with an insurance professional familiar with your type of business and situation. Whatever you do, don't buy a particular policy simply because it seems inexpensive. Many factors enter into the determination of premiums, including not only fine-print inclusions and exclusions of coverage, but also the insurance company's strictness in claims settlements, its financial condition, etc. The mere fact that an insurance company accepts a premium for policy coverage does not prevent it from later repudiating the policy or challenging the values stated as covered. It is a good idea to obtain appraisals which are acceptable to the insurance company when the policy is first written, as a way of reducing the likelihood of having a problem after a loss has occurred. Know exactly what you are buying. It is worth your while to shop around. The Insurance Company Institute has publications on various types of insurance available. In addition, insurance is regulated at the state level, generally by an Insurance Commissioner, whose office may be able to provide you with information about insurance companies, brokers, and agents.

Deductibles
Most insurance policies have a deductible clause. It means that the policyholder pays part of the claim, say the first $500 or 10 percent of the total, or it establishes a waiting period after which benefits go into effect. Insurance companies do this to weed out the numerous small claims which cost more in paperwork than they are worth. In return, the difference in premium costs makes it worthwhile. For example, if it costs you $50 extra in premiums to get full coverage and remove a $100 deductible, you are paying a premium rate of 50 percent on that $100 worth of insurance, which is very high.

Telling the Truth
A key ingredient of every insurance policy is that the policyholder has accurately completed the application. The statements made by you in connection with your insurance application are known as representations. The premise is that the insurance company is relying on your representations when assuming the risk and selling you insurance. If you make any material misrepresentations, one of two serious consequences can result: (1) the policy can be cancelled,

or (2) claims will be denied if the false or misleading statements are discovered when a claim is made.

For example, if you apply for fire insurance and tell the insurance company you've had no fires in the past ten years, they will assume that you take proper safety precautions and are a good risk. If you subsequently have a fire and, in the course of the investigation, the insurance company discovers that you have, in fact, had three fires in the last two years, it will refuse to pay the loss and will probably cancel your policy. You will, therefore, have wasted the money you spent on premiums. Had you disclosed your fire history, the insurance company might never have issued the policy, or might merely have set a much higher premium.

Similarly, life insurance applications must be accurately completed. If the application asks your hobbies and you are an avid skydiver, you must disclose that fact. It could affect the premiums the insurer will charge, or whether it will write a policy at all. It is better to make full disclosure, even if this will cost you more in premiums, since a policy procured through fraud or misrepresentation may be worthless.

Where to Buy Insurance

Insurance is available through three sources: independent agents, brokers, and directly from the insurance carriers through their agents.

The bulk of property insurance is written by independent agents and brokers. Since they can write insurance for a number of insurance companies, they are likely to be less biased and may be in a position to provide you with the best coverage. They are able to issue a binder on your property for a limited period of time from the moment you telephone them, and you are insured for that period of time. Since they are usually local, they can meet with you to analyze your insurance needs, and are on the spot when a claim has to be made.

A great deal of life insurance is written directly by the insurance companies through their own agents. Obviously, they sell only their own product, and are not likely to give you impartial advice on the merits and demerits of the policies issued by other companies.

Automobile and medical insurance can often be bought through the mail, without salesmen. This may save some money in premiums (since there are no commissions to pay), but it removes the personal touch and there may be some problems in obtaining payment when a claim is made. Be sure to check with your state's in-

surance commission before purchasing a mail-order policy.

Selecting an insurance broker or independent agent should be done with the same care as choosing a lawyer or an accountant. It should be a professional relationship. The stakes can be very high. Ask around. Consult other business people whose judgment you respect. You may wish to use the same agent or broker for all your insurance needs, since you are likely to have more clout when offering all your premium dollars to one person and that person is likely to be in a better position to integrate your insurance program. It may be that your life insurance agent will not be able to write casualty insurance, though the agent may be able to make some recommendations. Some insurance companies give multi-policy discounts; for example, most automobile insurers have a significant rate reduction for additional vehicles, and many will give better rates on both automobile and homeowner/renter insurance if they handle both policies.

You can send for an excellent, nontechnical booklet published by the Small Business Administration. "Insurance and Risk Management for Small Business." An "Insurance Check-list for Small Business" is available without charge from the Small Business Administration. (*See also* **Appraisal, Disability Income Insurance, Fine Arts Floater, Group Insurance, Liability Insurance, Life Insurance, Product Liability Insurance, Property Insurance, Unemployment Insurance, Workers' Compensation, Appendix C**)

INTELLECTUAL PROPERTY

Intellectual property is the collective term used to identify the ownership rights in various types of intangible property, including copyright, which protects original expression when reduced to a tangible form; patent, which protects new, useful, and non-obvious technological innovation (invention and functional design); trademark, which protects names, symbols, or logos used to identify particular goods and services; trade dress, which protects the "look and feel" of work; and trade secret, which protects any formula, pattern, or compilation of information used in one's business to obtain an advantage over one's competitors who do not know or use it. In recent years, the right of publicity has developed to enable individuals such as sports figures and actors to protect and exploit the economic value of their celebrity status. (*See also* **Copyright, Patent, Trademark, Trade Dress, Trade Secret**)

INTEREST

This word has both legal and financial meanings.

In legal terms, it means that you have some claim to certain property. For example, if you and a partner each invest $1,000 in a business, you each have a half-interest in the business. Similarly, when you sell a painting on installment and allow the purchaser to take possession of it, you retain a security interest in that painting.

In financial terms, interest is money earned in exchange for the use of money. If you think of money as a product which you rent, much as you might rent a car, the interest is the price you pay for the use of that product.

Interest rates are usually quoted on an annual basis, even if the period to which they apply is shorter. The interest rate on a retail charge account, for instance, may be quoted at 18 percent per annum; however, if your balance is $100 and you pay it off at the end of the month, you will pay only $1.50 in interest (1/12th of the annual amount, which in this case would be $18).

Maximum interest rates are often set by state law, in so-called "usury" statutes, although they vary from state to state. "Legal interest" is also defined by state and federal law; it is customarily nine percent per annum at the state level, and fluctuates at the federal level. The present trend among states is to deregulate the amount or percentage of interest that can be charged by lenders, relying instead on disclosure requirements contained in the various laws.

The financial world uses a whole host of interest terminology. For small businesses, two terms are important: simple interest and compound interest.

Simple interest is calculated on the amount of money involved in the loan, and is either paid to the lender when the principal is repaid at the end of the loan period, or is sometimes deducted from the loan in advance. It does not, itself, earn interest. This form of interest is most common when you borrow money.

Compound interest is paid on the principal plus previously earned interest. The previously earned interest, in effect, keeps increasing the principal amount, or the base upon which interest is calculated. Bank interest traditionally was calculated on a quarterly basis. With the introduction of computers, it is now usually calculated daily, so the amount on deposit grows every day and interest is paid on a higher amount each day. That explains why an annual interest rate of 6 percent will return (yield) not $6 but approximately $6.18 on every $100 deposit.

Manipulating your money to earn the best interest can be rewarding. It is wiser to put your money in a high-yield money market account than a no-interest checking account or low-interest savings account. If you will not need that money for some time, then certificates of deposit, which are customarily restricted for at least six months, would be sensible. There are a host of other options available, and you should consult with your financial advisor and/or banker to determine what specific arrangements will best serve the financial interests of your business.

The interest rate on charge accounts and credit cards can be deceptive because the monthly payment seems small. If you finance a $1,000 piece of equipment at 12 percent for one year, making monthly payments, your total finance charge will be $66.19. If you borrow the money from a bank at 8 percent, pay off the equipment in one lump sum, and repay the bank in 12 monthly installments, the finance charge amounts to only $43.86. (*See also* **Banks, Checking Accounts, Credit Cards, Loans, Mortgage**)

INVENTORY

Inventory, in its broadest sense, may be defined as an itemized list of assets. This includes, for example, your personal assets such as clothing and furniture, and your business assets such as paintings, sculptures, and the like. For purposes of this entry, only business inventory will be considered.

Artists rarely have much inventory in their possession. The cost, for example, of casting bronze sculptures is such that it is rarely incurred until a piece is sold, usually from an artist's proof. Similarly, the time necessary to complete an oil painting is so long that most successful artists will either have sold or consigned the work before beginning work on the next piece. Artists of two-dimensional works, particularly those who create prints, posters, and the like may have works in inventory.

A gallery, on the other hand, must maintain an inventory. Occasionally, the gallery will own the works in its inventory; more often, the inventory consists of work held on consignment. Most states have laws regulating the artist/dealer consignment relationship.

INVENTORY CONTROL

There is a cost associated with maintaining an inventory. This is true even if the gallery deals only in consigned works, since the gallery must pay rent, utilities, and other overhead charges which

must be spread over the cost of the inventory when sold. There are practical limitations on the quantity of inventory which can be maintained.

Keeping careful records of what goes in and out of inventory is essential to identifying when commissions are due and payable and which works sell and which don't. It is also critical for insurance purposes.

Since some jurisdictions levy inventory taxes, the dollar value of inventory may be needed to determine your inventory tax liability as well as your income tax liability. It is, therefore, a good idea to conduct a *physical inventory* at least once a year, as close to the end of the tax year as possible. That involves the actual counting of all the works in inventory and recording the count, together with the value of your basis, if any, in them; whether they are on consignment; the consignor's name; and the value of each consigned work.

To keep abreast of your inventory from day to day or month to month, a *perpetual inventory* control system is extremely useful. This need not be a complicated affair. Computer software is available for this purpose.

Why take a physical inventory if you keep a careful perpetual inventory? Experience has shown that the two almost never agree. Breakage, theft, and small errors in recordkeep-ing inevitably occur during the year. The physical inventory is the only one that comes close to 100 percent accuracy, and that's what's needed for tax purposes as well as your own business information. (*See also* **Computer Software, Consignment, Dealer, Financial Statements, Multiples, Tax**)

INVESTMENT

In some respects, every purchase or use of your energy is an investment, yet economists, accountants, and business advisers may differ on the precise definition of "investment." When you attend art school, you are investing in your future; if you are successful in your chosen career, you will realize a profit on that investment.

The money you use to acquire some form of property, whether tangible or intangible, with the expectation of a financial return is also an "investment" and this is the financial context in which the term is most commonly used. The return on investment ("ROI") takes various forms: stock dividends, an increase in the value of real estate, profits from the use of equipment, interest on loans, appreciation in value of artwork, and others.

Investments have two basic characteristics: They are generally of a long-term nature and they generally provide a reliable return at relatively low risk. It doesn't always work out that way, but that's the expectation when the investment is made.

Speculation is the antithesis of investment. Speculation can bring a high return, but at greater risk. Buying a horse is an investment; betting on it is speculation.

The quality of an investment is measured by its ROI—how much money you make on every dollar you invest. An ordinary savings account may pay 2 percent interest, or provide a 2 percent ROI. Corporate stock may yield an 8 percent dividend. A larger gallery may enable you to display and sell more artwork and increase your profit by 10 percent.

A consideration when making an investment is how readily it can be converted into cash if the need arises: *liquidity.* A savings account is easily convertible: just take the money out of the bank. A publicly traded stock is still considered relatively liquid, even though its value may fluctuate and you may not obtain the optimum return if you are forced to sell at a particular time. Used equipment is an even more difficult investment to convert into cash.

All of these factors influence whether or not you should make a particular investment, and also the rate of return. If you want to keep your cash position truly liquid, a savings account may be the best investment, even if it doesn't bring the highest return. Prudent business people will balance liquidity and ROI so that they can achieve reasonable security while fetching an adequate return. If the mortgage on your home or studio bears an interest rate of eight percent and you can obtain only a return of two percent on your savings account, your best investment might be to pay down your mortgage, assuming you have some extra money available. You should determine whether you will be in a position to retrieve some or all of the money prepaid to reduce your mortgage in the event of an emergency.

Investment decisions are complex, requiring a balancing of liquidity and return, as well as risk. Whenever contemplating an investment, you should consult your accountant, lawyer or other business adviser. (*See* **Accountant, Lawyer**)

INVESTOR (*See* **Collector, Investment**)

INVOICE

The invoice (also called a bill or bill of sale, and miscalled a statement) serves two purposes: (1) it lists in precise detail what was sold, at what prices and under what conditions, and how and where it was shipped, and (2) it is the formal request for payment.

Whether you use an elaborate printed invoice form with many duplicate copies or simply use your letterhead or a plain sheet of paper (with at least one copy), every invoice should contain the following information:

1. An invoice number. These should be numbered in sequence.
2. Your business name, address, telephone number.
3. The date of the invoice.
4. The name and address of the customer. Be sure to follow instructions if an order specifies that an invoice be directed to a particular department, such as the accounting department.
5. Where the merchandise was shipped.
6. When and how the merchandise was shipped (UPS, parcel post, F.O.B. etc.).
7. Payment terms, such as 2/10-net 30.
8. Claims limitations, such as accepting damage claims only if made within ten days of receipt of the merchandise.
9. The quantity, exact description, unit price, and total price of each item shipped.
10. The total price for all items.
11. Sales taxes, if any.
12. Shipping charges, if any.
13. The grand total.

The original copy of the invoice is sent to the customer. You keep at least one copy in numerical order in an appropriate file. Note on your copy of the invoice the date you receive payment, and transfer the invoice to the paid file. This provides a quick and easy check on what invoices are outstanding and which ones are significantly past due.

If you have a large volume of business that is billed, you may want to keep two copies: one to file under unpaid or paid, the other to file in a separate folder for each account. That provides you with a handy reference on the purchasing record of each collector. You should check such files periodically.

Most galleries require a "blind" copy of the invoice to be included in the shipment as a packing slip so that the person unpack-

ing the shipment can check the shipment against the packing slip. "Blind" means that the packing slip copy of the invoice shows everything except the prices. When the shipment has been verified, the packing slip is sent to the bookkeeper as proof that the merchandise was received in good order and that payment may be made.

Where numerous copies of an invoice have to be prepared, it is usually best to get them in preprinted sets. These sets normally provide a different color for each copy and also block out the price area on the packing slip copy. They also indicate the purpose for each copy: customer copy, file copy, packing slip, etc.

Sequential numbering is essential for a variety of reasons. It makes it easy to identify the particular invoice. It enables you to match up a check with the invoice being paid. Checks from stores or other business firms almost always indicate the invoice number for which the check is drawn. If a packing slip is used, it will enable the bookkeeper to coordinate the receiving report with its outstanding invoices, and expedite payment to you.

The grand total should never reflect discounts. Mark your copy of the invoice when payment is received to indicate that the discount was appropriately taken. The cash discount policy is one you have to be tough about. If you allow 2 percent for payment within ten days, then that's it. You may wish to add a provision to the invoice stating that there will be a late charge if payments are not made within 30 days. Note that the late charge disclosure must comply with state and federal truth-in-lending laws. You should be consistent in your dealings with your customers.

The conditions you set for returns or damage claims protect you. These provisions apply equally when you receive a bill. Examine shipped merchandise right away. Read the invoice carefully to see what your claim and return privileges are, and what kind of cash discounts you're entitled to.

You should have your attorney review your invoice form before having it printed. (*See also* **Business Forms, Computer Software, F.O.B., Sales Terms and Conditions, Sales Tax, Shipping**)

JOINT VENTURE

A joint venture is a partnership for a specific or restricted purpose. For example, a bronze sculptor and a glass artist might form a joint venture to produce a collaborative work. Generally, the rules governing joint ventures are the same as those governing partnerships. (*See also* **Contract, Copyright, Corporation, Limited Liability Company, Partnership, Sole Proprietorship**)

JOURNALS (*See* **Ledgers and Journals**)

K

KEOGH PLAN (*See* **Pensions**)

L

LABOR
(*See* **Apprentices, Employees, Independent Contractors, Wages**)

LAWYER

Sometimes referred to as an "attorney-at-law," a lawyer is a professional licensed by the state to represent clients in a variety of situations. Lawyers have traditionally represented their clients in court cases, though lawyers should also be used for pre-problem counseling and document drafting. In fact, proper use of the skills of an attorney as adviser, counselor, and preparer of appropriate documents will minimize your exposure to costly and time-consuming litigation.

Some lawyers are "generalists" and will assist with everything from real estate transactions and family law to criminal representation. With the increased complexity of today's business world, however, lawyers, like other professionals, have begun to specialize. It is probably better to hire a specialist in a certain area at a higher fee than a less-expensive generalist who will have to learn the specialty at your expense.

The New York State Bar Association provides this rule of thumb: "Get a lawyer's advice whenever you run into serious problems concerning your freedom, your financial situation, your domestic affairs, or your property."

Legal matters fall into two basic classifications: civil and criminal. Civil matters concern disputes between parties, such as breach of contract, product liability, personal injury, and the like. Criminal matters concern violations of the criminal law, such as murder, theft, and forgery. Civil matters generally involve money or property, whereas criminal violations could result in the imposition of fines, penalties, or imprisonment. You should obtain representation by an attorney experienced in the appropriate area of law whenever you are involved in litigation. The one exception to this rule is small claims court, where attorneys may not represent individuals.

You should not seek legal representation only when you are

involved in litigation. Lawyers may be excellent pre-problem counselors; the wording of a long-term contract that you sign may seem plain enough to you, but do you know how a court would interpret it?

When you discuss a matter with your lawyer, do not hesitate to discuss the fee as well. Fees generally depend upon the amount of time and extent of research required, and the skills of your lawyer. On relatively common matters, such as incorporating a family business or drawing up a simple will, the time element is fairly predictable and a fee can easily be estimated. More complicated matters are less predictable. You should request an estimate of the probable cost.

Contingent fee arrangements, where the lawyer gets paid a percentage of the recovery when a case has been won, is common in personal injury matters, but almost unheard-of for business and intellectual property litigation and routine legal advice.

Communications between a lawyer and a client are confidential. Except in the case of a crime being planned, where a lawyer is under an affirmative duty of disclosure, a lawyer cannot be compelled—indeed, is not permitted—to reveal what you discuss unless you give your permission. The purpose of this rule is to allow the free exchange between the lawyer and client so that the representation can be effective. Your lawyer can help you only if he or she is aware of all facts. Be sure to tell your lawyer everything, even the sordid details.

Where Do You Find a Good Lawyer?

Since all lawyers are required to be licensed, it is a matter of finding someone in whom you can have confidence, much as you would find a doctor or any other professional in whom you place your trust. Ask your friends or business acquaintances to recommend someone they have found satisfactory. You may want to talk to several lawyers before you settle on someone. The state or local bar association will likely be able to provide you with names of attorneys who practice in specific areas, but they will not provide endorsements. If your resources are very limited, the Legal Aid Society (or its local equivalent) may be of help, although they rarely assist with business matters.

For a list of lawyers on a state-by-state basis, see Martindale-Hubbell, at most law libraries. Unfortunately, Martindale-Hubbell contains—at most—only biographical information, degrees earned, and publications by the attorney, and requires the payment of an

advertising fee which some attorneys refuse to pay. For a digest of copyright lawyers, see the Copyright Directory, published by Copyright Information Services.

For information, and possibly free legal service, with art-related legal matters, contact a Volunteer Lawyers for the Arts organization, if one exists in your state (**Appendix F**).

For a book which is intended to sensitize you to many of the legal issues which you may encounter in your art business, see Art Law in a Nutshell, 2d ed. (*See also* **Volunteer Lawyers for the Arts, Appendix B, Appendix D**)

LEASE

A lease is a contract between the owner of property and one who wishes to use it for a specified period. Like any other contract, a lease spells out the rights and responsibilities of both parties during its term. It can be for personal property (office machines, such as computers, photocopiers, etc.), vehicles, and the like, or for real property (buildings, office space, studios, etc.). Leases are almost always drawn up by the owner's (lessor's) lawyer for the owner's benefit.

Real property leases include the amount of the rent, when it is to be paid, a description of the premises to be rented, the term (length) of the lease, and so forth.

There are, however, numerous other clauses. Who is responsible for painting? What restrictions are there on remodeling? (Some leases don't even allow you to put a nail in the wall without the landlord's permission.) Who pays for utilities? What type of sign will you be allowed to use? Who will be responsible for damage to the premises and its contents? Are there common area maintenance charges? Are heat, elevator service, and access to the building provided at night and on weekends? Is the security deposit kept in a separate account for you? Does it earn interest?

It is important that you carefully inspect the premises you are renting before you sign a lease. Will the floor sustain the weight of heavy equipment if you need it for your business? Can the electric wiring carry the load of heavy duty equipment such as kilns? If it can't, whose responsibility is it to install the proper wiring, if such installation is even possible? Are there any zoning, pollution, noise or other restrictions that would affect your use of the premises?

Such an inspection should also raise other questions. Determine whether everything you see on the premises before you sign the

lease will still be there after you sign it; the previous tenant may not have removed all of his or her property. Don't take for granted, for example, that the air conditioners in the windows will stay there after you move in, or that you won't be surprised with an extra charge above the stated rent to keep them.

If the lease specifies that you pay for your own utilities such as gas, water, and electricity, determine whether there are separate meters installed for your premises and, if not, how your share it calculated.

Inspect carefully to see that everything is in good repair: water supply, radiators, bathrooms, windows, floors, ceilings. The lease should specify who is responsible for maintenance.

If you want to fix up the place by putting in walls and partitions, new wiring, light fixtures and so forth, your right to do that must be spelled out in the lease, providing only that the end result meets all legal standards such as fire and building regulations, and that it doesn't lower the value of the landlord's property or increase his or her insurance rates. The lease should also specify your rights on termination—must you restore the premises to their original condition? May you remove any fixtures which you install? Absent a provision to the contrary, all "leasehold improvements" belong to the landlord and the lessee is not entitled to compensation for them.

If the lease permits you to remodel, be certain that you do not need to obtain the landlord's permission for every dab of paint you put on the wall. If the landlord is unwilling to give carte blanche for painting without prior permission, at least try to get a provision that the landlord's permission will not be unreasonably withheld.

One area of landlord responsibility that the tenant should rarely assume is the basic structural condition of the premises, or other conditions required by law. If the roof leaks, the landlord should fix it. If the fire department issues a notice of structural violation, it is the landlord's responsibility to fix, unless the tenant created the violation. The lease should be very specific on this subject.

Verbal promises by the landlord mean nothing. Get it in writing in the lease.

Artists have found themselves in trouble when they opened studios in premises leased for residential purposes. If the lease or the zoning regulations prohibit such activities, you can run into difficulties on several counts. The landlord may want more rent for the commercial use of the space; neighbors may complain if extensive noise, odor, refuse, or other objectionable conditions are associated

with the improper use of the premises; you may be fined by the municipality for zoning violations and not permitted to use the space for the purpose you desire. Some jurisdictions have enacted special laws permitting artists to live and work in the same space. You should determine whether such a law exists in your jurisdiction and whether it would be applicable to your situation.

The end of the lease is as important as the beginning. Virtually every lease includes a clause that the tenants leave the premises in the same condition as when they moved in. The deposit required by most landlords is one way in which they make sure that you pay for repairs which have to be made after you move out to restore the place to its original condition.

A sub-lease or assignment clause is also important. If you find it necessary to move out before the lease expires, do you have the right to find a new tenant to fill the remaining term of your lease? If you have that right, does the landlord have the right of approval of the new tenant? Can the landlord, for example, determine that a certain type of tenant is undesirable?

Finally we come to the renewal clause. Suppose you sign a two-year lease with an option to renew. Does it specify at what rent you renew? When do you have to exercise the option? What happens if you don't exercise the option? In some states, the law assumes that you have renewed the lease and all its terms if you have not notified the landlord otherwise in writing by a certain date.

In other cases, your lease may have expired, but you remain on a month-to-month basis. In the absence of a lease at that time, the landlord can charge you an increased amount, unless the original lease specifies otherwise.

In personal property leases, as for vehicles, office equipment, and the like, the issues are similar and you should be diligent in shopping for the best possible arrangement. Determine monthly payments, the lease period, responsibility for maintenance, early termination penalties, lease-purchase options, and the like. Tax benefits may be available for leasing.

The basic purpose here is to alert you to the necessity of reading all the terms very carefully, taking nothing for granted, assuming nothing that isn't put down in writing, and taking the time to think carefully about the implications of everything you sign. There are no standard terms; everything is negotiable. Be wary of the so-called "standard lease," since it will always benefit the lessor. You should also beware of so-called "master leases" which are common

in large real property units, such as shopping centers and malls.

Before you sign a commercial lease, you should consult a lawyer. Tell him or her what your requirements are, what you want to do and don't want to do, and let the lawyer analyze the contract to make sure that your interests are properly protected. (*See also* **Equipment, Lawyer, Tax, Zoning**)

LEGALITY (*See* **Lawyer**)

LETTER OF CREDIT

A letter of credit is a document in which a bank notifies its agent or correspondent bank that funds are to be paid immediately to the person named in the letter upon proper identification and, if appropriate, evidence that the purpose for which the funds are to be paid has been accomplished; e.g., a bill of lading to prove that shipment was made.

This document replaces the use of a check for payment, and makes money immediately available. In effect, it establishes a credit line for the recipient upon which he or she can draw as soon as the specifications of the letter of credit are carried out. Letters of credit are used primarily for very large transactions, as well as for long-distance and international transactions. (*See also* **Uniform Commercial Code**)

LIABILITIES (*See* **Financial Statements/Balance Sheet**)

LIABILITY INSURANCE

Any injury for which you or your business may be responsible can be covered by liability insurance. There are several forms of liability insurance:

1. *Personal Liability.* This can protect you as an individual; for example, if your dog bites the mailman or someone slips on the ice in front of your house.

2. *Public Liability.* This protects you as a business owner; for example, if a customer suffers an injury while visiting your studio or gallery.

3. *Product Liability.* This protects you if a defect in artwork created or sold by you causes injury.

Some artists and gallery owners buy specific short-term liability insurance to cover themselves at a show or exhibit in case a visitor is injured at their booth. (*See also* **Insurance, Product Liability Insurance**)

LICENSE

A license is the right for one to engage in some regulated activity. For example, states grant drivers' licenses, and municipalities grant business licenses and licenses to pet owners. In these instances, the purpose of the license is, presumably, to protect the public from certain dangerous activities or unscrupulous practices and/or to collect revenue.

A form of license applicable to the art business is the private license agreement. As with a license under government authority, a private license grants permission to engage in a certain activity. Here, though, the activity is usually the use for commercial purposes of the owner's (licensor's) rights in some creative work, known as "intellectual property." Intellectual property includes trademarks, patents, and copyrights, as well as trade secrets and trade dress.

For example, you have created a particular image in an oil painting, using a secret, unique process and marketed the work under your name. Under the copyright laws, you own a copyright in the image as soon as your original creation is "fixed in any tangible medium of expression." Your secret unique process is a trade secret (and might be patentable), and your name is your trademark. Soon thereafter, a gallery owner is captivated by your painting and wishes to sell limited edition prints of it. One option is for you to create the prints yourself. This may mean acquiring more space or equipment or hiring a master printer. A second option is for you to privately contract for the printing.

A further option is to allow the gallery to have the prints created. In this case, you will grant the gallery a license to reproduce your protected intellectual property. The license agreement may be fairly brief or quite detailed and lengthy, depending on which rights and the scope of each you are licensing, numbers and types of products, size of anticipated market, duration, and many other factors. For example, you may license the use of your design (copyright), your name (trademark), the secret formula and techniques you developed to create the image (trade secret), and perhaps your distinctive style (trade dress).

Other factors that you should consider and clearly specify in the license agreement, and this is by no means an exhaustive list, include: the licensee's territory, sublicensing and assign-ment rights and rights in derivative products, nondisclosure provisions to protect your trade secrets, amounts and timing of royalties and other

payments, whether royalties are based on "net" or "gross" proceeds, auditing provisions, quality control measures, termination provisions, and the like. For example, can the gallery market the prints throughout the world, or only in specific regions or countries? Can the gallery sublicense your design for use on calendars? If so, how will you get paid and will you have access to the books of the calendar publisher? To the gallery's books? How frequently are the books audited and who pays for the audit? If the gallery inadvertently (or purposely) discloses your trade secrets, are you entitled to damages? What controls do you have to ensure that the gallery continues to produce quality products under your trademark? Do you or the gallery have the right to terminate the license, and under what conditions? For cause (i.e., poor quality, lagging sales, non-payment, etc.)? At will? Automatically on a specified date?

Production of a few dozen prints may not justify the complexity and expense of such a license agreement. When a new product (such as images on apparel, toys, etc.) shows early signs of success, however, particularly if it can be produced in quantities responsive to the demand, licensing may provide an avenue to meet that response and to reap big personal rewards, even though you may be sharing the success with a distributor (who may manufacture the product or pay for manufacture).

As with any agreement or transaction in which you must put at risk significant property rights, a condition which certainly may exist in the licensing-agreement context, appropriate legal and financial advice should be obtained before you enter into the agreement or incur such risk. (*See also* **Copyright, Intellectual Property, Patent, Trade Dress, Trademark, Trade Secret**)

LIEN

A lien is a legal device by which one person (or other entity: bank, IRS, etc.) places a claim or encumbrance on the property of another to secure payment of a debt or obligation. If the debt is not paid, the lien can be foreclosed, or the property sold for the benefit of the creditor. In that respect, it is similar to a mortgage.

Here are two types of lien:

1. *Mechanic's Lien.* If you hire a carpenter to erect an addition to your studio, and a plumber to connect the pipes for the new sink, and then you don't pay them, they can file a lien against your property in the appropriate government office if they complied with the state lien laws. A landlord may find that a lien has been placed

on the property if a tenant contracts for work to be done on the rented premises and doesn't pay for it. A mechanic's lien usually takes precedence over all other encumbrances against the property, including a mortgage but excluding tax liens.

2. *Judgment Lien.* If someone sues you and wins a judgment for damages, they can also place a lien on your property, even though the cause of the lawsuit is totally unrelated to the property (unlike a mortgage or a mechanic's lien). The same procedure and the same results apply as in a mechanic's lien.

Liens fall into two general categories: possessory and non-possessory. In the case of a possessory lien, such as a mechanic's lien, an auto mechanic may retain possession of your vehicle until he is paid for the work he performed on it. In the case of a non-possessory lien, perfection is accomplished by filing a document evidencing the lien to the appropriate government office. Article 9 of the Uniform Commercial Code ("UCC") provides the procedure for perfecting a security interest in order to protect a lien. (*See also* **Mortgage, Uniform Commercial Code**)

LIFE INSURANCE

Life insurance is actually survivors' insurance. Life insurance is not based on the same kind of risk as property insurance. The risk to the insurance company is in how soon death will occur. Premiums are related to risk. If you are 20 years old and in good health, the probability of your dying anytime soon is substantially less than if you are 80. Statisticians (called actuaries in the insurance world) have figured out those probabilities, and have calculated the premiums so that, on the average, your life insurance is fully paid by the time you die.

Life insurance differs from property insurance in several other important respects:

1. The amount of coverage is not related to the value of the insured item since no dollar value can be placed on a human life. Everyone can choose his or her own dollar value in terms of how much money becomes available to the beneficiaries and what the premium payments are.

2. Most insurance policies have two parties: the insured and the insurance company. Life insurance has a third one: the beneficiary. The insured usually has the right to change beneficiaries at any time through proper notice to the insurance company. There are exceptions, such as a business which carries life insurance on a key em-

ployee, with the business as the beneficiary. There, the insured employee cannot change the beneficiary.

3. Most life insurance policies cannot be cancelled by the insurance company after a stated period of time, generally two years, except when the premiums are not paid or misrepresentations were made as to age or other important factors at the time the policy was issued.

4. Whole-life insurance policies have a cash value which increases over the years. This cash value belongs to and is paid to the insured if the policy is canceled or lapses for nonpayment of premiums. The cash value can also be borrowed by the insured. If a loan is outstanding at the time the insured dies, the loan is subtracted from the benefits and the balance is then paid to the beneficiaries.

5. Most whole-life insurance policies pay annual dividends based on the cash value of the policy and the earnings of the insurance company. They, therefore, represent not only protection, but also investment.

There are literally dozens of varieties of life insurance, but they fall into four major categories: ordinary (straight), limited payment, endowment, and term.

Ordinary (Straight) Whole Life is a policy on which the premiums remain constant over the life of the policy (i.e., the life of the insured) or the insured reaching age 100, and the face value of the policy is paid to the beneficiaries at the death of the insured.

Limited Payment is a whole life policy under which premium payments are made for a specified period. Thereafter, the premiums stop, but the policy remains in full force and payable to the beneficiaries at the death of the insured. It is more expensive than ordinary life in terms of the individual premium payments, but may be less expensive in terms of total premiums paid, especially if the insured is very young when the policy goes into effect.

Endowment policies are really savings plans with life insurance added (or vice versa). You pay premiums for a stated period of years. At the end of that time, if you are still alive, you are your own beneficiary. The face value of the policy is paid to you. If you have died in the meantime, your beneficiaries collect.

Term insurance is pure life insurance for a specified period of time, generally no more than five or ten years (although some policies provide guaranteed renewal for longer periods). Premiums are commonly constant for a specified period, usually five or ten years. Then coverage ends. Term policies have no cash or loan value, but

their premium rates are generally lower than those of other types of life insurance. Term insurance is used primarily to protect unusually heavy responsibilities during a limited period of time. For example, if you have teenagers, a five- or ten-year term policy can make sure the money is available to get them through college in case you're not around to pay the tuition. Mortgage insurance is, in effect, a form of term insurance on the life of the mortgagor (i.e., borrower) for the unexpired portion of the mortgage. If you die before the mortgage is paid off, the insurance policy pays the rest. There are no other benefits. The premiums for this type of insurance are constant throughout the entire term of the coverage, but the benefits decrease as the mortgage is paid off.

Adjustable Universal Life insurance, commonly known as "universal life," is a "bundled" contract; that is, a term life insurance policy combined ("bundled") with an investment fund.

Life insurance policies cannot be bought in the names of other people unless there is an insurable interest. A husband and wife can insure each other, and so can two business partners. A corporation can insure the lives of its executives, and a basketball team can insure the lives of its players. In all these instances there would be a demonstrable loss if the insured dies, and, therefore, an insurable interest.

Unlike property insurance, where the insurable interest must exist both when the policy is issued and when the claim is made, in life insurance that interest must exist only when the policy is issued. It becomes important, therefore, to examine your life insurance policies periodically to see if the beneficiary should be changed. Such instances occur when the beneficiary dies before you do, when there's a divorce, when a partnership is dissolved, or whenever some other reason for which the beneficiary was named ceases to exist. (*See also* **Group Insurance, Insurance**)

LIMITATIONS (*See* **Statute of Limitations**)

LIMITED EDITION

Limited edition is a term used to define the self-imposed limitation on the number of works of art bearing the same image. It includes limited edition prints and sculptures.

Limited edition prints may be created either completely by hand, that is, hand-pulled from handmade plates, such as wood blocks, metal etchings, or mylar sheets, or created by a photome-

chanical process. Only those prints which are fully created by hand are considered "fine art" for purposes of customs duty exemptions. When registering the image for copyright purpo-ses, if the edition is limited to 300 or fewer, it is considered "fine art" for the copyright deposit requirements. The Visual Artists Rights Act of 1990 ("VARA") covers limited edition prints of 200 or fewer which are signed and consecutively numbered. Because of the potential abuses which may arise when dealing with multiple images, most states have enacted laws requiring that the sale of limited edition prints be accompanied by certain prescribed disclosures.

Sculpture may also be created in limited editions. For customs purposes, only the first 12 pieces in any edition are exempt from customs duty as "fine art." The copyright law does not restrict the number of pieces in an edition. For purposes of VARA, however, the same limitation applies to sculpture as is applied to prints. Editioned sculpture is commonly cast in bronze, using the "lost wax" process, or in less expensive materials, such as "cold cast" bronze, which is actually a form of epoxy and not metal. Several states have extended the limited edition print laws to cover sculpture, while others have enacted special legislation for the purpose of requiring certain disclosures when selling editioned sculpture. (*See also* **Copyright, Customs, Visual Artists Rights Act, Appendix A**)

LIMITED LIABILITY COMPANY

Limited liability company ("LLC") is a relatively new business form which affords the owners the ability to limit their personal liability for business activities to their investment in the business while enjoying the tax treatment accorded unincorporated businesses; that is, the limited liability company is not a taxable entity. S-corporations afford the same liability limitation, though the tax treatment is not as beneficial as that afforded LLCs, and S-corporations have certain other technical limitations not imposed on LLCs. These include (1) there may no more than 35 human shareholders in an S-corporation, who must be American citizens, and (2) there may be only one class of stock in an S-corporation.

Since LLCs appear to be more desirable for many businesses, laws permitting their creation have been adopted by 35 states, and it is expected that most, if not all, other states will have enacted legislation by the end of the next legislative sessions. Three states which have not enacted their own limited liability company statutes

allow LLCs created elsewhere to register and conduct business in those states. You should consult with an experienced business lawyer to determine whether your state has enacted such legislation and whether this business form would be more advantageous for your business. (*See also* **Corporation, Partnership**)

LITHOGRAPHY (*See* **Prints**)

LOANS

There are a variety of types of loans. One kind of loan is obtaining money from another, typically for a price, which must be repaid. Another type involves lending tangible property to another, such as artwork to a museum.

Money loans can come from a variety of sources: friends and relatives who have confidence in you or your artistic skill, your own life insurance policies (if they have loan values), and lending institutions such as banks, credit unions, and the like. Even the credit extended by your suppliers is, in effect, a form of loan. The Small Business Administration is prohibited by its charter from lending money to anyone engaged in the art business, since it is felt by Congress that First Amendment rights of free speech and expression may be affected.

Loans should be distinguished from capital investments. Unlike loans, equity is repaid only if and when the business is dissolved. Equity serves as the basis on which the investor is paid a share of the profits, which, in C corporations, are known as dividends. While interest on a loan is required to be paid, dividends are customarily granted only at the discretion of a corporation's or limited liability company's governing board. For partnerships or other unincorporated for-profit associations, profit is distributed in accordance with the express agreement of the parties or, if there is no agreement, under the partnership statutes, equally to all partners.

The basic characteristics of a loan are that it must be repaid at some specified time, or in periodic installments, and that interest is charged for the use of the money.

Before making a loan, a potential lender will evaluate the likelihood of being repaid. This involves a number of questions. A lender will want to know why you need the money, what you plan to do with it, how and when the loan will be repaid, what your credit rating is, whether you or someone else can guarantee the loan, and so forth. The answers to questions such as these may determine not

only whether the loan will be granted, but how much interest will be charged. The greater the risk, the higher the interest may be. A loan guarantor is obligated to repay the loan if the borrower defaults; it may be very risky to guarantee someone else's loan.

There are at least three basic sources of funds, other than your own:

1. *Equity:* the money which investors provide. This does not have to be repaid unless the business is dissolved. Equity is the basis on which investors share in the profits. Equity may also be raised by issuing and selling securities (stock or investment contracts) to family, friends, close associates, and even the public at large. It is imperative that you have an experienced attorney review any of these transactions in order to assist you in complying with the federal or state securities laws.

2. *Trade credit:* the terms on which you can buy supplies without paying cash at the time of the purchase. You are, in effect, borrowing money for a short term until you pay your bill.

3. *Loans:* the money provided by others with a specific understanding of how and when the loan will be repaid, including the rate of interest.

Loans fall into two basic categories:

1. *Short Term.* These are loans for a period of up to 12 months. For example: You receive an order for one of your editioned bronze sculptures, to be delivered within 60 days, with payment of $6,000 to be made by the purchaser at the time of delivery. You contact the foundry which has the mold you previously created and request it to cast the piece. The foundry requires prepayment of the $1,000 casting cost. If you don't have the $1,000 readily at hand, you can borrow it for a short term because the lender expects that you will repay the loan as soon as you have been paid for the sculpture. If the foundry is willing to allow you 60 days' credit for the $1,000 casting costs, it may also be considered a short-term lender and may either charge you interest or not give you a cash discount for this service.

2. *Long Term.* These are loans which you expect to repay over a period of time which exceeds one year, usually in monthly installments. Such loans are made for major expenditures such as the purchase of equipment or real estate.

Short-term loans can often be made as unsecured loans, which means that your signature and your credit reputation are sufficient. Long-term loans, on the other hand, usually require some sort of collateral or other guarantee, the pledging of some asset which the

bank can foreclose on and sell if the borrower fails to repay the loans, or a personal guaranty. The most common of these is a real estate mortgage in which the real estate itself is the collateral. Other forms of collateral may include stocks and bonds, life insurance policies, accounts receivable, and signatures of co-makers or guarantors, who agree to be personally responsible if the borrower defaults.

What the lender needs to know includes some or all of the following:

1. How solvent is your business?
2. Are your books and records up to date and in good order?
3. How much do the owner or owners take out of the business in salaries, dividends and the like?
4. How many employees do you have?
5. How much insurance coverage do you have?
6. How large are your accounts receivable?
7. How large is your inventory?
8. What are the age and value of your fixed assets such as equipment? How are they depreciated?
9. What are your plans for the future?

For a business loan, the financial statements and tax returns are the principal documents a lender usually requires, especially for long-term loans. They indicate your financial condition and your profit picture. A series of such documents covering several years will identify a pattern and indicate to the lender how much of a risk it is taking by lending the money.

It is more difficult for new enterprises to raise funds through borrowing than for established businesses, since the new venture will not have a track record.

The amount of the loan is another important consideration both for the borrower and the lender. Here, again, the borrower's financial statements are a key factor because they reveal the borrower's likely ability to repay the loan.

Another factor which lenders take into account is your willingness to invest in your own business. If you make a long-range plan for expansion which will require a loan, it is wise to be able to invest some money of your own. If you approach the potential lender and indicate that you are personally willing to commit a significant portion of the required amount, you'll probably receive much more sympathetic attention. The lender will be more inclined to take the risk if it knows that you are sharing that risk.

The limitations a lender sets on the borrower, the rate of interest it charges, and the other terms of repayment are all related to the lender's interpretation of how great a risk it is taking. That does not mean, however, that every lender interprets the same set of facts the same way. Banks are more restricted in their flexibility than unregulated lenders. Some lenders are more conservative than others. Some have had good experience with small business loans or may have a policy of encouraging small local businesses to develop. Some may consider a particular type of collateral very secure, while others may not.

All of this influences the borrower's experience with a particular lender, and if the first approach does not succeed, or if the limitations and interest rates are not acceptable, it is sensible to approach another lender.

In addition to the financial documents which most lenders want to see, a carefully thought-out business plan also contributes a great deal to a successful application. The business plan should, among other things, set forth the amount of money desired and the use of those proceeds, what the conditions in your own business and in the field in general are, how you foresee your own business growth proceeding, any sales plans, how your business is managed, and so forth. Here, again, the business plan not only provides the lender with a picture of how safe the loan might be, but how thoroughly you have considered the need for the money and how competent your own understanding of your business situation is.

Borrowing money can be quite complex. Discussion of your financial needs with your accountant or your banker often provides much valuable information on the most practical ways to solve those needs through a wide range of borrowing opportunities.

Two excellent booklets on the subject are available without charge from the Small Business Administration: "ABCs of Borrowing" and "Sound Cash Management and Borrowing." Though neither deals expressly with the art business, they are informative for small business in general.

LOANS OF ARTWORK

Loans of artworks should be memorialized in writing. Regrettably, many individuals have loaned artworks to museums or other cultural institutions and either never obtained a loan agreement, or have mislaid it. Many museums are also remiss in documenting loans; some insti-tutions have virtually no record of the provenance

of works in their collections. As a result of this problem, some states have enacted laws whereby museums and other cultural institutions can perfect their title to works in their collections which have un-known lineages. The procedure usually requires some form of public notice, as well as notification to any possible claimant.

A loan document should contain, at a minimum, a detailed de-scription of the work, name and address of the lender, term of the loan, terms and conditions of the loan (i.e., whether the work may be photographed or otherwise reproduced, who will be responsible for transportation, insurance, and the like).

In the early 1970s, the United States government agreed to act as the insurer of a collection of Chinese artifacts which were loaned to the National Gallery and other American museums for display. Later, the Government acted as the insurer for the exhibition of a portion of the King Tut collection. These and other international exhibitions were so popular and the procedure for their implemen-tation so complex that Congress enacted the Arts and Artifacts Indemnity Act, which established a mechanism for insuring domes-tic and international museum collections. The Act is administered by the organization created by the Museum Services Act, known as the Museum Services Administration. (*See also* **Banks, Business Plan, Capital, Collateral, Credit, Equity, Financial Statement, Insurance, Interest, Mortgage, Museum, Security, Trade Credit, Appendix D**)

M

MAGAZINES (*See* **Periodicals**)

MAILING LISTS

Whether you use the mails to make announcements that will bring collectors to your gallery or studio, or whether you use the mails to generate mail-order purchases of your art, the mailing list is very important if you are engaged in retail sales.

Mailing lists come from two primary sources: your own lists of collectors or prospects which you compile over the years, and lists which you can buy from list brokers.

Your own list should be the most effective. Since the quality of a list is measured by how many names on it can be expected to buy, a list of collectors or others who have seen your work can be one of your most valuable assets.

Keep that list up to date. A card file maintained in alphabetical order is convenient. Also available are a variety of software programs for use on your personal computer and specialized mailing list programs, which print mailing labels, phone lists, and so forth. Whenever you have a new customer, whenever you come across a prospect, add it to the list.

Depending on your needs, that list may be sufficient for your purposes. An invitation to an opening, for example, may produce enough attendance from just such a list.

There may, however, be occasions when you want to reach a larger audience. There are literally hundreds of specialized lists available. The usual procedure is to buy the one-time use of such a list.

There are lists of doctors, society matrons, plumbers, and business executives. Lists of business executives may even be broken down by their titles or the size of their businesses. You can buy lists of art patrons, museum trustees, members of particular organizations, and many others.

The cost depends on the nature of the list, and almost always includes a complete set of mailing labels. Costs generally run between $35 and $50 a thousand, though some are higher.

Discuss your list needs with a reliable list broker, who should be able to give good advice and obtain special lists for you. If you can't find a satisfactory list broker locally, an inquiry to any of the brokers given in Appendix F may be helpful.

If you want to make a mailing to the members of a specific organization or the subscribers of a specific publication, a direct inquiry may be appropriate. For a fee, some of them make their lists available.

You can also pool your list with others in a compatible art business. For example, a number of galleries in Portland, Oregon jointly publish and mail a monthly flyer advertising their "First Thursday" openings.

The size and nature of a list is not the only consideration, however. How "clean" a list is must also be considered. "Clean" means how up-to-date the list is. During the course of a year, people move away, or die, or change jobs. On a list which has not been used and cleaned in a year you can expect as much as 20 percent or more of undeliverable mail. That's an expensive proposition when you consider that even a simple mailing piece will cost 50¢ or more. Ask a list broker how recently a list has been used and updated. If it wasn't very recently, ask for a credit on any undeliverable returns over 5 percent. Most reputable brokers will stand behind their promises of clean lists.

Before you make a commitment to rent a large list, you may wish to test it. Suppose a broker has four lists, each of which has 10,000 names. All four look good to you, but you can never be sure. Instead of buying 40,000 names and discovering that some of the lists were not suited to your purpose, buy only a representative sample of each list at first—say 1,000 names. Now you have a mailing of 4,000 pieces which will cost much less than taking a chance on 40,000.

Careful recordkeeping is necessary when you test or when you do any sort of mail promotion. You may accomplish this by coding the responses from a particular mailing. There's too much money tied up in using the mails to skimp on tracking down the results.

What kind of response can you expect from a list? That depends on the quality of the list and the nature of the promotion.Under normal circumstances, a list user considers 2 percent a satisfactory response.In other words, if you send out 10,000 pieces, 200 sales or inquiries would be considered acceptable. A response of 10 percent or higher could be expected from an unusually good list, such as your own collector list.

All of that has to be related to costs. To send out 10,000 pieces at a total cost of $5,000, for example, and wind up with a 2-percent response or 200 attendees at an opening where nothing is sold doesn't pay for the cost of the mailing. On the other hand, if you take in $10,000 on a 2-percent response, that may leave a nice profit.

You may never see the names on the original list since some list owners will make labels available directly to your printer or mail house for mailing purposes only, but you do have the names of people who respond. Add them to your own collector list for future mailings. (*See also* **Advertising, Catalogues, Post Office**)

MANNER OF

A term used by experts to describe a work of art which is believed to be in the style of a particular artist but not by that artist and probably of a later period. (*See also* **After, Attributed to, Authenticity, Studio of, School of**)

MAQUETTE

A maquette is a small-scale model of a three-dimensional work, created as a prototype for the work. These can be sold as separate works and are frequently displayed before the actual work is completed. Since maquettes are small and easy to work with, artists frequently experiment with them in order to achieve the result ultimately desired in the actual piece. For this reason, it is quite common to use a maquette as a marketing tool when trying to sell a larger work or as a means of satisfying the purchaser in the conceptual stages when a work has been commissioned. (*See also* **Sculpture**)

MARGIN

Margin is often confused with markup, particularly since both can be expressed in percentages. Margin and markup both represent the difference between the cost of works to be sold and their selling price. This difference is a factor in determining profit.

Markup is simply a percentage figure designed to determine a selling price, whereas margin is the actual percentage realized on sales. Margin has to take into account a variety of factors which don't concern markup: unsalable pieces, unsold works, a disappointing show, loss through damage or theft, etc.

Thus, in theory, margin and markup percentages would be identical if every work produced were sold. This is rarely the case.

It may be easier to understand this difference if it is expressed in dollars. Suppose you pull 100 limited edition prints which cost $10 to produce and are marked up to sell for $100. If every last one were sold, you would realize $10,000. That would also be your margin. It is quite common, however, for some to be off-register or not have even color, rendering them unsalable. You sell only 90, grossing $9,000. You clear $8,000 after deducting the $1,000 cost of producing all 100 pieces. That's your real margin, and it is lower than the anticipated profit.

To think of markup and margin as identical can be misleading if you consider them both in terms of profit. Artists often work on two levels of margin if they sell both at wholesale to or through galleries, and also sell at retail directly to the collector. The first margin is the difference between the cost of production and the wholesale price; the second margin is the difference between the cost of production and the retail price. The two margins are not the same.

Suppose your wholesale margin covers all your overhead and wholesale profit, and is set at 50 percent (half the wholesale price). The second margin will need to cover all of the same items plus the costs of selling.

Margin must be calculated carefully. Your financial statements will reveal at what point your margin is too low to generate a profit. If your margin is set too low, the mere fact that you are making sales does not necessarily mean that you will be earning a fair return. (*See also* **Markup, Pricing**)

MARKDOWN

There may come a time when you have some works on hand which you choose to sell below your normal asking price. The process is called a "markdown."

Markdowns occur for a variety of reasons. Sometimes a work is simply overpriced when compared to similar works in the marketplace. Markdowns are occasionally made toward the end of a show to avoid the need for carting home unsold works.

Markdowns are a legitimate business practice if they are used for legitimate reasons. If your work is always marked down from the "regular" price, then there is, in truth, no regular price at all; your business becomes simply a discount or price-cutting operation. Advertising regular prices that never existed may even be deemed deceptive or fraudulent advertising. (*See also* **Markup, Pricing**)

MARKETABILITY

When the noted artist Christo designed and created his "Running Fence" in California, few challenged the artistic quality of the work, yet it was not marketable. David Smith's large metal sculptures were well-recognized for their artistic qualities, yet, because of their size, few collectors would be in a position to purchase them for private collections. Shelley Lowell's erotic art might be technically proficient but most collectors would not add it to their personal collections, particularly if the art were to be displayed in the family house.

Marketability, then, is simply whether a given work can be sold to its intended collector. One of the key factors in marketability is price, but price is, by no means, the only factor. Indeed, price is rarely the collector's first concern. Before a collector asks how much, a tentative decision has already been made that it might be nice to own the particular work. Price follows the determination of need or desire.

Before a work can be sold, it must fill a need. The need may be utilitarian, such as a chair or table; it may be emotional, such as a limited edition print; it may be prestige, such as an original Frank Stella oil painting.

The next question is how the work meets that need. This is where such intangible elements as style, design, color, shape, even current fads or trends, become important. Tastes differ among people and change from one year to the next, one generation to the next.

Artists need not compromise their artistic integrity for the sake of popular appeal but, to survive economically, it is essential to create marketable work; that is, you should be sensitive to what collectors are buying and what they're not buying (and why). If they're not buying, is it a problem of style or price, or being behind or ahead of the times?

Don't merely imitate what successful artists are doing. At most art shows, there are always a few displays that have heavier traffic than others. See what's happening there. What's being sold? What's the appeal that draws collectors to those booths? What are the prices?

Listen carefully to what's happening at your own display. What are collectors particularly interested in? What are they buying and not buying? What are they asking for? Is price a problem? Don't be shy about asking them directly what's on their mind. It's the only way you can find out what you're doing right, what you're doing wrong, and where you can improve.

Also be sensitive to popular moods and current trends. Contemporary art and the Modern movement were popular during the Kennedy years; during the Reagan years, there was a resurgence of Western art, and realism was successful. During the 1980s, art galleries became popular among the so-called "Yuppies" and continue to flourish.

No matter how marketable something is, it will never appeal to everyone. Some people like classical music, some like country music, some like rock, and some like jazz. From an economic point of view, the importance of being concerned with marketability is whether your work appeals to a sufficient number of collectors to enable you to earn a living. (*See also* **Marketing**)

MARKETING

Marketing may be characterized as the method of converting merchandise into money.

Note the word "method." Marketing is not a single activity. "Marketing" and "selling" are often used interchangeably, but selling is only one part of the marketing process. Other elements of the total marketing operation include publicity, advertising, timing, pricing, the image of the galleries or shows through which an artist sells, even so fundamental a matter as design as it relates to market acceptability. A well-designed piece, such as a land sculpture, may receive critical acclaim but not be marketable.

Marketing, then, refers to all the things that happen to an artist's work between the time it is completed in the studio and the time the ultimate collector buys it. (*See also* **Advertising, Marketability, Pricing, Publicity, Public Relations**)

MARKUP

Markup is the term used to describe the difference between the cost of a work of art and its selling price. It is usually expressed in percentages. A great deal of confusion exists in the use of this word because markup can be calculated either from the cost price or the selling price. The percentage results are different, while the dollars remain the same. Whichever method is selected, consistency is essential.

If a gallery which bases its markup on the wholesale price purchases a work of art for $1,000 and sells it for $2,000, there is a 100 percent markup. Doubling the wholesale price to arrive at the retail price is known in many industries as "keystoning." If the markup

is based on the retail price, then the gallery's markup is 50 percent.

If an artist incurs expenses of $500 in the creation of a work and wholesales the piece for $1,000, the artist's markup is 100 percent. If the artist considers the wholesale price as the starting point, then the markup is 50 percent. Markup is critical because it has to cover all costs, as well as profit. Everyone in the art business must know how much markup is needed in order to remain solvent and operate profitably. (*See also* **Margin, Markdown, Pricing**)

MATERIALS (*See* Suppliers)

MEDIA (*See* Advertising)

MEDIATION (*See* Alternative Dispute Resolution)

MERCHANDISING (*See* Marketability, Marketing)

METRIC SYSTEM

The measuring system most common in the world today is the metric system, based on units of ten. The United States is the only major industrial nation still using the so-called British system of ounces and pounds, inches and feet, pints and quarts. Most of the rest of the world, including every other industrial nation, uses the metric system because it is easier and more efficient.

The United States Congress, which has a constitutional duty to set standards of weights and measures, determined, after lengthy investigation and study, that the United States should change over to the metric system, just as Great Britain and Canada had done. A 10-year changeover period was adopted but delays, mainly in the heavy industrial sector (where the changeover will have the largest economic impact), have pushed back full metrification in the U.S. until the turn of the century.

Many trades and professions, especially the sciences, have long used the metric system. Packages appear on supermarket shelves marked in both the old weights and their metric equivalents. Weather forecasters announce the day's temperature in both Fahrenheit and Celsius (centigrade). The United States is slowly beginning to think metric.

For the American art business, this will require some rethinking of familiar terms and even some retooling of familiar sizes.

Paintings will no longer be measured by feet and inches but,

rather, by meters and centimeters. Instead of buying an ounce of silver, a artist using precious metals will buy 28 grams.

The following table indicates the method by which approximate conversions can be calculated to metric and vice versa:

	When you know:	**You can find:**	**You multiply by:**
LENGTH	inches	millimeters	25
	feet	centimeters	30
	yards	meters	0.9
	miles	kilometers	1.6
	millimeters	inches	0.04
	centimeters	inches	0.4
	meters	yards	1.1
	kilometers	miles	0.6
AREA	square inches	square centimeters	6.5
	square feet	square meters	0.09
	square yards	square meters	0.8
	square miles	square kilometers	2.6
	acres	hectares	0.4
	square centimeters	square inches	0.16
	square meters	square yards	1.2
	square kilometers	square miles	0.4
	hectares	acres	2.5
MASS	ounces	grams	28
	pounds	kilograms	0.45
	short tons	metric tons	0.9
	grams	ounces	0.035
	kilograms	pounds	2.2
	metric tons	short tons	1.1
LIQUID	ounces	milliliters	30
VOLUME	pints	liters	0.47
	quarts	liters	0.95
	gallons	liters	3.8
	milliliters	ounces	0.034
	liters	pints	2.1
	liters	quarts	1.06
	liters	gallons	0.26

Converting temperatures takes a slightly more complex formula: When you know Fahrenheit, you can find Celsius by subtracting 32 degrees, dividing by 9 and multiplying by 5. When you know Celsius, you can find Fahrenheit by dividing 5, multiplying by 9 and adding 32.

MINIMUM WAGE

The federal minimum wage law, known as the Fair Labor Standards Act, was established in the 1930s for a number of reasons:

1. To create a floor below which wages cannot fall;

2. To raise the buying power of the lowest-paid workers;

3. To create a higher standard of living; and

4. To protect employers who pay a fair wage from unfair competition by employers who would not voluntarily pay such a wage.

The law covers the entire country and was last amended in 1990. Many states also have their own minimum wage laws which apply in some areas of work not included in the federal law, such as working papers for minors. In states where both state and federal minimum wage laws exist, the higher rates and standards apply.

As of 1992, the minimum hourly wage is $5.75. With some exceptions specifically stated in the law, no one can be paid less than that.

Overtime must be paid at a rate of 1 1/2 times the employee's regular hourly rate for all hours beyond 40 hours per work week. Overtime cannot be averaged over more than one work week; in other words, if an employee works thirty-eight hours one week and forty-four hours the next, he is entitled to four hours of overtime pay for the second week. Furthermore, the work week cannot be capriciously changed from week to week (to avoid overtime obligations). A change can be made only if it is intended to be permanent.

There are several important exceptions to the minimum wage law which could affect the art business:

1. The spouse, or children under age 21, of an individual owner of an arts business need not be paid the minimum wage or overtime.

2. Employees of an individual retail store are not covered by the minimum wage or overtime requirements when all three of the following conditions exist: a) the total sales volume is less than $250,000 a year; b) at least half the annual sales volume is made within the state where the store is located; and c) 75 percent of the annual dollar sales volume is for goods that are sold directly to the ultimate consumer and are not sold for resale.

3. Executive, administrative, and professional personnel are exempt from being paid a minimum wage or overtime. The law specifically includes in the category of professional employees those in the artistic fields whose work is original and creative. Thus, an apprentice who merely cleans brushes and gessos canvasses is not a professional employee, since the work is not original or creative. An apprentice who is expected to rough out sculpture or do back-

ground painting could very well be considered professional within the meaning of the law. The important thing is not by what title the employee is known, but what the employee actually does. When there is a question of qualifying for exemptions in this category, the basis on which the Labor Department determines eligibility is outlined in the Secretary of Labor's Regulations, 29 C.F.R. Part 541.

4. Salespeople who work away from the employer's premises on a commission basis are also exempt from both the minimum wage and overtime provisions. This exemption applies only to people who sell, however, not those who do other work off the employer's premises.

5. Under certain circumstances and with special certificates from the Department of Labor, students can be employed at wage rates below the minimum on a part-time basis or during school vacations. This also applies to learners in vocational education programs.

Where piecework rates exist, they must be so constructed that an employee can, under reasonable circumstances, earn the equivalent of the minimum hourly wage.

The federal law also requires that no differentials in wages are allowed if they are based on the employee's sex, color, or other discriminatory reason. Wage differentials are permitted only when they are based on seniority, merit, or any other job-related factor.

The Labor Department is quite strict in the enforcement of this law. Failure to pay minimum wages or overtime is a federal offense. Not only can the Secretary of Labor or the employees themselves go to court to recover unpaid wages, but serious violations may also be subject to civil or criminal prosecution.

The law requires employers to keep accurate records on wages, hours, and other information. Such records must be kept for at least three years (two years for time cards, piecework tickets, etc.).

Questions on wages, overtime, hours, discrimination, and other subjects covered by the Fair Labor Standards Act can be directed by both employers and employees to any of the offices maintained throughout the country by the Wage and Hour Division of the U.S. Labor Department. The telephone book white and blue pages list them under "U.S. Government, Department of Labor, Employment Standards Administration." (*See also* **Apprentice, Employees, Wages)**

MODEL RELEASE (*See* **Photographs**)

MONEY ORDER

If you have a checking account, you can write your own checks. If you have a savings account, you may use cashier's checks. Regardless of whether you have a bank connection, you can obtain money orders.

Money orders are available from a variety of sources, including banks, the U.S. Post Office, American Express, and others. They are written in specific amounts and are sold to anyone with the cash to buy them. A fee may be charged, which may be based on the amount of the money order.

Money orders can be cashed, upon proper identification, at any office of the agency which issued them (e.g., any post office in the case of postal money orders), or they can be deposited like checks in a bank account. (*See also:* **Checking Account, Credit Unions**)

MORAL RIGHTS (*See* **Droit Morale**)

MORTGAGE

A mortgage is a conveyance by a borrower to the lender of a conditional title as security for the repayment of a loan, usually made for the purchase or refinancing of land and/or buildings (real property). In effect, the borrower (mortgagor) grants to the lender (mortgagee) a conditional transfer of title (ownership) to the property, even though the borrower is in possession of it and is the legal owner of it. The borrower can do anything with the property, including selling it. In the case of a sale, the loan obligation secured by the mortgage must either be paid off or transferred to the new owner. When the loan is paid off, the mortgage, by its terms, is terminated. That is, the "fee" (legal title) in the property automatically revests in (returns to) the borrower (owner).

Mortgages are usually paid off in monthly installments over a period of years. If the borrower defaults on the mortgage, there are a variety of options available to the lender, including accelerating the loan or foreclosure. If the loan is accelerated, the entire balance of principal, interest, and other charges is immediately due and payable. In the event of foreclosure, the lender may sell the property. If the property is sold for more than the amount due on the mortgage, the excess must be paid to the borrower.

Mortgage transactions, like most financial transactions, require careful consideration and examination of all the details. Important among these are the rate of interest and term of the loan. While fractional differences between interest rates may seem insignifi-

cant, the amount of money involved can be significant. Interest rates can be "fixed" or "variable." This means that the interest may fluctuate as the economy changes. The fluctuation may be based on a variety of factors, though the most common is the Consumer Price Index as determined by an identified bank. Variable rates generally have a floor, or minimum rate, though they rarely, if ever, have a ceiling.

A few other questions: does the lender allow the mortgage to be assumed by a subsequent buyer if the property is sold before the mortgage is paid off? That may be important, because an assumable mortgage makes it easier to sell a property.

What (if any) are the penalties if you are late with a payment or want to prepay the balance of the mortgage before it is due? Are you required to pay into an escrow account at the bank from which the bank pays your annual or semiannual real estate taxes, insurance premiums, etc. (but on which it pays you no interest), or can you put the money in your own savings account, earn interest, and pay the taxes and other bills yourself? Are you prohibited from giving a second mortgage?

A second mortgage (or third, fourth, etc.) is given to secure any additional loans on the property. For example: Suppose the total price of the property you want to buy is $90,000. You make a down payment of $10,000 and obtain a first mortgage loan of $80,000. You may want to remodel the property, which will cost $10,000. You may be able obtain this sum by granting a second mortgage on the property. A second mortgage can also be used to raise cash on a piece of property you already own if you have a first mortgage at a low rate of interest which you don't want to disturb by refinancing that first mortgage at a higher interest rate. Second mortgages may also be used to generate additional cash for other purposes, such as purchasing a vehicle or financing a vacation. In this case, the amount lent may be a percentage of the amount of equity the borrower has in the property; this is commonly known as a "home equity loan."

First mortgages are generally granted to a bank or other large institution for the basic financing of a property. Second mortgages are also granted to banks but there is an increasing number of non-bank lenders engaging in the second mortgage business. In the event of a foreclosure, the first mortgage has a claim ahead of the second mortgage if there are not sufficient funds to pay off both. Since the risk is greater to a second mortgagee, the interest rate on a second mortgage is generally higher than on a first, and the

term is generally shorter, usually not more than 15 years.

Banks and other lenders normally require that the property be insured against loss from fire and the like.

A loan on a piece of personal property (i.e., other than real estate), such as an automobile, is usually protected by a security interest, which is perfected by filing a UCC Financing Statement in the appropriate governmental office and otherwise complying with Article 9 of the UCC. The basic principles of payment, interest, insurance, and foreclosure apply in such mortgages, as well. (*See also* **Collateral, Interest, Lien, Loans, Uniform Commercial Code**)

MULTIPLES

This term defines works of art of which more than one piece is made from the same basic image. These would include, for example, prints, posters, and editioned sculptures. Since all the pieces are crafted by hand, each differs in some detail, however slightly, from the others. Multiple production is distinguished from mass production, in which large numbers of absolutely identical pieces are turned out by machines, even though the original design may have been created by a skilled artist.

Since there are some abuses which may result from limited edition multiples, many states have enacted laws requiring disclosure of certain information when multiples are sold. (*See also* **Artist's Proofs, Limited Edition, One-of-a-Kind, Pricing, Sculpture, Trial Proofs, Wages, Appendix A**)

MUSEUM

Museums have traditionally been scholarly institutions, collecting works of historic or artistic significance, often displaying such work for public viewing.

This approach has changed significantly in recent years with the advent of museums that not only mount a great many exhibitions and change them frequently, but which also conduct lectures, tours, demonstrations, concerts, and other activities for the public. An even more recent innovation is the actual participation by the public in museum activities, such as art classes and workshops. Most museums also operate shops in which reproductions and even original works can be rented or purchased.

While museums do acquire works from living artists, they are not a major market, though museum shops may be. Participation in temporary exhibitions and invitational museum shows can pro-

vide important exposure of an artist's work to the public. There may be little money in it (except for prizes and purchase awards, in some instances), but the prestige of having his or her work shown in a reputable museum may add considerably to an artist's selling potential.

When work is lent to a museum for exhibition purposes, a written form should clearly outline the length of time involved, who is responsible for shipping and insurance, an accurate description of the object(s) being lent, and the conditions under which the work will be exhibited. Be sure that each work has proper attribution. Such a written form should also safeguard all the owner's rights in the work, including reproduction rights.

Museums will occasionally ask artists to donate work to the museums' collections. Making such a donation is a business decision, although if the museum has an acquisition budget, the artist should certainly try to persuade the museum to purchase the work. Under the Internal Revenue Code, artists who donate their own creations may take a tax deduction only for the costs of materials involved. A few states have enacted tax laws which provide artists with greater incentives, by allowing greater deductions for state tax purposes; i.e., fair market value. These states are Oregon, Maryland, Arkansas, Michigan, and Kansas.

Since there is some prestige for an artist having work in a museum collection, donations should be thought of as a form of promotion rather than for immediate economic rewards.

If an artist makes such a contribution, he or she must be sure that the conditions are specified in writing, especially whether the museum has the right to put the piece in storage or to sell it, or whether it must be returned if there is no further interest in exhibiting it.

Museums are engaged in many business activities. It is, therefore, important for the institution to act in a businesslike manner. For an excellent periodical discussing the business issues which are important to cultural institutions, see *The Cultural Business Times* (Appendix D). (*See also* **Advertising, Charitable Contribution, Loan of Artwork, Publicity, Tax, Unrelated Business Income, Appendix B, Appendix D**)

N

NATIONAL ENDOWMENT FOR THE ARTS

The National Endowment for the Arts ("NEA") is an independent agency of the federal government created by Congress to encourage and support American art and artists. It pursues its mission by awarding grants to individuals and organizations concerned with the arts throughout the United States.

The Endowment describes its mission thus: "To foster the excellence, diversity and vitality of the arts in the United States; and to help broaden the availability and appreciation of such excellence, diversity and vitality."

There is a specific program for visual arts, as well as a separate program for museums. Grants are available in numerous categories. Some grants are made to non-profit organizations on a matching fund basis, some are made directly to individual artists.

Deadlines for grant applications occur on different dates for different grants. Specific details about each grant are spelled out in the Endowment's "Guide to the NEA." (*See also* **Government Activities, Grants, Appendix B, Appendix D**)

NATIVE AMERICAN GRAVES PROTECTION AND REPATRIATION ACT

In response to pressure by Native Americans for the return of human remains and other cultural properties, the Smithsonian Institution was required, as part of the National Museum of the American Indian Act, to cooperate and make the appropriate returns. Subsequently, in 1990, Congress passed the Native American Graves Protection and Repatriation Act, which carried the Smithsonian policies further. Under the Act, human remains and associated funerary objects must be returned by anyone possessing them to the appropriate tribe or lineal descendent or group who prove by a preponderance of the evidence, that they are culturally affiliated with the remains and associated funerary objects. The legislation also categorized Native American "cultural items": funerary objects, sacred objects, and cultural patrimony. Museums and pub-

licly-funded universities are required to inventory their collections and make these inventories available to Native Americans for inspection. Certain items are subject to repatriation by the appropriate tribe. The Act also restricts the trade of artifacts excavated from tribal or public lands after the effective date of the law and limits access to Indian sites. (*See also* **Endangered Species, Treaty**)

NET

When this word precedes another word, such as price, profit, income, worth, or weight, it means that deductions have been taken and that the described subject is free and clear.

When used as a verb, it usually indicates the means of achieving a final, true income or profit, after all expenses and taxes have been deducted from the selling price, as in "I should net $100 on each of these prints."

There is a great danger in not precisely defining this term. In a leading case, author Art Buchwald charged that "net profit," as used in his movie arrangement for Coming to America, inappropriately entitled the production company to deduct from its gross receipts such items as payments on future movie deals, overhead, meals, entertainment expenses, and a vast array of what he characterized as frivolous charges. The court agreed with Mr. Buchwald and criticized the practice. This case underscores the importance of meticulously defining the items which may be deducted from "gross" to arrive at "net." In addition, net income should be distinguished from net profit.

The opposite of net is gross. (*See also* **Accounting, Financial Statements, Gross**)

NET PRICE

The price after allowing for discounts. If a gallery offers to sell a print to the public for $100 but sells to another gallery at a 10 percent discount, the net price to the selling gallery is $90. (*See also* **Discounts**)

NON-PROFIT ORGANIZATION

A non-profit, or not-for-profit, organization is created for the purpose of serving the public. It may be incorporated under the state non-profit corporation code or it can be an unincorporated association. It may or may not be tax-exempt. If a non-profit organization desires tax-exempt status, it must apply to the Internal Revenue

Service for a ruling on its eligibility. The IRS evaluation can take some time. The organization may also have to qualify for tax exemption under the state tax laws. Only organizations which are characterized by the IRS as tax-exempt under Section 501(c)(3) of the Internal Revenue Code may entitle donors to take charitable deductions for donations. Most museums, arts commissions, and art schools are qualified as tax-exempt under both federal and state tax laws. Before making a donation to such an organization, you should determine whether it, in fact, has achieved this status. (*See also* **Charitable Contribution, Corporation, Museum, Tax, Unrelated Business Income**)

O

OBSCENITY

The United States Supreme Court has defined "obscenity" as relating to "works which depict or describe sexual conduct" and developed a test for determining whether a work is legally obscene. The test, known as the "Miller test," requires a determination of:

(a) Whether the average person applying contemporary community standards would find that the work, taken as a whole, appeals to the prurient interest . . .,

(b) whether the works depict or describe, in a patently offensive way, sexual conduct specifically defined by the applicable state law, and

(c) whether the work, taken as a whole, lacks serious literary, artistic, political, or scientific value.

The court also stated "that sex and obscenity are not synonymous, and a reviewing court must, of necessity, look at the context of the materials, as well as its content."

A work of art, even erotic art, is not necessarily obscene. The determination of the work's character will depend on a host of other factors, and will be on a case-by-case basis. Unfortunately, the characterization is quite complex and will, of necessity, occur after the work has been completed. An artist choosing to create erotic art should seek the advice of an experienced art lawyer before marketing the work. Exposing the work to the public could result in criminal liability if it is ultimately determined that the work is obscene.

Obscenity may also refer to lewd or disgusting language or behavior, which may not result in criminal liability yet may subject the perpetrator to ostracism or social censure. (*See also* **Performance Art, Pornography**)

ONE-OF-A-KIND

One-of-a-kind means exactly that! There is no other object like it, not even a second copy by the same artist. This may be achieved

in fine art photography by manipulating the negative to produce a certain unique effect in the print. Likewise, computer-generated art may have unique characteristics, depending on a variety of factors.

A representation by the artist that the work is unique has been held to be enforceable when it turns out not to have been true. This is because unique works of art tend to have higher values than multiples created by the same artist. An Otsuka original, for example, is almost certainly worth more than an Otsuka multiple, even of comparable size and complexity. (*See also* **Multiples**)

ORDER (*See* **Commission**)

ORGANIZATIONS (*See* **Appendix B**)

OUTSTANDING CHECK
Any check which you have written but which has not yet been paid by your bank is an outstanding check. Outstanding checks have to be calculated in the monthly reconciliation of the bank statement, and should be closely monitored. If a check is outstanding for an unusually long time, it is wise to find out why it has not been cashed. Perhaps it was lost or stolen, in which case a stop payment order should be issued and a new check written. (*See also* **Bank Statement**)

P

PACKING

If your work is to be transported for any distance, either for exhibition or delivery to a purchaser, it is important to have the work properly packed. Fortunately, modern technology has provided a great variety of excellent packaging materials. While many of these materials solve packing problems, they may contribute to environmental problems, to which many artists are sensitive.

Bubble paper is one of the most economical and most versatile for protection against shock but, because it is made of plastic, it is not environmentally sound. It may be recyclable but the problem will ultimately surface, and many people do not recycle. Shredded or crumpled paper, and various types of paper or plastic padding, are also readily available. Again, the plastic raises environmental issues.

But breakage is not the only concern. Some objects must be protected against moisture, others from extremes in temperature. The construction of the outer package should be related to the weight of the content, so, for example, a heavy sculpture is not shipped in a light corrugated container.

It is best to wrap breakable objects securely, fill the insides of cavities or hollow pieces with crumpled paper, wrap all pieces separately, protect exterior protuberances, and pack in small boxes which are then packed into larger shipping crates.

Items which need protection against moisture, such as prints, should be rolled in rigid tubes which conform to the width of the piece so that there is no shifting inside the tube during transit.

If you ship a number of breakable items in one crate, observing a few simple suggestions will go a long way toward reducing breakage:

1. Wrap all items individually in paper at least two layers thick.

2. Place at least three inches of crumpled paper or other cushioning material, such as excelsior, on the bottom of the crate.

3. Place larger or heavier items on the bottom of the crate.

4. Cushion well between layers. If the pieces are fairly heavy

and have to be packed in the same crate, corrugated dividers are advisable between the pieces, in addition to cushioning material.

5. Start packing from the outside edge of the box and continue filling toward the center.

6. Flat works should be packed on their edges. Never place them flat.

7. If only one item is being packed, place it in the center of the crate with cushioning under, over, and around it.

8. Fill the crate to within three inches of the top, then fill the last few inches with paper or other cushioning material.

9. Mark the outside of any crate containing breakables "FRAG-ILE" and identify "This Side Up" and "Other Side Up."

Every package should contain a packing slip. The packing slip can be enclosed inside the package, or preferably, fastened securely to the outside in a separate envelope prominently marked "Packing Slip Enclosed."

An excellent source of information is the United Parcel Service, which has done considerable research into the subject and has various ideas and suggestions in print for its customers.

Many artists and galleries use the services of professional art packers, who devote the time and money necessary to keeping up with the latest developments in materials and techniques. In addition, they are responsible if a problem should arise. The expense of using a professional may appear high but, in fact, not having to deal with damaged work and the enhancement of your reputation by your care in transporting valuable art may far outweigh the costs.

Concerned members of the art business community have been sensitive to environmental issues and have substituted so-called "environmentally sound" packing materials. Real popcorn, which is biodegradable and may be consumed by birds, may serve as a substitute for plastic popcorn or peanuts. Excelsior (finely shredded wood) may be preferable to plastic bubble paper. Using recycled material, where possible, is recommended. The financial cost of natural or recycled material may be slightly higher than synthetics but the environmental savings may well justify the difference. (*See also* **Invoice, Shipping**)

PARTNERSHIP

When two or more people own a business, it can be organized as a partnership. This requires an agreement between the parties. It should be written, but can be oral or even implied by their dealings.

The big danger in a partnership is that each partner has full power to contract debts for the partnership and each partner is personally liable for those debts, regardless of which partner incurred them. If the business goes under, the creditors can collect not only from the assets of the business but also from each partner's personal income and assets such as savings, homes, cars, etc.

It is important to avoid becoming partners by accident. The laws of many states interpret a close business relationship in which two or more people agree to work together as equivalent to a partnership. The absence of a written agreement doesn't make the relationship any less binding. Any relationship of this nature should be set forth in writing so that an unintentional partnership is not created.

The Uniform Partnership Act has been adopted in some form by almost every state. This law establishes certain presumptions which will apply to a partnership unless the parties agree otherwise. There is only one area in which the parties cannot affect their own arrangements; that is, with respect to the rights of creditors. Some of the presumptions may present the partners with shocking results; for example, the statute provides that, unless the parties agree otherwise, there is a presumption that they will share equally in profits and losses. This is true even if one partner's contribution of capital and on-going participation is much greater than that of the other partner(s). There is also a presumption that no partner is to be compensated for work performed, unless there is a specific agreement to the contrary. The only compensation to which a partner is entitled without a specific arrangement is the annual share of profits.

When a partnership is established, it is best to have an agreement describing each partner's participation — for example, how much of a share each partner has, whether they are active or inactive (silent) partners, and what happens if one partner leaves. If one partner dies, for example, the law provides that the partnership is dissolved and the business may have to be liquidated, unless provisions are made in the contract for the remaining partner(s) to carry on by buying the deceased partner's share from his or her heirs. Since that may involve a sizable sum of money which often is not readily available, partners can take out insurance on each others' lives, specifying that the proceeds are to be used to pay the heirs for the deceased partner's share.

There is no formality required for the establishment of a general partnership. If you are forming a limited partnership, however,

then you must file documents evidencing the partnership with the appropriate state or local office (the Secretary of State or other state office and, in addition, in some states, the County Clerk or other county officer).

Whichever form of partnership you desire, it should be formed with the assistance of a skilled business lawyer after you have carefully thought through your business plan. (*See also* **Contract, Corporation, Joint Venture, Limited Liability Company, Sole Proprietorship**)

PATENT

A patent is a document issued by the government which certifies an inventor's claim to his or her invention, and protects the rights in his or her discovery. Patents cover inventions of a mechanical or utilitarian nature, as distinguished from copyright, which protects artistic creativity, or trademarks, which protect brand names.

But what exactly is an invention?

Raymond Lee, a former U.S. Patent Examiner and one of the nation's foremost authorities on patents, puts it this way: "Suppose that while preparing a batch of dye, you accidentally dropped part of your breakfast into the vat and discovered, much to your surprise, that it improved the color coverage considerably. Would that make you an inventor? Absolutely—provided you remember what it was you dropped in."

A wide variety of inventions may be eligible for patent protection. The four which are probably of most concern to artists are: mechanical, process or method, composition of materials, and design. Letters patent are issued for the first three, which are valid for 17 years and may not be renewed. Design inventions are eligible for design patent protection, which lasts for 14 years.

A *mechanical patent* is granted for an object the mechanical construction of which is new and different. A totally new device for bronze casting, for example, would be eligible for a mechanical patent.

A *process* or *method patent* is granted for new ways of producing an object. A new method of varnishing a painting, for example, could be eligible for a process or method patent.

A *composition of materials patent* is granted for a method by which existing materials are mixed or compounded to create new and different materials. This generally applies to such products as medicines, plastics, and other chemical formulations. It could also apply to a totally new mixture for silicate bronze or paints.

A *design patent* protects new and original designs or ornamentations for functional objects, not the way those objects are constructed. The design patent covers how an object looks, while the mechanical patent covers what the object does. If the object has no function at all but is purely decorative, then copyright laws apply.

For an imaginative example, we again quote Mr. Lee: "If you invented a new kind of radio, you would apply for a mechanical patent. If that radio, in addition to being new inside, also looked like a grapefruit, you would need both a mechanical patent and a design patent. If you made a conventional radio look like a grapefruit, just a design patent would suffice. If you created a grapefruit sculpture with no radio inside, it would fall under copyright."

Unlike copyright, which is quite simple to perfect, achieving patent protection is much more difficult. It requires careful documentation of your invention. Specific sketches and notes at the earliest stages of discovery, dated and witnessed, help to document your priority.

A preliminary patent search will usually determine whether someone else already holds a patent on a discovery which is the same as or similar to yours. This generally costs between $300 and $500, depending on the complexity of the search.

Once your patent application has been filed, you are entitled to claim "patent pending" on the product of your invention. This affords a certain amount of protection and establishes a claim in case someone else comes up with a similar idea later on. If you desire international protection for your invention, you must apply for a patent in every country within which you desire protection. This must be done promptly after your application for a U.S. patent is filed and, in no event, after the U.S. patent has been issued. Once letters patent have been issued, you should use "Patent No. _____" on the product

The legal work required in filing an application and prosecuting a patent is best done through a patent agent or patent attorney. The applicant is permitted to do it, but the complications are monumental. If you seek legal assistance, it must be from a lawyer who is registered to practice before the patent bar. At this point, extensive patent searches have to be conducted, drawings and specifications have to be prepared, forms have to be filled out, and filing fees have to be paid.

It is important to do this properly and speedily become someone else may file first. In addition, there is a one-year bar in patent

law; that is, if you do not file for your patent within one year of the date you first disclosed the invention to the public, you can never obtain a patent on that invention.

The costs for such legal services are rarely below $1,500 for design patents, $2,500 for mechanical patents, and can be much higher. It's worth the effort and expense if you intend to exploit your invention.

If your invention cannot be discovered by someone else after the product employing it is on the market, so-called "reverse engineering," then trade secret protection may be more beneficial than patent protection, since trade secrets may last forever or until they are independently discovered. For example, if you desire to patent a new formula for paint, which formula contains one or more catalysts not discoverable after the paint dries, trade secret protection will be appropriate.

Before you retain a patent attorney, ask about fees and what he or she will do for you. The address of the U.S. Patent Office is Washington, DC 20231. A detailed booklet, "General Information Concerning Patents," is available. (*See also* **Copyright, Intellectual Property, License, Trademark, Trade Dress, Trade Secret, Appendix D**)

PATINA

Patina is the effect produced on the surface of bronze by oxidation, either artificial or natural, usually copper green, though more modern patinas include browns, grays, moss green, etc. The term is also loosely or figuratively applied to the surface texture of old furniture, silver, or any other surface.

In recent years, foundries have used chemicals to produce the same rich patina as originally occurred naturally when bronze was exposed to the elements. In addition, some artists have begun to experiment with more exotic or multiple surface colors, achieving some interesting results.

Gilding should be distinguished from patinaing, and is occasionally used to set off a particular part of a sculpture which may or may not have been patinaed. Scientists have discovered evidence of gilding on some ancient bronzes, and some contemporary artists gild, for example, the beak and talons of an otherwise patinaed bird of prey.

PAYROLL TAX (*See* **Withholding Tax**)

PENSIONS

Self-employed artists and those who are employed by businesses without pension plans can set up their own retirement funds and gain considerable tax advantages.

1. If your business is a sole proprietorship, limited liability company, or partnership, you can each year deposit up to 15 percent (but no more than $7,500) of your self-employed income in a Keogh Plan.

2. If you are employed by a business which does not have a pension plan, you can start your own Individual Retirement Account (IRA) with up to 15 percent (maximum $2,000) of your annual salary.

3. Dividends, rents, interest, etc. are not eligible for inclusion under either the Keogh or IRA plans.

4. The money you put into your Keogh or IRA plan is not taxable in the year in which it was earned. The deposits, as well as the interest they earn, are taxable when you withdraw them. The assumption is that you will be in a lower tax bracket when you retire and can also take advantage of special retirement tax benefits then. For example, if your self-employed income this year is $20,000, and you put $3,000 into your Keogh Plan, you pay taxes on only $17,000. You are, in effect, postponing your tax obligation on the other $3,000 until you retire and presumably are in a lower tax bracket. If you are in the 28 percent bracket now, you save $840 this year.

5. You must leave the money in your Keogh Plan until you are at least 59. If you withdraw it earlier, you not only have to pay back taxes based on your tax rate in the year that you earned that money, but you'll also face stiff penalties.

6. If you die before age 59 1/2, your beneficiaries receive immediate payment. If you are permanently disabled before 59 1/2, you may receive your full amount at once, with no penalties.

7. If you have employees who work for you at least 20 hours a week and five months per year for three years, you must include them in your Keogh Plan and contribute the same percentage of their earnings as you contribute for yourself. Employees have full vested rights to all contributions made in their behalf.

How to Invest

There are a variety of ways to invest your Keogh Plan: mutual funds, annuities, bank accounts, certificates of deposit, etc. Whatever plan you choose, it must be one that is approved by the Internal Revenue Service.

If the amount each year is not substantial, you may wish to put the funds into certificates of deposit. They bear a high rate of interest and the deposits are protected. The savings institution acts as a trustee and generally charges no fee.

Talk to your lawyer, accountant, financial advisor or banker. They can give you the best advice on starting a Keogh Plan that suits your particular circumstances, or whether to start one at all. (*See* **Tax**)

PERFORMANCE ART

This is a relatively new art form in which an individual or group of individuals attempt to make a statement through their activity and the props they use. Performance artwork has included such creations as nude cavorting on stage by a former porno queen, political statements such a museum presentation of lovemaking by two lesbian lovers with video accompaniment, flag-burning, and vomit art by political activists who swallow colored material and regurgitate at certain events. Most performance art is controversial and the artists are activists. Many have unsuccessfully applied to art agencies, such as the National Endowment for the Arts ("NEA"), for grants and their rejection has been the subject of some litigation.

Performance art is protected by the First Amendment, though many of the performance artists intentionally attempt to expand the boundaries of protection by developing new and more exotic presentations. For example, the ex-porno star uses a speculum on stage and invites audience inspection. One performer challenged members of the audience to shoot him with a loaded revolver. Another invited observers to sit on the tops of ladders in a room which was later partially filled with water which was electrically charged.

Some performance art has been accused of going beyond controversy and, in fact, being illegal. For example, violating the obscenity laws or subjecting the observers to false imprison-ment. (*See also* **National Endowment for the Arts, Obscenity, Performing Arts**)

PERFORMING ARTS

Performing arts may or may not be political, but performing arts must be distinguished from the politically-charged "performance art." Performing arts include theatre, music, dance and the like. It can be documented at least as early as ancient Egyptian dance or Greek theatre, and it has evolved throughout the ages. Performing artists include actors, dancers, singers, and musicians.

The work of performing artists is, itself, transient but, through the advent of modern technology, such as film, video, and sound recording, can be preserved. The embodiment of the performance in any form, including notation, is protectible under the copyright statute. If, for example, a dance is presented spontaneously, it is not protected unless the presentation is captured in audio-visual form (such as film or video) or the movements are notated. Notated choreography is, itself, protectible. (*See also* **Copyright, Performance Art**)

PERIODICALS

Since art is a creative process, an artist's education never really stops. New ideas, new techniques, and new opportunities continue to emerge.

A great deal of information can be found in the art periodicals which are published throughout the world. Some of these are elaborate magazines with full-color illustrations, others are newspapers, some are simple but informative organizational newsletters.

Some deal with the arts in general, while others are devoted to only one medium or genre. Some are published monthly, many every other month, quite a few only four times a year. (*See also* **Appendix D**)

PETTY CASH

Proper bookkeeping and accounting methods require that all expenses be paid by check and entered on the books under the proper category.

There are always small expenses, such as local carfare or delivery tips, which are impractical or too small to warrant writing a check. A petty cash fund is established for this purpose. The petty cash fund is usually very small, typically $50 to $100.

To establish the petty cash fund, a check is drawn and cashed. The cash is kept separate from all other monies, usually in a cash box for this purpose. Whenever a small payment is made from the petty cash fund, a slip of paper ("petty cash voucher") showing the date, the amount withdrawn, its purpose, and the person making the withdrawal is placed in the petty cash container along with the remaining petty cash money. The combination of cash on hand and vouchers must always total the original amount of the fund.

When the fund reaches a certain point, generally around $20, all the vouchers are added up, and a new check is written in the

amount of the vouchers. That brings the petty cash fund back up to its original amount.

When preparing the business' financial statements, the accountant will apportion the petty cash payments into the proper expense categories.

The petty cash fund should be used only for business expenses. It should not be a substitute for a bank. Even the owner of the business must be rigorous in following the procedure established for petty cash use. (*See also* **Accounting, Financial Statements**)

PHOTOGRAPHS

Photographs record events (vacation snapshots, wedding pictures, news photographs, etc.) serve as a sales tools (advertising or catalogue illustration, publicity stills, slides of craftwork, etc.) or may, themselves, be art.

The technical aspects of photography could fill a library, though there are at least two books which are worthy of note: *Photographing Your Product* and *Photography for Artists and Craftsmen*. These books concentrate on the technical aspects of photographing art and assume a basic understanding of photography on the part of the reader. Numerous other books and manuals on photographic techniques and the use of equipment, both elementary and advanced, are available in libraries, bookshops, and photographic supply stores.

Almost everyone has handled a camera at one time or another, but there is a big difference between snapshots and photographs of works of art.

When you photograph a work of art, you can arrange all sorts of lights, backgrounds, reflectors, positions, and the like, and you can shoot the same subject over and over again with various exposures, shutter speeds, lighting arrangements, etc., until you feel fairly confident that you have the shot you want.

Photography is, itself, an art and requires a certain minimum amount of equipment: a fairly good camera and a tripod, at the very least. Flash equipment is not very useful for photographing art, since you need better light control, but sunshine will be ideal for certain effects and will work if you can't afford elaborate lighting equipment. Photographing art presents special problems, such as capturing textures in sculpture, avoiding reflection in varnished paintings, and so forth.

Some reading, some practice, and some experimentation will provide most artists with the basic skills to photograph their work.

Whether you take the pictures yourself or hire a professional photographer to do it for you (for a sales presentation or a juried show, for example), there are some basic principles.

For artwork, the most common photographs are 35mm color slides. They are comparatively inexpensive, they can be mailed easily, they can be projected so that more than one person can see them simultaneously (such as a jury), and they provide faithful color reproduction. They may also be used for registering your copyright. Slides are also very useful for museum archives.

Slides which are used for selling or jury purposes should be as simple in composition as possible so that nothing detracts from the art object. Backgrounds should be neutral (white, gray, or black) and uncluttered. Extraneous subjects should be used only if they play a key role, such as providing a comparison frame of reference. The size of a large painting may be put into proper perspective by placing a simple chair next to it.

The same basic rules apply to black-and-white or color photographs to be used for advertising or catalogue illustration. Remember that you are selling art, not fancy photographs. The illustration serves to give visual support to the selling text and the specific details which are provided through words. You want the viewer to see the object, not the photograph. Publicity Photos

The rules change a little bit with publicity pictures which you hope to have printed as news (without charge) in newspapers or magazines. Now a little human interest becomes important. Standing next to your sculpture may add drama, as well as personality. Having a photo of you presenting a work to a noted figure will add prestige.

Another form of publicity photograph is a picture of yourself creating your art, receiving an award, exhibiting at a museum. You'd be surprised what editors consider newsworthy. If the photograph shows someone doing something visually interesting, it has a good chance of appearing in print. The law of averages is at work here, too. You can't expect to see yourself in the papers every week, but if you or your publicist submits photographs to editors periodically, you're bound to increase your opportunities for having something used. This is particularly true of small-town newspapers which may not have their own staff photographer and are always on the lookout for interesting pictures to enliven their pages.

Competition being very keen among editors, it is best not to send the same photograph to several newspapers in the same town at the same time. If you've taken several pictures, you can submit

different ones to each editor, even if the subject matter is similar.

If you hope to have your photographs published in a newspaper or other two-color periodical, don't submit Polaroid snapshots. Avoid color slides or prints, too; they lose a lot when they are converted to black and white. Editors almost universally prefer 8"-X-10" black-and-white glossies, and it is wise to give editors what they want. These glossies are also relatively inexpensive to reproduce in quantity. Identification

Be certain that all photographs are properly identified. Write your name and address on the cardboard frame of every slide and on the back of every print. Use a soft pencil on the back of prints; ball-point pens press through to spoil the image. Alternatives are rubber stamps or adhesive labels.

Slides that are submitted for selling purposes should be coded to the price list or whatever other information you send along.

Publicity photographs must have a caption securely attached. The best way to do this is to type the caption on a piece of paper with two or three inches of blank space at the top. Then tape the top of the sheet to the back of the photograph so that the caption sticks out below the photo. For mailing purposes, you fold the part that sticks out over the front of the picture. When the editor opens it, he or she doesn't have to turn the picture over to see what it's all about. Be sure the caption also includes your name, address, and phone number so that it can be easily identified with the accompanying press release.

Mailing

For slides, the best method is to wrap them securely and mail them in a padded envelope. If that's not possible, surround them with corrugated or chipboard protection. If it's only a few slides, two pieces of chipboard in an envelope will usually do the trick, but mark the envelope "Hand Cancel" so that it doesn't go through the cancelling machines at the post office.

Prints should always be sent in an envelope large enough to hold them without folding, and backed with a piece of chipboard. Mark the front of the envelope "Do Not Bend." Address the envelope before you insert the photos to avoid possible damage from the pressure of a ball-point pen.

If you want your slides or prints returned, be sure to enclose a self-addressed, stamped envelope of the proper size and with the proper postage.

Model Release

If an individual is recognizable in any photograph that is used for commercial purposes, it is necessary to obtain a model release, even if it's your best friend or someone who works for you. If the model is a child, get a release signed by the parent or guardian. The best time to have a release signed is at the time the picture is taken. True, this can get ticklish at times, but you can always say that your lawyer or your printer told you to get a release. If someone refuses to sign a release, don't use the picture under any circumstances. You'd only be inviting trouble.

The model release (a form available at major photographic supply stores or in a number of the books listed in Appendix D) is the legal means by which an individual whose likeness appears in a photograph gives permission for the photographer or anyone claiming through the photographer to use that photograph for advertising or other commercial purposes. Such releases are not necessary for non-commercial use such as publicity photos, but most photographers consider it advisable to obtain a model release for all purposes. You never know when you might want to use the picture for advertising or other commercial purposes. (*See also* **Portfolio, Press Release, Publicity, Appendix D**)

PORNOGRAPHY

Pornography is frequently defined as including obscene work, though "pornography" appears be a narrower term and relate only to that which is obscene in the legal sense. (*See* **Performance Art, Obscenity**)

PORTFOLIO

A professional portfolio contains a presentation of your work and you. The portfolio consists of your resume, clippings, or reviews, and slides or photos of your work.

To show clippings to best advantage, cut them carefully out of the newspaper or magazine and mount them flat under two-sided acetate sheets. Do the same thing with gallery programs or other documents.

Black-and-white or color prints can also be mounted under two-sided acetate sheets. For 8" X 10" prints, 10" X 12" sheets are most suitable since they allow you to show prints either vertically or horizontally without turning the portfolio binder around.

For color slides, photo supply stores have plastic sheets which are clear on one side and frosted on the other to diffuse light. They

can accommodate a dozen 2 1/4" X 2 1/4" transparencies or twenty 35mm slides which can be easily removed for showing in a slide projector.

Arrange the slides or prints in some logical sequence, if possible, so that the person who looks at them doesn't have to jump from one idea to another.

If you plan to make a sizable number of presentations to galleries and museums, have a few of your best slides converted into color prints. It's much easier to examine them, especially if a slide projector or viewer is not readily available. Be sure it's a good shot; every defect is magnified when a poor slide or negative is enlarged.

The portfolio itself can be one or more ordinary loose-leaf binders or a more professional zippered case which has the three-ring binder feature built in. Don't skimp on this. It's the first impression a person gets of your work and your attitude.

You should keep your portfolio in a clean, safe, cool place. You should not leave it on a worktable or some potentially disastrous location. Slides and prints get dirty and warped easily. (*See also* **Architects, Photographs, Publicity, Resume**)

POST OFFICE

The government activity that touches most of us on a daily basis is the post office —officially the United States Postal Service.

Mail is transported in four basic categories (postal rates quoted are as of the date of this publication):

First Class

All handwritten or typewritten letters, bills, and other individualized material must be sent via first class mail, although almost anything else may be sent first class. First class mail is completely private and may not be opened for postal inspection.

If you move, the post office will forward first class mail to your new address at no extra charge for one year, provided you notify your old post office of your new address before you move. First class mail for which no new address is available is returned to the sender as undeliverable.

First class mail under twelve ounces generally receives air mail delivery. Over twelve ounces it is called "priority mail" and, according to the post office, receives "the fastest transportation service available."

The maximum weight for first class mail is seventy pounds; the

maximum size is 108 inches in length and girth combined. First class mail should be marked "First Class" whenever it is not of normal letter size.

First class postage for mail weighing less than thirteen ounces costs 29¢ for the first ounce, 23¢ for each additional ounce. Post cards, which are handled as first class mail, cost 19¢ each. Rates for first class mail weighing over eleven ounces (priority mail) and up to five pounds vary based on weight. Rates over five pounds and up to 70 pounds are based on weight and distance by zone. A six-pound priority mail package from New York to Philadelphia, for example, costs $5.55, to California $7.65.

Second Class

This is a special category for newspapers and periodicals, and is of little importance to artists. Second class mail is never forwarded.

Third Class

This category may be used for single pieces of printed matter or merchandise weighing less than a pound, or for large mailings of identical pieces sent under a special bulk rate.

Delivery time for third class mail is unpredictable. It has been known to take as long as three weeks to reach distant parts of the country, especially during heavy mail volume periods such as Christmas. It usually waits until everything else moves.

Third class mail is not forwarded, nor is it returned to the sender, unless it is marked "Return Postage Guaranteed" or "Forwarding and Return Postage Guaranteed." That means the sender guarantees to pay the extra postage for the extra handling. "Return Postage Guaranteed" is often used by senders of third class mail to get the undeliverable pieces back and clean up their mailing list to remove the names of people who have moved. Such mail can also be marked "Address Correction Requested," in which case the post office will provide for a nominal charge (35¢) the new address (if it has one) and you can determine whether to retain the name on your list at the new address.

The single piece rate for third class mail is the same as for first class for each of the first four ounces. Above that it becomes considerably lower. In other words, there's no point in using slower third class for pieces that weigh less than five ounces. The rate increments for heavier first and third class pieces are compared as follows:

	Third Class	First Class
to 6 ozs.	$1.21	$1.44
to 8 ozs.	1.33	1.90
to 10 ozs.	1.44	2.36
to 12 ozs.	1.56	2.82
to 14 ozs.	1.67	2.90
to 15.9 ozs.	1.79	2.90

For bulk mailings, an annual permit fee is required, in addition to a one-time application fee. The postal rates vary according to the nature of the material that is mailed, in some instances according to zone distance, and whether the mailer is a nonprofit organization or a commercial enterprise. However, third class bulk rate is the least expensive way of mailing large quantities of identical material.

Third class bulk rate mail is governed by very specific rules and regulations. If you plan to make such mailings and take advantage of the lower rate, consult your post office before you have anything printed.

Fourth Class

This is also known as parcel post, and here's where the post office has some competition from such organizations as United Parcel Service.

Rates depend on weight and distance. Special rates apply to books and some other materials. Packages sent over long distances get faster delivery by the use of priority mail or express mail, since those move by air. The cost, of course, is higher. A six-pound package mailed from New York to California costs $4.54 via fourth class mail against $7.53 via priority mail.

Fourth class mail will be forwarded (if a new address is available) if additional postage is paid by the recipient. Fourth class mail that is undeliverable will be returned to the sender if the sender pays the additional postage. This extra postage is computed on the basis of the applicable fourth class rates.

Express Mail

Express mail service is available for mailable items up to 70 pounds in weight and 108 inches in combined length and girth. The Post Office even provides pick-up service for a single fee of $4.50, regardless of the number of items per pick-up.

Express mail rates are $9.95 for letters up to eight ounces and

$13.95 up to two pounds for various Express Mail services—Post Office to addressee, Post Office to Post Office, same day airport service, or custom designed service. Consult your local Post Office for rates over two pounds and up to the seventy pound limit.

A six-pound New York to Seattle package would cost $12.70 from post office to post office, and $23.50 from post office to addressee. The minimum charge to mail even a letter anywhere in the country is $9.95 from post office to post office, $9.35 from post office to addressee.

Business Reply Mail

Mailing pieces which ask for an order or for payment of a bill often enclose a self-addressed envelope in which the recipient can send the order or the check. Experience has shown that such an envelope encourages recipients to respond. For many years, those envelopes almost always had the return postage included in the form of a business reply permit number in the upper right corner.

With the rapid increase in postage rates in recent years, more and more such reply envelopes no longer include reply postage. The envelopes are simply self-addressed, and the recipient is expected to use his or her own stamps, especially on bill payments.

However, business reply mail with return postage is still used when a mailer wants to produce a large number of replies and is willing to pay the postage to get them. The post office will supply the exact form and wording in which this permit must be shown on the reply envelope. The actual postage is paid when the postal carrier returns the reply envelopes, or through an account established at the delivering post office if the volume is large enough.

The postage for Business Reply Mail is calculated in one of two ways. If a mailer pays an annual account maintenance fee of $185, the cost per piece is 9¢ in addition to first class postage, or 38¢ for a letter, 28¢ for a post card. Mailers using the BRMAS Bar Code and 9-digit zip code pay only 2¢ in addition to first class postage. In the absence of the annual account maintenance fee, the cost is 40¢ per piece in addition to first class postage, or 69¢ for the regular letter. Anyone who expects to receive at least 700 pieces of business reply mail a year is ahead of the game by paying the $185 fee. In all cases, an annual fee of $75 must be paid for the use of a business reply permit number.

The post office performs various services for its clients in connection with the delivery of mail. Among these are:

Registered Mail. This provides insurance protection for domestic first class mail and is handled with special precautions. Rates vary according to value. The minimum $100 of insurance costs $4.50, $1,000 costs $5.25. For higher values, consult your Postmaster.

Insured Mail. This provides insurance of up to $600 for domestic third class, fourth class, and priority mail containing printed matter or merchandise. Rates range from a minimum of 75¢ for value up to $50, to $6.20 for value between $500 and $600.

Certified Mail. This provides only a receipt and record of delivery at the post office. It travels no faster than first class and provides no extra security. The fee is $1 in addition to the postage.

Return Receipt. A receipt showing when, where, and to whom the mail was delivered is available for registered, insured, or certified mail. When requested at the time of mailing it can show when and to whom it was delivered ($1), plus the address where it was delivered (add 35¢). If the return receipt is requested after mailing, it costs $6 and will show only when it was delivered and who signed for it.

C.O.D. Mail. Payment for merchandise ordered by the addressee will be collected by the post office and remitted to the sender by postal money order. The maximum amount is $600. The fees for C.O.D. service range from $2.50 to $7 and include collection of the postage and money order fee from the addressee. C.O.D. fees include insurance protection against loss or damage. C.O.D. may also be sent as registered mail.

Special Delivery. This service assures prompt delivery of mail when it arrives at the delivering post office, including Sundays and holidays. Costs range from $7.65 to $9.30, depending on weight and class. The normal special delivery charge for a letter is $7.65 in addition to the postage.

Special Handling. This service is available only for third and fourth class mail. It is difficult to determine exactly what special handling means, except perhaps that the post office will take special care not to run over the package with a truck. The fees in addition to postage are $1.80 for up to ten pounds and $2.50 for an item over ten pounds.

Money Order. If you can't send a check, you can buy a postal money order for a maximum amount of $700, which the recipient with proper identification can cash at any post office or deposit in his or her bank like a check. The fee is 75¢ for any amount up to $700.

Following are five points to observe to help speed your mail through the U.S. Postal Service:

Zoning Improvement Plan ("ZIP") Code. This identifies the precise post office to which your mail is destined. It is required for all but first class mail, and strongly recommended for first class mail as well. Every post office has a zip code directory which you can consult. Be sure your own zip code is included wherever your address is printed: on stationery, envelopes, labels, advertising, catalogues, and so forth. The Postal Service has expanded ZIP Codes to further specify the recipient location. The so-called ZIP+4 uses the standard 5-digit ZIP Code followed by a dash and four additional digits which uniquely identify the street address. For example, each house will have its own four-digit extension. Office buildings will each have their own extension but many office suites (such as a whole floor) will have a separate extension. The Postal Service maintains ZIP Code information telephone numbers through which ZIP+4 identifiers may be obtained. These telephone numbers are listed in the governmental listings of phone books.

Stampless Mail. Mail without stamps is no longer being delivered with postage due paid by the recipient. If you don't put stamps on the mail, it is returned to you. If your mail goes out without both postage and a return address, it winds up in the dead letter office.

Proper Packing. Improper packing is a major problem for the post office. Wrap all parcels carefully, and place the name and address of the recipient inside the package as an extra precaution in case the wrapping comes undone.

Clear Handwriting. Names and addresses which cannot be deciphered cause delays in the post office. Mail with undecipherable addresses winds up in the dead letter office.

Change of Address. The post office provides postcard forms on which you can notify publishers of newspapers or magazines to which you subscribe of your new address. Most publications require 30 to 60 days to change their records, and they generally request that you send the mailing label with your new address for better identification on their computerized mailing lists.

The change-of-address forms are free, except for postage. You can also use them to notify friends, relatives, department stores, insurance companies, and others who have occasion to write to you. It will get the mail to you more quickly. Unfortunately, it will get the bills to you more quickly, too. (*See also* **Freight Forwarders, Shipping, United Parcel Service**)

POSTHUMOUS

In the art business, "posthumous" refers to work which is repro-
duced or completed after the death of the artist. It applies to prints,
limited edition sculptures, posters, photography, and any other
work which is reproduced or completed after the artist's death.
Many reproductions involve creativity in their execution and
completion, so the fact that a work is posthumous is important since
the artist cannot have been involved in this aspect of the work.

The fine print disclosure laws and multiples laws require iden-
tification of posthumous work. (*See also* **Estate Planning, Mul-
tiples, Prints, Appendix A**)

PRESS RELEASE

A press release is a document issued for the purpose of disseminating
information to the media. The format is traditional and should be used.

1. A press release should always be typed, double-spaced, on
one side of the sheet only. If the release runs to more than one page,
type "more" at the bottom of each page except the last, where you
type "end."

2. The press release should be typed on 8 1/2" X 11" letter-size
white paper, with plenty of margin space on all sides so that the
editor can make notations, corrections, or changes.

3. If the press release is not typed on stationery, the name and
address of the sender should be typed at the top, centered on the
page. Skip a few spaces and, at the left, type the date the release
is sent, and immediately below it type the earliest date it is to be
used. If it can be used any time, type "For Immediate Release."
Otherwise, type: "For release on _____."

Lined up with the date lines, but far to the right, type the name
of the individual who can be contacted for further information, and
immediately below it that person's telephone number (include area
code).

When you write the press release, remember a few basic rules
of newspaper writing. First of all, get all of the important informa-
tion into the first paragraph. Those are the five Ws of journalism:
when, where, who, what, and why, plus how. Not all six apply to
every story but, where they do, they should lead off the release.

The subsequent paragraphs should be written in descending
order of importance, so that the least important information comes
at the end. When a story must be reduced because of space con-
straints, it is cuts from the end.

What will appeal to a particular newspaper is unpredictable but one type of press release is almost sure to be ignored: a release which sounds like nothing more than an ill-disguised sales pitch. Editors are interested in news and features; sales messages belong in the advertising columns.

Study newspaper writing style by reading the papers from that point of view. Sentences are short. So are paragraphs. Good stories are written to appeal to readers, not the egos of writers. Using fancy words with obscure meanings will reduce the odds of the press release being used. The simpler and more direct the press release, the better its chance of being printed.

If the editor thinks there may be a feature story in the activity announced in the press release, a reporter will be assigned to contact you. If the reporter has never heard of National Welded Sculpture Week, he may want to know more about it for a possible feature. Anything in your release that might intrigue an editor is a bonus.

Timing is an extremely important factor. A daily newspaper can process a release for print overnight if it wants to. A weekly newspaper often has deadlines a week ahead of publication date. Monthly magazines usually require information two and even three months ahead of time to get it into print.

Most newspapers and magazines, even small weeklies, have special editors for special departments. A general news release can go to the city editor. A release on a gallery opening could also go to the arts editor. A release on a new line of wearable art should go to the fashion editor. Since editors are busy people, sending a release to the wrong department could be counterproductive. A phone call to determine the name of the appropriate editors is worthwhile.

Finally: photos. Don't submit color slides or poor-quality photos. Most editors want 8" X 10" black-and-white glossies, with the picture caption and your name and address securely taped to the back. Some papers will take 5" X 7" shots, but the bigger size stands a better chance. Getting a picture into the papers is worth the investment to have a good one taken. If it's a photograph of artwork, be sure to indicate which side is up.

Two tips on mailing photos:

1. Never fold the picture. Get a large enough envelope and use a piece of cardboard for protection.

2. Address the envelope before you enclose the picture. Ad-

dressing the envelope later may find the ballpoint pen pressing through and defacing the photograph. For that same reason, never write on the back of a photo, except very lightly with soft pencil or crayon. (*See also* **Advertising, Photographs, Publicity, Public Relations**)

PRICE (*See* **Pricing**)

PRICE FIXING (*See* **Robinson-Patman Act**)

PRICING

Pricing artwork may be as much of an art as creating it. There is no rigid formula for establishing the "correct" price. There are, however, several factors to be considered in determining the price for which artwork is to be sold.

1. How much does it cost to produce?
2. How much does it cost to operate the business which creates the work?
3. How much profit do you want to make?
4. What is the cost of selling the work?
5. Will the collector buy it at the price?

The cost of production, overhead, selling, and the desired profit margin can all be determined with a fair amount of accuracy.

Number five is the tricky one. It doesn't matter how rational you think the price is: If there are no collectors who'll buy it at that price, forget it!

Customer acceptance of a price is based on both economic and psychological reasons. First, of course, there's the question of want or need. It is unlikely, for example, that many people would buy this book if it were priced at $100 a copy. There simply aren't many artists who see the need for so expensive a book. Conversely, if this book were priced at 39¢, many artists might ask: "If it's so cheap, can it be any good?"

The customer's perception of the value of a product to fill a need, then, affects price.

The collector's desire for prestige and recognition also affects the price. Some people will pay ten or more times the amount for an original Picasso than they will for a mass-produced poster. They pay the price so that they can be the first (or the only) people owning that particular work.

The same principle applies to one-of-a-kind works created by

an artist. A bronze created by a well-known sculptor will fetch a better price at a gallery than a similar work created by an unknown sculptor will bring at a mall exhibit, even though the casting cost is the same and the works may both be beautiful.

There's also the collector's financial means to be considered. There are more middle-class collectors interested in art than dynastic ones. A $100,000 bronze may well be worth the price but there is a limited market for such work.

While works of art are not interchangeable, there is a form of competition between works. If you offer a work at one price and a very similar work is being offered elsewhere at a lower price, there must be some very good reasons why your price is higher or you will likely lose the sale. That doesn't mean your price should be based solely on what the competition charges, but the marketplace is such that this factor must be included in your calculations if you're both after the same collector. The fact that you pay a much higher rent or want to make a better profit is irrelevant. If, however, you have a better reputation, use better materials, or your craftsmanship is obviously superior, then you can justify a higher price. If, on the other hand, your competitor is simply more efficient and can, therefore, charge less for a similar work of, say, decorative art, then he or she is going to make the sale.

Price, in the last analysis, is simply a way of expressing the value of a product in terms of money. As we've seen, there are a great many elements which determine the value of any product. Perhaps the most important element in pricing works of art is aesthetics.

Turning to the procedure for establishing the price for a work of art, there are two basic ways to go about this: (1) determine the ultimate selling price and then work backward to establish materials costs, production procedures, and other steps necessary to meet that price; or (2) find out how much everything costs and set a price on the basis of those figures.

Experienced artists and gallery owners probably know by instinct in what general price range a particular work should fall. It is a good idea for a new artist to confer with gallery owners, dealers, and other art professionals in order to determine an acceptable price. For some artists, the pricing procedure starts from the other end: calculating the cost of production, materials, labor, overhead, and profit to arrive at a price, and perhaps making adjustments if the price is not right.

Every business activity involves two types of costs: fixed costs

and variable costs. Fixed costs are those that remain constant, regardless of how much you produce. These are almost always included in overhead. Your rent, for example, goes on month after month, even when you go on vacation and create nothing.

Variable costs are those which relate directly to production. Creating ten paintings requires ten times as much canvas as producing one painting. If you reduce production and lay off an apprentice, you also reduce your labor cost.

In both cases, there may be slight variations. The telephone bill, generally a fixed cost, is likely to be somewhat lower when you're on vacation, although there's still a monthly minimum.

Increasing production may enable you to achieve a slightly lower cost per unit for raw materials if you get a better deal for buying a larger quantity.

Determining price requires a certain amount of recordkeeping during the creation process. Artists who produce one-of-a-kind works find this much simpler than those who produce multiples. They need to maintain cost records only for the one work they're working on at a given time.

Those who produce works in multiples, however, must be much more careful. Following are some of the major categories of expense; many of these are discussed in more detail under their own subject headings. In all cases, the dollar amounts for each expense item must be apportioned to the individual works produced, either by fixing the actual cost of time or materials related to the item, or by converting expenses into hourly averages and then applying them to the time it took to produce a given item.

Production Costs
1. Raw Materials
2. Wages (your own included)

Selling Costs
1. Advertising (including brochures)
2. Shows and exhibitions
3. Operating a gallery, a showroom, or renting a kiosk
4. Commissions to dealers
5. Wages (your own included)
6. Photography

Overhead
1. Rent
2. Utilities
3. Water
4. Telephone
5. Stationery and supplies
6. Packing materials
7. Maintenance
8. Repairs
9. Transportation
10. Taxes
11. Insurance
12. Bad debts
13. Depreciation
14. Loss through damage and theft

Not every artist or gallery itemizes all of these expenses. Selling costs are often included in overhead, for example. On the other hand, a metal sculptor, being a heavy user of electricity and acetylene for a welding torch, may want to apportion some of his utility costs directly to the work being produced.

Overhead is most easily totalled into a weekly or monthly figure, reduced to a per-hour overhead cost, and then applied to the cost of the various items according to the time it takes to make them. Thus, if your overhead is $3 per hour, and you pull two prints per hour, the price for each print must include $1.50 for overhead.

It is important not to overlook an overhead expense, since it can affect you in at least two ways: (1) If you don't list a cost item as a business expense, you cannot use it as a tax deduction; and (2) if you overlook a business expense, you will not include it in your pricing.

One essential overhead ingredient that is all too often overlooked is the service time you spend on non-creative work such as billing, shipping, bookkeeping, cleaning up, going to the post office, and so on.

In developing your formula, first make a list of all your major overhead items. Use the list above and add other categories you consider important in your operation. Next to each item, indicate the total amount you spend (or expect to spend) for that item in one year.

Certain amounts are easy to identify, such as rent and insurance premiums. Others have to be estimated, based on previous experi-

ence or some specific plans you have made. If you attended only two shows last year, for example, but plan an extensive tour this year, that item should be increased proportionately.

Although a monthly overhead calculation is the ultimate goal, you must start with an annual total because many items (insurance premiums, show expenses, repairs) don't occur every month.

If the list you've made up has been calculated carefully, taking into account price increases for utilities and supplies, additional insurance, etc., you now have a total of your annual overhead expense. For purposes of developing a pricing formula, let us create an example in which the total overhead amounts to $3,816. Divide that by 12 to come up with a monthly figure: $318 in this example.

Two methods now present themselves for figuring that overhead cost into the price of a specific work.

1. *Assign a certain dollar amount of overhead to each hour of production.*

For this method, you have to determine how many hours you spend in actual production of your artwork, not counting the hours spent on such activities as bookkeeping and selling. Let us assume that you are a printmaker who averages 140 hours a month of actual creative work time.

Dividing the 140 monthly hours into the $318 monthly overhead gives us an hourly overhead figure of $2.27. That means a print which takes an hour to produce must have $2.27 included in its price to account for overhead. If the print takes 20 minutes (one-third of an hour) to make, 76¢ should be added to its price for overhead. If it takes ten hours to produce an original work, then overhead of $22.70 must be included.

2. *Increase each dollar of production cost (materials and labor) by a specific percentage to account for overhead.*

Let us assume that the total cost of materials and labor in your art business is expected to be around $13,600 this year, based on previous experience and future plans.

Divide that production cost figure into the overhead figure from the previous example ($3,816), and you find that overhead costs are equivalent to 28 percent of production costs.

All you need do from now on is to add 28¢ for overhead to every dollar of production cost. If labor and materials for a specific item total $8, you add $2.24 (8 x 28¢) for overhead.

If you want to simplify this and avoid the long division every time you try to calculate the cost, make up a chart that shows the

overhead cost in relation to specific dollars of production. Taking the same 28 percent example, we would have a chart like this:

Production Cost	Overhead
0.25	.07
0.50	.14
1.00	.28
2.00	.56
3.00	.84
4.00	1.12
5.00	1.40
6.00	1.68
7.00	1.96
8.00	2.24
9.00	2.52
10.00	2.80

Once you've made these calculations, you can save a lot of time when you price your artwork, and know that you've priced it accurately to reflect all your costs.

The figures we've discussed here are used primarily for pricing. For tax purposes, your accountant will determine the actual overhead costs. That figure can be important to you in two ways: (1) to compare with the estimates you used, and (2) as a basis for next year's estimates.

With experience, some artists have even arrived at a pricing formula based on some specific element of the production process. If you discover, after several years of careful recordkeeping, that the ultimate wholesale price always turns out to be ten times the cost of raw materials used in making the item, then it becomes a simple matter of keeping track of the cost of materials and multiplying by ten. But that's risky unless you're on sure ground, and even then it has to be constantly examined and reexamined to determine whether other factors have changed sufficiently in cost to affect the formula. If your rent doubles, for example, it could throw the whole calculation out of whack.

By and large—especially for artists just getting started—it is safest to pin down every last expense item and add it into the total. How to do this is discussed under the appropriate subject headings such as Overhead, Wages, etc.

Revising the Price

Suppose you've done all your calculations and you discover, to your chagrin, that the price comes out too high. You aimed for $2,000 and it came out $2,200. If your calculations are based on a prototype, you'll undoubtedly find savings in the production process when you begin to produce multiples.

The normal tendency is to simply cut $200 off the price. This will cut into your profit, and may even result in a loss. You should review your expenses and determine whether there are ways to cut costs.

Odd Pricing

It is common in retail marketing to price products at a figure below the next highest round number price. Thus, a pound of bananas is 59¢ instead of 60¢, a radio is $49.95 instead of $50, and a car costs $18,995 instead of $19,000.

This is known as odd pricing, and is done on the assumption that customers think the price is much lower than it actually is. Marketing experts have questioned whether that's true, and many marketers agree that it has little bearing on such products as artwork, where prestige, originality, creativity, and similar attributes are as much a part of the product as the material of which it is made.

Artists, themselves, rarely use odd pricing when selling directly to collectors, though many galleries do.

Pricing for Profit

As long as your costs are covered, you can set prices according to the biggest profit return you can get. Sometimes a lower price will bring a bigger profit: if a printmaker prices a work at $100, which includes a $20 profit, a $4,000 profit will be realized if 200 prints are sold. If the price is reduced to $90, the profit will be only $10 per piece. If, however, 500 prints are sold at the lower price, the profit will be $5,000.

This does not suggest that the volume will necessarily be larger if the price is lower. You may not even want to produce a larger volume. But it is a consideration that should be considered when calculating the price for artwork.

When you are both an artist and dealer—opening your own gallery or selling at a show—you are, in effect, buying from yourself at wholesale and adding a markup to cover your operating expenses, wages, and profits. The temptation may be great to sell exclusively at retail, but this may not be cost-effective, because you

will likely have a greater volume when a number of galleries handle your work and you are free to continue creating new work. (*See also* **Advertising, Debts—Bad, Exhibitions and Shows, Insurance, Inventory, Margin, Markup, Retailing, Shipping, Tax, Telephone, Wages**)

PRINTED MATERIALS

While your artwork is your most important medium of communication, your printed material—advertisements, brochures, letterhead, and the like—often precedes it. What the prospective collectors see about your work is often their first introduction to it and establishes their initial impression.

It costs no more to have something printed that is well-designed and expresses your individual style or personality than to print inferior material. A basic design or logo for your business, carried through all of your printed materials, establishes that image in the marketplace.

A friend in the advertising business or a helpful printer can provide valuable suggestions on how to produce your printed materials at the lowest possible cost, how to print several different pieces at the same time to get more for your printing dollar, or how to take advantage of special colors or papers to make your printed material uniquely yours.

Desktop publishing is available for all your publishing needs, from business cards to brochures. The cost of desktop publishing is dramatically lower than traditional printing and the quality, in most instances, is comparable. (*See also* **Advertising, Business Forms, Catalogue, Computer Hardware, Computer Software, Direct Mail, Portfolio**)

PRINTER'S PROOF

A proof for an edition of prints bearing the artist's signature, indicating that the artist has found the printing plate satisfactory, and used as a standard against which other prints from the edition are compared. A printer's proof is also known as a *bon á tirer* (literally, a print good to print). (*See also* **Artist's Proofs, Multiples, Prints, Working Proofs**)

PRINTS

The artist Albrecht Durer (1471-1528) is often credited with being the father of modern printmaking. His use of woodblock

printmaking, as a means of multiplying images, established a process which has continued to evolve. Printmaking today encompasses everything from woodblocks and copper and steel engravings to mylar sheets and xerography. The United States Customs law defines "prints," for purposes of duty-free entry, as including "only such as are printed by hand from plates, stones, or blocks etched, drawn, or engraved by photochemical or other mechanical processes." Printmakers and other involved in the art business have criticized this definition as being too narrow, in light of modern technology. Today, few prints are pulled by the artist's hand or under the artist's direction; more commonly, they are either photomechanically reproduced or produced by master printers.

There have been many abuses in the print business; for example, situations where artists, including Salvador Dali, hand-signed blank paper to which photomechanical images were later added. In response to problems such as this, many states have enacted print disclosure laws which require that certificates containing prescribed information accompany the print when sold or transfer. *See* **Appendix A** for a list of state multiples laws. (*See also* **Artist's Proofs, Customs, Limited Edition, Multiples, Trial Proofs, Working Proofs**)

PRODUCT LIABILITY INSURANCE

The laws which impose millions of dollars of liability on General Motors for defective vehicles or A.H. Robins for a defective birth control device are known as "product liability laws" and also apply to artists for work which causes injury to others. The injury can be either to a person, such as a gallery employee being hit by a collapsing sculpture, or economic, such as the lost sales which resulted from the gallery's being closed for repairs on the date scheduled for an opening.

Product liability insurance is available to protect you in case of a lawsuit based on some defect in the artwork for which you are responsible, or some characteristic about which you should have warned the collector. It doesn't matter whether the artist sold the work directly to the collector or whether it was sold through a gallery; the maker of the product, as well as the gallery, can be held responsible.

The best product liability insurance, of course, is to make the artwork as safe as possible, and to alert the collector if special precautions have to be taken. If you warn the collector that there are

some limitations on the use of the work, as, for example, when creating a mosaic glass wall with stress, weight and other structural limitations, you may have fulfilled your obligation, though the law is not clear on this point. If, however, a kinetic artwork which has an electrical motor moving parts of it shorts and causes injury to a collector who touches it, you are likely to be held liable.

Fortunately for most artists, most types of artwork are not seen as inherently dangerous, so that product liability insurance coverage is fairly inexpensive and generally available. For artists whose work is more likely to cause injury, it is especially important to obtain such insurance. (*See also* **Insurance**)

PROMOTION (*See* **Advertising, Catalogue, Direct Mail, Printed Materials, Publicity, Public Relations**)

PROOF (*See* **Artist's Proof, Hors commerce, Printer's Proof, Trial Proof, Working Proof**)

PROPERTY (*See* **Assets, Equity, Mortgage, Property Insurance, Property Tax**)

PROPERTY INSURANCE

A wide range of insurance coverage is available to protect you against loss by theft, fire, flood, storm, or the like.

The most common of these is known as comprehensive insurance, which covers a number of related risks at a premium rate lower than that for covering those risks separately. Typical of such policies is a homeowner's or renter's insurance policy, which is available in most states and includes protection against loss from fire, wind damage, vandalism, theft, personal liability, and so forth. Similar types of policies are available for businesses.

Premiums for property insurance policies vary widely, depending on the potential risk. A frame building, for example, generally costs more to insure than a brick building. Hurricane insurance is quite expensive to obtain in areas frequently subject to hurricanes; this is also true of earthquake insurance.

Separate policies to protect against theft or burglary can also be obtained. This is especially important to artists who put their work out on consignment to galleries because, although galleries should provide insurance protection for work that is on their premises, they often don't. Laws in some states have increased the

protection given to consignor-artists by making consignee-galleries liable for damage to or loss of consigned works.

The best protection an artist can have is to maintain his or her own insurance coverage. This may be done by adding a fine arts floater to another policy or through an inland marine policy with a personal property floater.

Theft and burglary insurance also varies in cost, depending on the crime rate in the insured's area, and the nature of the coverage. Premiums may be higher for artists working in precious metals, for example, than those working in oils.

Each individual's property insurance coverage should be tailored by the insurance agent or broker to suit the specific needs for coverage, the potential size of the loss, and the cost of the premiums. (*See also* **Fine Arts Floater, Insurance**)

PROPERTY TAX

Property tax is a common form of municipal taxation. Most cities, counties, and states use property taxes as the primary source of their revenue.

Property taxes fall into two categories: real estate and personal property. Real estate (with some exceptions, such as religious buildings and some farmland) is taxed locally. A specific tax rate per dollar of value, known as the millage rate, is established, and each piece of taxable property is then assessed according to its value. The assessed value is not necessarily the same as the market value of the property. Thus, taxes can be increased in two ways: either by raising the millage rate or by reassessing the property at a higher value.

Another form of property tax in some states is the automobile license, which is a state property tax.

An inventory tax, which exists in some states, is also a property tax. Artists and galleries in states where inventory taxes exist should be careful to control their inventories, particularly near the assessment date. (*See also* **Tax**)

PROSPECT LIST (*See* **Mailing List**)

PROVENANCE

The pedigree of a work of art. It includes, among other things, the authenticity (including attribution), prior ownership, and historical significance. Provenance also includes the legality of the work's

transfer, import and export, and the prominence of prior owners. Provenance is most relevant to major historical works, though it need not take any prescribed form. Letters, government documents, history books, and the like have all been used to establish provenance. Some legislation requires certificates which establish a provenance for the work. For example, items which are to be imported into the United States under the General System of Preference (GSP) section of the U.S. Customs law, must have documentation regarding age and material. Similarly, fine print legislation and multiples laws which have been enacted in many states require disclosure of the provenance of the works covered by those laws. (*See also* **Attribution, Authenticity, Customs, Multiples, Prints**)

PUBLIC DOMAIN

Works of art may be protected from reproduction and other exploitation by copyright or other intellectual property laws, such as trade dress. If a work is not protected, then it is in the public domain and it may be copied by anyone without restriction. Work may enter the public domain when the period of copyright protection has elapsed, when formalities previously required for copyright creation were not adhered to, or if there is no other form of intellectual property protection. Once a work has entered the public domain, it cannot be protected. If, for example, a public domain sculpture of Uncle Sam is modified by adding an eagle and a dog, the newly-created eagle and dog may be entitled to copyright protection, but the public domain Uncle Sam cannot.

The federal government cannot, itself, copyright work, although it may own copyrights created by others and assigned to it. (*See also* **Copyright, Patent, Trade Dress**)

PUBLICITY

There are several ways to gain visibility in the media: One is to pay for advertising; the other is to be the focus of a story. Any mention you get in the media is publicity, and good publicity is often the result of an effort on the part of the person being publicized. Many entertainers hire publicists expressly for this purpose. So do some visual artists.

The first step toward getting publicity is to overcome your modesty or shyness.

The second step is to realize that editors are always on the lookout for interesting stories.

For the artist, publicity has at least two values. One is ego gratification. It feels good to see something nice about yourself in the news. The other value, even more important to your business, is that publicity is a sales tool.

To get the most out of publicity, a few basic principles should be observed:

1. *Timing.* Your publicity should coincide with a major exhibition of your work or your release of a new suite of work. Always keep the sales potential in mind.

2. *Directness.* Make your presentation as simple and as straightforward as possible. Editors can (and often do) rewrite and cut to suit their own styles. If the editor thinks there's more to the story than your announcement, a reporter may be assigned to interview you. Accommodate the reporter's needs and deadlines.

3. *Angle.* Provide the editor with a news peg if possible. A new suite of work, a gallery opening, an award, moving into a new studio, an unveiling of a monumental sculpture, the presentation of your work to a notable figure—these are all news pegs.

4. *Press List.* Your publicity will typically be with newspapers and radio or television stations in your area, and with regional and national magazines. Occasionally, your local emphasis may expand if, for example, you are featured in a location outside your regular market.

It is a good idea to maintain a list of press contacts; this can be done as simply as maintaining 3" X 5" index cards or a computerized record. If there is more than one contact at a given newspaper (city editor, arts editor, feature editor, etc.), make up a separate entry for each. Keep a record for each entry of the contacts you've made, the date, and the results. If you don't succeed on the first contact, it is good to know when to make another, and you can time it according to the dates shown for that entry. Make a note of the reaction: Were they favorably impressed, polite or curt, enthusiastic or disinterested? Did they tell you to call again at a specific later date? Do they want photos? All of this is useful because the more you can tailor your publicity to the particular editor's needs, the better your chance of getting it into the media.

Note: Particularly in small towns, unless the subject is a general news announcement, such as a gallery opening, it is best not to give the same story to more than one editor at a time. Give the editor a few days or a week to make a decision on a feature story. If the first one isn't interested, then take it to the next. Your credibility with editors will be jeopardized if they unknowingly run the same feature story.

5. *Approach.* Most members of the media are approachable. In some instances, a phone call will generate enough interest for a reporter to be assigned to the story. In other instances, it is better to issue a press release.

Aside from the print and electronic media, there are numerous other publicity opportunities for artists and their work. You may persuade a restaurant, hotel, bank, or other place of public accommodation to display your work. If you are fortunate enough to be selected for a public commission, the work itself will advertise you as a successful artist in that locale. A guest appearance on a radio or television talk show is another good opportunity to reach large numbers of people. Some artists have donated their work to charities for the purpose of obtaining media visibility. When, for example, the Oregon Vietnam Veterans Memorial needed to raise funds for maintenance, a local artist created an editioned bronze and donated the mold to the charity; his contribution was featured in the newspaper as well as on local television news programs.

You should collect as much as possible of the publicity about you and your work and use it as part of your own promotional materials. Reprint some of the articles that have appeared about you in the newspapers or magazines. Make a list of the radio or television stations on which you've been mentioned or have appeared; you can videotape these appearances yourself or, often, arrange to obtain a copy from the station. What others say about you and your work is often more compelling than what you say yourself. (*See also* **Advertising, Photographs, Press Release, Public Relations**)

PUBLIC RELATIONS

Public relations means exactly that: relations with the public.

Public relations covers every aspect of your contact with the outside world: salesmanship, price, publicity, advertising, community involvement, display, even your own appearance and conduct when you encounter your public at shows and exhibitions, or when you see a buyer for a gallery.

How do you create your image as an artist? Generally, in much the same way you have created an image of yourself as an person. People have certain impressions of you: stingy or generous, soft-spoken or blunt, calm or excitable, talkative or quiet. There is no one trait and no one time when images take hold. They are the cumulative experience people have of you.

Craftsmanship counts. So does reliability. If you get a reputation

for always missing promised dates, or for great variations in the craftsmanship of your works, your reputation will suffer.

Price is another factor. The higher the price, the greater the public's perception of quality (and vice versa). Though there are some limits to this theory, if your work is priced too high, no one will buy it, and if it's priced too low, the wrong people may buy it.

There are at least two aspects of public relations: The first is how you conduct yourself as an artist, as a professional, and as a businessperson. The second involves the many things you can do to obtain notoriety. This need not always be related directly to sales, although you would hope that your public relations ultimately produces more sales.

For many artists, hiring the services of a publicist or public relations agency is important. These professionals have the knowledge and experience to assist in obtaining maximum visibility. The cost of hiring professionals may be worth it, since the results they achieve should ultimately produce sales, and their activities leave the artist time to create. (*See also* **Advertising, Photographs, Press Release, Publicity, Salesmanship**)

Q

QUALITY CONTROL

Quality control has application to all of the work you produce, though, presumably, you will not permit any art which you consider substandard to be sold or displayed. For example, when Picasso died, vast quantities of work was found in his studio which, it is believed, the artist retained because it was substandard.

When creating work which is to be reproduced in multiples by others, such as master printers or foundries, quality control is essential. To maintain a reliable reputation, multiple items must meet the same standards as the foundry proof or printer's proof, and should be critiqued by the artist before the multiple is signed and numbered.

Work that does not meet the standard established by the artist should be cancelled, if a print, or melted, if a sculpture. Allowing your name to be associated with inferior work will injure your reputation. It is for this reason that the Visual Artists Rights Act of 1990 permits an artist of work covered by that law to require his or her name to be disassociated from work which the artist deems to have been so altered as to be injurious to his or her reputation. (*See also* **Foundry Proof, Hors commerce, Multiples, Printer's Proof, Prints, Trial Proof, Visual Artists Rights Act, Working Proof**)

R

RECORDKEEPING

Business records should be retained for at least three years, the statute of limitations for tax audits covering items other than fraud or non-disclosure of income. The statute of limitations for tax fraud is six years, and there is no limit for concealment.

Some records should be kept longer. For example, if you remodel a building, adding value, the costs of remodeling will be added to your "basis" in this building and that information will be necessary whenever you sell the building.

Information regarding the purchase price of assets, including stocks, bonds, works of art, and other items on which you may be required to pay income tax when sold, should also be retained until the information is needed. (*See also* **Accounting, Audit**)

RELEASE (*See* **Photographs**)

RENTAL SALES

When a business buys equipment or other property, the tax laws allow depreciation as a tax deduction. This allowance does not apply to works of art, though at least one case involving inexpensive prints given to children in a dentist's waiting room allowed depreciation for those pieces. Tax deductions are often available to businesses, however, if the art is rented rather than purchased. This approach can provide a good source of income for some artists and galleries. In addition, many individuals like to live with a work of art before committing to its purchase.

There are a variety of rental plans, the most popular being rental sales and lease-finance agreement.

Rental sales normally involves a short-term arrangement, sometimes for only a few months, after which the work is returned to the artist or gallery. The monthly fees are fairly modest, normally between 5 and 10 percent of the retail price. If the piece is not returned in good condition, the renter is required to buy it.

A lease-finance contract often runs for several years and is re-

newed automatically. The artist or gallery sets an annual rental fee, which is tax-deductible to a business renter. The concept here is that the annual fees will have paid the equivalent of the retail price by the time the initial contract period is up. Thereafter, the contract is automatically extended at a fairly low annual rental, which continues to produce income for the artist beyond the original retail price.

Arrangements like this should involve an experienced business attorney; they may offer financial advantages to the artist or gallery and tax benefits for a renting business. (*See also* **Museum, Tax, Unrelated Business Income**)

RENTING (*See* **Lease**)

REPOSSESS (*See* **Collateral, Foreclosure, Installment, Mortgage**)

RESALE ROYALTY (*See Droit de Suite*, **Royalty**)

RESERVE

A reserve is an amount established by one who consigns work to be auctioned and by the auction house as the minimum price below which the work may not be sold at the auction. The Uniform Commercial Code provides that all work sold at auction is presumed to be sold with a reserve unless specifically identified as without reserve. Customarily, the reserve price is kept secret; in some jurisdictions, after the auction, auction houses will disclose the reserve and whether bids at the auction did not reach the reserve. (*See also* **Auction**)

RESTRIKES

Restrikes are sculptures which are cast from molds taken from a previously cast sculpture rather than from the original creation. Since restrikes are second-generation works, distortions and irregularities are common. They are not considered "authentic" works and are frequently cast posthumously. Some museums have made reproductions of works in their collections and, if identified as a museum reproduction, the work is what it purports to be. If, however, the identification of the work is altered so that a purchaser believes that the work is an original casting, then the sale is fraudulent.

Restrikes may not legally be made without the artist's permis-

sion while the copyright is still in force, though once the copyright expires and the work is in the public domain, it may then legally be copied without permission. Many of Frederic Remington's popular works are in the public domain and restrikes, therefore, abound. Several collectors were defrauded by sellers who represented restrikes as authentic Remingtons. To be sure that a work is what it purports to be, you should check the provenance.

Restrikes should be distinguished from unauthorized pieces which exceed the agreed edition size. It is rumored that the foundry which originally cast Remington's work created more pieces than the artist permitted and sold them "through the back door." While these works were created from the original mold, they were neither critiqued nor signed by the artist and, therefore, are not considered approved works in the edition. Unfortunately, they are virtually unidentifiable. Reputable foundries are very careful to avoid this situation, and multiples laws which have been enacted in most jurisdictions address this problem by requiring certain disclosures and imposing statutory penalties for incorrect statements.See Appendix A for a list of multiples laws. (*See also* **Copyright, Multiples, Public Domain**)

RESUME

A resume is a brief summary of your professional training and experience. A resume is used as a way of introducing yourself for a wide variety of purposes: when you approach a gallery, when you seek a job or teaching position, when you want to furnish background material for a newspaper interview. It traditionally consists of several clearly defined sections, each of which should be identified and separated from the others:

1. *Personal statistics.* Name, address, telephone number, media in which you work.

2. *Work experience, including teaching positions.* Start with the most recent one and work backwards. Indicate what your job function was and include dates of employment and references.

3. *Professional experience.*Exhibitions, gallery shows, awards, honors, workshops you've conducted, lectures you've given, articles you've had published, membership in professional organizations, etc. Also in this section should be a list of collections to which your work belongs. Be specific: for example, the Peabody Collection of the Seattle Art Museum.

4. *Educational background related to your work.* Complete

educational background is usually needed if you're applying for a teaching position.

5. *References.* Two personal references and two professional references from people not related to you are normally sufficient. The references are customarily stated to be available upon request and are not actually included with the resume.

A resume (as distinguished from a *curriculum vitae,* should not exceed two pages and should ideally be one page).

If you have extensive professional and work experience, education, honors, publications, and the like, you may wish to prepare a *curriculum vitae* in addition to your resume. A *curriculum vitae* is frequently several pages long and includes much more detailed entries than a resume.

Resume services are quite common and may assist you in preparing a quality document. (*See also* **Architects, Computer Software, Photographs, Portfolio**)

RETAILING

Retailing means selling to the ultimate consumer. Some artists become involved in retailing by selling directly to collectors from their studios or at retail art exhibitions; others may operate their own galleries.

While the profit margin might appear more attractive from retailing, there are still costs associated with that activity, and you should determine whether it is appropriate for you. Retail outlets, such as galleries, may perform valuable services for the artist, such as:

1. finding buyers which the artist might not otherwise find;

2. offering a wide variety of work which itself attracts business;

3. advertising;

4. displaying art attractively;

5. extending credit to their customers;

6. furnishing parking space and otherwise being conveniently located.

It has been estimated that performing these functions costs the average retail outlet approximately 45¢ of every retail sales dollar. When a gallery buys artwork at 50¢ of the retail sales dollar, that leaves about a nickel for profit.

On the assumption that an effective retail sales operation conducted by an artist would also cost approximately 45¢ of every retail sales dollar, the question of a retailer's markup takes on a new perspective. The artist's belief that a gallery doubles the wholesale

price and makes a considerable profit on the artist's labors is incorrect. Whether the gallery's 5 percent profit is warranted by the services provided by the retailer as an outlet for artwork is the correct inquiry.

You must determine whether it is more productive and profitable for you to work for the 5 percent retail profit or spend the same amount of time in your studio creating artwork. The issue is not the gallery's profit, but how you can spend your time and talent most productively and profitably, and what gives you the greatest satisfaction. The assumption has to be made that you are an artist because that's what you like to do and it's what you do best. If your creative and production time are more profitable than your retail selling time, there's nothing wrong with having someone else make a profit selling your work at retail.

Establishing and maintaining good relations with your gallery is a prime ingredient for continued success. The first sale is always the hardest. Once a gallery agrees to handle your work, do everything you can to keep the gallery satisfied. It provides you with continued sales. Here's a brief checklist of good gallery relations:

1. *Maintain quality.* Every new piece of your work should be at least as good as the last piece you sold or consigned.

2. *Maintain price.* Comparable artwork should never be sold or consigned to different galleries at different prices. Aside from the fact that it's illegal under the Robinson-Patman Act, it's also poor business practice. A gallery won't continue to handle your work if it learns that you or another gallery is undercutting it.

3. *Deliver work in a timely manner.* There's nothing worse than a gallery receiving work a week after the opening at which it was to be displayed. Make certain that delivery schedules are clearly stated.

4. *Pick the right outlet.* Every gallery has its own personality and following. If you create Western and wildlife paintings, you shouldn't waste your time trying to sell your work through a gallery which handles abstract sculpture. The quality and price range of your artwork and the galleries in which your work is sold have to be mutually compatible. (*See also* **Consignment, Contract, Order, Salesmanship, Shipping, Wholesaling**)

ROBINSON-PATMAN ACT

This federal law was enacted by Congress in 1936 to prohibit any practice which would tend to stifle free competition in the

marketplace. Among the law's major prohibitions is price discrimination between customers and other special concessions which are not justified by cost or other business reasons. Thus, it is unlawful to sell a sculpture to one gallery at a lower price than a comparable work is sold to another gallery. Differences in price based on quantity are legal; a price based on an order for 100 pieces can be lower than a price based on one piece. Special concessions which affect the price are also illegal; you cannot charge one gallery for shipping costs and pay the costs for an identical order to another gallery. The shipping charges themselves can vary, of course, depending on the actual costs involved. You can also differentiate among various groups of customers, say, by making local delivery free but adding shipping charges to deliveries beyond 100 miles.

The essential thrust of the Robinson-Patman Act is to protect competition by making it illegal for one customer to have an unreasonable advantage over another, whether at the wholesale or retail level.

The law also protects artists when they buy raw materials and supplies. It is illegal for your supplier to charge you one price for 100 pounds of clay and charge another sculptor in your area a lower price for the same quantity.

None of this prohibits special sales or other price reductions, as long as all customers buying the product under the special conditions are treated equally. There is nothing in the Robinson-Patman Act which would prohibit you from entering into exclusivity arrangements and not selling to or through a competing gallery, so long as your exclusivity arrangement is not for the purpose of engaging in price-fixing or in any other unlawful conduct. You are not required to make a sale. (*See also* **Gallery, Retailing**)

ROYALTY

A royalty is a per-unit payment for the use of a particular piece of property. The term originally described the payment a king would receive for granting rights to the use of his lands, hence the expression royalty. It is still used to determine payment for such land uses as oil drilling, whereby the owner of the land is paid a specific amount per barrel of oil extracted from the land. The term is also used to describe payment for the use of intellectual property, including copyrights, patents, and trademarks.

For artists, a royalty is generally a specified percentage of the per-unit sale of the artist's protected creative work.

If you create an image which is then reproduced in quantity as a poster, you can either sell the design outright for one lump sum or you can agree on a royalty based on a specific amount for each poster sold.

The determination should be based on the artist's estimate of the potential income of an outright sale versus a royalty arrangement. A royalty arrangement obviously entails a certain amount of risk and monitoring.

Royalties for merchandising art on products generally range anywhere from 5 to 15 percent of the merchandiser's net receipts. Royalty agreements often provide for a step-up in percentages as the number of units sold increases. This is because the setup costs for manufacturing will have been amortized over the first run, and additional runs will be must less costly to the producer.

A kind of royalty which is required by statute in some jurisdictions and may be required by contract is the so-called "resale royalty."

It is wise to consult an experienced art lawyer before signing any royalty agreement. (*See also* ***Droit de Suite,* License**)

S

SAFETY

You should observe industrial hygiene and safety principles in your studio. Hazardous materials and processes must be recognized, evaluated, and controlled. The artist must learn to identify materials, to read labels and material safety data sheets, and to keep records of materials and processes used in the studio. If it is not clear whether the materials or processes can be harmful to health, advice can be sought from numerous sources such as government agencies, artists organizations, and publications, as well as from industrial hygiene and safety professionals. This latter group can provide help in controlling safety and health hazards in any workplace. They can recommend appropriate ventilation, machine guarding, and protective equipment advice, and the cost of their services is tax-deductible to a business and may be tax-deductible for certain individuals, as well.

Following are some safety guidelines which should be adhered to and a list of agencies and individuals you can contact for additional information.

1. Public Law 10-695, passed by Congress in 1988 and effective as of November 1990, requires manufacturers to label art products that contain ingredients that may be chronic health hazards; for example, inks or paints that contain solvents which might not cause problems with occasional, short duration use, but which might cause nerve damage over a prolonged period of concentrated use. Of course, the law has some limitation, in that it applies only to art materials, and many artists use materials or processes which are not specifically identified as art materials and processes. Artists, therefore, have an increased responsibility to learn about the materials they use. If you work with metals, you must know what happens when a metal is heated. If you work with resins, you must know the health effects of the resin components, and how and when adverse effects are likely to be caused. If you work with fibers, you must know about the health effects of dyes and dusts. Problems continue to surface; for example, it is now recognized that many

glazes contain harmful lead and that lead crystal should not be used for prolonged storage of consumable liquids. The State of California has even passed legislation to monitor those who are involved in creating any pottery vessel which may be used in connection with food.

2. Follow safety rules, use guarding devices, and wear appropriate protective equipment when using machine tools of any kind. Do not wear jewelry or loose-fitting garments such as scarves, ties, necklaces, or the like.

3. Read instructions thoroughly and *follow them.*

4. Have electrical wiring and tools checked periodically by a professional electrician to be sure connections are in good condition and that tools are properly grounded.

5. Have an emergency response plan and post it in the studio and near a phone. It should describe what to do in case of a spill, a splash in the eyes, a bad cut or puncture, and who to contact, such as 911, etc.

6. Ventilate properly. Remember that, for any system to work, whatever amount of air is exhausted from a space, an equal amount of air must be brought in to replace it. Be sure that your exhaust system does not interfere with existing furnace or other exhausts.

7. Don't eat in the workshop and avoid working in your kitchen.

Agencies that provide information:
Occupational Safety and Health Administration, (OSHA), National Institute of Occupational Safety and Health (NIOSH).

Organizations and Individuals:
Center for Safety in the Arts; Arts, Crafts, and Theater Safety (ACTS); Gail Barazani, researcher and writer on occupational health in the arts (*see* **Appendix B**).

Books:
Ventilation: A Practical Guide; Artist Beware; The Artist's Complete Health and Safety Guide (*see* **Appendix D**). (*See also:* **Fire Prevention**.)

SALE
A sale is accomplished when you have entered into a contract for your work. This is true even if you have not yet delivered the item in question and, under the Uniform Commercial Code, you can contract for a work of art to be created in the future. This is known as

a commission and both you and the party commissioning the work are bound. Even though that party cannot force you to create the work, you may be liable for monetary damages. The Uniform Commercial Code provides that, unless the parties agree otherwise, payment for work is due when the work is tendered to the purchaser. It is, therefore, important to determine where and when you have technically "tendered" your work of art to the purchaser. The UCC provides that, customarily and unless the parties agree otherwise, the work is to be tendered at the seller's place of business or, if there is none, at the seller's home.

In order to avoid problems, you should specifically agree with the purchaser that you are to be paid for your work as soon as it is tendered. In the case of consignments, a sale does not take place until the work is purchased by the ultimate consumer. The consignee gallery holding the work is merely a sales agent and not considered a purchaser. Artist-dealer consignment laws establish norms for payment and other terms. (*See also* **Contract, Financial Statements, Sales Terms and Conditions, Uniform Commercial Code**)

SALESMANSHIP

Artwork, theoretically, should sell itself. Collectors should seek out quality work and purchase it. Price should not be a consideration. Unfortunately, reality does not match theory. Some salesmanship is necessary to sell works of art. You must, therefore, determine the motivation of those with whom you will be dealing.

A gallery's concern is whether the work can be sold at a profit, whether it fits the gallery's image, and whether the price is appropriate.

On the other hand, a collector's concern is whether the work is aesthetically pleasing, consistent with the collector's acquisition policy, and whether the collector can afford it. The reasonableness of the price for a work of art is far less important to most collectors than aesthetics and desirability.

Selling or consigning artwork requires the availability of a good portfolio. It is necessary to present a spectrum of work and to provide the viewer with an opportunity to evaluate color, medium, subject matter, composition and the like.

Effective salesmanship usually involves effective showmanship. Demonstrating your work at art shows adds interest to your display; explaining what inspired a particular work often increases its appeal. Some artists wear costumes, while others appropriate an air

of eccentricity. If you're sensitive to the response of your listener, you're more likely to be successful. Know when to stop, change direction, or consummate a transaction.

There are at least two major obstacles which many artists find difficult to overcome. If you are not, by nature, an extrovert, the approach to potential purchasers may be awkward and you should, perhaps, employ the services of an artist's representative. It is not necessary to be aggressive; indeed, that turns a lot of people off. An effective sales approach requires that the seller display some real interest in the customer. Sitting in the back of a booth at a show, nose buried in a book, is not likely to produce much sales activity. The potential buyer must at least get the impression that you are interested in selling.

A few character traits may interfere with an effective sales presentation: impatience, haughtiness, condescension, sloppiness, distraction. What comes across when you sell—including body language—is as important as any of the words you speak, sometimes more so. Being positive and confident almost always works better than being negative and apologetic.

The other obstacle is rejection. Since your artwork is so important an extension of your personality, there is a tendency to consider a refusal to buy as a personal affront or rejection. Many aspiring artists have been crushed and emotionally drained when a gallery or collector didn't like their work sufficiently to buy. But perhaps it wasn't their thing, or they simply didn't have the money. An individual may feel that your work is quite good and meritorious, but not compatible with a particular collection.

Be sure that the presentation of artwork is as good as the work itself. Even the finest sculpture or painting will lose its appeal if it is improperly displayed. Good lighting, mounting, placement and the like are critical for an effective art presentation. (*See also* **Artists' Representatives, Collector, Exhibitions and Shows, Marketability, Photographs, Portfolio, Publicity, Public Relations, Wholesaling**)

SALES REPRESENTATIVES (*See* **Artists' Representatives**)

SALES TAX

Most states and many municipalities impose a tax on retail sales to consumers. The tax is collected at the point at which the sale is made, and is based on a percentage of the price. The amount of the

tax varies from place to place, as does the type of product or service on which it is collected. In some areas, for example, restaurant meals or services are taxable, in others they are not. Food bought at retail is almost never subject to sales tax, although non-food items may be taxed.

Artists and galleries which sell at retail in areas where sales taxes apply must get a certificate from the local taxing authorities which authorizes them to collect the sales tax. How, when, and where the sales taxes are then forwarded by the retailer to the taxing authorities varies, but it is always illegal to retain the collected sales tax as personal or business income. Records must be kept to relate total sales to sales tax collections. Sales receipts and invoices are usually sufficient for this purpose. The sales tax must always be shown as a separate item from the price.

A sales tax situation peculiar to the art business involves selling at shows in areas where there are sales taxes. In some cases, the show management is authorized to obtain one blanket sales tax certificate and the exhibitors must either report their sales or handle them through the show management. In other cases, where the authorities do not permit this or where it is impractical, each exhibitor must obtain a temporary sales tax certificate for the period of the show. Where this is necessary, the show management will instruct all exhibitors how to go about it. (*See also* **Sales Tax Exemptions**)

SALES TAX EXEMPTIONS

On the principle that a sales tax is paid only once, by the collector, the sales tax need not be paid on materials bought by an artist for the purpose of creating artwork which will later be resold. Nor do artists have to collect sales taxes on artwork they sell to a gallery which will then resell to collectors.

In both cases, a resale number or sales tax exemption number is needed by the artist. This document is known by different names. Contact the appropriate sales tax authorities in your area for information on how to obtain this document.

When you sell your work to a gallery for resale, the gallery will furnish you with its own resale number, which authorizes you to make the sale without charging the sales tax. This is important in the event that the tax collector audits your books and wants to know on what basis you sold your work without collecting the sales tax. If you don't have the gallery's resale number (which is normally indi-

cated on the gallery's invoice), you will have to pay the sales tax, whether or not you collected it.

Sales and shipments you make to collectors outside your sales tax area are normally not subject to the sales tax assessed in your area. A New York artist (where sales taxes apply) who ships merchandise to a state where there are no sales taxes (such as Oregon), does not have to collect the New York sales tax. However, if the out-of-state customer comes to the New York artist's studio, buys the artwork there and takes it home, the sales tax has to be collected. Some jurisdictions require that sales tax be paid by the purchaser at the rate assessed in the purchaser's jurisdiction, even if the work was shipped from out-of-state.

Any raw materials or supplies you buy which will become part of a work for resale are not subject to a sales tax. You must, however, furnish your resale or exemption number to your supplier as proof that you are entitled to buy the materials without paying a sales tax.

Other supplies, such as stationery, paper clips, and similar items which do not ultimately become part of your artwork, are subject to the sales tax when you buy them because you are the final consumer of those items. (*See also* **Sales Tax**)

SALES TERMS AND CONDITIONS

The logistics of making a sale directly to a collector of an existing work of art are fairly uncomplicated: You deliver the artwork and receive payment for it, and the transaction is completed.

Making a sale to a gallery, agreeing to a commission, or selling a bronze to be cast for the purchaser, involves a more detailed set of specifications which are known as sales terms or conditions of sale. They should be contained in a sales document, frequently known as an order confirmation form, or in a contract.

Under the Uniform Commercial Code, there is a contract whenever the fundamental terms have been agreed to. Generally, these would be the product and evidence that there was an agreement. All other terms can be filled in by the so-called "gap fillers" of the UCC, but neither you nor the party with whom you are dealing may be happy with these implied terms. It is, therefore, wise for you to spell out the terms which you deem acceptable to your art business. These would include, in addition to sales price and a description of the work:

1. *Shipping Terms.* Who pays the shipping charges; are there freight allowances and on what basis are they calculated; is ship-

ment made freight prepaid or freight collect; do you make C.O.D. shipments?

2. *Packing charges.* Are packing costs included in the price, or what is the extra charge?

3. *Claims for loss or damage.* State your policy clearly on claims for damage or loss.To whom should claims be made (usually the carrier who moved the shipment), what is the time limit, etc.?

4. *Credit.*To ship on open account to a gallery or collector with whom you do not have a prior relationship is inviting trouble. Sales terms should indicate what kind of credit information is required. If the full purchase price is not prepaid, when is the balance due? If the balance is not paid when due, will you be able to collect attorneys' fees and costs for collecting the balance?

5. *Governing law.* In interstate transactions, which state law will govern? It is always better to have your own state law regulate your transactions, particularly if you have a strong artist-dealer consignment law. It is also more convenient for you to be able to sue an out-of-state purchaser in your own state's courts. (*See also* **Consignment, Contract, Credit, F.O.B., Shipping, Uniform Commercial Code**)

SAVINGS BANK

A bank whose main function is to handle savings accounts on which it pays interest, although it also performs numerous other banking functions, most notably in mortgage lending. In many states, savings banks are not permitted to handle checking accounts. (*See also* **Banks, Commercial Bank**)

SCHOLARSHIPS (*See* Grants)

SCHOOL OF; FOLLOWER OF

A term used to describe a work which is believed by experts to be by a pupil or follower of a specific artist. (*See also* **Attributed to, Authenticity, Manner of, Studio of**)

SCHOOLS (*See* Education, Grants)

SCULPTURE

A three-dimensional work of art. The term "sculpture" is used but not precisely defined in art legislation, such as the Visual Artists Rights Act ("VARA") and its state counterparts. There has been

some controversy surrounding the definition of "sculpture." Thus, in *City of Carlsbad v. Blum* (S.D. Cal. 1993), the question was whether a landscape work containing pools, foliage, walkways, fences, a cupola, and other architectural features was a sculpture within the coverage of VARA and the California Arts Preservation Act, or was an architectural work covered by the federal architectural statute. The artist claimed that her work was a landscape sculpture and, thus, protected for her lifetime plus 50 years. The City disagreed, alleging that it could remove fence pieces which blocked the view of the ocean and alter the work. (*See also* **Visual Artists Rights Act**)

SECURITY

A major expense item in business these days is loss through vandalism and theft. If the opportunity presents itself, a vandal or thief will take advantage of it. A professional criminal is less likely to tackle a major museum than a little-known gallery.

Most major museums and galleries have installed sophisticated security systems, which include burglar alarms, laser devices, guards, and the like.

Artists usually have neither the means nor the need for this kind of security, but there are some simple, common-sense steps that can prevent damage and loss.

Shoplifting

Shoplifting is not confined to retail stores. In fact, some galleries and museums have experienced significant losses during business hours. A well-respected Oregon gallery suffered the loss of a small painting during a regular gallery opening; the piece was pried off the wall, mounting screws and all.

The former director of the Brooklyn Museum told a story of receiving a package in the mail containing a work which had, just the day before, been on display in one of the Museum's galleries. The note contained in the package informed the director that the Museum's security was extremely poor and that, next time, the stolen work would not be returned. Interpol publishes a list of stolen artwork which, if recovered, would rival the most-prestigious collections in the world's museums. The International Foundation for Art Research also publishes a list of recent thefts.

While shoplifting is not as prevalent in the art world as it is in department stores, it is still quite common. It is not likely that some-

one will make off with a large painting or heavy sculpture, but fine jewelry and other small works are certainly not immune. Less valuable items are also at risk, because shoplifters are not all professionals who make their living fencing what they steal. Some people steal for kicks or on a dare. Others steal because they like the item and don't want to pay for it.

You can't keep everything under lock and key. One of the reasons people go to galleries or art shows is because they can examine the artwork. There are two basic ways to reduce shoplifting losses under these circumstances.

1. Keep displays neat and arrange them so that you can easily keep an eye on everything. Keep very valuable things, like gold jewelry, under glass or behind you. If a customer you don't know wants to examine the item, you should not leave the artwork with the customer unless you are able to keep an eye on it.

2. Keep an eye on customers. Most are honest. If someone is carrying an umbrella when it's not raining, however, or wearing a cape or coat when it's warm, be especially observant. Umbrellas, shopping bags, coats, even baby strollers are devices in which stolen goods can be hidden.

Be very careful before accusing someone of stealing. If you're wrong, you could be liable for defamation and, if you restrain the person, for false imprisonment. On the other hand, leniency only encourages thieves who will continue to steal from others and may even visit you again. Ask the suspect to return what they took, if possible. A question such as "Did you pay me for the small bronze you took?" will often produce an apologetic return of the item, or a denial that anything was taken.

Burglary

Most burglars are never caught. Some statistics put the rate of unsolved burglaries at 80 percent. Even if the burglar is caught, the artwork may be damaged.

Prevention is more advantageous that retribution. While most artists and galleries are not likely to need or want the sophisticated security systems used by museums, there are a number of less complex (and less-expensive) methods to prevent burglary.

First, install a good lock. That will deter the spur-of-the-moment burglar who tries doors and enters those that are easy to open. Restrict the issuance of keys to those employees who really need them, and ensure that terminating employees return keys before leaving.

Second, burglars prefer to work in the dark. Keep a few lights on inside a studio and, where appropriate or feasible, keep the outside lit, as well. Inexpensive automatic timers or photoelectric switches will turn on lights automatically when it gets dark. Keeping lights on all day when you're away so that they will also be on after dark is a dead giveaway that the premises are unattended. Outside lighting should cover dark areas and alleys.

If you are in an area where burglary is a particularly high risk, ask the local police department for suggestions on other methods for protecting your gallery or studio.

Never leave artwork visible in an unattended vehicle. Vandalism

Theft is not the only problem to which you should be sensitive. Vandals occasionally destroy works of art merely as a means of making a statement. For example, when Tony Shafrazi temporarily defaced Picasso's *Guernica* while it was on exhibit at the Metropolitan Museum of Art, the vandalism was for the purpose of making a political statement. On the other hand, the slashing of Rembrandt's *Night Watch* had no such purpose. While it would not be appropriate for you to attempt to replicate the elaborate precautions which were taken after this tragedy, you can reduce the likelihood of having work vandalized.

The most important step you can take is to be sure that all work is visible to you when on display.

No matter how carefully you protect yourself, it is an unfortunate fact of life that you can still be a victim of burglars or vandals. Being suspicious of everyone and everything will result in paranoia, but ignoring potential troubles can drive you out of business. Being alert and taking some common-sense preventive measures is a good middle ground to reduce such losses. (*See also* **Collection Problems, Exhibitions and Shows, Insurance**)

SELLING (*See* **Consignment, Marketing, Retailing, Salesmanship, Exhibitions and Shows, Wholesaling**)

SEMINARS (*See* **Education**)

SERIGRAPHY, SERIGRAPHS (*See* **Prints**)

SHIPPING

Shipping art can be accomplished in a host of ways.Each is suited to a particular need. The post office, for example, delivers every-

where in the world, while UPS may not. The per pound rate of United Parcel Service is lower than the post office rate, and they pick up as well as deliver, but there is a separate pickup charge.

Both United Parcel Service and the post office have size and weight limits, and there are some shipments (flammable liquids, for example) which they won't handle.

Shipments that weigh more than the 50-pound UPS limit or the 40-pound post office limit can go either via motor carriers or freight forwarders (look in the yellow pages under "Freight Forwarders"). Both pick up at your end and deliver at the other end.

The basic difference between motor carriers and freight forwarders is that motor carriers use only trucks and generally charge more but get the shipment to its destination faster. Freight forwarders pick up your shipment, take it to a central point where it is consolidated with other shipments into a large truck, railroad car, freighter, or cargo plane, and send it off to its destination, where it is transhipped to local trucks for delivery. That takes more time, but generally costs less.

Freight rates are complicated and are regulated by the Interstate Commerce Commission. The rates are divided into numerous classifications based on the type of merchandise being shipped, its density, fragility, gross weight, distance, and other factors. There is usually a minimum charge based on 500 pounds, and insurance coverage is available.

Some companies, for example DHL and Federal Express, guarantee overnight delivery anywhere in the United States and deliver in most other countries, and pick up as well as deliver. Shipping directly via an airline on a specific flight can get a package to its destination even faster, but it has to be delivered to the airport at your end and picked up at the airport at the other end. Since such shipments are always more expensive than normal ground transportation or UPS and postal air service, the time element has to be balanced against the cost. Companies that handle air shipments are found in the yellow pages under "Air Cargo."

Using a bus service for delivery to nearby areas can often be the fastest way to move a package. It is cheaper to deliver the package to the bus station at your end and have it picked up at the bus station at the other end, but most bus companies offer a package express service which goes door-to-door. It also may be slightly more expensive to send the package "next bus out," but you can thus advise the recipient which bus will carry the work.

For more complicated situations (for example, shipping a very fragile piece overseas), shipping agents will take care of all the details: packing, shipping, customs declarations, and so forth. This is likely to be more expensive, and you should evaluate its desirability in a particular situation. *(See also* **C&F, C.I.F., Customs, F.O.B., Freight Allowance, Packing, Post Office, United Parcel Service**)

SHOWS (*See* **Exhibitions and Shows**)

SITE SPECIFIC
A term used to describe a work of art which is created in situ and retains its integrity only when it is in that location. In *Serra v. United States*, the artist created a large Corten steel sculpture in the shape of an arc which bisected Federal Plaza in New York City. The work was disturbing to users of the Plaza and the government sought to have the work removed. It was argued that the work was site-specific and, thus, removal was equivalent to destruction. It was also claimed that removal would, among other things, interfere with the artist's free expression. The court bypassed these arguments and held that the government had not consented to be sued over these issues and the defense of sovereign immunity barred the artist's claims.

In a case brought by two artists, Spafford and Mason, to prevent the Washington State Legislature from removing murals which had been created specifically for the legislative chambers as part of percent-for-art-program, the Washington State Court held that the work was site-specific art which belonged to the public and which had rights transcending those of the artist or the State. Notwithstanding its conclusion regarding site-specificity, the court permitted the State to remove the Mason works, which were merely bolted to the wall and could be removed without being damaged. The Spafford works, which epoxied to the wall, could not be removed without destruction and, thus, were permitted to remain *in situ*. In reaching its conclusion, the court relied on the contract provision prohibiting destruction of the works, rather than the notion that site-specific works retain their integrity only when in the space for which they were created.

Both of these cases predated the Visual Artists Rights Act and it is believed that VARA would be applicable to protect site-specific works in the future. (*See also* **Droit Morale, Visual Artists Rights Act**)

SLIDES (*See* **Photographs**)

SMALL BUSINESS
Administration The Small Business Administration ("SBA") is a government agency which was created for the purpose of assisting small businesses. Unfortunately, its charter prohibits financial assistance to art-related business, since it was felt by Congress that this might interfere with First Amendment free expression.

Another significant service rendered by the SBA to small businesses—including art businesses—is an extensive and expanding list of publications on a wide range of business subjects, discussed in clear and easy terms. These include such topics as cost control, business life insurance, cash flow, sales agents, budgeting, accounting procedures, and many more. Many of these publications are free; the cost for others is very modest. A complete list is available at any SBA office or from Washington, DC. Ask for *The Small Business Directory*. (*See also* **Government Activities**)

SMALL CLAIMS COURT
Small claims courts exist in every state to help people resolve small claims. "Small" means different things in different places. The range is generally $500 to $2,500 for the maximum amount for which suit may be brought.

The concept of Small Claims Court is that most small claims are not complex enough to require the expertise of an attorney. That's why many states don't even permit lawyers in Small Claims Court unless they are representing themselves or a corporation. If you face a lawyer in Small Claims Court, it is the judge's responsibility to make sure that your interests are properly represented. Most complex legal procedures and many technical rules of evidence don't apply. The proceedings are informal, quick, and inexpensive. Staff members are often available to help people fill out the forms. Filing fees average around $50.

More and more states are requiring alternative dispute resolution—mediation or arbitration—for small claims cases.

Small Claims courts have one drawback: most states do not allow for an appeal except in very limited circumstances. The judge's decision is usually binding. (*See also* **Alternative Dispute Resolution, Collection Problems**)

SOCIAL SECURITY

Social Security is a federal program enacted in 1935 which has become the basic method of providing income to people after they retire or become severely disabled, and to their survivors when they die.

Ninety percent of working people, including the self-employed (such as artists), pay into the Social Security fund. Nearly one out of seven Americans receives a Social Security check each month. This includes not only retirees, but the disabled and the survivors as well, regardless of age.

People over age 65 and the disabled, regardless of age, have health protection under Medicare, which is administered by the Social Security Administration.

The basic idea of Social Security is a simple one. Employees, employers, and self-employed people make Social Security contributions during their working years. When the person retires, becomes disabled, or dies, monthly cash benefits are paid to replace part of the earnings that are lost.

Employers and employees pay an equal share of Social Security contributions. If you are self-employed, you pay contributions at a somewhat lower rate than the combined rate for an employee and an employer, but that does not reduce the ultimate benefits.

As long as a person has earnings from employment or self-employment, the contributions must be paid, regardless of the person's age and even if they are already receiving Social Security benefits.

Social Security contributions are calculated on a combination of two factors: a tax rate and an annual income base. These are established by Congress and change periodically. The tax rate is applied to all income up to a certain maximum which also changes periodically. In other words, even if the *rate* were to remain the same or go up only slightly, an individual's total Social Security tax can increase substantially if the annual base is increased.

An employee's Social Security contributions are deducted by the employer from wages every payday. The employer matches the employee's payment and sends the combined amount to the Internal Revenue Service, which is the collection agency for the Social Security Administration.

Self-employed people whose annual earnings exceed a specified minimum must include their Social Security contributions when they calculate their estimated tax payments and pay any difference when they file their individual income tax. This is required even if no income tax is owed.

Wages and self-employed income are entered on each individual's Social Security record during the working years. This record is used to determine retirement benefits or cash benefits. A fairly complicated formula is used to determine the average annual income earned since 1950. The monthly checks are reduced proportionately for workers who retire sometime between age 62 and age 65. Delaying retirement beyond age 65 earns extra credits and increased monthly checks. There is also a minimum for people who have worked under Social Security at least 20 years but whose earnings were unusually low.

Social Security benefit amounts are increased automatically each July if the cost of living in the previous year has risen by more than 3 percent over the year before. Future benefits will also go up because they are based on the higher payments made into the fund.

People who work for more than one employer in the same year and pay Social Security taxes on both incomes can get a refund on any payments in excess of the required maximum. The two employers don't get any refund.

For retirees between ages 65 and 70 who continue to have employment income, Social Security benefits are reduced by a ratio of benefits to earnings. Anyone over that age can earn any amount without reduction in benefits.

Social Security records are maintained by the contributor's Social Security Number. All U.S. citizens—including newborns—and non-citizens who work in the U.S. must obtain a Social Security Number. It is also used for identification on income tax returns and on many other official documents. A Social Security card can be obtained at any Social Security office (there are about 1300 throughout the country), and must be shown to an employer before beginning work. The amount withheld from wages for Social Security purposes is also reported to every employee on the W-2 form, which is furnished to all employees once a year for income tax purposes.

Social Security benefits do not start automatically; you must apply for them. The Social Security Administration lists the following conditions under which you can apply for benefits:

1. If you are unable to work because of an illness or injury that is expected to last a year or longer, no matter what your age.

2. If you are 62 or older and plan to retire.

3. When you are within two or three months of 65, even if you don't plan to retire. You will still be eligible for Medicare, even if you continue to work.

4. Qualified beneficiaries of a decedent.

All the information in your Social Security file is confidential. An excellent booklet, "Your Social Security," is available without charge from any of the 1300 Social Security offices. They are listed in the telephone book white or blue pages under "U.S. Government, Health, Education and Welfare, Social Security Administration." (*See also* **Keogh Plan, Pensions, Wages**)

SOLE PROPRIETORSHIP

This is the simplest method for organizing a business. Few formalities are needed. Most municipalities require even sole proprietors to obtain a business license. Most states require filing a certificate if you conduct the business under an assumed name instead of your own. The Secretary of State's office in most states can tell you what and where to file.

Even a sole proprietorship is well-advised, especially for tax purposes, to have a business checking account and a federal taxpayer identification number. Talk to your banker or business adviser about this.

If the business has employees other than the proprietor, it has to maintain and pay for workers' compensation insurance, Social Security taxes, and the like. Avoiding these fringe costs on the owner's earnings is often regarded as a benefit of the sole proprietorship form. On the other hand, the absence of such benefits to the owner when the need for them arises can be one of the disadvantages of this form of organization.

Finally, and importantly, the sole proprietor is personally and fully liable for the debts of the business. If the business fails, its creditors can go after the owner's non-business income and assets such as car, home, and savings. (*See also* **Corporation, Joint Venture, Limited Liability Company, Partnership**)

SOUTHWEST ASSOCIATION ON INDIAN AFFAIRS (SWAIA)

The Southwest Association on Indian Affairs ("SWAIA") was initially created as a political organization but has evolved into the promoter of the preeminent show of Native American art, held annually in Santa Fe, New Mexico.

SWAIA also distributes Native Peoples, a prestigious Indian art magazine, and assists Indian artists with business seminars and conferences. (*See also* **First Nation Arts, Appendix B, Appendix D**)

STATEMENT

A statement is a recapitulation of a set of financial transactions or conditions, such as bank statements, financial statements, income statements, and others.

When the word "statement" is used alone, it generally refers to a statement of account. This is a recapitulation sent by a seller to a buyer, usually on a monthly basis, to indicate all purchases and payments made during the period and any unpaid invoices from prior periods.

The statement lists each purchase according to the invoice number and lists each payment received, either by date or by invoice number against which it is credited. The final balance is what is owed by the buyer to the seller on the date the statement is prepared.

The difference between an invoice and a statement is twofold: (1) A statement is not a request for payment, only a recapitulation of what is owed and what's been paid; and (2) a statement does not generally indicate why or for what the money is owed. That's why invoice numbers are used for reference. (*See also* **Accounting, Banks, Checking Account, Financial Statement, Invoice**)

STATUTE OF FRAUDS

This is a law which was initially passed to prevent fraud and perjury by requiring certain important transactions to be evidenced by a writing. These included transactions in real property, disposition of money or other property after death, and transactions for personal property over a specified value. The law is quite complex and there are numerous technical exceptions; for example, if the transaction has been completed, the Statute of Frauds would not apply. Today, the Statute of Frauds still applies to most transactions in real estate, wills or other distributions after death, and, under the Uniform Commercial Code, transactions for the sale of goods which exceed $500. "Goods" are defined as including works of art. (*See also* **Contracts, Uniform Commercial Code**)

STATUTE OF LIMITATIONS

The legal system provides remedies for nearly all injuries, yet there comes a time when the potential claimant should be prevented from asserting those rights if they have not been pursued. It is for this reason that "statutes of repose" have been enacted as defenses to otherwise valid claims. Some of these are known as "statutes of limitation."

In some situations, the law fixes the period for the statute of limitations, such as three years for copyright infringement. In other cases, the law is intentionally silent and the court must determine whether, in fairness, a reasonable period has elapsed so as to bar the claim. These statutes of repose, known as "laches," apply in, for example, trademark cases and other situations where it is felt that the complainant, knowing of the wrong, has allowed it to continue, misleading the perpetrator into believing that its actions were acceptable. As a matter of public policy, in some cases, there is no statute of limitations, such as murder or concealment of income for income tax purposes. (*See also* **Lawyer, Small Claims Court**)

STOP PAYMENT

If you tell your bank not to pay a check which you have already issued, it's known as a stop payment order. There is usually a charge for this service.

Proceed with caution. In most states, it is against the law to stop payment on a check except for very good reason. Such reasons include a check that was lost in the mail, or where a contract has been cancelled but the check has already been issued as a down payment and not been returned. To stop payment on a check for an otherwise valid transaction may be illegal or a breach of contract.

A valid stop payment order must, of course, be given before the check has cleared your bank. In commercial transactions, this has to be done before midnight of the day following the day the check was issued. The stop payment order may be telephoned to the bank, but must be confirmed in writing as soon thereafter as possible.

Be sure to make a checkbook entry to indicate that a check has been stopped. (*See also* **Checking Account**)

STUDIO OF

A term used by experts to describe a work by an unknown hand executed in the style of a specific artist under the artist's direct supervision. (*See also* **Authenticity, Attributed to, Manner of, School of**)

SUITE

A number of works constituting a set, series, sequence, or the like. A collection of work by the same artist which is somehow related may be considered a suite; for example, a series of prints depicting the four seasons or the 12 months. (*See also* **Collections, Limited Edition, Multiples**)

SUPPLIERS

Since the raw materials and the tools and equipment you use are major expense factors in any artist's budget, the suppliers of these items are important sources with whom a relationship should be developed.

Artists who produce their work for sale are usually entitled to purchase their supplies at wholesale prices, or at least at some discount from the retail price. A neighborhood art supply store which buys its stock at wholesale prices for resale to hobbyists can't realistically be expected to sell at wholesale to professional artists. What they offer is convenience. Artists who buy supplies in large quantities or who purchase expensive pieces of professional equipment can often establish a business relationship with manufacturers or wholesale distributors. In states which have a sales tax, the artist is usually required by the manufacturer or distributor to provide his or her resale number in order to qualify for the wholesale price.

The advantage of the lower price is sometimes offset by the fact that the merchandise frequently has to be ordered by mail and that minimum quantities are often required. With good planning to meet the minimum requirements and to account for the time element, the savings can be considerable.

A continuing relationship with a supplier generally also provides the artist the opportunity to obtain the goods on credit. Credit is rarely available to new customers until they've established a track record through pre-payment or a number of C.O.D. orders. Some suppliers and manufacturers also require a minimum monthly dollar volume in order to qualify for credit purchases.

It is occasionally feasible for several artists to join together to buy supplies in large quantity and thus obtain a better price. This is especially true of supplies such as packing materials, office supplies, and other items not specifically related to the artwork being created. Buying clubs, such as OfficeMax, Costco, and the Office Club, are good sources of common materials, particularly office supplies and the like. Some charge a membership fee, which can be split among several individuals, and which is deductible as a business expense.

A reliable supply dealer or manufacturer also keeps customers informed of new products, new equipment, new colors. A good relationship with a supply dealer also makes it much easier to return a defective product or make exchanges.

Where do you select such supply dealers or manufacturers?

Much depends on the personalities involved, on the reputation of the supplier, on the artist's needs in terms of delivery, selection, and so forth.

Art publications provide information both on what's available and who has it. Other artists, art schools, and arts organizations can usually be helpful in making suggestions based on experience.

Manufacturers and suppliers who sell by mail furnish catalogues, price lists, and other ordering information. They sometimes charge a small fee for the catalogue, which can usually be applied to the first order. In some cases, as with paper and the like, they will also furnish samples of material. (*See also* **Cooperatives, Credit, Equipment, Trade Credit**)

T

TAX

A tax is the compulsory payment of money, established and enforced by law, to a governmental body for purposes of meeting the general expenses of government. Taxes are normally based on a percentage of the value of the taxable subject, e.g., income, property, sales. Taxes are not based on the use of a specific benefit.

Compulsory payments which relate to a specific benefit or service are not generally called taxes, even though they are also established and enforced by law and paid to a governmental body. These costs, including license fees, highway tolls, and sewer assessments, are usually fixed amounts instead of percentages.

In the case of artists who devote their full time to producing artwork for sale, all reasonable and customary business expenses are deductible, even if they exceed the year's income from the sale of art.

In the case of people who have other jobs but who work at their art regularly in their spare time with the intent to sell, business expenses may be deductible up to the amount of income realized from the sale of art in any given tax year.

In the latter category, it is very important to observe the Internal Revenue Service guideline which establishes a presumption that an activity is a business rather than a hobby if it makes a profit in three out of five consecutive years. People who pursue art purely as a hobby probably cannot deduct their expenses.

A critical factor, if the IRS questions your business deductions, is your intent. In other words, did you really intend to make a profit? Did you really intend to conduct a business, even if only part-time? Your business intentions will be much easier to substantiate if you have kept a good set of financial records, if you can show that you have invested in materials and equipment, have a separate business bank account, have advertising literature with your business name, and similar evidence; in other words, conducted your art activities

as a business. For example, purchasing this book, as distinguished from merely borrowing, will go far in establishing your credibility as a business person.

Under the three-out-of-five-year rule, you are more likely to be able to substantiate your position that you are a professional artist and not a hobbyist if you show a profit early in the five-year period. There are legal methods by which you might be able to manipulate some deductions. For example, you may legally prepay certain expense items, such as insurance premiums or rent, thus "bunching" your deductions in one year and reducing them in the next year. Similarly, you may postpone buying certain items until after year-end. There may come a time, especially in a year when income and expenses are very close, when you find it worthwhile to defer some expense items in order to show a profit that year. That will, in turn, allow you to take all the deductions in the next year.

No matter what tax category you're in, the most essential point to remember is that a sound and consistent method of recording every expense item is required if your return is audited. (*See also* **Accountant, Accounting, Capital Gains, Customs, Estimated Tax, Income Tax, Property Tax, Sales Tax, Sales Tax Exemption, Social Security, Tax Preparer, Unemployment Insurance, Withholding Tax**)

TAX PREPARER

A tax preparer is an individual who assists a person or business with preparation of tax returns. To represent a taxpayer in the tax courts and before the Internal Revenue Service, however, the preparer must be a Certified Public Accountant (CPA), an attorney, or an Enrolled Agent. An Enrolled Agent must have passed a stringent four-part test. There is no licensing or state regulation of tax preparers except in the state of Oregon, where tax preparers must be state-licensed.

To become a Licensed Tax Preparer in Oregon, an individual must pass a state-administered test. A Licensed Tax Preparer may sign tax returns on behalf of another but only under the direction of a CPA, attorney, or Licensed Tax Consultant who has satisfied even more demanding requirements. (*See also* **Accountant, Audit, Computers, Income Tax—Business, Income Tax—Personal**)

TELEPHONE

The telephone has become not only the major mode of modern communication, but also one of the items in the monthly overhead. As a result of deregulation, telephone services are quite competitive.

Shop Around for the Best Buy

Services

There may be only one telephone company in town, but that company will likely offer many different services. These are the four most common ones, depending on your location and your needs:

1. Individual-line message rate service, with a monthly allowance of message units, usually fifty.

2. Individual-line message rate service with no message unit allowance. This is most economical for telephones which are used primarily to receive incoming calls rather than make outgoing calls. Once the outgoing calls reach thirty or forty a month, this service is no longer economical.

3. Individual-line flat rate service which allows an unlimited number of calls within a specified calling area.

4. Party-line flat rate service. This is the least expensive but, if another party on your line is using the phone, you cannot use the line.

Equipment

You should also shop around for the best buy in telephone equipment. Phones come in a variety of styles, colors and features. You may wish to rent a phone from your local phone company. If you wish to purchase a phone, they are available from the phone company and most business equipment outlets. Telephones today are integrated with all kinds of equipment, such as clock-radios and fax machines, and other technologies. Phones can even be cordless, video, or cellular. While cordless phones provide some convenience, they have some drawbacks. Some models do not have the sound quality of traditional phones, and there may be some privacy issues in using them.

Message Units

In many parts of the country, especially in metropolitan areas, the message unit is the way telephone usage is measured and billed. One call is not necessarily one message unit. Distance and time both determine how many message units the call will cost. The time of day when the call is made can also determine the cost of each message unit.

The actual charges are different in different parts of the country, but the message-unit principle is the same wherever it applies. Read the front pages of your telephone book carefully to see how it works in your area.

The secret is to make calls as brief and to the point as possible without being abrupt. If a customer calls, be considerate. Don't interrupt yourself to conduct other business while the caller hangs on. Just waiting for you to come back on the line costs the caller money. That's common courtesy, even in areas where message units are not counted.

Long Distance

Place as many calls as you can by direct dialing. Once you use the operator for such services as person-to-person, collect, and credit card calls, the cost goes up substantially.

Charges differ according to the time of day you place your call. The highest rate is charged during customary business hours.

The charge for a long distance call is determined by the time at the point where the call originates. Placing a call from Los Angeles to New York before 8 A.M. gets the call to New York before 11 A.M. since there's a three-hour time difference. Conversely, placing a call in New York at 6 P.M. can still reach a business office in Los Angeles at 3 P.M. It does not pay, therefore, to make a call at 4:55 when a five-minute wait can cut the cost of that call by a third or more.

In the front pages of your telephone directory you will find the long distance rates to major points from your calling area. It is often worthwhile to dial direct and take a chance on reaching the person you want rather than placing an expensive person-to-person call. You can generally afford several direct station-to-station calls during the bargain hours for the cost of one person-to-person call. And if you connect the first time you're ahead. Even if you don't reach the party, most businesses have answering machines, services, or voice mail.

The operator-assistance charges do not apply if you need help because there's trouble on the line when you try to dial the call directly. But be sure to tell the operator about it.

Wrong Numbers

If you reach a wrong number, call the operator, tell him or her you reached a wrong number, and ask for credit. That applies for local calls where message units are counted as well as long distance calls.

Keeping Track

If your business phone and your home phone are one and the same, the business calls are a tax-deductible business expense. Long distance calls are easy enough to identify—the telephone bill shows the number you called and the date you called it. For local business calls, keep a log of telephone calls. Every time you make a local call, note it in the log. If you're in a message-rate area, estimate how many message units you used, based on the length of time and distance you talked, and make a check mark for each message unit. At the end of the month it's easy enough to add up the business calls by counting the check marks.

Cellular (Mobile) Telephones

Cellular phones have become a popular business tool. They provide business people with the opportunity to make or receive calls nearly everywhere. There is considerable competition between both cellular phone manufacturer and the cellular network companies. It is, therefore, worthwhile to shop around before purchasing a cellular phone or subscribing to a cellular network. These phones are extremely convenient, yet there are medical, environmental, and privacy issues which have not yet been resolved.

Facsimile ("Fax") Machines

Fax machines have made the phone even more valuable to the successful business. By connection to a standard phone line in your home or business, fax allows instant transmission and receipt of copies (facsimiles) of documents via the telecommunications network, such as confirming memoranda, shipping instructions, even photographs, sketches, and diagrams. Faxing makes it possible for two individuals a few miles or several states apart to negotiate the terms of a contract, usually within the time it takes to make a phone call or two.

It may be more efficient to have a phone line dedicated to use by your fax machine. It is possible, however, to get by with a single line, connecting the fax only when you are actually going to send or receive a document.

Modem

Another device which has enhanced telecommunication facilities for the small business in recent years is the modem. A modem (modulator/demodulator) is a device which converts the "serial" or

"asynchronous communications" output of a computer into sound (and vice versa) so that it can be transmitted via the telecommunications network between distant computers.

Modems give their users access to an ever-increasing number of database services, including electronic mail; hotel, travel and airline reservations; home shopping; newswire services; periodicals; legal, medical, and general information databases; and many others.

Beep Tone

If you hear a beep tone every fifteen seconds while you're talking, it means that your conversation is being recorded.

Debt Collection

The law prohibits making harassing or threatening telephone calls to obtain money that is owed. Don't make such calls. And if you get a call like that, contact your telephone company business office.

Fraud

It is illegal for anyone to use a credit card or charge calls to another number without authorization. If you lose your telephone credit card, or if you find calls on your bill that you did not make, contact your telephone company business office. Be careful when using your own telephone credit card to protect the number.

Displaying Your Phone Number

It's good business to let your collectors know how to get in touch with you. List your telephone number, including the area code, on all letterheads, business cards, invoices, promotional literature, and wherever you put your name in print.

Information Please

The charge for directory assistance varies (and must be waived for the legally blind). It pays to look up numbers yourself. Where such information charges are in effect, the telephone company normally makes directories for areas other than your own available upon request; there is sometimes a charge for these directories. In New York state, for example, a telephone user may request each of more than 100 directories published in the state. Area codes for the entire country are printed in the front section of all telephone directories. (*See also* **Pricing**)

TERMS OF SALE (*See* **Sales Terms and Conditions**)

THEFT (*See* **Security**)

THEFT INSURANCE (*See* **Property Insurance**)

TITLE (*See* **Bailment, Installment, Lien, Loans, Mortgage, Uniform Commercial Code**)

TRADE CREDIT

One of the sources of short-term financing of your business is the use of trade credit. This is the money you owe your suppliers until you pay your bill.

Once your credit reliability has been established, you can purchase equipment and supplies without paying cash at the time of purchase. At the end of the month, you will get a bill which usually must be paid within 30 days. It is possible, therefore, to borrow that money for as long as 60 days without paying any interest.

That may not be a major factor in your financing if you buy only a few dollars' worth of supplies each month. But suppose your monthly purchases total $2,000, and you always have a $2,000 balance billed at the end of the month; you have in effect borrowed $2,000 all year long. At an interest rate of 8 to 10 percent, you save around $200 a year in interest charges. If you pay your bills within ten days after receipt, you often save another 2 percent which many suppliers give as a discount for prompt payment.

What you are doing, in effect, is having your supplier finance part of your operation. The supply dealer benefits from this arrangement because credit terms are extended only to reliable customers. Credit is one of the services the supplier offers to keep you as a good customer.

When work is consigned to a dealer for sale, the artist is, in fact, a trade creditor and is providing the dealer with the same kind of loan discussed here. (*See also* **Capital, Credit, Credit Card, Discounts, Loans**)

TRADE DRESS

This is a relatively new form of intellectual property protection which is available without registration on the non-functional "aspects" of certain items. Packaging is functional and, thus, not

copyrightable, yet products are frequently identified by their distinctive packaging—for example, Campbell's red-and-white soup cans and the deckle-edged heavy paper and romantic look of Blue Mountain Greeting Cards. The distinctive "look and feel" of an item is known as its "trade dress," which is protectible. (*See also* **Intellectual Property, Trademark, Copyright, Patent, Trade Secret**)

TRADE LIBEL (*See* **Disparagement of Art**)

TRADEMARK

A trademark is described in the Trademark Act of 1946, as amended in 1989, as "any word, name, symbol, or device, or any combination thereof adopted and used by a manufacturer or merchant to identify its goods and distinguish them from those manufactured or sold by others."

A trademark serves not only to indicate who made the product, but often suggests a certain level of quality based on the manufacturer's past performance. Typical trademarks known far and wide are the oval Ford symbol, the distinctive lettering of Coca-Cola, the Nike swoosh, and many others.

When an artist uses a unique symbol to mark his or her work, it is a trademark. While trademarks need not be registered, registration helps to protect the owner's exclusive right to use the trademark.

The difference between trademarks and trade names is that a trademark identifies a product, while a trade name identifies the producer of the product. When a trade name is designed in a unique fashion and is used on the product, it can become a trademark and be registered as such.

Trademarks must appear on the merchandise or its container, or be associated with the goods at the point of sale, and must be used regularly in interstate commerce to remain valid. Certain material may not be used in trademarks, such as the United States flag, the likeness of a living person without his or her permission, and several others.

Generic marks, i.e., words which are the noun describing a product or service, such as "chair" for a chair, are not protectible. If a mark is "merely descriptive," such as *TV Guide* for a publication listing television offerings, then it may be protectible if it has acquired a "secondary meaning" by notice of use, promotion, and visibility.

Before a mark is actually used in commerce, an "intent to use" application covering the proposed mark may be filed with the Patent and Trademark Office. Once the mark is actually used, this filing will mature into a registration.

Trademarks which are already in use may be federally registered with the U.S. Patent and Trademark Office, Washington, DC 20231, by furnishing a written application, a drawing of the mark, three specimens or facsimiles of the mark as it is actually used, and a fee of $210. The registration is valid for ten years and can be renewed for further ten-year terms. When a trademark is not used regularly on a product or its container, the registration lapses, even if the ten-year term isn't up.

After a mark has been federally registered, notice of the registration should accompany the mark wherever it is used. Various means are available to do this, the most common being ® which is placed right next to the mark. Note that ® may be used only in connection with federally-registered marks.

Variations of a trademark are service marks, to identify a service rather than a product; certification marks, which are not related to a specific product or manufacturer, but might indicate regional origin, method of manufacture, or union label; and collective marks, used by members of an association, cooperative, or other organization. All these can be registered in the same fashion as a trademark.

The Patent Office does not give legal advice regarding trademarks, nor can it respond to inquiries whether certain trademarks have been registered. The Patent Office does maintain a file of registered marks which are arranged alphabetically where words are included, or otherwise by symbols according to the classification of the goods or services in which they are used. These files are open to the public in the Search Room of Trademark Operations in Washington, DC, and it is advisable to have the files searched to determine whether the same or a similar trademark has already been registered.

A detailed booklet, "General Information Concerning Trademarks," is available for 50¢ from the Superintendent of Documents, U.S. Government Printing Office, Washington, DC 20402.

During the period when the application for federal registration is pending, it is common to use the designation ™ for trademarks, and ˢᴹ for service marks. These designations have no official status but merely give notice of a claimed property right in the mark.

There is also a state trademark registry in every state in the Union. State registration is beneficial only within the registering state and does not permit the use of ®. The remedies for infringement laws are often different from those available under the federal statute. (*See also* **Copyright, Intellectual Property, Patent, Trade Dress, Trade Name, Trade Secret**)

TRADE NAME

Many businesses use a name for public identification which differs from the name of the owner. You may be Sam Jones, but the sign on your door reads Fine Art Gallery. That's a trade name.

Since trade names can't be held legally responsible for anything, it is almost universally required that a trade name be registered with some governmental authority, often the Secretary of State or the county clerk.

The initials *d/b/a* or *dba* (doing business as) appears on such documents as legal papers and credit reports to tie the trade name to the owner, as in: "Sam Jones *d/b/a* Fine Art Gallery." Trade names may also be known as "assumed business names" (abns) or "fictitious business names."

To protect a trade name from unauthorized use by others, it may be registered with the federal government as a trademark if certain conditions are met. (*See also* **Intellectual Property, Trademark**)

TRADE SECRET

A trade secret is any information which is non-public and which provides a commercial advantage. It could include, for example, a formula for a paint color, customer or supplier lists, or the like. Trade secrets are protectable only so long as they remain secret, and one who improperly discloses a trade secret may be liable for damages. It is a good idea to identify your trade secrets as such by labeling and to make them available only on a "need-to-know" basis. Employees or others who are given access to them for valid business reasons should be required to sign an agreement not to use or disclose the secret without your express written permission. Since trade secret law and trade secret protection are quite complex, you should consult with an experienced intellectual property lawyer in order to establish a trade secret program if you feel your business has trade secrets. (*See also* **Intellectual Property, Copyright, Patent, Trademark, Trade Dress**)

TRANSPORTATION (*See* **Freight Allowance, Freight Forwarders, Post Office, Shipping, United Parcel Service**)

TRAVEL (*See* **Business Trips, Tax**)

TRAVELER'S CHECKS

Traveler's checks are extremely popular because they are very safe to carry, and are recognized almost everywhere in the world. The safety factor exists because purchasers sign their checks once when they buy them, and then again when they use them.

Two precautions: (1) Do not accept a traveler's check unless the person who offers it signs it in your presence. Compare the signatures and accept the check only if they match; and (2) a traveler's check with both signatures but no endorsement is as good as cash if it is lost or stolen. Immediately upon receiving a traveler's check as payment, indorse it with your name, the words "for deposit only," and your checking account number. Then handle it like any other check on your bank deposit slip.

A new feature in traveler's checks is a check which may be used by either of two designated parties.

TREATY

A treaty is an agreement between two or more nations which commits them to grant rights or to take some action. Treaties may be bilateral—which means between two nations, or multilateral—that is, between many nations. They may be self-executing; that is, merely becoming a party to the treaty makes the treaty operable within the nation; or the treaty may require the enactment of a special law, known as enabling legislation, for the purpose of making it effective in that nation.

A nation may adopt all of a treaty's provisions or may become a party "with reservations" or "with exceptions." This means that the nation does not agree to and is not bound by all of the treaty's provisions. Many multilateral treaties are periodically reviewed and revised by some administering organization; for example, the Universal Copyright Convention is administered by UNESCO, and the Berne Copyright Convention is administered by the United Nations General Assembly. (*See* **Berne Copyright Convention; Buenos Aires Convention; Native American Graves and Repatriation Act of 1991; UNESCO Convention on the Means of Prohibiting and Preventing the Illicit Import, Export and Transfer of Ownership of Cultural Property; Universal Copyright Convention**)

TRIAL PROOF

In editioned prints, a proof pulled before the printer's proof that isn't satisfactory. Trial proofs are rarely preserved or offered for sale, although they may be very interesting because artist's frequently draw revisions on them. These are not included in the edition but, if they are ever sold or otherwise transferred, a disclosure form complying with the multiples laws should be used. (*See also* **Artist's Proofs,** *Hors commerce,* **Multiples, Prints, Working Proofs**)

U

U.S. DEPARTMENT OF COMMERCE (*See* **Government Activities**)

U.S. DEPARTMENT OF LABOR (*See* **Employees, Government Activities, Wages**)

UNEMPLOYMENT INSURANCE

Unemployment insurance is a government program which provides cash benefits to unemployed people who are seeking work but have not yet found a job. Eligibility requirements and the size of weekly checks vary from state to state. Benefits are funded by mandatory payments made by employers in the form of a payroll tax. The weekly check received by the unemployed is based on the amount of money the individual earned during the qualification period.

Unemployment insurance is exactly what the name implies: insurance which provides benefits as a matter of right, as long as the unemployed applicant meets the conditions of the law.

The specific rules and regulations which apply in the different states are available through each state's Department of Labor. (*See also* **Employees, Insurance, Wages, Worker's Compensation, Tax**)

UNESCO CONVENTION ON THE MEANS OF PROHIBITING AND PREVENTING THE ILLICIT IMPORT, EXPORT AND TRANSFER OF OWNERSHIP OF CULTURAL PROPERTY

This treaty was first open for signature in the early 1970s, though only the so-called "art-rich" third world nations such as Mexico and Guatemala were parties to it. The United States became a party in 1983. Under the treaty, a signatory nation will assist any other signatory nation by prohibiting the import of certain identified works of art or cultural property. In the United States, the U.S. Information Agency is charged with responsibility for determining whether the United States will assist a requesting nation in protecting identified works of art or cultural property.

This treaty does not automatically prohibit a country from permitting an item which has been illegally exported from its country

of origin to be imported. The complex treaty procedure requires a country desiring to protect cultural property to first identify, with some particularity, the threatened cultural property, request that other signatory nations seize that cultural property if it is attempted to be imported, and obtain agreement by the country obtaining the request to cooperate.

To date, the United States has assisted several countries in reclaiming some cultural artifacts, such as Peruvian pre-Columbian art.

Without this treaty, it has traditionally been held that a country will not ban the import of a work of art or cultural property even if it has been illegally exported from its country of origin. Countries generally will not enforce either the criminal laws or the tax laws of another country unless they have agreed to do so by treaty. (*See also* **Treaty**)

UNIFORM COMMERCIAL CODE (UCC)

The Uniform Commercial Code (UCC) is the evolutionary embodiment and codification of the law of commercial transactions. Begun in the 1940s as a joint project of the American Law Institute and the National Conference of Commissioners on Uniform State Laws, the Code (or UCC) brought together in a single document many of the common law principles and a number of earlier uniform laws governing such transactions. Some of these laws are:

Uniform Negotiable Instruments
Uniform Warehouse Receipts Act
Uniform Sales Act
Uniform Bills of Lading Act
Uniform Stock Transfer Act
Uniform Conditional Sales
Uniform Trust Receipts Act

Since its first enactment in Pennsylvania in 1953, effective July 1, 1954, the UCC has undergone a number of revisions with reissues of Official Text and Comments in 1958, 1962, 1966, 1972, 1977, and 1987. All states except Louisiana have adopted one or another version of the UCC, either in whole or in part, and many have adopted later amendments as they appeared. Some states have incorporated their own language and modifications while maintaining the basic UCC matrix.

The purpose of the UCC has been to simplify, clarify, and modernize the law governing commercial transactions. Its underlying policy is to permit the continued expansion of commercial practices through

custom, usage, and agreement of the parties. Both of these goals have been very successfully achieved by making the law fairly uniform throughout the various jurisdictions that have adopted the UCC.

Today, the UCC continues to deal comprehensively with the various statutes relating to commercial transactions. Its articles cover broadly and specifically many aspects of personal property and contracts and other documents concerning them, including: Article 1—General Provisions (and definitions); Article 2—Sales; Article 3—Commercial Paper; Article 4—Bank Deposits and Collections; Article 5—Letters of Credit; Article 6—Bulk Transfers; Article 7—Warehouse Receipts, Bills of Lading, and Other Documents of Title; Article 8—Investment Securities; and Article 9—Secured Transactions, Sales of Accounts, and Chattel Paper.

A new section, Article 2A—Leases, was added in the 1987 edition of the UCC. Many states have already adopted Article 2A into their commercial codes, with effective dates beginning in 1989. It is likely that most states will follow suit over the next few years. (*See also* **Collection Problems, Consignment, Contract, Foreclosure, Lease, Letter of Credit, Lien, Sales Terms and Conditions**)

UNITED PARCEL SERVICE

Private firms such as United Parcel Service ("UPS") have, for many years (UPS since 1907), provided an alternative to the post office and, with the steady deterioration of postal service accompanied by hefty increases in postal rates, these alternatives have become real competition.

United Parcel Service makes delivery by truck to any place in the continental United States, and ships by air to major cities, Alaska, Hawaii, Puerto Rico, Canada, and over 180 other countries and territories.

UPS provides a number of advantages over postal service:

1. Every parcel is automatically insured up to $100 (additional insurance at 30¢ per $100).

2. UPS's delivery charges are often cheaper than the post office's.

3. Delivery time is often faster than the post office's. It takes one day to deliver parcels locally via UPS. To send a package all the way across the country by truck takes five days, two days by air (guaranteed).

4. UPS will accept parcels larger than those accepted by the post office. UPS parcels can measure up to 130 inches in length and

girth combined. The post office maximum is 108 inches. (Girth is like waist: measured all around at the middle.)

5. UPS picks up as well as delivers. You don't have to drag the packages to the post office and wait in line there. Furthermore, UPS will make delivery attempts three days in a row if no one is available to receive the parcel on the first try. The post office leaves a slip in the mailbox on the first day to notify you of their attempt to deliver. Then you have to pick up the package yourself or call the post office to have it redelivered.

Rates

UPS shipping rates are, like the post office, based on weight, distance, and manner of shipment (ground or air). On that basis alone, UPS is usually less expensive than the post office. However, there is a minimum weekly pickup charge which applies whether you make only one shipment or a thousand.

For only an occasional shipment, then, the post office may be less expensive (although not always). However, if you ship 100 packages a week, then the cost of each shipment is increased by only a few cents, which still keeps it way below the post office rates.

Regular Accounts

Businesses which ship many parcels on a regular basis can establish an account with UPS. Account holders are supplied with a record book stamped with an individual account number, cost charts, and special shipping labels. You fill out a daily slip that lists and describes all the parcels being sent out that day. The UPS truck comes by regularly every day to pick up all the packages, and the UPS driver signs for them.

Tracing

Since every package is signed for, from pick-up to delivery, it is simple enough to trace a parcel which may have gone undelivered. In such cases, UPS furnishes a Xerox copy of a signed receipt within three days, or handles the claim if a package was lost. Rates for the regular account service vary in different parts of the country, and billing is done once a week. The same weekly minimum pickup charge applies to regular accounts as well, but amounts to almost nothing when the minimal charge is distributed over hundreds of packages.

Insurance

A package sent by ground may be insured up to $5,000 if it is brought to UPS by the customer, up to $2,000 if it is picked up by UPS. Since UPS insurance is limited (the post office will insure for any amount), it is not advisable to send irreplaceable or unusually valuable objects, such as one-of-a-kind craftwork, via UPS.

Restrictions

UPS does not deliver to Canada or overseas. It makes no Saturday or Sunday pick-ups, except that it makes Saturday pick-ups for next-day air deliveries in many areas. UPS does not handle packages weighing more than 70 pounds.

For artists or galleries which ship numerous parcels, UPS often provides a less costly and less bothersome alternative to the post office. For single pieces, or those that require considerable insurance coverage, the post office is the better way. (*See also* **Post Office, Shipping, Transportation**)

UNIVERSAL COPYRIGHT CONVENTION (UCC)

This treaty was open for signature in the mid-1950s and provides international protection for copyright owners in the nations which have become parties to it. The protection must be at least as good as the protection available for nationals where enforcement occurs.

In order to obtain international protection under the UCC, a copyright owner must obtain a copyright in a signatory nation, comply with that nation's copyright laws, be a citizen or domiciliary of a nation which is a party to the UCC, and use the international copyright symbol © in the copyright notice, along with the full name of the copyright owner and the year of first publication.

Eighty-three countries are parties to the UCC. While this treaty is quite beneficial for international protection, it is not as popular as the Berne Copyright Convention, which has 88 signatory nations.

The UCC is administered and periodically revised by UNESCO. This means that the administering entity considers and recommends modifications to the treaty which must be agreed to by a signatory nation in order for the change to be binding on it. (*See also* **Berne Copyright Convention, Buenos Aires Convention, Copyright, Treaty**)

UNRELATED BUSINESS INCOME

Qualified non-profit corporations, such as museums, often engage

in commercial activities. For example, they may have public restaurants, gift shops, and rental-sales galleries. If the primary function of the organization is commercial, however, then it should not be entitled to tax-exempt status. The Internal Revenue Service periodically reviews the extent of a museum's commercial activities, in order to make this determination.

When in doubt about the extent of its commercial activities, a non-profit organization should apply to the IRS for an advisory opinion known as a "Revenue Ruling." These Rulings customarily state the facts as presented by the requesting organization and, based on those facts, the determination by the IRS whether the organization should be permitted to retain its tax-exempt status. If a Ruling is requested before engaging in the commercial activity—which is very common—and a negative response is received, the organization should not engage in the activity and jeopardize its tax-exempt status.

According to the Internal Revenue Code, a non-profit tax-exempt organization such as a museum may engage in *some* commercial activity, provided the commercial activity is for the purpose of assisting the organization in fulfilling its mission and provided that the commercial activity is closely related to the non-profit function of the organization. If a museum is located in close proximity to a number of restaurants, operating its own restaurant is unnecessary and could jeopardize the organization's tax-exempt status. Museum gift shops which sell souvenirs must be careful to handle only items which are related to museum exhibitions.

The extent of commercial activity can also be a problem. For example, when the Metropolitan Museum was asked to license reproduction of certain patterns in its fabric collection, it applied to the IRS for a Ruling, since it was anticipated that the royalties from this project would be several hundred thousand dollars. The IRS ruled that the unrelated business income would not jeopardize the Museum's tax-exempt status, though the unrelated business income would be taxable.

Some organizations actually set up wholly-owned business corporations as subsidiaries for their commercial activities. (*See also* **Museum, Non-Profit Corporation, Income Tax—Business, Tax**)

UTILITIES (*See* **Pricing**)

V

VANDALISM (*See* **Security**)

VENDOR

A vendor is, simply, one who sells. This term is commonly used by lawyers, which is why you often find it in sales contracts and on order forms. It is also used by purchasing agents as a generic reference to any source of supply.

When an artist sells artwork to a collector, the artist is the vendor. When buying raw materials from a supplier, the supplier is the vendor.

VISUAL ARTISTS RIGHTS ACT ("VARA")

For years, art advocates urged Congress to grant American artists rights comparable to those available under the European *droit morale*. While some states did pass moral rights legislation, the laws were geographically limited to the enacting state's boundaries and there was no uniform state law. Every state moral rights statute is unique and differs from every other state statute.

Senator Edward Kennedy (D-Mass.) first introduced a bill which covered most aspects of both resale royalties *(droit de suite)* and moral rights *(droit morale)*. There were numerous hearings, compromises, and revisions; in 1990, Congress passed the Visual Artists Rights Act ("VARA") as an amendment to the U.S. copyright law.

Two years earlier, the United States became a signatory to the Berne Copyright Convention, which grants Americans copyright protection for their work in some 88 countries. The Berne Union requires all signatories to provide certain minimum moral rights protection within the signatory country. The United States' representative to the Berne Union claimed that U.S. law satisfied these minimum requirements, despite the fact that many critics disagree. When VARA was enacted two years later, it was felt by some that it would fill in any gaps in U.S. law necessary to satisfy the minimum moral rights requirements for the Berne treaty. Some commentators feel that VARA does not, itself, satisfy the Berne moral rights requirements.

VARA is narrower in scope than the copyright law and covers only "a painting, drawing, print, or sculpture, existing in a single copy, or limited edition of 200 or fewer signed and consecutively numbered." The coverage also extends to "a photographic image produced for exhibition purposes only as a signed, numbered edition." The rights granted by VARA belong solely to the artist and are not transferable. VARA protects the integrity of a work within its scope; i.e., it prohibits intentional alteration or distortion of a work by anyone other than the artist. It is believed by some that removal of site-specific work is within the scope of VARA.

Remedies for violation of VARA include all damages for copyright infringement except penal sanctions. In addition, an artist has the right to demand (1) that he or she be properly credited as the creator of his or her covered works, (2) that the artist's name be removed from any work not created by him or her, and (3) that the artist's name be removed from any work which the artist deems to be so altered or distorted as to be injurious to his or her honor or reputation.

VARA does not include a resale royalties provision, though the Copyright Office has been required to provide Congress with a study regarding the propriety and benefits of resale royalties. The study, which was completed in 1992, was equivocal and reached no concrete conclusion.

Eleven states have moral rights legislation, which grant artists broader protection than VARA. It is not clear whether these state laws may expand the protection available for artists in those jurisdictions or whether VARA will define the limits of artists' moral rights automatically available in the United States.

Artists may continue to use contracts containing moral rights protection and those contracts should continue to be enforceable. (For a sample contract, *see* **Appendix G** and ***The Deskbook of Art Law***.) The extent of protection which may be achieved through contract is limited only by the skill of the person writing the contract. Generally, well-established artists will be in a position to demand contractual moral rights protection. (*See also:* **Berne Copyright Convention, Contract, Copyright,** ***Droit de Suite, Droit Morale***)

VOLUNTEER LAWYERS FOR THE ARTS

Volunteer Lawyers for the Arts (VLA) began in the late 1960s when three New York lawyers recognized the need for legal specialists to

assist the art community. The concept caught on and spread throughout the country. Today, more than half the states have some form of VLA organization providing art-related legal services.

The organizations initially provided *pro bono* (free) legal services to artists and art-related organizations with art-related legal problems. Today, many of the organizations charge based on a sliding scale for the services provided.

Most of the organizations have an educational component and present seminars for their constituents. Some of the organizations also publish books and newsletters. Most VLA groups have art law libraries and make publications available either for free or at a nominal charge. (*See* **Appendix F**)

W

WAGES

Since most artists work by themselves, many confuse wages with profits. Since they get both, it may not seem important to make a distinction.

But it is important. All wages, including the artist's own, are part of the production costs which determine the price you will ultimately charge for your work, and are as important as materials, equipment, overhead, shipping, and other costs. Profits are added afterwards, and represent your training, your investment, your management skills, even your creative talents. The actual work you or others do must be calculated as wages. This is often the single largest ingredient in the cost of production.

The productive time you put into your work covers the time you spend at your easel or sculpting table. But don't overlook the service time you spend repairing equipment, packing art, running errands, doing the bookkeeping, designing a brochure, selling at shows, and uncountable other functions.

How, then, can an artist figure his or her own wages? It is impractical, in most cases, to keep a time sheet to record your time as a chemist at $100 an hour, a laborer at $10 an hour, a bookkeeper at $20 an hour, and so on. It is important, however, to keep a diary of labor time invested by you, your family, friends, and employees in the production of various types of artwork. This helps not only to price objects properly, but to determine whether the various objects bring the proper return, and to project future pricing possibilities for similar works.

The artist must determine his or her salary according to a few reasonable assumptions:

1. What would it (or does it) cost to hire someone to replace me in one or more of my functions?
2. What could I earn if I did the same work for someone else?
3. What do I need in terms of money, and will it fit into the price structure of the artwork I produce?

There are a good many artists who might find, on close exami-

nation, that they work for as little as a dollar or two an hour. There's nothing wrong with that if you decide that's what you want to do, or if you have some other source of income, such as teaching. But if you work at that salary level simply because you've never figured out what you're actually earning, it may be wise to analyze the situation a bit more carefully.

If one work takes one day to produce, and another work, selling for the same price, takes two days, then you are obviously cutting your hourly pay in half when you create the second work.

You have several alternatives for solving that problem:

1. If you can find a more efficient creative method, you may be able to complete the second work sooner, effectively giving yourself a raise.

2. Perhaps you can increase the price of the second work to properly reflect the time you spend producing it.

3. You can cut back on producing the second kind of work and concentrate on the more profitable kinds of work.

4. You may wish to produce your work in multiples, such as prints or editioned sculpture.

Your efficiency and experience are key elements in this situation. An obvious example: a foundry can undoubtedly produce more editioned sculptures per week if several are cast and finished at the same time than if they are completed individually.

The specific procedure you develop depends on a variety of circumstances: the nature of the work, how much room you have to work in, how many people you have working with you, the capacity of the equipment, etc. Everyone has different problems, different purposes, different work styles. In general, it helps if you can organize the various stages of producing multiples of an object by repeating each step several times before going on to the next step.

How do you figure out the time cost for each piece if you make several at a time, especially if you work on a variety of works during the same period?

You'll simply have to keep a careful record of time spent on each type of work, and then divide the time into the total number of works produced. It doesn't matter whether the various steps occur consecutively or are carried out on different days. As long as you make a note of all the time you spend on each group of items, it's a matter of simple addition.

Once you have the time elements down on paper, there are various ways to calculate the wages per piece that must be included

in the final price. The simplest method works somewhat as follows:

Let us assume that you want to earn $50 per hour and work forty hours per week. That's a total of $2,000. You are working on an editioned bronze sculpture and find that you need a total of four hours to produce each piece. That averages two pieces per day. The value of your productive time is thus $200 on each piece.

But look how dramatically your production procedure can affect your wages. If, instead of four hours, you need five hours to make the same pieces, your production is down to eight pieces per week. Your production time per piece now costs $250 ($50 multiplied by five). That will mean an increase in the price of the finished object.

None of this is intended to offer an iron-clad formula. There are many methods of cost accounting to help you calculate such things. But the key factor is to apply every expense item to a specific artwork so that the price accurately reflects the cost.

Raw materials and actual production time are fairly easy to apportion. Service time and other overhead have to be averaged. How to apply these averages is discussed under "Overhead."

Examine and reexamine your production methods and cost factors on a regular basis. It is the only way you can determine whether you are paying yourself a decent wage or whether you get your money's worth for the wages you pay others. (*See also* **Accounting, Employees, Income Tax, Independent Contractors, Pricing, Social Security, Tax, Withholding Tax**)

WARRANTY

A warranty is a contract. There are two kinds of warranties: express and implied. An express warranty is one which states a specific fact. If you sell a painting, stating that it is by Picasso, you have given an express warranty of authenticity. If the buyer discovers that it is a forgery, the transaction may be rescinded. The Uniform Commercial Code (UCC) provides remedies for the breach of an express warranty. That law defines an express warranty as any statement, description, or sample which relates to the work being sold and becomes part of the basis of the bargain.

The UCC also implies a number of warranties into any transaction for the sale of art. These include an implied warranty of title, merchantability, fitness for a particular purpose, and against infringement. If the work is stolen, there is a breach of the implied warranty of title. The merchantability warranty is breached when the artwork is not accepted by dealers or others who hold them-

selves out as art professionals as being what it purports to be. This would apply, for example, to the sale of an obvious fake or forgery. If a work of art is purchased for a specific purpose and the dealer knows of that purpose, implied in that transaction is the warranty that the work must be fit for the known purpose. Selling a Remington sculpture for a museum collection implies that the bronze must be authentic and fit for a museum display.

Sales talk is quite another thing. If a gallery salesperson tells a collector that a work of art is the most beautiful piece ever created and should increase in value, no warranties have been implied or expressed. This type of opinion is known as "puffing" and are not provable facts. (*See also* **Uniform Commercial Code**)

WHOLESALE DAYS (*See* **Exhibitions and Shows, Wholesaling**)

WHOLESALING
There are three ways in which an artist can sell artwork:
 1. Sell directly to the collector (retailing);
 2. Sell to a gallery or other outlet which, in turn, sells the work to the collector (wholesaling);
 3. Furnish the work to a gallery with the understanding that you are paid only if and when the work is sold to a collector (consignment).

The difference between the three involves both work and money. Let us assume that you have a work of art which is sold to the collector for $1,000.

If you retail it directly, you get the whole $1,000 but you also have the work and expense of retailing, such as operating a gallery or taking a booth at a show.

If you wholesale to a gallery which then resells the work, you generally get 50 percent of the retail price, $500 in this example. Since you have none of the work and problems of retailing, you can spend your time in producing more artwork, and you can presumably sell a greater number of pieces.

In consignment selling, you generally receive about 60 percent of the retail price, approximately $600 in this example. You are, however, investing your time and money in the gallery's inventory, and there are other dangers and problems associated with consignment selling.

Retailing and consignment are discussed in greater detail elsewhere in this book. Here, we will concern ourselves only with the

wholesaling operation, in which a gallery purchases your work outright and pays you for it, whether or not it then resells the work to its collectors.

Some artists do not understand, and even resent, the notion that a gallery doubles the price of work it buys from them. Statistics show, however, that most of that markup is not profit, but spent for rent in expensive high traffic locations, for payroll, advertising, delivery, and all the other costs associated with running a gallery. Most galleries consider a five percent profit on the retail price an acceptable ratio. In other words, their profit on that $1,000 craft item might be around $50.

If you have priced your work properly at the wholesale level, the wholesale price should bring you a satisfactory profit. What you lose (or think you lose) in retail markup should be more than compensated by the fact that you can sell larger quantities of your work through wholesale distribution.

What type of retail outlet you approach depends in large measure on how much you can produce and the marketability of your work. If your production is limited, stick to the smaller galleries.

Wholesale buyers normally use their own order form to buy from you. Read all the conditions on the form carefully. Are you prepared, for example, to allow a 2-percent discount if the bill is paid within ten days? Can you meet the delivery date? Do you understand the billing procedure? Does the order form include the store's sales tax exemption number so that you don't have to collect the sales tax?

Major galleries and gallery chains are bureaucracies. If the paperwork isn't done right, everything comes to a dead stop. On the other hand, having a major gallery or gallery chain which keeps you profitably busy all year can be worth the extra effort to meet the bureaucratic requirements.

How do you approach wholesale buyers? In a small gallery, it's fairly simple: the owner does the buying. Telephone first to make an appointment. Don't just drop in.

With large galleries or gallery chains, the process is a bit different. Depending on how the organization's buying operation is organized and what kind of art you are selling, you may have to see whoever is responsible for buying the particular type of item you have to offer. A phone call will generally tell you whom you have to see and when.

Buyers are busy people. Be clear and succinct. Bring your portfolio and resume, or any other information requested by the buyer

during your telephone conversation. Be prepared to leave all this material and information with the buyer.

Try to acquaint yourself with the particular gallery's general merchandising approach and clientele, so that you can discuss your artwork from the gallery's point of view. If the gallery specializes in limited edition prints, then don't try to sell it your bronze sculptures.

The other major area of investigation concerns the gallery's pricing. Does the gallery already sell work comparable to yours? At what prices? Are their price lines compatible with yours? A quick trip through the gallery will reveal whether your work fits into the gallery's merchandising and pricing patterns.

This type of approach is all well and good for local galleries, but how do you establish relationships with galleries elsewhere?

There are a variety of methods. Artists' representatives can assist in placing work in galleries all over the world. Art shows, such as Art Expo and the like, are excellent opportu-nities for artists to display their work to gallery owners. Ads in art magazines are also quite common, and favorable reviews by noted critics can establish your career. Some artists and galleries have run successful ads in airline magazines, business publications, and the like.

Finally, in the enthusiasm of making a sale, don't ignore the business aspects: How does the gallery purchaser pay its bills? What is its credit rating? There's no point in making a sale if you don't get paid for it. Ask around. Talk to some other artists who have sold to or through the same gallery. Most states have special legislation relating to the artist-dealer consignment relationship. (*See also* **Artists' Representatives, Consignment, Credit Reference, Gallery, Retailing, Salesmanship**)

WILL (*See* **Estate Planning**)

WITHHOLDING TAX

Regardless of how much you earn, some portion of an employee's wages or salary must be withheld by the employer from each paycheck for the payment of the employee's income taxes. The employer acts as the collection agent for the Internal Revenue Service and for state and local governments which impose income taxes.

If you are an employer, there are several specific procedures to follow:

1. You must obtain an Employer Identification Number by filing form SS-4 with the Internal Revenue Service.

2. The IRS then provides you with a number of copies of Form 501, which has to accompany the remittance of the tax money you withhold from your employees (including yourself, if you are incorporated and draw a salary).

3. The employer deposits the tax money in its bank with Form 501, according to the following schedule:

a) if the total Social Security taxes (both employer and employee contributions) and federal withholding taxes is less than $200 at the end of a quarter then no monthly deposit is required and you must only pay the tax due with your quarterly 941 report.

b) Generally, if at the end of a month, the tax due is greater than $500, you must make the deposit within 15 days after the end of the month. However, certain large employers may be required to make semiweekly payments..

The bank gives you a receipt for the deposit and, in turn, deposits all the money and all the Forms 501 with the Internal Revenue Service.

Every calendar quarter, every employer is required to file Form 941 directly with the Internal Revenue Service. This form is a summary of all the withholding tax payments that were made on behalf of the business' employees during that quarter.

4. Between January 1 and January 31 of each year, every employer is required to furnish a W-2 form to all employees, showing wages for the prior calendar year. This is a summary of all the wages paid during the previous year, and all income taxes and Social Security taxes withheld during that period. The W-2 form is needed by the employees to file with their income tax returns. The form must be furnished to all employees who were on the payroll at any time during the previous year, even if they worked for only a day and even if they are no longer employed by you. If a terminating employee requests that his or her Form W-2 be provided at the time of termination, the employer is required to do so.

One important observation: When cash supply is short, some employers are tempted to use the witheld tax money for other purposes. That's a temptation which should be resisted. Failure to deposit the withholding taxes is a very serious federal crime and may subject the owners of a business to personal liability even if the business is insolvent.

Any individual who is not an employee of another (i.e., self-employed) is required to pay his or her own estimated tax on a

quarterly basis. This is one of the areas where individuals who are independent contractors can get into trouble. Since they are not employees of another business, they are required to make quarterly estimated payments; failure to do so will subject the independent contractor to penalties and interest payments. (*See also* **Income Tax, Tax, Wages**)

WORK AREA

Since artists spend so much time in their studios, the manner in which these work areas are designed can contribute greatly to the satisfaction of working in them, and to the efficiency in producing artwork.

Following are some helpful suggestions:

1. If you work at home, make the work space serve your artwork exclusively. First, it helps to justify the tax deduction which you may be able to claim as a business expense. Secondly, it makes it so much easier to find things, to get down to work, and to protect the work you've produced. If you constantly have to set up and take down your tools and equipment, you'll spend unnecesary time getting ready to work.

2. Be comfortable. There's no reason why artists should suffer. Is the easel so low that you have to bend over unnecessarily? Or is it so high that your arms get tired too soon? Is the light good enough to avoid eye strain? Are your surroundings too hot, too cold, or too noisy to provide the proper attention to your creative work?

3. The physical layout of your work area is important for both safety and production. Electrical outlets should be readily available wherever you use electric tools or equipment. Extension cords running all over the place are a prime source of accidents and fire. Equipment and workbenches should be located in some logical relationship to each other so that you don't have to drag your work from one end of the studio to the other and back during the various stages of production. It makes sense, for example, to have your chisels and other tools near your sculpting table.

4. Plenty of shelving, peg boards, and other storage devices help to keep raw materials, supplies, and tools easily accessible and in good condition. Small supplies can be kept in jars or cans. Dangerous tools should be protected and hazardous substances such as flammable liquids should be properly stored. (*See also* **Fire Prevention, Safety, Workers' Compensation**)

WORKERS' COMPENSATION

The law has always held an employer liable for injuries or death suffered by his employees if the condition arose from the employer's negligence in not providing safe working conditions.

Workers' compensation laws in every state now allow employees or their heirs to recover damages from the employer's workers' compensation insurance carrier for injuries or death suffered by employees while on the job, regardless of whose fault it was, unless it was self-inflicted or caused by intoxication. The laws vary from state to state, and so does the extent of the insurer's liability, but, in most states, an employer is required to carry workers' compensation insurance.

Premiums are generally based on a percentage of the payroll as related to two factors: the hazard of the job and the claims history of the employer. Premiums may be reduced, therefore, by increasing safety precautions and preventing injuries.

Artists need not carry workers' compensation insurance if they work alone. The moment you hire an employee, however, even a part-timer, the workers' compensation law of your state will likely apply. Before you put anyone on the payroll, talk to your insurance broker or contact your state labor department to find out what's required of you under your state workers' compensation law. Even if you are not required to obtain workers' compensation insurance for yourself or a single employee, you may voluntarily do so and the cost of such insurance may be worthwhile. The premiums are a deductible business expense and one work-related injury is sufficient to put you out of business if you're not insured. (*See also* **Employees, Safety, Tax, Unemployment Insurance**)

WORKING PROOFS (*See* **Artist's Proofs, Hors commerce, Trial Proofs**)

WORKSHOPS (*See* **Education**)

X

XEROGRAPHY

Xerography is a photomechanical process for reproducing a printed image. Some artists have created original works using this process by combining several distinct images in a single reproduction.

The term derives from the specific process developed by the Xerox Corporation employing its machines. Since XEROX is a registered trademark and in danger of become generic by the common misuse of it both as a noun and a verb, the corporation has been extremely aggressive in reminding the public that "You can't xerox a xerox on a xerox." You should properly be photocopying on a Xerox, Canon, Mita, or the like.

Y

YEAR-END

The term used by accountants, tax preparers, and others involved with financial information, to describe the close of a year for a variety of business and tax purposes. Most often, the business year is the same as the calendar year, but it may be a "fiscal year," which is any prescribed 12 consecutive months. For tax purposes, individuals and S corporations must operate on a calendar year; their "year end" will, therefore, be December 31. The Internal Revenue Service has taken the position that a business which does not properly designate another fiscal year will be on a calendar year.

When applying for a loan, the lending institution may demand a copy of the most recent year-end financial statement as a means of evaluating the credit worthiness of the business. (*See also* **Accounting, Financial Statement, Loan, Tax**)

Z

ZONING

Most cities and towns impose regulations on the use to which various areas under its jurisdiction can be put. Thus, some sections or streets may be zoned for residential use only, others for retailing or light manufacturing or heavy industry. Zoning regulations sometimes specify the number or size of buildings in relation to land area. This is done to preserve the character of a community and to protect residential areas, for example, from the noise of heavy industry. A grandfather clause in most zoning regulations permits activities which existed prior to the establishment of the regulations to continue. That's why you might find a gas station or a drug store on a street otherwise zoned for residential use only.

Zoning regulations can sometimes have an important impact on the conduct of an art business. If you have a easel in the basement, for example, and you don't have heavy customer or truck traffic coming to your door, it is unlikely that you would be found in violation of residential zoning regulations in most areas. If you install a large kiln or a foundry operation, or open a retail outlet, you can almost count on having the authorities at your door, especially if the neighbors complain.

Most zoning regulations have provisions for granting an exception, known as a variance. This is process is begun by you petitioning for the variance. Hearings are held in which you present your case and your neighbors or such agencies as health, building, or fire departments have an opportunity to state their objections. The fire department, for example, may consider an open-hearth forge at the end of a narrow dead-end residential street of frame houses an additional hazard. The neighbors may simply object to the additional traffic from a retail operation.

Before you make major alterations in your studio or building, be sure they conform with the zoning regulations. Violations can be very expensive to correct.

Some jurisdictions have enacted special laws which permit artists to work in their residences. Other jurisdictions have allowed

artists to live in commercially-zoned studios. The first of these laws was passed in the SoHo district of New York City, where the Volunteer Lawyers for the Arts' first major project was to draft and successfully lobby through a law permitting artists to live in manufacturing lofts where their studios were located. A number of other jurisdictions have enacted comparable laws. California, for example, has adopted enabling legislation permitting local municipalities to pass special zoning laws for artists. (*See also* **Lease**)

APPENDIX A

Print and Multiples Disclosure Laws

Several states have enacted statutes to regulate the fine print and multiples market. They are California, Georgia, Hawaii, Illinois, Maryland, Michigan, Minnesota, New York, North Carolina, Oregon, and South Carolina.

West's Ann. Cal. Civ. Code §§ 1740 to 1745 (1983, Supp. 1992)

O.C.G.A. §§ 10-1-431 to 10-1-433 (1986)

Hawaii Rev. Stat. § 481F (1984, Supp. 1991)

Ill.— S.H.A. ch. 121 1/2, § 361 et seq. (Supp. 1991)

Md. Code, Comm. Law §§ 14-501 to 14-505 (1991)

M.G.L.A. §§ 422.351 to 442.367 (1991)

Minn. Stat. Ann. §§ 32.08 to 32.10 (1992)

N.Y.— McKinney's Arts & Cultural Affairs Law §§ 15.01 to 15.19 (Supp. 1991)

Or. Rev. Stat. 359.300 to 359.315 (1991)

S.C. Code 1976, §§ 39-16-10 to 39-16-59 (Supp. 1990)

APPENDIX B

Organizations

American Association of Museums
(AAM)
1225 I Street, N.W.
Washington, DC 20005
(202) 289-1818

**American Association of State
and Local History** (AASLH)
Patricia Michael, Executive Director
172 Second Avenue N., #202
Nashville, TN 37201
(615) 255-2971

American Council for the Arts
1 East 53rd Street
New York, NY 10022

Arts, Crafts and Theater Safety
(ACTS)
Director, Monona Rossol
181 Thompson Street, #23
New York, NY 10012
Publishes Arts Facts, *a monthly
newsletter updating regulations
and research affecting the arts.*

Center for Safety in the Arts
Director, Michael McCann
5 Beekman Street
New York, NY 10038
(212) 227-6220
Publishes Art Hazards News, *10 is-
sues yearly.*

College Art Association
275 Seventh Avenue
New York, NY 10001
(212) 691-1051
Dome Publishing Co.
Providence, RI 02903

Federal Trade Commission
Pennsylvania Avenue at 16th Street
Washington, DC 20580
(202) 326-2222

First Nation Arts
69 Kelly Road
Falmouth, VA 22405
(703) 371-5615

Ideal System Co.
P.O. Box 1568
Augusta, GE 30903

National Artists Equity
P.O. Box 28068
Washington, DC 20038-8068
(202) 628-9633

National Endowment for the Arts
(NEA)
1100 Pennsylvania Avenue, N.W.
Washington, DC 20506
(202) 682-5400
TDD (202) 682-5496

National Institute of Occupational
Safety & Health (NIOSH)
1-800-356-4674

New York Artist's Equity
498 Broom Street
New York, NY 10013
(212) 941-0130

Occupational Safety and Health
Administration (OSHA)
(202) 523-9667

Office of Student Financial
Assistance
U.S. Department of Education
Washington, DC 20202

SBA Publications
P.O. Box 30
Denver, CO 80201-0030

SBA Answer Desk
1-800-368-5855
653-7561 in Washington, D.C.

Small Business Administration
Washington, DC 20416

United States Copyright Office
Library of Congress
Washington, DC 20559

United States Customs Service
1301 Constitution Avenue, N.W.
Washington, DC 20229

List Brokers for Organizations:

Dependable Lists, Inc., 257 Park Ave., South, New York, NY 10010

R.L. Polk & Co., 551 Fifth Avenue, New York, NY 10017

Fred Woolf List Co., 309 Fifth Ave., New York, NY 10016

Alan Drey Co., Inc., 600 Third Ave., New York, NY 10016

Fritz S. Hofheimer, Inc., 88 Third Ave., Mineola, NY 11501

Noma List Services, 2544 Chamberlain Rd., Fairlawn, OH 44313

Names Unlimited, Inc., 183 Madison Ave., New York, NY 10016

APPENDIX C

Artist-Dealer Consignment Statutes

These statutes have been enacted in 29 states and the District of Columbia.

Alaska	Alaska Stat. §§45.65.200 to 45.65.250 (Michie 1989).
Arizona	Ariz. Rev. Stat. Ann. §§44-1771 to 1773 (West 1987).
Arkansas	Stat. Ann. §§4-73-201 to 207 (Michie 1987).
California	Cal. Civ. Code § 1738 (Derring 1991).
Colorado	Colo. Rev. Stat. §§6-15-101 to 104 (1990).
Connecticut	Conn. Gen. Stat. Ann. §§42-116k to 116m (West 1990).
District of Columbia	D.C. Code §§ 28:9-114 (1991).
Florida	Fla. Stat. §§686.501 to 503 (1989).
Idaho	Idaho Code §§28-11-101 to 106 (Michie 1990).
Illinois	Ill. Rev. Stat. ch. 121-1/2, para. 1401 to 1408 (1989).
Iowa	Iowa Code §§556D.1 to 556D.5 (1989).
Kentucky	Ky. Rev. Stat. Ann. §§365.850 to 875 (Baldwin 1991).
Maryland	Md. Com. Code Ann. §§11-8a-01 to 04 (Michie 1983).
Massachusetts	Mass. Ann. Laws ch. 104a, §§1 to 6 (Law. Co-op. 1990).
Michigan	Mich. Comp. Laws §§442.311 to 312a (1990).

Minnesota	Minn. Stat. §§324.01 to .05 (1990).
Missouri	Mo. Rev. Stat. §§ 407.900 to .910 (1989).
Montana	Mont. Code Ann. §§22-2-501 to 505 (1990).
New Hampshire	N.H. Rev. Stat. Ann. §§352:3 to 352:12 (1989).
New Jersey	N.J. Rev. Stat. §12A:2-330 (1990).
New Mexico	N.M. Stat. Ann. §§ 56-11-1 to 3 (1989).
New York	N.Y. Arts & Cult. Aff. Law §§11.01, 12.01 (McKinney 1991).
North Carolina	N.C. Gen. Stat. §§ 25C-1 to 5 (1990).
Ohio	Ohio Rev. Code Ann. §§1339.71 to 1339.78 (Baldwin1991).
Oregon	Or. Rev. Stat. §§359.200 to 359.255 (1989).
Pennsylvania	73 Pa. Cons. Stat. §§3122 to 2130 (1989).
Tennessee	Tenn. Code Ann. §§ 47-25-1001 to 1007 (1990).
Texas	Tex. Rev. Civ. Stat. Ann. art. 9018 (Vernon 1989).
Washington	Wash. Rev. Code Ann. § 18.110 (1990).
Wisconsin	Wis. Stat. Ann. §§ 129.01 to 129.08 (West 1989).

APPENDIX C2

Art Sellers Covered by the Statutes:

Alaska: "Art dealer" means a person engaged in the business of selling works of art, other than a person exclusively engaged in the business of selling goods at public auction.

Arizona: "Art dealer" means a person engaged in the business of selling works of fine art, other than a person exclusively engaged in the business of selling goods at public auction.

Arkansas: "Art dealer" means a person engaged in the business of selling works of art.

California: "Art dealer" means a person engaged in the business of selling works of fine art, other than a person exclusively engaged in the business of selling goods at public auction.

Colorado: "Art dealer" means a person engaged in the business of selling works of fine art, other than a person exclusively engaged in the business of selling goods at public auction.

Connecticut: "Art dealer" means a person, partnership, firm, association or corporation other than a public auctioneer who undertakes to sell works of fine art.

District of Columbia: "Art Dealer" means an individual, partnership, firm, association, or corporation, other than a public auctioneer, that undertakes to sell a work of fine art created by another.

Florida: "Art dealer" means a person engaged in the business of selling works of art, a person who is a consignee of a work of art, or a person who, by occupation, holds himself out as having knowledge or skill peculiar to works of art or rare documents or prints, or to whom such knowledge or skill may be attributed by his employment of an agent or broker or other intermediary who, by occupation, holds himself out as having such knowledge or skill. The term "art dealer" includes an auctioneer who sells works of art,

rare maps, rare documents, or rare prints at public auction as well as the auctioneer's consignor or principal. The term "art dealer" does not include a cooperative which is totally owned by artist members.

Idaho: "Art dealer" means a person engaged in the business of selling works of fine art, other than a person exclusively engaged in the business of selling goods at public auction.

Illinois: "Art dealer" means a person engaged in the business of selling works of fine art, other than a person exclusively engaged in the business of selling goods at public auction.

Iowa: "Art dealer" means a person engaged in the business of selling works of fine art, in a shop or gallery devoted in the majority to works of fine art, other than a person engaged in the business of selling goods of general merchandise or at a public auction.

Kentucky: "Art dealer" means a person engaged in the business of selling, as either a primary or supplemental source of income, works of fine art, other than a person exclusively engaged in the business of selling goods at public auction.

Maryland: "Art dealer" means an individual, partnership, firm, association, or corporation, other than a public auctioneer, that undertakes to sell a work of fine art created by someone else.

Massachusetts: "Art dealer" means a person engaged in the business of selling works of fine art, other than a person exclusively engaged in the business of selling goods at public auction.

Michigan: "Art dealer" means a person engaged in the business of selling works of fine art, other than a person exclusively engaged in the business of selling goods at public auction.

Minnesota: "Art dealer" means a person engaged in the business of selling works of fine art, other than a person exclusively engaged in the business of selling goods at public auction.

Missouri: The term "art dealer" means a person engaged in the business of selling fine arts. The term "art dealer" does not include any person engaged exclusively in the business of selling goods at public auction.

Montana: "Art dealer" means a person engaged in the business of selling works of fine art, other than a person exclusively engaged in the business of selling goods at public auction.

New Hampshire: "Art dealer" means a person, including an individual, partnership, firm, association, or corporation, engaged in the business of selling works of art, other than a person exclusively engaged in the business of selling goods at a public auction.

New Jersey: "Art dealer" means a person engaged in the business of selling crafts and works of fine art, other than a person exclusively engaged in the business of selling goods at public auction.

New Mexico: "Art dealer" means a person primarily engaged in the business of selling works of art.

New York: "Art merchant" means a person who is in the business of dealing, exclusively or non-exclusively, in works of fine art or multiples, or a person who by his occupation holds himself out as having knowledge or skill peculiar to such works, or to whom such knowledge or skill may be attributed by his employment of an agent or other intermediary who by his occupation holds himself out as having such knowledge or skill. The term "art merchant" includes an auctioneer who sells such works at public auction, and except in the case of multiples, includes persons, not otherwise defined or treated as art merchants herein, who are consignors or principals of auctioneers.

North Carolina: "Art dealer" means an individual, partnership, firm, association, or corporation that undertakes to sell a work of fine art created by someone else.

Ohio: "Art dealer" means a person engaged in the business of selling works of art, other than a person exclusively engaged in the business of selling goods at public auction.

Oregon: "Art dealer" means a person, other than a public auctioneer, who undertakes to sell a work of fine art created by another.

Pennsylvania: "Art dealer." A person engaged in the business of selling crafts and works of fine art, other than a person exclusively engaged in the business of selling goods at public auction.

Tennessee: "Art dealer" means a person engaged in the business of selling works of art, other than a person exclusively engaged in the business of selling goods at public auction.

Texas: "Art dealer" means a person engaged in the business of selling works of art.

Washington: "Art dealer" means a person, partnership, firm, association or corporation, other than a public auctioneer, which undertakes to sell a work of fine art created by another.

Wisconsin: "Art dealer" means a person engaged in the business of selling works of fine art, other than a person exclusively engaged in the business of selling goods at public auction.

Art Works Protected by the Statutes:

Alaska: "Work of art" means an original or multiple original art work including: (A) visual art such as a painting, sculpture, drawing, mosaic, or photograph; (B) calligraphy; (C) graphic art such as an etching, lithograph, offset print, or silk screen; (D) craft work in clay, textile, fiber, wood, metal, plastic, or glass materials; (E) mixed media such as a collage or any combination of art media in this paragraph; (F) art employing traditional native materials such as ivory, bone, grass, baleen, animal skins, wood and furs.

Arizona: "Work of fine art" means an original or multiple original art work which is: (a) A visual rendition, including a painting, drawing, sculpture, mosaic or photograph. (b) A work of calligraphy. (c) A work of graphic art, including an etching, lithograph, offset print or silkscreen. (d) A craft work in materials, including clay, textile, fiber, wood, metal, plastic or glass. (e) A work in mixed media, including a collage or a work consisting of any combination of subdivisions (a) through (d).

Arkansas: "Art" means a painting, sculpture, drawing, work of graphic art, pottery, weaving, batik, macrame, quilt, or other commonly recognized art form.

California: "Fine art" means a painting, sculpture, drawing, work of graphic art (including an etching, lithograph, offset print, silk screen, or a work of graphic art of like nature), a work of calligraphy, or a work in mixed media (including a collage, assemblage, or any combination of the foregoing art media).

Colorado: "Work of fine art" or "work" means: (a) A work of visual art such as a painting, sculpture, drawing, mosaic or photograph; (b) A work of calligraphy; (c) A work of graphic art such as an etching, a lithograph, an offset print, a silk screen, or any other work of similar nature; (d) A craft work in materials, including but not limited to clay, textile, fiber, wood, metal, plastic, or glass; (e) A work in mixed media such as a collage or any combination of the art media set forth in this subsection.

Connecticut: "Fine art" means (1) a work of visual art such as a painting, sculpture, drawing, mosaic or photograph; (2) a work of calligraphy; (3) a work of graphic art such as an etching, lithograph, offset print, silk screen, or other work of graphic art of like nature; (4) crafts such as crafts in clay, textile, fiber, wood, metal, plastic, glass or similar materials; and (5) a work in mixed media such as a collage or any combination of the foregoing art media.

**District of
Columbia:** "Work of Fine Art" means a original art work which is: (a) a visual rendition including a painting, drawing, sculpture, mosaic, or photograph; (b) a work of calligraphy; (c) a work of graphic art including an etching, lithographic, offset print, or silk screen; d) a craft work in materials including clay, textile, fiber, wood, metal, plastic, or glass; or (e) a work in mixed media including a collage or a work consisting of any combination of works included in this subsection.

Florida: "Art" means a painting, sculpture, drawing, work of graphic art, pottery, weaving, batik, macrame, quilt, print, photograph, or craft work executed in materials including, but not limited to, clay, textile, paper, fiber, wood, tile, metal, plastic, or glass. The term shall also include a rare map which is offered as a limited edition or a map 80 years old or older; or a rare document or rare print which includes, but is not limited to, a print, engraving, etching, woodcut, lithograph, or serigraph which is offered as a limited edition, or one 80 years old or older.

Idaho: "Fine art" means a painting, sculpture, drawing, work of graphic art, including an etching, lithograph, signed limited edition offset print, silk screen, or a work of graphic art of like nature; a work of calligraphy, photographs, original works in ceramics, wood, metals, glass, plastic, wax, stone or leather or a work in mixed media, including a collage, assemblage, or any combination of the art media mentioned in this subsection.

Illinois: "Work of fine art" means: (a) A visual rendition including, but not limited to, a painting, drawing, sculpture, mosaic, videotape, or photograph. (b) A work of calligraphy. (c) A work of graphic art including, but not limited to, an etching, lithograph, serigraph, or offset print. (d) A craft work in materials including, but not limited to, clay, textile, fiber, wood, metal, plastic, or glass. (e) A work in mixed media including, but not limited to, a collage, assemblage, or work consisting of any combination of paragraphs (a) through (d).

Iowa: "Fine art" means a painting, sculpture, drawing, mosaic, photograph, work of graphic art, including an etching, lithograph, offset print, silk screen, or work of graphic art of like nature, a work of calligraphy, or a work in mixed media including a collage, assemblage, or any combination of these art media which is one of a kind or is available in a limited issue or series.

"Fine art" also means crafts which include work in clay, textiles, fiber, wood, metal, plastic, glass, or similar materials which is one of a kind or is available in a limited issue or series.

Kentucky: "Fine art" shall include, but is not limited to, a painting, sculpture, drawing, work of graphic or photographic art, including an etching, lithograph, offset print, silk screen, or work of graphic art of like nature, a work of calligraphy, a work of folk art or craft, or a work in mixed media including a collage, assemblage, or any combination of the foregoing art media.

Maryland: "Work of fine art" means an original art work which is: (1) A visual rendition including a painting, drawing, sculpture, mosaic, or photograph; (2) A work of calligraphy; (3) A work of graphic art including an etching, lithograph, offset print, or silk screen; (4) A craft work in materials including clay, textile, fiber, wood, metal, plastic, or glass; or (5) A work in mixed media including a collage or a work consisting of any combination of works included in this subsection.

Massachusetts: "Fine art," a painting, sculpture, drawing, work of graphic art, including an etching, lithograph, offset print, silk screen, or work of graphic art of like nature, a work of calligraphy, or a work in mixed media including a collage, assemblage, or any combination of the foregoing art media.

Michigan: "Art" means a painting, sculpture, drawing, work of graphic art, photograph, weaving, or work of craft art.

Minnesota: "Art" means a painting, sculpture, drawing, work of graphic art, photograph, weaving, or work of craft art.

Missouri: The term "fine arts" includes: (a) Visual art such as paintings, sculptures, drawings, mosaics, or photographs; (b) Calligraphy; (c) Graphic art such as etchings, lithographs, offset prints, silk screens, and other works of a similar nature; (d) Crafts, including any item made by an artist or craftsman through the use of clay, textiles, fibers, wood, metal, plastic, glass, ceramics, or similar materials; (e) Works in mixed media such as collages or any combination of the art forms or media listed in paragraph (a), (b), (c), or (d) of.this subdivision.

Montana: "Fine art" means a painting, sculpture, drawing, work of graphic art (including an etching, lithograph, signed limited edition offset print, silk screen, or work of graphic art of like nature), a work of calligraphy, photographs, original works in ceramics, wood, metals, glass, plastic, wax, stone, or leather, or a work in mixed media (including a collage, assemblage, or any combination of the art media mentioned in this subsection).

New Hampshire: "Work of art" means an original art work that is any of the following: (a) A visual rendition including, but not limited to, a painting, drawing, sculpture, mosaic, or photograph. (b) A work of calligraphy. (c) A work of graphic art, including, but not limited to, an etching, lithograph, offset print, silk screen, or other work of similar materials. (d) A craft work in materials, including, but not limited to, clay, textile, fiber, wood, metal, plastic, glass, or similar materials. (e) A work in mixed media, including, but not limited to, a collage or a work consisting of any combination of the items listed in subparagraphs (a) through (d) of this paragraph.

New Jersey: "Craft" means an artistic rendition created using any medium, including, but not limited to, a collage and other works consisting of any combination of painting, drawing, sculpture, photography and manual creation in clay, textile, fiber, wood, metal, plastic, glass, stone, leather or similar materials.

"Fine art" means an original work of visual or graphic art created using any medium, including but not limited to, a painting, drawing or sculpture.

Wisconsin: "Work of fine art" means an original art work which is: (a) A visual rendition including, but not limited to, a painting, drawing, sculpture, mosaic, or photograph; (b) A work of calligraphy; (c) A work of graphic art, including, but not limited to, an etching, lithograph, offset print or silk screen; (d) A craft work in materials, including but not limited to clay, textile, fiber, wood, metal, plastic or glass; (e) A work in mixed media, including, but not limited to, a collage or a work consisting of any combination of pars. (a) to (d).

Special Provisions:

Alaska: Artist-consignor may waive the right to trust-property protection, if such waiver is clear, conspicuous, and agreed to in writing by the artist. No waiver is valid with respect to proceeds from work initially placed on consignment but later purchased by the art dealer-consignee. Nor shall any waiver inure to the benefit of the consignee's creditors in a manner inconsistent with the artist's rights.

Arizona: Any waiver by artist is void. An art dealer who violates the statute is liable to the artist for damages of $50 plus actual damages, including incidental and consequential damages, sustained by the artist, and reasonable attorney fees.

Arkansas: Any waiver by artist is void. An art dealer who violates the statute is liable to the artist for a civil penalty of $50 plus actual damages, including incidental and consequential damages, sustained by the artist. Reasonable attorneys' fees and court cost shall be paid the prevailing party.

California: Any waiver by artist is void.

Colorado: Any waiver by artist is void. An art dealer who violates the statute is liable to the artist for a civil penalty of $50 plus actual damages, including incidental and consequential damages, sustained by the artist. Reasonable attorneys' fees and court cost shall be paid the prevailing party.

Connecticut: Any waiver by artist is void. Artist-consignor is required to give notice to the public by placing a tag on the work stating that it is being sold under consignment or by posting a conspicuous sign in consignee's place of business giving notice that some works are being sold under consignment. Statute requires a written agreement covering (1) payment schedule for sale proceeds; (2) responsibility of gallery for loss or damage; (3) written agreement as to retail prices; and (4) artist's written consent to displays and credit on displays.

District of Columbia: None.

Florida: Any waiver by artist is void. Artist-consignor is required to give notice to the public by placing a tag on the work stating that it is being sold under consignment or by posting a conspicuous sign in consignee's place of business giving notice that some works are being sold under consignment.

Idaho: The art dealer, after delivery of the work of fine art, is an agent of the artist for the purpose of sale or exhibition of the consigned work of fine art within the state of Idaho. This relationship shall be defined in writing and renewed at least every three (3) years by the art dealer and the artist. It is the responsibility of the artist to identify clearly the work of art by securely attaching identifying marking to or clearly signing the work of art.

Illinois: If the sale of the work of fine art is on installment, the funds from the installment shall first be applied to pay any balance due to the artist on the sale, unless the parties expressly agree in writing that the proceeds on each installment shall be paid according to a percentage established by the consignment agreement. Customer deposits shall be used to pay the amounts due the artist within 30 days after such deposits become part of the payment for the work. Any agreement entered into pursuant to this subsection must be clear and conspicuous.

Iowa: Any waiver by artist is void.

Kentucky: Maryland: None.

Massachusetts: Artist can give written waiver of right to have sale proceeds applied first to pay any balance due artist. If gallery buys artworks for its own account, proceeds shall be trust funds until artist is paid in full.

Michigan: Artist may waive right to have sale proceeds in any twelve month period in excess of $2500 considered trust funds. If gallery buys the artwork, artist must be paid in full and no waiver of trust fund provision is permitted.

Minnesota: Missouri: Montana: New Hampshire: New Jersey: New Mexico: None.

New York: Artist-consignor may waive the right to trust-property protection of sale proceeds exceeding $2500 in any twelve month period beginning with the date of the waiver. To be valid, such waiver must be clear, conspicuous, in writing, and signed by the consignor. No waiver is valid with respect to proceeds from work initially placed on consignment but later purchased by the art dealer-consignee. Nor shall any waiver inure to the benefit of the consignee's creditors in a manner inconsistent with the artist's rights.

North Carolina: Ohio: None

Oregon: The art dealer may accept a work of fine art on consignment only if the dealer and artist enter into a written contract establishing: (1) the retail value of the work; (2) the time within which the proceeds of the sale are to be paid to the artist; (3) the minimum price for the sale of the work; (4) the percentage of the proceeds to be retained by the dealer. Any provision of a contract or agreement whereby the consignor waives any of the statute is void.

Pennsylvania: Tennessee: Texas: None.

Washington: The art dealer may accept a work of fine art on consignment only if the art dealer enters into a written contract with the artist which states: (a) the value of the work; (b) the minimum price for the sale of the work; (c) the fee, commission, or other compensation basis of the art dealer. Any portion of a contract that waives any portion of this statute is void. The gallery can only display the work if notice is given that it is the work of the artist and artist gives prior written consent to the particular use or display. If the gallery violates the statute, it is liable to the artist for $50 plus actual damages, and the artist's obligation for compensation to the dealer is voidable. The court may award the artist reasonable attorney's fees.

Wisconsin: Statute requires a written contract that establishes: (1) an agreed on value for the artwork; (2) the time after sale in which payments must be made to the artist; and (3) the minimum sale price for the consigned artworks. If the gallery fails to enter into such a written contract, a court can void the artist's obligations to the gallery. Also, the gallery can only display an artwork if it credits the artist as creator and has the artist's consent to the particular display. If the gallery violates the statute it must pay the artist $50 plus actual damages and attorney's fees.

APPENDIX D

Bibliography of Printed References

Art Marketing Source Book for the Fine Artist
edited by Constance Franklin-Smith
Art Network
P.O. Box 369 Renaissance, CA 95962
336 pages; ISBN 0-940899-19-1, $21.95 softcover

Art Marketing Handbook for the Fine Artist
by Constance Franklin-Smith
Art Network
P.O. Box 369 Renaissance, CA 95962
192 pages; $24.95 softcover

Art Law in a Nutshell, 2d ed.
by Leonard D. DuBoff (1993)
West Publishing Co.,
P.O. Box 64526 St. Paul, MN 55164-0526 • (612) 228-2778
350 pages; ISBN 0-314-01335-0 softcover

The Artists Complete Health and Safety Guide
by Monona Rossol
Allworth Press, 10 E. 23rd Street, New York, NY 10010 • (212) 777-8395
328 pages; $19.95 softcover

**Be Your Own Boss: The Complete, Indispensable, Hands-On Guide to
Starting and Running Your Own Business** by Dana Schilling (1984)
Penguin, 375 Hudson St. New York, NY 10014 • (212) 366-2000; 800-331-4624

Business & Legal Forms for Fine Artists
by Tad Crawford
Allworth Press, 10 E. 23rd Street, New York, NY 10010 • (212) 777-8395
128 pages; $12.95 softcover

Business Forms & Contracts (In Plain English)® for Craftspeople, 2d ed.
by Leonard D. DuBoff (1993)
Interweave Press, 201 E. Fourth Street Loveland, CO 80537
(303) 669-7672; 800-272-2193
110 pages; ISBN 0-934026-83-1 $14.95 softcover

The Business of Being an Artist by Daniel Grant
Allworth Press, 10 E. 23rd Street, New York, NY 10010 • (212) 777-8395
224 pages; ISBN 0-9607118-5-6 $16.95 softcover

Caring for Your Art by Jill Snyder, illustrated by Joseph Montague
Allworth Press, 10 E. 23rd Street, New York, NY 10010 • (212) 777-8395
176 pages; ISBN 0-9607118-1-3 $14.95 softcover

Copyright Directory Copyright Information Services, a division of
Association for Educational Communications and Technology
1025 Vermont Avenue, N.W., Suite 820 Washington, D.C. 20005
134 pages; ISBN 1-914-143-22-0 $78.00 hardcover

Cultural Business Times bi-monthly publication of Fred B. Rothman and
Company, Denver, Colorado

The Deskbook of Art Law, 2d ed. by Leonard D. DuBoff & Sally Holt Caplan
Oceana Press, 75 Main Street Dobbs Ferry, NY 10522 • (914) 693-8100
two volumes; ISBN 0-379201-57-7 $350.00 hardcover

"Fire Safety Fact Sheet" Publications 91-41 and 3088
OSHA Information,
Room N-3647, U.S. Department of Labor, Washington, DC 20210

Form Book of Art Law by Leonard D. DuBoff
Fred B. Rothman and Company, Denver, Colorado, 1994

"Guide to the NEA" Visual Arts Fellowship Program
National Endowment for the Arts, Washington, DC 20506
(202) 682-5400; TDD: (202) 682-5496

"Insurance Checklist for Small Business"
Small Marketer's Aid #148
Small Business Administration, Washington, DC 20416

"Insurance and Risk Management for Small Business"
Small Business Management Series No. 30, 2d edition
Superintendent of Documents
U.S. Government Printing Office, Washington, DC 20402

The Law (In Plain English)® for Art and Craft Galleries
by Leonard D. DuBoff (1994)
Interweave Press, 201 E. Fourth Street Loveland, CO 80537
(303) 669-7672; (800) 272-2193
156 pages; ISBN 0-934026-87-4 $14.95 softcover

The Law (In Plain English)® for Small Businesses, 2d ed.
by Leonard D. DuBoff (1991)
Wiley & Sons, 605 Third Avenue New York, NY 10158-0012 • (212) 850-6000
240 pages; ISBN 0-471-53617-2 $29.95 hardcover
ISBN 0-471-53616-4 $14.95 softcover

Legal Guide for the Visual Artist by Tad Crawford
Allworth Press, 10 E. 23rd Street, New York, NY 10010 • (212) 777-8395
256 pages; $19.95 softcover

Licensing Art & Design by Caryn R. Leland
Allworth Press, 10 E. 23rd Street, New York, NY 10010 • (212) 777-8395
8395ISBN 0-927629-046, 112 pages, $12.95

Make It Legal by Lee Wilson
Allworth Press, 10 E. 23rd Street, New York, NY 10010 • (212) 777-8395
272 pages; $18.95 softcover

Money for International Exchange in the Arts by Jane Gullong
Allworth Press, 10 E. 23rd Street, New York, NY 10010 • (212) 777-8395
200 pages; ISBN 1-879903-01-6 $14.95 softcover

Money for Visual Artists by Suzanne Niemeyer
Allworth Press, 10 E. 23rd Street, New York, NY 10010 • (212) 777-8395
244 pages; ISBN 1-879903-05-9 $14.95 softcover

On Becoming an Artist by Daniel Grant
Allworth Press, 10 E. 23rd Street, New York, NY 10010 • (212) 777-8395
192 pages; ISBN 1-880559-07-2 $12.95 softcover

The Photographer's Business and Legal Handbook
by Leonard D. DuBoff (1989)
Images Press, Inc., 22 E. 17th Street New York, NY 10003 • (212) 675-3707
156 pages; ISBN 0-929667-02-6 $18.95 softcover

Photographing Your Product for Advertising & Promotion:
A Handbook for Designers and Craftsmen by Norbert Nelson (1971)
Van Nostrand-Reinhold Co., 115 Fifth Avenue New York, NY 10003
(212) 254-3232; 800-926-2665

Photography for Artists and Craftsmen by Claus-Peter Schmid, (1975)
Van Nostrand-Reinhold Co., 115 Fifth Avenue New York, NY 10003
(212) 254-3232; 800-926-2665

Protecting Your Rights and Increasing Your Income:
A Guide for Authors, Graphic Designers, Illustrators, and Photographers,
by Tad Crawford
Allworth Press, 10 E. 23rd Street, New York, NY 10010 • (212) 777-8395
60 minute audio cassette; ISBN 0-9607118-0-5 $12.95

"Sound Cash Management and Borrowing" Publication FM9
SBA Publications, P.O. Box 30 Denver, CO 80201-0030

"Tax Guide for Small Business" Publication 334
Internal Revenue Service, U.S. Government Printing Office
Washington, DC 20402

Ventilation: A Practical Guide
Nancy Clark, Thomas Cutler, Jean-Ann McGrane (1980)
Center for Occupational Hazards 5 Beekman Street, New York, NY 10038
(212) 227-6220
128 pages; $15.99 hardcover, $7.95 softcover

Westart P.O. Box 1396 Auburn, CA 95603

"Your Social Security" Social Security Office
See telephone book in U.S. Government pages for local office.

APPENDIX E

FORM VA
For a Work of the Visual Arts
UNITED STATES COPYRIGHT OFFICE

REGISTRATION NUMBER

VA VAU
EFFECTIVE DATE OF REGISTRATION

Month Day Year

DO NOT WRITE ABOVE THIS LINE. IF YOU NEED MORE SPACE, USE A SEPARATE CONTINUATION SHEET.

TITLE OF THIS WORK ▼ **NATURE OF THIS WORK ▼** See instructions

PREVIOUS OR ALTERNATIVE TITLES ▼

PUBLICATION AS A CONTRIBUTION If this work was published as a contribution to a periodical, serial, or collection, give information about the collective work in which the contribution appeared. **Title of Collective Work ▼**

If published in a periodical or serial give: **Volume ▼** **Number ▼** **Issue Date ▼** **On Pages ▼**

2 a

NAME OF AUTHOR ▼ **DATES OF BIRTH AND DEATH**
Year Born ▼ Year Died ▼

Was this contribution to the work a "work made for hire"?
☐ Yes
☐ No

AUTHOR'S NATIONALITY OR DOMICILE
Name of Country
OR { Citizen of ▶_____
{ Domiciled in ▶_____

WAS THIS AUTHOR'S CONTRIBUTION TO THE WORK
Anonymous? ☐ Yes ☐ No
Pseudonymous? ☐ Yes ☐ No
If the answer to either of these questions is "Yes," see detailed instructions.

NATURE OF AUTHORSHIP Check appropriate box(es). **See instructions**
☐ 3-Dimensional sculpture ☐ Map ☐ Technical drawing
☐ 2-Dimensional artwork ☐ Photograph ☐ Text
☐ Reproduction of work of art ☐ Jewelry design ☐ Architectural work
☐ Design on sheetlike material

NOTE
Under the law, the "author" of a "work made for hire" is generally the employer, not the employee (see instructions). For any part of this work that was "made for hire" check "Yes" in the space provided, give the employer (or other person for whom the work was prepared) as "Author" of that part, and leave the space for dates of birth and death blank.

b

NAME OF AUTHOR ▼ **DATES OF BIRTH AND DEATH**
Year Born ▼ Year Died ▼

Was this contribution to the work a "work made for hire"?
☐ Yes
☐ No

AUTHOR'S NATIONALITY OR DOMICILE
Name of Country
OR { Citizen of ▶_____
{ Domiciled in ▶_____

WAS THIS AUTHOR'S CONTRIBUTION TO THE WORK
Anonymous? ☐ Yes ☐ No
Pseudonymous? ☐ Yes ☐ No
If the answer to either of these questions is "Yes," see detailed instructions.

NATURE OF AUTHORSHIP Check appropriate box(es). **See instructions**
☐ 3-Dimensional sculpture ☐ Map ☐ Technical drawing
☐ 2-Dimensional artwork ☐ Photograph ☐ Text
☐ Reproduction of work of art ☐ Jewelry design ☐ Architectural work
☐ Design on sheetlike material

3 a
YEAR IN WHICH CREATION OF THIS WORK WAS COMPLETED This information must be given ◀Year in all cases.

b **DATE AND NATION OF FIRST PUBLICATION OF THIS PARTICULAR WORK**
Complete this information ONLY if this work has been published.
Month ▶ _____ Day ▶ _____ Year ▶ _____ ◀ Nation

4
COPYRIGHT CLAIMANT(S) Name and address must be given even if the claimant is the same as the author given in space 2. ▼

TRANSFER If the claimant(s) named here in space 4 are different from the author(s) named in space 2, give a brief statement of how the claimant(s) obtained ownership of the copyright. ▼

See instructions before completing this space.

APPLICATION RECEIVED

ONE DEPOSIT RECEIVED

TWO DEPOSITS RECEIVED

REMITTANCE NUMBER AND DATE

DO NOT WRITE HERE
OFFICE USE ONLY

MORE ON BACK ▶ • Complete all applicable spaces (numbers 5-9) on the reverse side of this page.
• See detailed instructions. • Sign the form at line 8.

DO NOT WRITE HERE
Page 1 of _____ pages

EXAMINED BY	FORM V
CHECKED BY	
☐ CORRESPONDENCE Yes	FOR COPYRIG OFFICE USE ONLY

DO NOT WRITE ABOVE THIS LINE. IF YOU NEED MORE SPACE, USE A SEPARATE CONTINUATION SHEET.

PREVIOUS REGISTRATION Has registration for this work, or for an earlier version of this work, already been made in the Copyright Office?

☐ Yes ☐ No If your answer is "Yes," why is another registration being sought? (Check appropriate box) ▼

a. ☐ This is the first published edition of a work previously registered in unpublished form.

b. ☐ This is the first application submitted by this author as copyright claimant.

c. ☐ This is a changed version of the work, as shown by space 6 on this application.

If your answer is "Yes," give: **Previous Registration Number** ▼ **Year of Registration** ▼

5

DERIVATIVE WORK OR COMPILATION Complete both space 6a & 6b for a derivative work; complete only 6b for a compilation.

a. **Preexisting Material** Identify any preexisting work or works that this work is based on or incorporates. ▼

6

b. **Material Added to This Work** Give a brief, general statement of the material that has been added to this work and in which copyright is claimed. ▼

See instruction
before comple
this space.

DEPOSIT ACCOUNT If the registration fee is to be charged to a Deposit Account established in the Copyright Office, give name and number of Account.

Name ▼ **Account Number** ▼

7

CORRESPONDENCE Give name and address to which correspondence about this application should be sent. Name/Address/Apt/City/State/Zip ▼

Area Code & Telephone Number▶

Be sure to
give your
daytime pho
◀ number

CERTIFICATION* I, the undersigned, hereby certify that I am the

Check only one ▼

☐ author

☐ other copyright claimant

☐ owner of exclusive right(s)

☐ authorized agent of _____

Name of author or other copyright claimant, or owner of exclusive right(s) ▲

8

of the work identified in this application and that the statements made
by me in this application are correct to the best of my knowledge.

Typed or printed name and date ▼ If this application gives a date of publication in space 3, do not sign and submit it before that date.

 date▶ _____

☞ Handwritten signature (X) ▼

MAIL CERTIFI-CATE TO	Name ▼	YOU MUST • Complete all necessary spaces • Sign your application in space 8	**9**
Certificate will be mailed in window envelope	Number/Street/Apartment Number ▼	SEND ALL ELEMENTS IN THE SAME PACKAGE 1. Application form 2. Nonrefundable $20 filing fee in check or money order payable to *Register of Copyrights* 3. Deposit material	The Copyright Offi has the authority to a just fees at 5-year int vals, based on chang in the Consumer Pri Index. The next adjust ment is due in 199 Please contact t Copyright Office aft July 1995 to determi the actual fee schedul
	City/State/ZIP ▼	MAIL TO Register of Copyrights Library of Congress Washington, D.C. 20559	

July 1992—100,000

☆U.S. GOVERNMENT PRINTING OFFICE: 1992-312-432/60,00

APPENDIX F

Volunteer Lawyers Organizations

CALIFORNIA

California Lawyers for the Arts (CLA)
Fort Mason Center
Building C, Room 255
San Francisco, California 94123 • (415) 775-7200

California Lawyers for the Arts (CLA)
1549 Eleventh Street, Suite 200
Santa Monica, California 90401 • (310) 395-8893

San Diego Lawyers for the Arts
Attention: Peter Karlen
1205 Prospect Street, Suite 400
La Jolla, California 92037 • (619) 454-9696

COLORADO

Colorado Lawyers for the Arts (COLA)
208 Grant Street
Denver, Colorado 80203
(303) 722-7994

CONNECTICUT

Connecticut Commission on the Arts (CTVLA)
227 Lawrence Street
Hartford, Connecticut 06106
(203) 566-4770

DISTRICT OF COLUMBIA

Washington Volunteer Lawyers for the Arts
Att: Joshua Kaufman
918 Sixteenth Street, N.W., Suite 503
Washington, D.C. 20006
(202) 429-0229

Washington Area Lawyers for the Arts (WALA)
1325 G Street, NW -- Lower Level
Washington, D.C. 20005
(202) 393-2826

FLORIDA

Volunteer Lawyers for the Arts/Broward
and Business Volunteer Lawyers for the Arts/Broward, Inc.
5900 North Andrews Avenue, Suite 907
Fort Lauderdale, Florida 33309 • (305) 771-4131

Business Volunteers for the Arts/Miami (BVA)
150 West Flagler Street, Suite 2500
Miami, Florida 33130 • (305) 789-3590

GEORGIA

Georgia Volunteer Lawyers for the Arts (GVLA)
141 Pryor Street SW, Suite 2030
Atlanta, Georgia 30303 • (404) 525-6046

ILLINOIS

Lawyers for the Creative Arts (LCA)
213 West Institute Place, Suite 411
Chicago, Illinois 60610
(312) 944-2787

KANSAS

Kansas Association of Non-profits
c/o Susan J. Whitfield-Lungren, Esq.
400 North Woodlawn, East Building, Suite 212
Post Office Box 780227
Wichita, Kansas 67278-0227
(316) 685-3790

LOUISIANA

Louisiana Volunteer Lawyers for the Arts (LVLA)
c/o Arts Council of New Orleans
821 Gravier Street, Suite 600
New Orleans, Louisiana 70112
(504) 523-1465

MARYLAND

Maryland Lawyers for the Arts
Belvedere Hotel
1 East Chase Street, Suite 1118
Baltimore, Maryland 21202-2526
(410) 752-1633

MASSACHUSETTS

Lawyers for the Arts
The Artists Foundation, Inc.
8 Park Plaza
Boston, Massachusetts 02116 • (617) 227-2787

MINNESOTA

Resources and Counseling, United Arts
429 Landmark Center
75 West 5th Street
St. Paul, Minnesota 55102 • (612) 292-3206

MISSOURI

Saint Louis Volunteer Lawyers and Accountants for the Arts (SLVLAA)
3540 Washington
Saint Louis, Missouri 63103 • (314) 652-2410

Kansas City Attorneys for the Arts
c/o Rosalee M. McNamara
Gage & Tucker
2345 Grand Avenue
Kansas City, Missouri 64108 • (816) 474-6460

MONTANA

Montana Volunteer Lawyers for the Arts
c/o Jean Jonkel, Esq.
P.O. Box 8687
Missoula, Montana 59807 • (406) 721-1835

NEVADA

Mark G. Tratos
c/o Quirk & Tratos
550 East Charleston Blvd.
Las Vegas, Nevada 89104 • (702) 386-1778

NEW JERSEY

New Jersey Bar Committee on Entertainment and The Arts
Christopher Sidoti
c/o Mathews, Woodbridge & Collins
100 Thanet Circle, Suite 306
Princeton, New Jersey 08540-3662
(609) 924-3773

NEW YORK

Volunteer Lawyers for the Arts Program
Albany/ Schenectady League of Arts (ALA)
19 Clinton Avenue
Albany, New York 12207 • (518) 449-5380

Volunteer Lawyers for the Arts (VLA)
One East 53rd Street, Sixth Floor
New York, New York 10022 • (212) 319-2787

Arts Council in Buffalo and Erie County
c/o Karen Kosman, Program Coordinator
700 Main Street
Buffalo, New York 64141 • (716) 856-7520

NORTH CAROLINA

North Carolina Volunteer Lawyers for the Arts (NCVA)
c/o William F. Moore, Esquire
P.O. Box 26513
Raleigh, North Carolina 27611-6513 • (919) 832-9661

OHIO

Volunteer Lawyers and Accountants for the Arts (VLAA)
c/o The Cleveland Bar Association
113 Saint Clair Avenue, Suite 225
Cleveland, Ohio 44114-1253 • (216) 696-3525

Toledo Volunteer Lawyers for the Arts
c/o Arnold Gottlieb
608 Madison Avenue
Toledo, Ohio 43604 • (419) 255-3344

OKLAHOMA

Oklahoma Volunteer Lawyers and Accountants for the Arts
Post Office Box 266
Edmond, Oklahoma 73083 • (405) 340-7988

PENNSYLVANIA

Philadelphia Volunteer Lawyers for the Arts (PVLA)
The Arts Alliance Building
251 South 18th Street
Philadelphia, Pennsylvania 19103
(215) 545-3385

RHODE ISLAND

Ocean State Lawyers for the Arts (OSLA)
P.O. Box 19
Saunderstown, Rhode Island 02874
(401) 789-5686

TENNESSEE

Tennessee Arts Commission
Bennett Tarleton
320 Sixth Avenue N.
Nashville, Tennessee 37243-0780
(615) 741-1701

TEXAS

Austin Lawyers and Accountants for the Arts (ALAA)
340 Executive Center Drive
Austin, Texas 78731
(512) 338-4458

Texas Accountants and Lawyers for the Arts/Dallas
c/o Katherine Wagner
2917 Swiss Avenue
Dallas, Texas 75204
(214) 821-2522

Texas Accountants and Lawyers for the Arts (TALA)
1540 Sul Ross
Houston, Texas 77006
(713) 526-4876

UTAH

Utah Lawyers for the Arts (ULA)
170 South Main Street, Suite 1500
Post Office Box 45444
Salt Lake City, Utah 84145-0444
(801) 521-3200

WASHINGTON

Washington Lawyers for the Arts (WLA)
219 First Avenue S. Suite 315-A
Seattle, Washington 98104
(206) 292-9171

OTHER VOLUNTEER LAWYERS GROUPS

AUSTRALIA

Art Law Centre of Australia
Att: Michael McMahon
The Gunnery
43 Cowper Wharf Road
Woolloomooloo
New South Wales 2011
02-356-2566

CANADA

Canadian Artists' Representation Ontario (CARO)
Artist's Legal Advice Services (ALAS - Ontario)
183 Bathurst St., 1st Floor
Toronto, Ontario M5T 2R7, Canada
(416) 360-0780

Canadian Artists' Representation Ontario (CARO)
Artist's Legal Advice Services (ALAS - Ottawa)
189 Laurier Avenue E.
Ottawa, Ontario K1N 6P1, Canada
(613) 235-6277

Canadian Artists' Representation Saskatchewan (CARFAC)
Artist's Legal Advice Services (ALAS - Saskatchewan)
210-1808 Smith Street
Regina, Saskatchewan S4P 2N3, Canada
(306) 522-9788

PUERTO RICO

Voluntarios Por Las Artes/Volunteers for the Arts
563 Trigo Street
El Dorado Blvd., Suite 5-B
Miramar, Puerto Rico 00907
(809) 724-0700

INDEX